HISTORY OF AN ART

DRAWING

HISTORY OF AN ART

DRAWING

Jean Leymarie
Director of the Académie de France, Rome

Geneviève Monnier
Curator of the Cabinet des Dessins, Musée du Louvre, Paris

Bernice Rose
Curator of the Department of Drawings,
The Museum of Modern Art, New York

SKIRA

RIZZOLI
NEW YORK

© 1979 by Editions d'Art Albert Skira S.A., Geneva

Reproduction rights reserved by A.D.A.G.P. and
S.P.A.D.E.M., Paris, and Cosmopress, Geneva

Published in the United States of America in 1979 by

Rizzoli International Publications, Inc.
712 Fifth Avenue/New York 10019

Introduction and Chapters 1-5 translated from the French by Barbara Bray

Library of Congress Catalog Card Number: 79-64709

ISBN: 0-8478-0239-6

Printed in Switzerland

Table of Contents

INTRODUCTION

Jean Leymarie

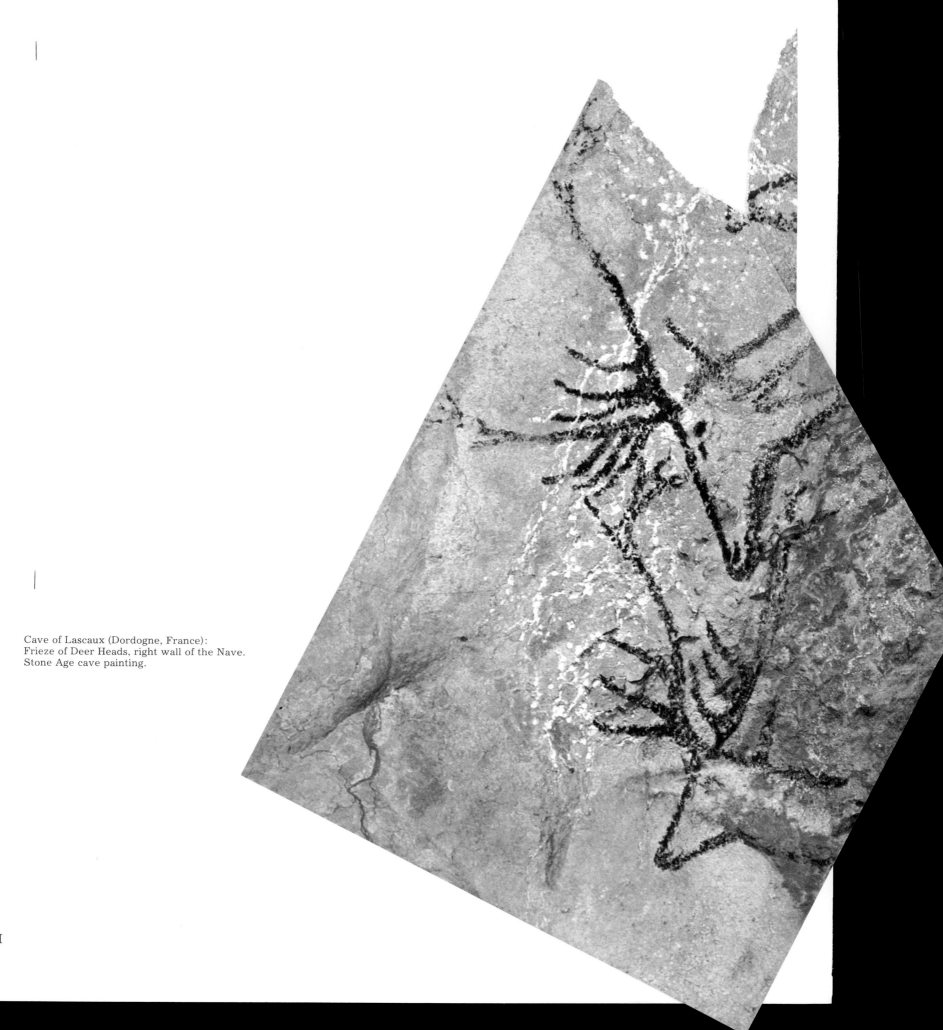

Cave of Lascaux (Dordogne, France):
Frieze of Deer Heads, right wall of the Nave.
Stone Age cave painting.

The Departments of Drawings connected with museums, libraries and art schools are becoming more accessible and, without neglecting the necessary precautions, give periodic showings of their treasures, which were long reserved for connoisseurs alone. Exhibitions and publications devoted to drawing are on the increase, coinciding with a revival of interest in graphic activity and answering to a growing curiosity about this fundamental yet confidential aspect of art. Of all art forms, none is more difficult to reproduce in its inherent tenor and nuances than drawings; none suffers more from change of scale, and their occasional presentation at exhibitions, usually behind glass, fails to convey that peculiar emotion known only to the happy few who have browsed among the originals at leisure: "A portfolio of prints and drawings, opened by lamplight, in those peaceful hours late at night, inclines the mind towards the most severe and beautiful secrets" (Henri Focillon).

On the subject of drawing there are theoretical and technical treatises, teaching manuals, scholarly catalogues arranged by artists, schools or collections, many books of reproductions ranging from cheap popular works to near-perfect facsimiles, and three or four standard works for the expert. As for the present book, its illustrations were chosen and arranged with a view to recreating something of the atmosphere of fervour and wonder peculiar to the Departments of Drawings in which both authors are fortunate enough to work. It is an attempt to offer the non-specialist reader an inner approach to European drawing, to familiarize him or her with its history and fashions, its techniques and styles, its functions and purposes, and its more recent metamorphoses, and to do this by choosing aptly from the different masters, genres and nationalities, and from the institutions in Europe and America where the finest sheets are preserved.

A strange challenge to the powers of mind and hand, this art of representing the coloured mass of objects or recording one's inner visions on a thin flat surface by means of lines which do not exist in nature. "The mind's most obsessive temptation may well lie in drawing," wrote Paul Valéry under the influence of Degas and the latter's passion for line. A thing as mysterious and primordial as language itself, of which it sets up a universal type, drawing is the womb of art. With the whole heritage of the planet before it, our age looks back to the remotest past, to the pre-historic caves of France and Spain, the most fabulous example being the Lascaux cave, discovered as recently as 1940. This cave imposes its powerful spell and symbolic hold even before one comes face to face in the semi-darkness with its astounding display of overlapping paintings, engravings and drawings in their dominant tones of black and red. At Lascaux there are human figures, hand-prints, abstract signs, but the main theme is the procession of animals, in a style at once realistic and magical whose unsurpassable mastery and compelling power have been acknowledged by the great painters of today. After the impressive rotunda of bulls coupled with horses, a narrow corridor leads to the main nave. On the right side extends a frieze of deer which seem to glide along the rock-face as if swimming in a moving stream, the antlers of their upraised heads forming supernatural patterns of lines. Georges Bataille, in his *Lascaux or The Birth of Art* (1955), has written about this cave with the combined insights of a poet and an ethnologist; he has memorably described these uncanny works in which the animal presence is recorded in all its otherworldly grace and gentleness; and he has evoked the thrill akin to metempsychosis that must have been felt by the Magdalenian hunters who created them for their unexplained rites. The miracle of art as it springs to life here lies in the hallucinatory accuracy of the line, in its untrammelled ease, in the spontaneity of an identifying vision not yet touched by the conceptual and geometrized patterns of agrarian societies.

Antique painting proceeded originally from outline drawing and was in effect a matter of tinted drawing. Egyptian art represents a supreme attunement between style and life, between the numerical grid and the observation of reality. Both in paintings and bas-reliefs, it is based entirely on a system of linear patterning whose hieratic canon was fixed for eternity. The initial outlines were done in red ochre, corrected or redrawn in charcoal by another hand. Squared preparatory drawings, didactic copies of standard motifs, and even freehand sketches independent of the prescribed code of execution, have come down to us in thousands on the potsherds or flakes

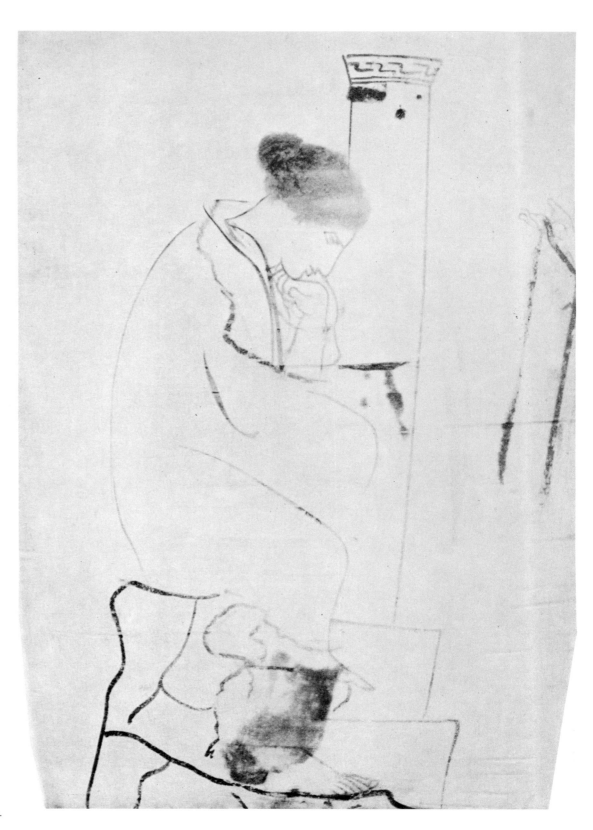

Greek vase painting:
Woman Seated at her Tomb,
detail of an Athenian oil-flask
from a grave at Oropos (Attica).
Third to last quarter of the
5th century B.C. (Height 180 mm.)
Staatliche Antikensammlungen, Munich.

of limestone known as *ostraca*. Coloured vignettes and line drawings illustrated the Books of the Dead written on papyrus and containing spells and instructions for the after-life. In Egypt draughtsman and scribe were one, working with forms derived not from visual appearances but from a conception of being and truth.

The Greek fable attributing the invention of drawing to a girl who outlined her lover's shadow on a wall bears out the ancient primacy assigned to silhouette and contour. Of Apelles, the most famous painter of antiquity, patronized by Alexander, we are told that he attached great importance to the drawing of outlines, practising every day: he outdid all his rivals in his power of drawing a fine and steady line. In a revealing passage in his *Politics,* which incidentally runs counter to the dogma of mimesis, Aristotle approved the teaching of drawing at school, because, he says, it helps us to grasp and appreciate the beauty of the human body – that beauty which the Greeks were the first to extol, handing it down to future ages as a model and standard of plastic perfection.

The great Greek wall and panel paintings, considered equal or even superior to sculpture, are almost entirely lost and we can imagine them only from written accounts. Also, to some extent, from the vase paintings which, on a limited scale, enable us to trace over the centuries the

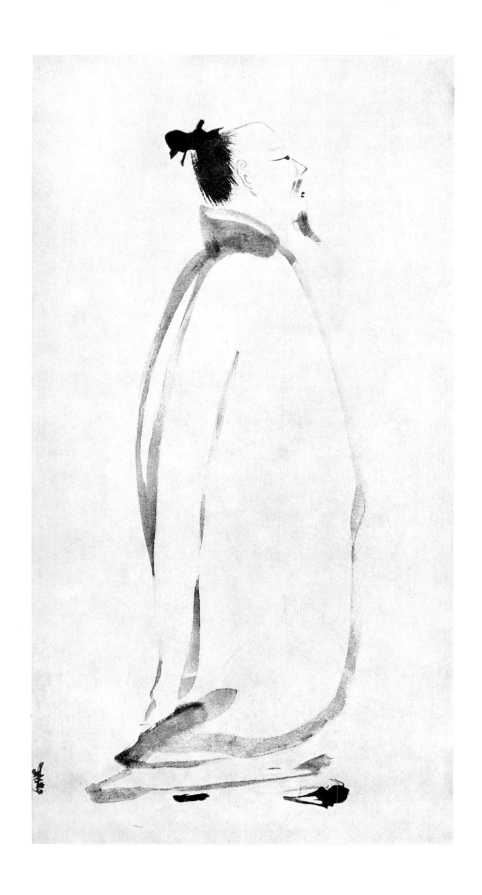

Liang K'ai (active mid-13th century):
Li Po Chanting a Poem.
Hanging scroll, ink on paper.
(Width 308 mm.)
Commission for the Protection
of Cultural Properties, Tokyo.

complete evolution of Greek drawing and the triumph of line which it reflects. The sequence of periods and styles is now well known, with their characteristics, their achievements, their ever renewed symbiosis between forms and setting. The most moving phase, restricted to Athens and the classical age, is that of the white-ground funerary lekythoi, narrow cylindrical oil-flasks used, apart from their domestic employment, for anointing the dead, and then placed in or on the grave; hence their preservation. The cream or ivory ground is much more fragile than the clay surface or the ebony-coloured coat on which the traditional black and red figures are so sharply silhouetted, but its surface texture, as soft and clear as fine paper, is admirably suited to supple linework and the new polychromy that went with it. The detail reproduced here, from a late fifth-century Attic lekythos, shows a young woman, the dead woman, sitting barefoot on a rock, beside her tomb: seen in profile, her chin sunk on her hand, she meditates on her destiny, at the threshold of the Underworld where the soul finds release. How admirable the harmony of this figure, the economy of line, the yellow hair, the deft strokes of red and terra-verde or umber, the suggestive indication of place, the rapt and graceful attitude, the delicacy of feeling conveyed not by the face but by the whole figure. This anonymous masterpiece, owing something to Polygnotos, dates from the time of Parrhasios, the first painter of whom it is

recorded (by Pliny) that his drawings on panel and parchment were preserved by later artists for purposes of study. In the chapter on painting in his *Natural History*, Pliny dwells on the qualities of Parrhasios' line, which to us sound Botticellian, and in a significant paragraph, often referred to by Renaissance theorists, speaks of the ease with which Parrhasios overcame the peculiar difficulties of the contour line, which, he says, should not outline the planes but "should turn at its extremity and end in such a way as to imply something beyond itself and even reveal what it hides."

To indicate in two distinctive works, external to the content of this book but throwing light on it, the nature of Western drawing at its ancient best and the nature of Far Eastern drawing at one of its finest moments, we may compare this Attic lekythos with a Chinese ink-wash drawing of the Sung period. The vast Chinese empire, unified like the Egyptian empire through the prestige of writing, dedicated temples to calligraphy, in Chinese eyes the supreme art and fundamental discipline. The same soft-haired brush, so different from the hard European stylus, served for writing and drawing, and the hand that would master it required as long and rigorous a training as a musician's fingers. It was held loosely in the unsupported hand, perpendicular to the scroll of silk or paper, and the wrist alone moved—with the ease and freedom of a goose's neck, as the Chinese scholars put it. The brush-drawn line is the first principle of Chinese art, and the

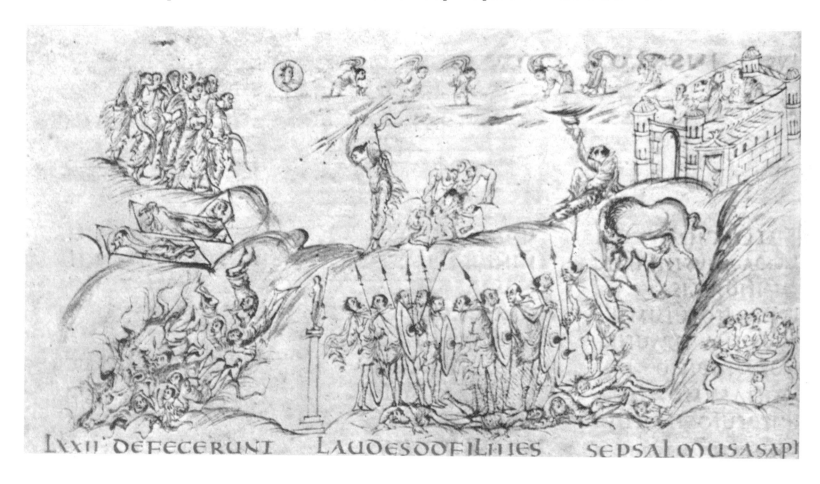

Utrecht Psalter (Reims, c. 820):
Allegorical illustration of Psalm LXXIII.
Pen and brown ink and brown wash. (105 × 215 mm.)
University Library, Utrecht, Holland.

infinite variations of direction, tension and speed impressed on the unshaded, unmodelled line are attuned to the nature of the motif and convey the sense of its inner life. With the end of the Sung dynasty, the literati painters, adepts of Ch'an Buddhism, withdrew to the contemplative life of the hilltop monasteries around the lake and city of Hang-chou, described by Marco Polo as the wonder of the world. Their painterly means were reduced to the "boneless" monochrome wash, from which they drew the quintessence, the aerial elixir of Chinese animism. One of the leading members of the group in the mid-thirteenth century was Liang K'ai, who had left the Imperial Academy after having been awarded its highest honours. He painted landscapes, the predominant art form, but also imaginary portraits of earlier philosophers and poets, among them *Li Po Chanting a Poem,* a masterpiece of simplification and resonant vitality. In China painting and poetry have always gone together. The great T'ang poet is pictured in the throes of inspiration, exhilarated by the rhythm of the verse springing spontaneously to his lips. He stands out in profile against the grey ground of the blank paper, wearing a long cloak which covers the entire figure from neck to heels, hiding both arms and hands, only the elliptical patches of the feet being visible. The raised head is thrown back in a noble, vibrant pose, with

pointed goatee, a tuft of black hair, parted lips and eager gaze. Chinese connoisseurs use a technical vocabulary of their own, untranslatable in any other language, to appreciate the niceties of ink-monochrome painting on paper, the flexibility of the brush-line, whether broad or fine, steady or diaphanous, and its tonal shadings between pearl-grey and jet-black. The abbreviated style of the so-called *p'o-mo* or "broken ink" method is carried here to its farthest point and yet meets the two contradictory requirements of formal freedom and expressive characterization.

In the art of medieval Europe beauty lay above all in colour and its exaltation on the flat surface. The gold and azure of mosaics and stained glass, of precious stones and sumptuous fabrics, reflected the celestial light which it was the mission of art, in the service of religion, to set aglow in the house of God. Plotinian spirituality transcends nature imitation and radiates through mystical emanation. The books written by hand and decorated with paintings are one of the most significant creations of the Middle Ages, that rich and complex period: the pictures in these manuscripts are known as illuminations or miniatures, precisely because of their luminous power and the intense red colour (minium) of the initial letters and borders. In his treatise on the medieval arts and crafts *(De diversis artibus),* the twelfth-century monk Theophilus describes in detail the preparation and mixing of colours, but to drawing he makes only a brief reference, of a moral rather than a formal order. For drawing was seen as having no independent value, no individual inflexion: it was taken for granted owing to the practice of calligraphy and the use of set formulas. These were contained in the pattern or model books, repertories of figures and motifs taken from earlier prototypes and fixed by tradition: on this stock of formulas the artist or craftsman could draw as needed. The most famous medieval pattern book is that of Villard de Honnecourt, a French architect of the thirteenth century who noted down in it the works and monuments he saw during his travels in France, Switzerland and even as far as Hungary. His pattern book was meant to transmit impersonally the normative principles of drawing in his day—drawing which, in his own words, is "such as the art of geometry determines and teaches it." Geometry in the medieval sense differed from both its Greek and its Renaissance meaning: it meant not the harmonious ordering of natural structures but an abstract, ornamental schematization of them, it meant the rejection of organic appearances in favour of a conceptual diagram of them. When Villard sketches a lion from life, he is careful to inscribe the animal's head in a circle drawn with the compass. When he ventures to draw nudes, unassimilable to the Gothic conventions and mentality, he ends up with awkward figure patterns. But on the whole his planimetric method of abridged outlines proves effective and accurate in the delineation of attitudes and silhouettes in action.

The spirited handling of line, now in celestial, now in demonic terms, but always unrestrained by rules, found full scope in the Middle Ages in the borders of illuminated manuscripts. And the masterpiece of illustrational drawing, in pen and ink, without the addition of colour, is the Carolingian Psalter executed about the year 820 at the abbey of Hautvillers near Reims, long preserved in England, often copied, and now at Utrecht. The nervous, impetuous pen strokes, stemming from antique and Early Christian sources and receptive to insular and Arab influences, delineate airy buildings, embattled armies, ethereal landscapes, bucolic flocks, fierce dogs and lions, illustrating the Psalms of David with an extraordinary verve, now lyrical, now epic in its mood, depending on the rhythm of the poetry.

The notion of actual size was determinant in the Middle Ages, which scarcely admitted any enlargement or reduction of scale. Architects drew on the ground itself the plan of the building to be erected and made exact models for the construction details. Fresco painters, whose workshop was the building site, laid out their compositions directly on the wall with the red iron oxide pigment known as sinopia. The rescue work of restoration and preservation carried out after the Second World War, using skilled techniques for separating the rough undercoating of lime and sand plaster *(arriccio)* to which the sinopia was applied, from the upper layer of fine lime plaster *(intonaco)* on which the fresco painting was done, has revealed the secrets of design behind early Renaissance painting and enriched the history of drawing with a new chapter on monumental mural art.

The transition around 1400, most evident in northern Italy, from the model book to the sketchbook, from set formulas to personal experiment, opened the way for the modern conception of drawing. This transition can be seen taking place in the Codex Vallardi (Louvre), an album made up in part from Pisanello's sketchbooks. Trained in Verona and untouched by Florentine art, Pisanello combined the stylization of late International Gothic with the fresh naturalism of the early Renaissance. He drew birds and hunting animals, reinvented the nude, landscape and portraiture, designed ornaments and costumes. In his wandering life and passionate curiosity he anticipates Leonardo. His visionary frescoes and classic portrait medals reveal him as one of the most accomplished draughtsmen of European art.

In his *Libro dell'Arte* so much admired by Renoir, a craftsman's handbook written in Padua about 1390-1400 and based on the workshop tradition of Giotto, Cennino Cennini draws the crucial distinction between idea and execution, between manual drawing and mental design, and justifies imaginary vision and copying from the masters, but assigns the key role to life studies.

In the mid-fifteenth century the *Commentaries* of Ghiberti, an intuitive sculptor still attached to the old beliefs, and the systematic treatises of Alberti, expounder of perspective and the new rationalist humanism, extended to sculpture and architecture the basic theory and practice of drawing, which thus became the common unifying principle of the three major visual arts. At the same period the Venetian sketchbooks of Jacopo Bellini (Louvre and British Museum) contain architectural studies drawn in perspective and elaborate designs for painting, sculpture and ornamentation, in a graphic style confident now of its means and purpose. The importance of drawing steadily increased during the later fifteenth century: it became, in the sovereign conception and practice of Leonardo, "not only a science but a deity," permitting the precise exploration of areas where language is powerless, anatomy for example; permitting too, in its instinctive power, the revelation of the mystery. Some artists, like Mino da Fiesole, covered the walls of their house with drawings.

Florentine art, which begins with the legend of Giotto as a shepherd boy drawing one of his father's sheep on a smooth stone, comes as the heroic conquest of form, and the chiselled line of its master goldsmiths brings to mind the Greek vase painters. But there are scarcely any drawings earlier than those of Pollaiuolo, a painter and engraver versed in all the arts, a pioneer in the study of anatomy, and the essential link between Masaccio and Michelangelo: his drawings of the nude, like the muscular *Adam* in the Uffizi, concentrate on the tension of the faintly modelled contour all the plastic energy of the human body. Moving between the enchanted circle of Lorenzo the Magnificent and the imprecations of Savonarola, Botticelli found glory and refuge in drawing, resuscitating Venus as the very goddess of art and proving himself, like an Oriental, the poet of the arabesque which Kant considered the supreme pattern of beauty. Berenson, born about the time when Ruskin and the English Pre-Raphaelites were rediscovering Botticelli after a long and unaccountable eclipse, reserves for this "master of the line in movement" a special place in his *Drawings of the Florentine Painters* (1903). With her horn of plenty, her floating draperies and train of roguish children, the allegorical figure of Autumn in the British Museum, which appears to have once been in Vasari's collection, remains the paradigm of Tuscan art and one of the world's most beautiful drawings, for its swaying rhythm, its soaring élan, its melodic elongations beyond anatomical accuracy. The eye delights in following out the movement of the lines drawn in black chalk, gone over with pen and ink, washed with water-colour and heightened with white on paper tinted pink. In Florence all of Verrocchio's disciples, Botticelli, Leonardo and above all Lorenzo di Credi were very fond of this *carta tinta*, paper tinted in delicate shades of yellow, pink, green or mauve which added its mysterious aura to the musicality of the line. Venice at the same period adopted the famous *carta azzurra*, blue paper coloured directly in the fibre, lending itself to pictorial effects, and also much used by the French painters of the seventeenth and eighteenth centuries. In the silver-point illustrations on parchment for Dante's *Divine Comedy*, which he interpreted as the poem of the soul, Botticelli's seraphic line is at its purest and subtlest, suggesting the curves of the empyrean that neither words nor any medium but drawing can attain.

The early sixteenth century or High Renaissance brought with it the integral visualization of knowledge transmitted through line by an unequalled pleiad of great artists vying with each other. Leonardo, who carried as far as possible the analogical quest of Man and Cosmos by way of drawing, asked himself: "Which is better, to draw from nature or from the antique? And which is more difficult, outlines or light and shadow?" This dual conflict worked itself out in his own evolution and in that of the age which he initiated: reliance on optical experience as against traditional forms and formulas, absorption of outlines in the atmosphere by shading, by *sfumato*. In the private musings that show the bent of his mind and vindicate the boldest steps of the moderns, he calls for eager reverie before the stains on old walls and surrender to unconscious urges, to what he calls the formless shape *(componimento inculto)*.

Michelangelo, in his titanic power and concentration on the human body, dominates his century. He mastered each of the arts one after the other, and for each he recognized the germinal function of line. Twice in his long career he destroyed the accumulated stock of his studio in order to wipe out every trace of the preparatory labour that went into his work. As a young sculptor he drew chiefly in pen and ink, and the incisive lines that determine form and its tension penetrate the coatings of the paper as if it were a piece of marble. In his studies for the Sistine Chapel, which (regrettably, some think) arouse more interest today than the frescoes themselves, he uses red chalk, which gives both the fullness of the outline and the softness of the modelling. The independent and indeed sublime drawings of his later years, when physical beauty gives way to the transfiguring power of faith, are usually in black chalk: allegorical compositions presented to the young patrician who inspired them, or religious visions welling up from within, like phosphorescent gleams in the dark. The white of the paper is no longer a substitute for texture but a focus of light in a space with no other reference but its own radiation. In a letter of April 1544 Aretino wrote to Michelangelo to assure him that two charcoal strokes from his hand, *due segni di carbone,* on a scrap of paper, were worth more in his eyes than all the jewels received as presents from kings.

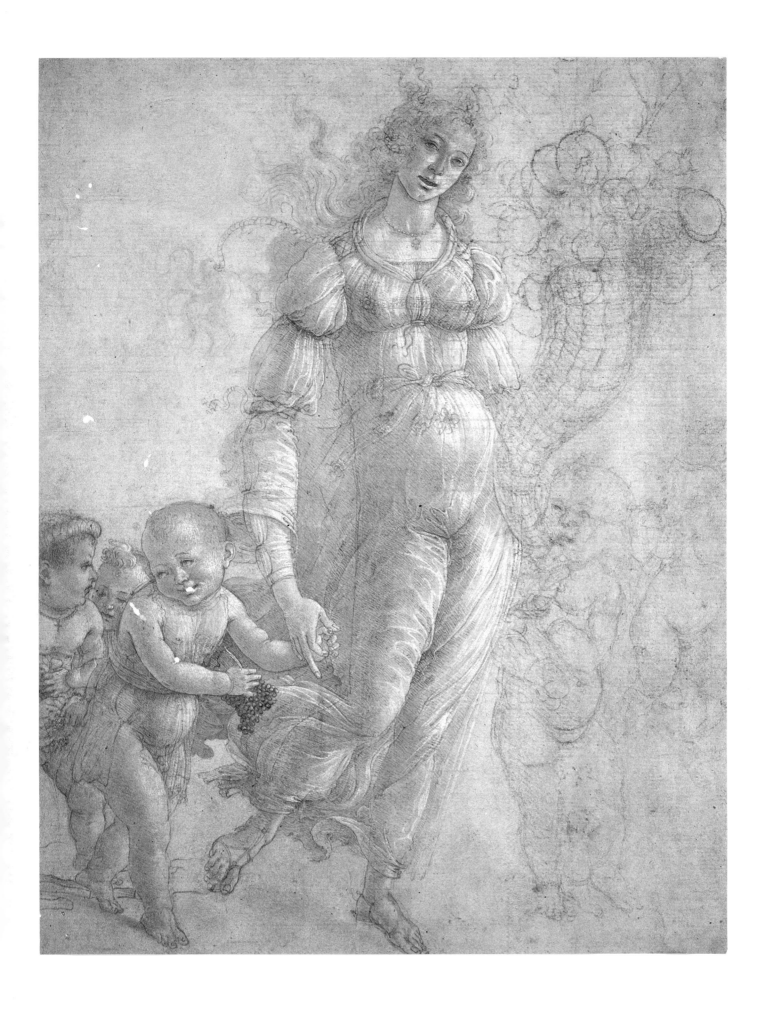

Sandro Botticelli (1445–1510):
Abundance or Autumn, c. 1475–1480.
Pen and brown ink and faint brown wash
over black chalk on paper tinted pink,
heightened with white. (317 × 253 mm.)
British Museum, London.

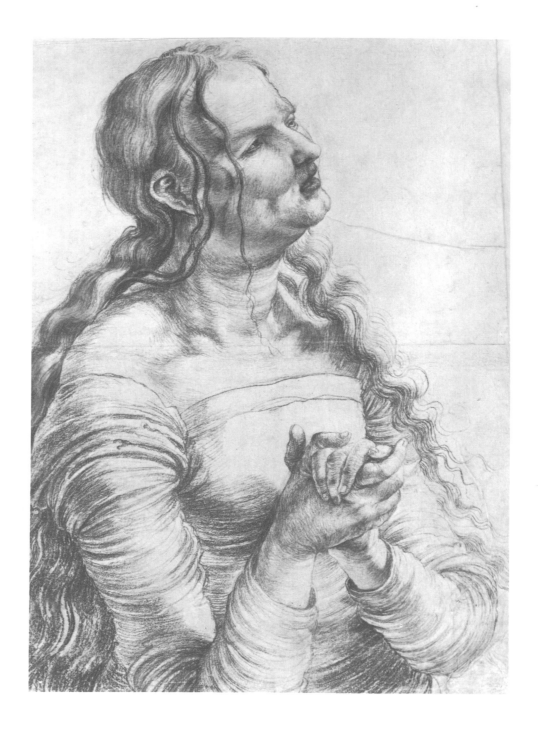

Leonardo and Michelangelo experienced the torment and the ecstasy of the *unfinished,* of the soul exceeding or denying its corporal limits. Raphael's drawings, whose supple outlines bathe in the light they generate, achieve with ease the classical ideal of linear perfection. "Any sheet by him is worth gold or precious stones," wrote the Venetian aesthete Ludovico Dolce in 1559, and in the century of Watteau the French connoisseur Mariette thus defined his distinctive supremacy: "Others jot down on paper their first ideas and one can see that they are after something: Raphael, on the contrary, even when apparently carried away by the vehemence of his imagination, at once produced works which are already so well concerted that to bring them to completion there was little more to add."

In Venice Giorgione transformed the *sfumato* of Leonardo into colour vibrations, associated man with nature and incorporated drawing into pictorial practice. For the scholarly art lovers who were his friends, and who already collected drawings for their own sake, he painted his easel pictures charged with mysterious poetry, done without any preparatory sketch and without any definite subject. His heir was Titian, who developed his lyricism in terms of the musicality of colour–in terms, that is, which are the very contrary of those of Florence. The few drawings assignable to Titian vouch for the magnificence of his style and the fundamental contribution he made, still underestimated, to the enlargement of the artist's graphic range. His landscape studies number among the prototypes of the genre and have always been much appreciated. The splendid half-length portrait of a young woman in the Uffizi, in black chalk on a brown ground, casts an indefinable spell through the very simplicity of the technical means: the majestic firmness of the volume with its blurred outlines, the tremulous modulation of the chalk strokes over the hair and garment, the flawless harmony between the intensity of the physical presence and its spiritual background of dream and nostalgia.

Dürer made two stays in Venice and responded to the enchantment of the lagoon without forswearing his fundamentally Germanic style and his vocation as a realist. The art of line that

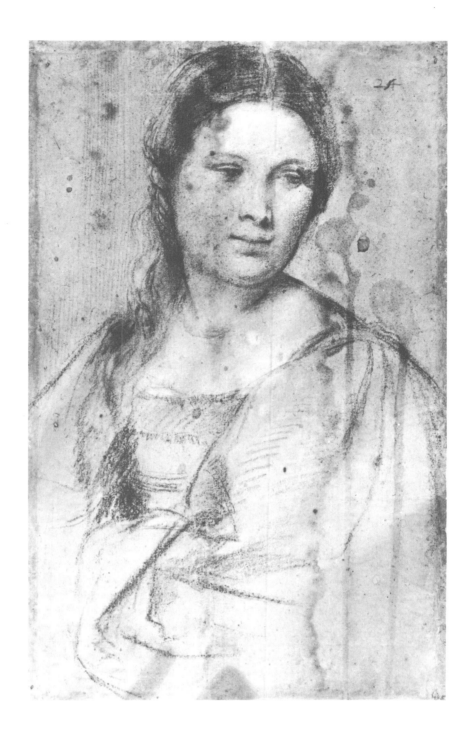

◁ Matthias Grünewald
(c. 1475–1528):
Grieving Woman with
Clasped Hands, c. 1512-1515.
Black chalk heightened
with white. (400 × 300 mm.)
Oskar Reinhart Collection
"Am Römerholz," Winterthur,
Switzerland.

Titian (c. 1490–1576):
Portrait of a Young Woman.
Black chalk on brown paper.
(419 × 265 mm.)
Uffizi, Florence.

he practised universally, in all media, with the possible exception of red chalk, was a means of grasping the essence and particularity of each form, for according to his own credo "art is actually in nature and he who can wrest it from her possesses it." From Dürer's immense achievement as a dedicated draughtsman (several sheets being, for the first time, signed and dated), two series of works stand out, and both add a new dimension to the conception of the travel diary and the sketchbook: the early landscape watercolours (c. 1495), made during his crossing of the Alps, and the late silver-point portraits (1520-1521) made during his journey through the Netherlands.

The most memorable drawings of German art, at the opposite pole from Raphael and Italian art, are not Dürer's but those of one of his contemporaries whose destiny was that of an outsider: Grünewald, rediscovered with enthusiasm in the early twentieth century by the expressionist painters of his own country. The widow of this forgotten genius sold a whole batch of his extraordinary drawings to Hans Grimmer, and from him they later passed into the hands of Uffenbach. The German painter and art historian Joachim von Sandrart, who in Rome was the companion of Claude and Poussin in their rambles in the Campagna and whose *Teutsche Academie* (1675-1679) is a mine of information about the art life of his time, writes nostalgically of the visits he paid as a schoolboy in Frankfurt to his neighbour Uffenbach, who showed him his unregarded treasures. The drawing of an old woman with clenched hands, in the Reinhart Collection at Winterthur, is the unsparingly truthful portrait of a living model and one of the visionary studies for the *Isenheim Altar* at Colmar, a masterpiece of Christian dramaturgy. The streaks and spirals of the line denote the paroxysm of pain to which the whole body is a prey, with its haggard eyes, dishevelled hair and convulsive hands. Running like a fluid through the whole figure is a strange spectral light obtained with black chalk and a white heightening squeezed on with the thumb. The sureness of line and depth of expression are no less marked than in Dürer, but they have an impassioned vibrancy unequalled elsewhere. The contrast of

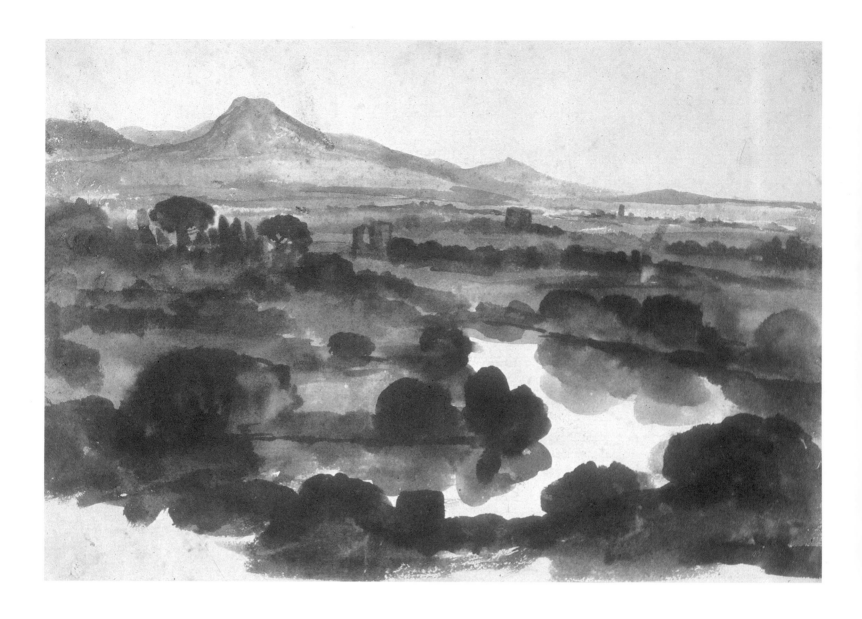

style between Titian's drawings and Grünewald's is the contrast of two worlds, one compounded of dreamy sensuality, the other of mystical frenzy.

Mannerism, arising in the sixteenth century from the break-up of classicism and spreading through Europe, was a crisis of form which led to an overwrought, intellectual style of drawing, in all the graphic media. In this period were founded the Academies, for the purpose of teaching the art of drawing, and with them came a spate of theoretical publications. Vasari, founder of the first Academy of Design (1563), in Florence, defined the status of drawing when he called it "the father of all the arts" and he made the first systematic collection of drawings, carefully mounting them in albums. His classic book of art history and biography, the *Lives of the Most Eminent Italian Painters, Sculptors and Architects* (1550), of which his collection of drawings constituted the illustrations, was followed by many speculative writings on art, culminating in the treatise of Federico Zuccaro *(L'Idea de' Pittori, Scultori ed Architetti,* 1607). President of the Academy of St Luke in Rome and maker of a most interesting series of drawings showing his brother Taddeo at work on urban and rural building sites, Federico Zuccaro categorically separated the *idea,* in the Platonic sense, from its materialization, the intention from the drawing, and in contradistinction to the *disegno esterno* he proposed a theology of the *disegno interno* that we all carry within us as "the scintillation of the godhead." Broken down, the Italian word *di-segno* becomes "the sign of God." Among the most active centres of international Mannerism, where all the arts were governed by line and subject to its vagaries, were Fontainebleau, represented at its best by Primaticcio, and the brilliant court of the Emperor Rudolf II in Prague, where one of the major personalities was the Antwerp draughtsman Spranger. Carel van Mander, whose life was saved by the Italian officer to whom he had occasionally given a drawing, extolled the graphic skill and virtuosity of the Mannerist artists in his *Schilderboek* (1604). Bruegel, whose pictures were collected by Rudolf, transcended the stylizations of Mannerism thanks to his organic power, and his robust and sober figure drawings in pen and pencil on white paper bear the inscription: *naert het leven,* from life.

Mannerism was superseded by the naturalism of Caravaggio, of whom not a single drawing is known. Other great masters of the Golden Century, Velazquez, Hals, Vermeer, have likewise left no drawings, because they drew as they painted, after the Venetian example, modifying in the course of execution. Drawing with them became an integral part of the actual process of painting, while yet preserving at every stage its autonomy and specific character. Both Rubens

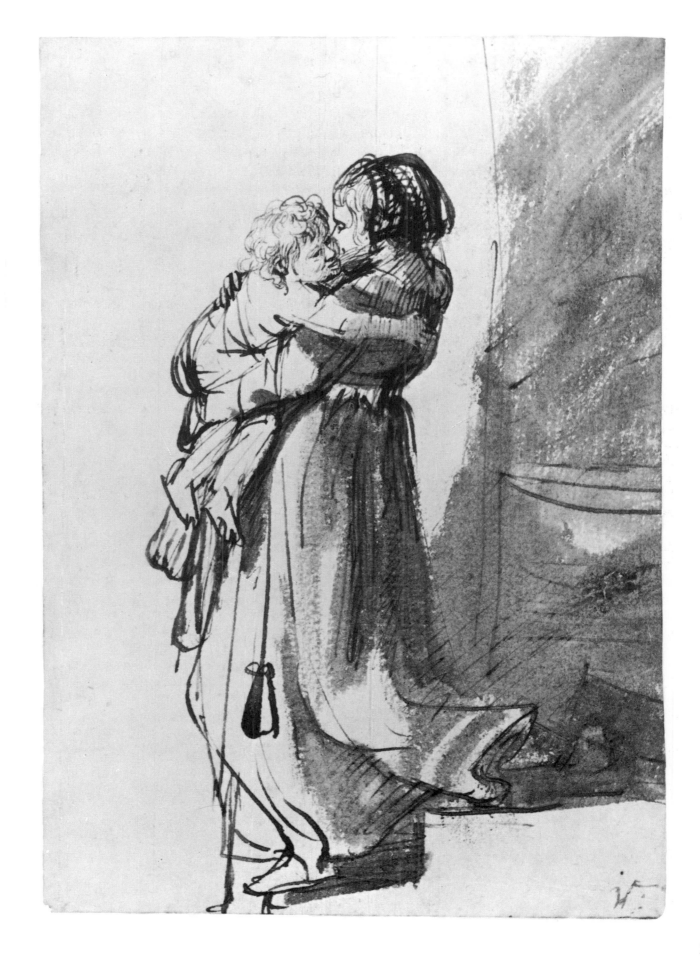

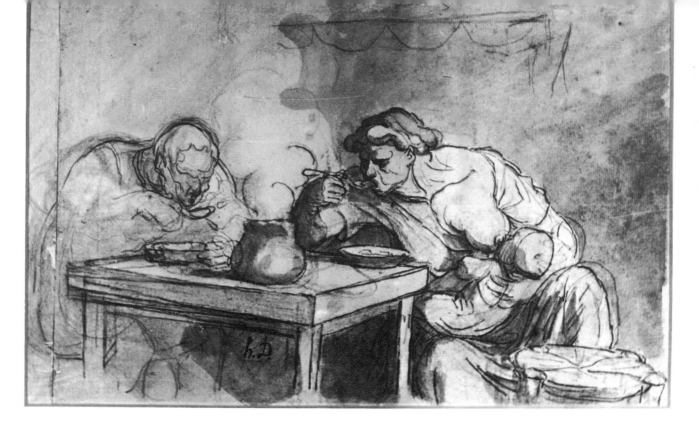

Honoré Daumier (1808–1879):
The Soup. Pen and Indian ink over black crayon,
with brown wash and watercolour. (280 × 400 mm.)
Cabinet des Dessins, Louvre, Paris.

and Rembrandt, those two antithetical giants, one incarnating Baroque ostentation, the other grappling with inner solitude, collected and copied the drawings of other artists; both, with unflagging dedication, drew for their works and for their own pleasure. The Morgan Library drawing of a mother coming downstairs with her child in her arms reveals, in the intimist vein of the Dutch masters, the superlative genius of Rembrandt, his power of formal and psychological characterization with the simplest means, pen and wash. The vertical purse-string is the axis of balance between the angular lines of the restive child and the duplicated curves of the young woman on the stairs. The tender tie between these two beings, uniting their contrary movements, is expressed by the contact of their cheeks.

The pictorial form substituted for plastic form or linear contour lent itself to the growth of landscape, both in the Low Countries newly conquered by man and in the Roman Campagna with its age-old relics of human achievement. The amazing tachist wash drawings of Claude Lorrain in the British Museum, unappreciated by Ruskin but admired by Roger Fry, can bear comparison with their Chinese counterparts. The grandest of them all is the view from the heights over the Tiber and the Campagna, with the gleaming water, the trees, shrubbery and ruins, the distant tower and the Alban hills on the horizon. The sequence of open, almost abstract forms through the immense expanse, in the quiet of evening, is such as could only stem from an Arcadian understanding of nature and unerring control over the surface rhythms of the drawing—neither, in such conjunction, ever to be found again. The poetic resonance is as pure as in Botticelli, if in another key, not the swaying arabesque of the human body but the suspension of space over waves of light.

Reflection on matters of art, initiated by artists, then taken up by connoisseurs, continued in Italy, chiefly in Rome and Venice, and spread to France. An interminable quarrel began between the partisans of line who looked to Poussin and the partisans of colour who looked to Rubens. Poussin's early work was done under the influence of Venetian colour painting, and Félibien, the spokesman of classicism, explains his conversion as follows: "Arriving in Rome he was touched by the excellence and beauty of the ancient statues he saw there, and he devoted part of his time to visiting the places where the most famous ones are. He then reached the firm belief that the true basis and prime foundation of painting is drawing." Le Brun, secretary of the Academy of Painting and Sculpture in Paris, entered the dispute and declared: "A pencil is enough to express everything about nature, including human passions." The most judicious views on drawing are to be found, however, in the writings published around 1700 by the best champion of colour, Roger de Piles, who noted, with the sensibility of a modern: "In making a drawing the artist surrenders to his genius and shows himself just as he is." His views were restated by the Comte de Caylus in his famous discourse on drawing, of June 1732: "Drawings are one of the most attractive things for a painter or an art lover, and it is certain that a man is well advanced in the knowledge of the arts when he knows how to read them."

Drawings were being collected ever more eagerly, and the finest collection in Paris was that of Pierre Crozat, catalogued after his death in 1740 by his friend Mariette. Watteau's genius developed fast when he became a guest in Crozat's house and could there familiarize himself at leisure with the drawings of such masters as Rubens, Veronese and Titian. He found his most

congenial medium, mid-way between drawing and painting, in the three-crayon technique—white, red and black chalk. The charm of a drawing, for the knowing viewer, lies in following the movement of the hand that traced it. The classic draughtsmen were fond of drawing hands, and of all the hands drawn by the greatest, including those of Erasmus by Holbein, the most exquisite are Watteau's hands of women and musicians.

The century that began with Watteau's *fêtes galantes* and fragrance of Cythera ended with the whiff of brimstone given off by Goya's hallucinating wash drawings, as he rent the masks and probed the darker instincts. During the nineteenth century the old conflict between line, declared by Ingres to be "the probity of art," and colour, given a new orchestration by Delacroix, broke out anew. Each of these great artists drew in the way best suited to his style, one through the contour and the curve, the other through the middle and the ovoid mass. The unclassifiable art of Daumier proceeded from caricature. He combined the plastic power of Michelangelo with the luminism of Baroque to record the social types of his time, bringing them before us with an unvarnished truthfulness worthy of Balzac. *The Soup* in the Louvre is on a level with Rembrandt

Pierre Bonnard (1867–1947):
Landscape in Southern France, c. 1918-1920.
Pen and ink. (282 × 220 mm.)
Private Collection, Paris.

in its human warmth, with Goya in its dramatic concision and pent-up violence. The most complete, most exacting draughtsman of his century, classic in his taste, modern in his curiosity, and the only one who was able to hark back to the Renaissance conception of art, was Degas. It was left for Cézanne–Chinese in his refinement of design, Romanesque in his foursquare solidity–to bridge the gap between volume and surface and marry form to colour, a marriage soon to be broken off by the discontinuous patterns of Cubism and the collage technique.

The adventure of contemporary drawing and its radical experiments is described in a separate chapter of this book. Two artists who fail to find a place in it may be mentioned here: Bonnard and Giacometti, both of whom abided by visual appearances, but not by the traditional systems. Miraculously combining candour of vision with an Oriental shrewdness of mind, Bonnard is the first draughtsman whose hand is entirely free and mobile, unrestricted by established coordinates, and we are only beginning to discover the inventive freshness of his art. "Drawing," he said, reversing the conventional notions, "is a matter of feeling; colour is a matter of thinking." Hesitating, and shifting this way and that, his line conjures up without tying it down the shape of things perceived by the eye or suggested by memory. Giacometti lived for the sake of seeing and drawing; he drew in order to see better, deeper, farther. "What must be said, what I believe," he wrote, "is that both in painting and in sculpture the one thing that really matters is line. You must cling solely and exclusively to line. Contrive to master that, and all the rest will follow." In his passionate quest of the absolute he dreamed of working out a code as strict as that of the Egyptians or the Byzantine masters, but the torment and wonder of line by which he was possessed held him chained, in existential solitude, in the unbridgeable gulf between the eye and its object, to the Ixion's wheel of the *unfinished*. The fiery wheel revolved, and reality flashed by, in a burst of sparks and cinders.

Alberto Giacometti (1901–1966):
Landscape, View of Maloja (Engadine), 1930.
Pen and Indian ink. (215 × 265 mm.)
Alberto Giacometti Foundation,
Kunsthaus, Zürich.

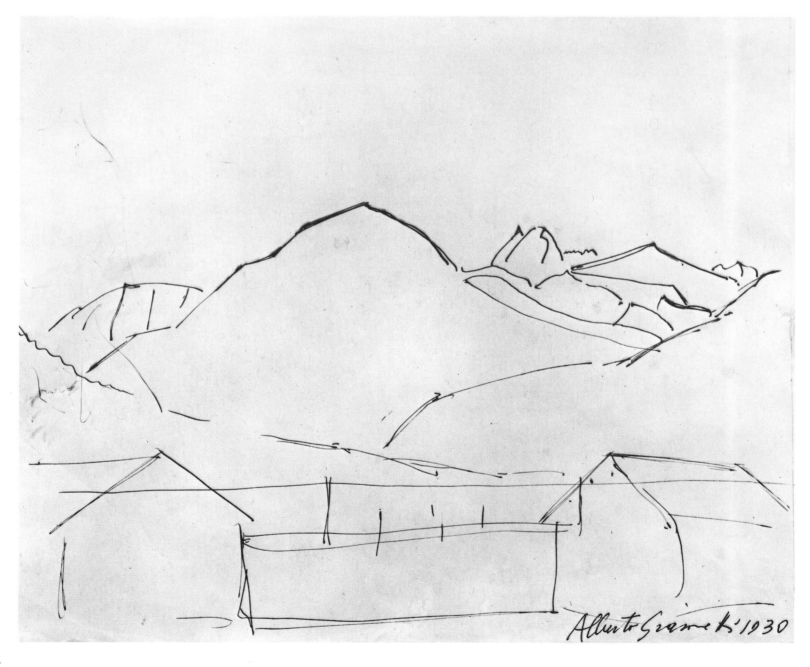

SUMMARY

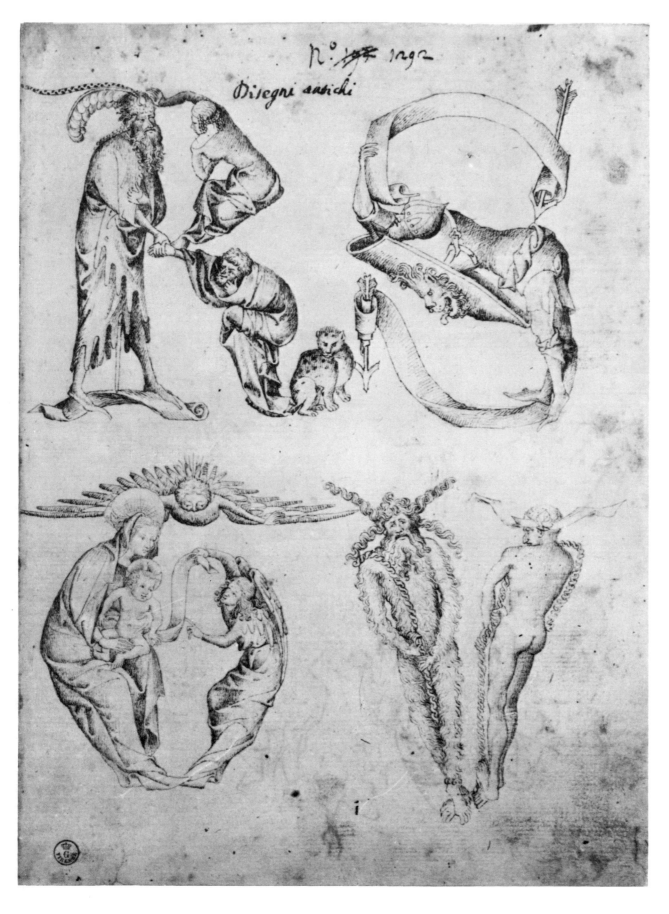

Calligrapher, miniaturist and draughtsman were united in the person of the medieval monk, at the beginnings of Western illustration and of those compilations of images which were brought together first in the scriptoria of abbeys and monasteries, then in the workshops of painters and architects and, from the thirteenth century, in the lay ateliers of the universities. In all three cases, the pictures were to begin with closely connected with the text. The introduction of parchment in the early second century, superseding wooden tablets and papyrus scrolls, led to the appearance in the fourth century of the manuscript volume known as a codex (from Latin *caudex*, trunk of a tree). Generally of a rectangular format, the codex consisted of parchment or paper leaves bound up together. The codices used as drawing books by medieval artists contain a series of unrelated details, noted down as reminders for later use. The pictures appear to be jotted at random on the parchment leaf, with no thought for scale or organization, a

◁ Tyrol? (early 15th century):
Four anthropomorphic letters (RSOV).
Pen and brown and grey ink. (297 × 216 mm.)
Uffizi, Florence.

Florentine Workshop (15th century):
Study of a Hand (detail). Verso.
Metal point heightened with white on purple-pink prepared paper.
(Entire sheet 203 × 250 mm.)
Uffizi, Florence.

disparate assemblage of motifs seen or copied (from paintings, sculptures or illuminations) or simply imagined (fables and bestiaries). This impression of a random medley is also due to the additions and changes continually made by successive generations of artists, who would sometimes change the order and numbering of the leaves and even rebind the manuscript. These pattern or model books, then, have often come down to us as a miscellany of contributions by different hands and of different periods. Some are simply an accumulation of motifs; others bring together copies made from whole cycles of paintings or sculptures. Considered as a working tool, as a reservoir of images for ready reference, the model books sometimes consist of a selection of stereotyped or standardized subjects; it was for the artist to adapt them to his purpose. The usual absence of any real arrangement or composition means that the rendering of space is also absent. Occasionally it is vaguely suggested by a ground line, but spatial recession only begins to be expressed with the depiction of figures in movement. The model books share certain characteristics with illuminated manuscripts their presentation in the form of a bound volume, their material support (usually parchment), some of their media (ink, gouache). What is very different is the page lay-out: that of the model book is the result of a fragmentary vision which scatters details here and there over the leaf; that of the illuminated manuscript offers a studied composition filling the whole surface of the leaf. Their purposes were different, the model book being an aid to memory, the illuminated manuscript an illustration. Finally, their iconography differs, that of the model book being essentially documentary; the pictures, whether religious or secular, are removed from their original context, so that the artist may use them according to the demands of his patron or of the work in hand. The model book thus represents an intermediate stage between the art of illumination and the art of drawing.

Illustrations and repertories

Scriptorium of Kloster Allerheiligen,
Schaffhausen (late 11th century):
Initial Letter from St Augustine,
"De trinitate dei libri XV."
Stadtbibliothek, Schaffhausen.

The drawings in the codices, early examples of which appeared at the beginning of the fourth century, might have a dual function, and serve either as illustration to a text or as part of a repertory of forms or objects. Both types often occur in one volume, the first belonging to the category of illuminated manuscripts and the second to that of model books. In the earliest manuscripts, text and pictures are sometimes closely intermingled on the page and may both be the handiwork of one person, usually a monk. This double page is part of an illustrated codex made up of 212 leaves of parchment and executed in pen and ink by Adémar de Chabannes, a monk of Limoges and later of Angoulême whose work was exceptional at that time. The book contains extracts from early texts (Prudentius, Hyginus, Aesop's Fables, the New Testament). The pictures are closely linked to the content of some of the texts, which seem to have been compiled for

Adémar de Chabannes (c. 988–1034):
Model Book of 212 parchment leaves, c. 1025:
Folios 179 v. and 180 r. illustrating the Astronomicon of Hyginus.
Pen and ink. (Page size 210 × 150 mm.)
University Library, Leyden.

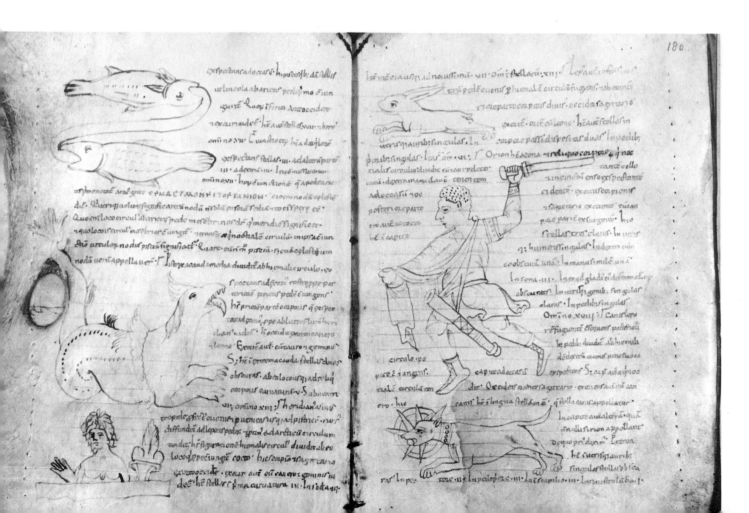

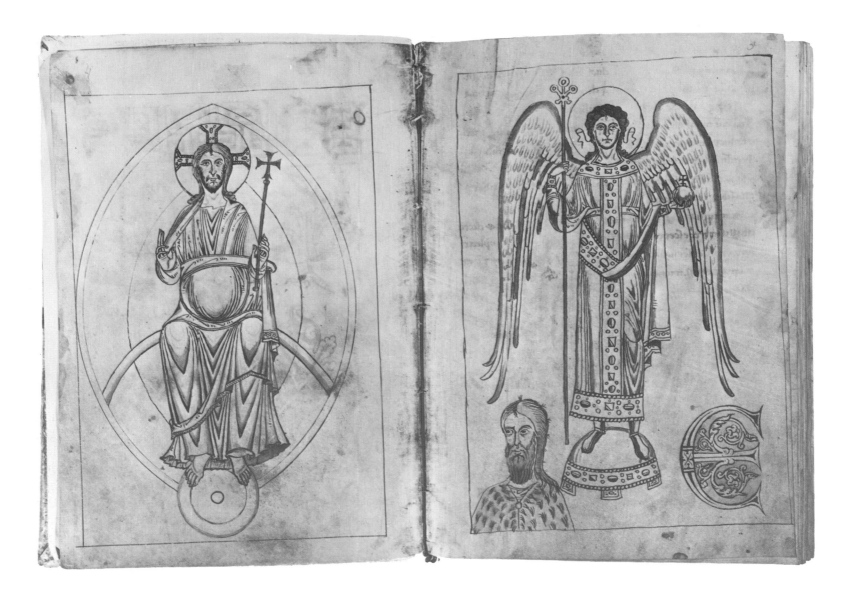

Scriptorium of Einsiedeln (first half of the 12th century):
Two parchment leaves from a Liber Officialis:
Christ seated on a Rainbow within a Mandorla (left)
and Archangel carrying Staff and Orb, with
bust of St John the Baptist and initial E (right).
Pen and brown ink with faint brown wash.
(Each page 260 × 183 mm.)
Stiftsbibliothek, Einsiedeln.

Adémar's personal use. He is thought to have done the drawings first and then added the writing between the scenes, which are remarkable for their narrative variety and include architectural details, vegetation, trees and people in costume. The source of these models may lie as far back as the fifth and sixth centuries, when certain prototype images and texts were compiled. These were copied and handed down by monks who might each interpret them in their own way. The model books brought together iconographical images inspired by other works of art, so that they might be handed on from one scriptorium to another. There was then no other method of reproduction for transmitting images and subjects from generation to generation. The drawings in model books tend to be somewhat impersonal prototypes revealing little of the style of the draughtsman, usually anonymous. There was great activity in the scriptoria of Switzerland in the eleventh century, particularly in Benedictine abbeys like St Gall, Einsiedeln (founded in the early tenth century and active in this field throughout the eleventh), and Schaffhausen (founded about 1050). Capital letters and initials gave rise to great decorative virtuosity; this was an important stage in the history of calligraphy. In some manuscripts of the period, writing, pictures and drawings combine to form a harmonious synthesis of form and content, signifier and signified. In this double page from a manuscript produced by the Einsiedeln scriptorium, the drawings, which are of exceptionally good quality, are unrelated to the text which follows. They are regarded as being among the greatest achievements of the medieval model books. Despite the obvious Byzantine influence, they show considerable originality in their interpretation of the model.

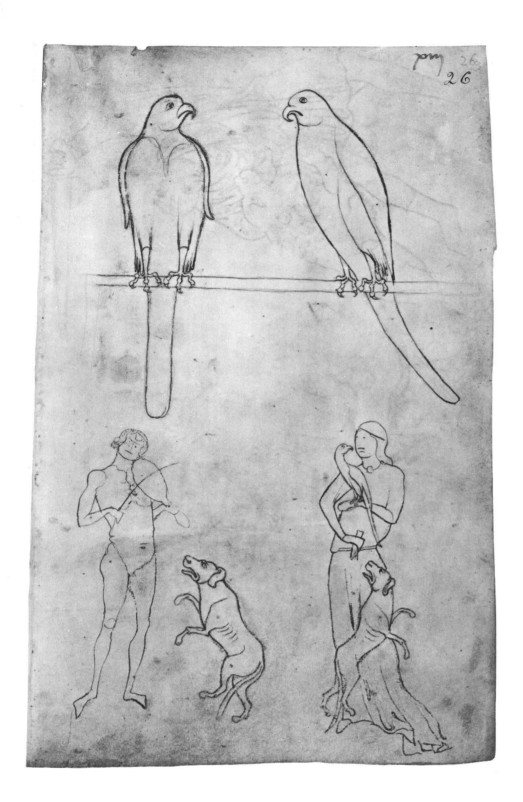

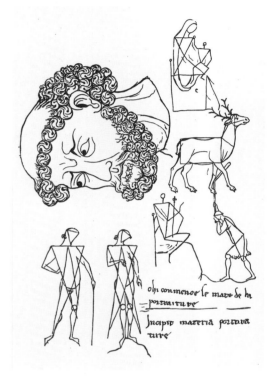

Villard de Honnecourt (active c. 1230–1240):
Model Book of 33 parchment leaves:
details of folios 26 and 18.
Pen and ink over lead point or stylus.
(Page size c. 240 × 160 mm.)
Bibliothèque Nationale, Paris.

Giovannino de' Grassi (active 1389–1398): ▷
Model Book of 31 vellum leaves:
Anthropomorphic alphabet on folio 30.
Pen and ink tinted with colour. (260 × 175 mm.)
Biblioteca Civica, Bergamo.

This famous manuscript by a French architect from Picardy consists of thirty-three parchment leaves drawn with pen and ink, sometimes over an underdrawing in lead point or stylus. Half sketchbook, half pattern book, it deals with a variety of subjects: ground plans, projects for statues, buildings and timber roofs, rough sketches of human figures, animals and floral motifs, and notes on the buildings and monuments that Villard de Honnecourt saw on his travels through France, Switzerland and Hungary. He copied down ancient sculptures, Byzantine wall paintings and Romanesque frescoes, interpreting them in the Gothic style of his time. Part of the book is devoted to figures treated geometrically to make drawing easier. It is difficult to divide the drawings into iconographical categories, and the task of distinguishing religious figures from secular ones is increased by the fact that they are usually set down separately on the page, away from their verbal context. The manuscript contains almost no group compositions apart from two scenes depicting several figures. Characters are identified by their accessories or attributes rather than their expressions, the latter being rigid and repetitive and suggesting that the artist did not go in for real observation. This is counterbalanced, however, by the energy and assurance with which he depicts attitudes. Most of the human studies are nudes, a great innovation at that time. Among the various novelties which characterize this collection are his curiosity about the human body, the attempt to depict movement, the geometric patterning of figures, and the planimetric structure.

This page is from the famous Bergamo manuscript, which consists of thirty-one leaves of vellum

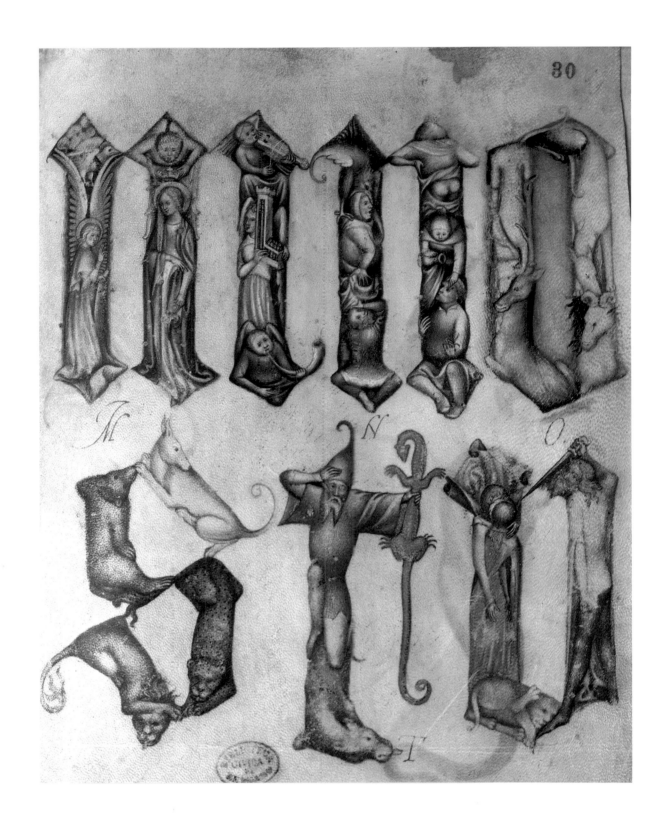

and contains drawings mostly of animals, birds, plants, emblems, designs for embroidery or manuscript margins, and several groups of human figures. It is one of the best known of all model collections, partly because of its quality and partly because it has served as a point of comparison around which many works of art originating in Lombardy about 1400 can be grouped. The attribution to Giovannino de' Grassi, an architect, sculptor and miniaturist, is based on an inscription on folio 4 verso: "iohininus de grassis designavit." But the unevenness in the quality of some drawings suggests that more than one artist contributed to the book. The series of sheets containing the anthropomorphic alphabet were originally sewn on to the pages of the book, but have now been integrated into the codex. Such a model book probably belongs in the context of the active and stimulating ambience of the Visconti court in Milan, where Grassi occupied a high position among the many artists working in contact with one another in connection with the cathedral; they would sometimes work together on the same manuscript. The animal drawings, which set the keynote of the manuscript, are probably studies from nature; they are done in watercolour with an almost miniaturist technique rendering delicately every aspect of hide or feathers. Many drawings in this manuscript were copied and reproduced, and are now to be found, repeated directly or in reverse, in other collections. The representation of animals, seen much earlier in Persian and Arab miniatures, was carried on in the first half of the fifteenth century in Lombardy, central Italy and Tuscany: variations may be traced from one sketch book to another and in contemporary frescoes by Uccello, Pesellino and Gozzoli.

Examples
of
courtly illustration

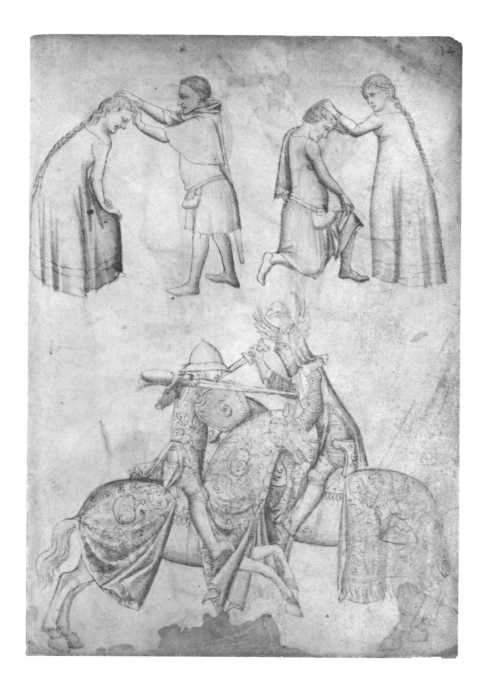

During the thirteenth century the *chansons de geste* and the chivalric romances appeared in France, giving rise to court art and to new manifestations of courtly love. This tradition passed first into Lombardy and thence to the rest of Italy. These Franco-Italian productions, and those of artists from the Low Countries who had been affected by Italian influences, increased in volume to form what was to be called International Gothic art. This delighted in representing people engaged in conversation, dancing, and strolling through gardens accompanied by exotic beasts; other favourites were ladies with falcons, and hunting and jousting scenes. Drawings in watercolour, gouache and pen, often on vellum, were very close to the art of illuminated manuscripts, but their themes were also to be found in contemporary murals and tapestries. Judging by the clothes, this drawing, which shows, above, a scene of benediction (or unction) and, below on the same page, a couple of horsemen charging one another with their lances in a tournament, seems to belong to 1360-1370. Other pages in the same manuscript illustrate the months of the year. The anonymous artist may have been from central Italy. He seems to be imitating the style of Giotto, while giving it a more rustic turn. The lay-out is spacious and assured and gives a feeling of space, although no background is suggested.

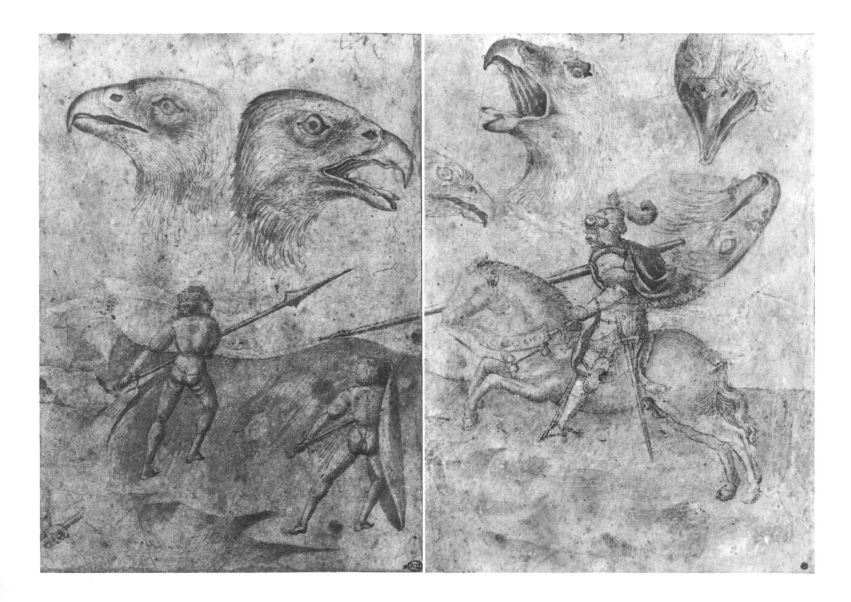

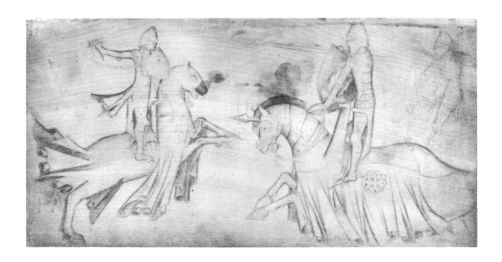

Paolo Uccello (1397–1475): △
Two sheets from a sketchbook:
Knight on Horseback, Six Eagles' Heads
and Foot-soldiers with Spears.
Pen and brush wash on paper rubbed with
red chalk. (Left 234 × 172 mm.; right 236 × 178 mm.)
Musée des Beaux-Arts, Dijon (left)
and Albertina, Vienna (right).

Jacquemart de Hesdin (last quarter of the 14th century):
Model Book of six panels of prepared boxwood held
together by strips of parchment: Tournament Scene.
Silver point on boxwood panel prepared
with a thin wash of gouache. (70 × 130 mm.)
The Pierpont Morgan Library, New York.

In a model book from Bohemia, the subjects are varied and may be either sacred or profane, and the people are usually presented in pairs, whether of apostles, prophets or lovers. The changes subsequently made in the costumes, to bring them up to date, show that the manuscript was in continuous use as a model book over a period of years. Its novelty lies in the gesticulation of the figures, caught in the heat of action (sometimes simply conversing): this heightens the impression of life and animation. Another novelty lies in the shading used to convey the idea of relief and volume.

Jacquemart de Hesdin is known for his manuscript illuminations, and this tournament scene is one of his few surviving drawings. Of high quality, it is one of a series of six drawn on boxwood panels held together by strips of parchment, a very rare example of such early "sketchbooks." The drawings are done in silver point on prepared boxwood.

In a double sheet from a sketchbook now broken up and dispersed, Paolo Uccello displays an exceptional dynamism and unerring skill in the expression of movement, as the two foot-soldiers armed with spears prepare to defend themselves against the onset of the armoured knight on horseback. The six studies of an eagle's head were doubtless drawn directly from nature.

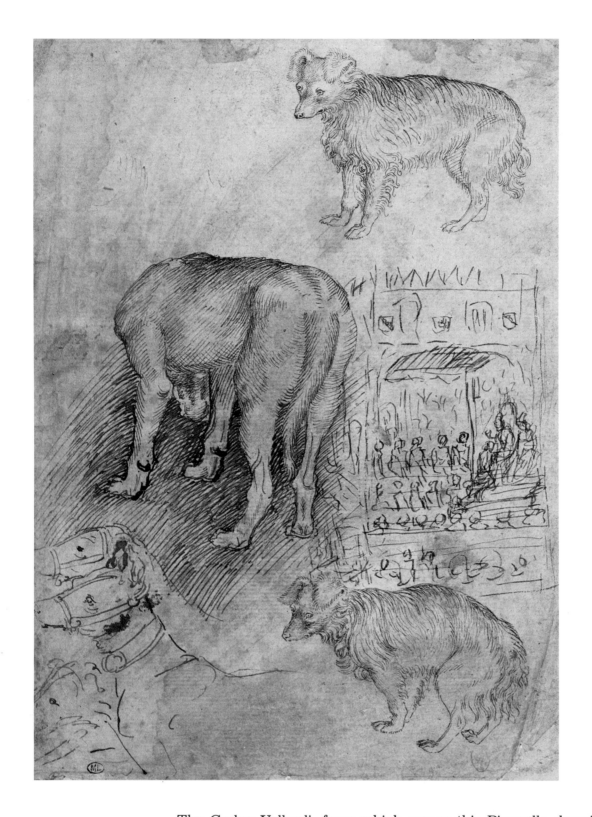

Pisanello (c. 1395–c. 1450):
Codex Vallardi: Sketch of a Palace
and Six Studies of Dogs.
Pen and brown ink on red-tinted paper.
(250 × 180 mm.)
Cabinet des Dessins, Louvre, Paris.

The Codex Vallardi, from which comes this Pisanello drawing, consists of 378 leaves; it was acquired by the Louvre in 1856 from an Italian collector, Guglielo Vallardi of Milan. Of this miscellaneous collection of drawings, the nucleus was brought together in the first half of the fifteenth century, apparently in Pisanello's workshop. Lumped together are sheets from the sketchbooks of Pisanello and his workshop, Lombard illuminations and later drawings (some of them attributed to Leonardo da Vinci). Pisanello was keenly interested in the work of his predecessors, as is shown here by copies made after ancient sarcophagi and certain studies of animals recalling the style of the Bergamo model book of Giovannino de' Grassi. Degenhart has suggested that the Codex Vallardi combines the remnants of several collections of drawings which it might be possible to reconstruct by a thorough study of the sheets (sizes, watermarks, coats of preparation). He postulates the existence of small sketchbooks containing studies made from nature, characterized by rapid strokes in metal point with discontinuous contours; these studies were later reworked and added to on larger sheets, thus converting the nature studies into standardized models for ready use. On this stockpile of images Pisanello could draw as the need arose; they were useful chiefly for his work as a designer of medals, weapons, jewellery, textiles and letters. With Pisanello the conception of the model book changes: it ceases to be a pattern as movement and expressiveness begin to be studied directly from nature. Closely connected though he is with the world of Late Gothic culture, Pisanello stands out as an isolated innovator, without any direct disciples. A precursor of Renaissance ideas as regards creative originality and nature observation, he foreshadows Leonardo.

The Bellini sketchbook in the Louvre is made up of 92 parchment leaves, mostly drawn in silver point and lead point, and often redrawn with the pen; only a few of the drawings are heightened with watercolour or wash. Another Bellini sketchbook of 99 paper leaves, frequently prepared, is in the British Museum; the drawings are in lead point, partly redrawn with the pen. Both books were probably already bound when Jacopo Bellini made the drawings in them some time between 1450 and 1455. The old tradition of pattern books is still discernible in them: several leaves are filled with drawings of animals, chiefly lions. Their *mise en page* recalls the procedure which consists in delineating each model in its entirety so that any part of it might be used. The animals, among them the panther, are drawn in side view (following the convention of that day), but with greater realism than was the case with Giovannino de' Grassi. Animal subjects are in the minority in these two sketchbooks, where other themes predominate: copies after the antique (statues, altars, ornaments, medals), architectural drawings, and religious scenes built up with careful observance of the laws of perspective. The new prominence given here to architecture is undoubtedly connected with the work of Leon Battista Alberti (1404-1472), Jacopo Bellini's contemporary, who was one of the first to study architecture for its own sake, as distinct from sculpture and the decorative arts. The finish and elaboration of each composition in Bellini's sketchbooks distinguishes them from all the medieval model books. Here, with Jacopo Bellini, we seem to have one of the first examples of drawing done for its own sake – composed, framed, fully worked out, meaningful.

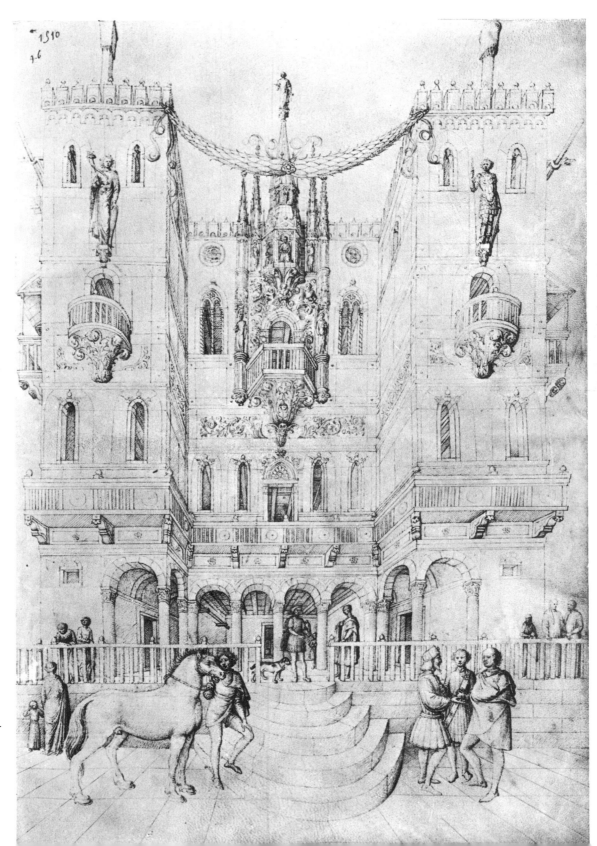

Jacopo Bellini (c. 1400–1470/71):
Paris Sketchbook of 92 parchment leaves:
Study of Architecture, folio 42, c. 1450.
Pen and ink over silver point.
(427 × 290 mm.)
Cabinet des Dessins, Louvre, Paris.

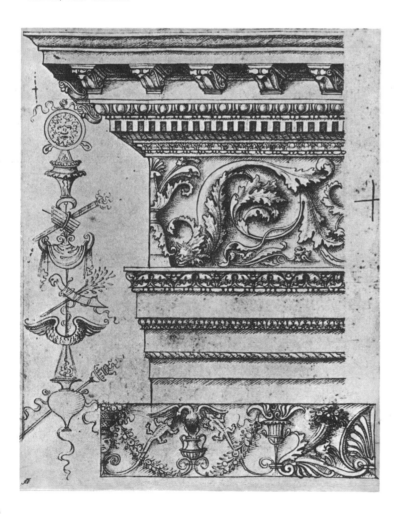

Benozzo Gozzoli (1420–1497):
Studio Model Book of 19 leaves executed
by Gozzoli's pupils, copying elements
of his frescoes: Horse and Architecture, c. 1460.
Silver point heightened with white and bistre
wash on prepared paper. (225 × 155 mm.)
Museum Boymans-van Beuningen, Rotterdam.

Domenico Ghirlandaio (1449–1494):
Codex Escurialensis of 82 leaves:
Architectural Motifs, folio 21 verso, c. 1491.
Pen and bistre wash on paper. (330 × 230 mm.)
Escorial, near Madrid.

Studio model books

Giuliano da San Gallo (1445–1516):
Sketchbook of 52 parchment leaves:
Judith with the Head of Holofernes, folio 32.
Pen and brown ink. (260 × 120 mm.)
Biblioteca Comunale degli Intronati, Siena.

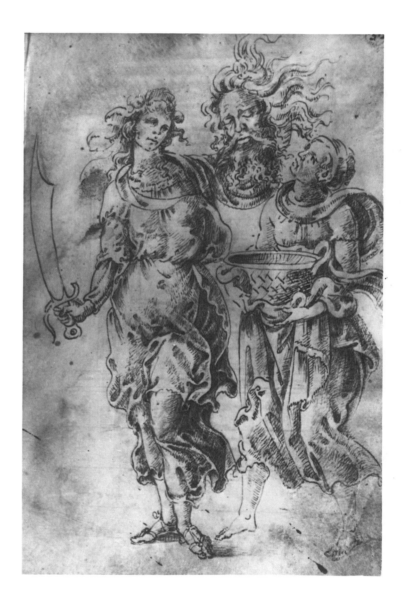

This figure drawing from the sketchbook of the architect Giuliano da San Gallo represents Judith holding up the severed head of Holofernes, accompanied by a handmaiden with a basin; a variant of it is in the Albertina in Vienna. In the workshops of the Renaissance artists, the pattern books used were often the outcome of several artists' collaboration in the same works. An outstanding example is the Codex Escurialensis made by Domenico Ghirlandaio and his assistants about 1491. It contains sketches of ruins, architectural motifs and copies after the antique. The Rotterdam sheet with an architectural fragment and a horse is part of a studio model book of nineteen leaves on paper prepared with a coloured surface. The drawings are set down on each leaf without any regard for lay-out and cover a wide variety of motifs: Biblical and ecclesiastical figures, genre scenes, animals, ornaments, details of

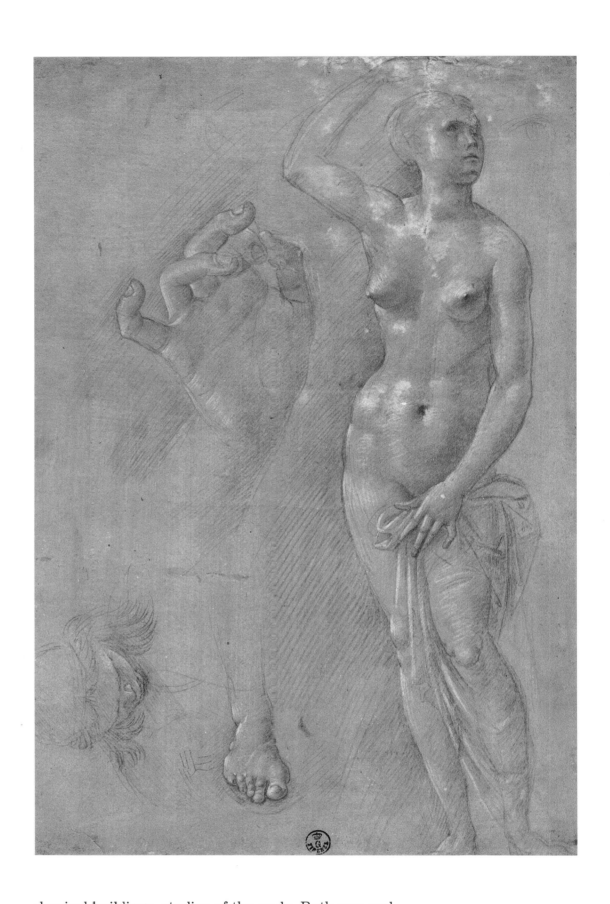

Florentine Workshop (15th century):
Study of Venus, c. 1470-1480.
Metal point heightened with white gouache
on orange pink paper. (273 × 190 mm.)
Uffizi, Florence.

classical buildings, studies of the nude. Both pen and
silver point are used, the latter predominating. This
model book is thought to be a compilation of drawings
made by young artists in Benozzo Gozzoli's Florentine
workshop; some are copies after the master's frescoes.
The purpose of the book, in which several hands can
be traced, was evidently didactic. Some of the motifs
were drawn twice; of some, copies exist in other col-
lections. From another model book comes a study of
Venus. Attributed to various masters (Botticelli, Gra-
nacci, Lorenzo di Credi, Jacopo del Sellaio, etc.), this
drawing is a good example of the methodical analysis
of the human figure carried out by artists in the Floren-
tine workshops of about 1470-1480. Details of a hand
and foot are carefully worked out in close-up, being
drawn in metal point and heightened with white
gouache.

There is evidence early in the Renaissance to show that artists used to preserve the drawings of other masters. For example, Pisanello collected the loose sheets of Michelino da Besozzo and Stefano da Verona. In every age, artists have exchanged drawings and given one another their works as presents. Sometimes too the master of a workshop would give studies to his pupils or apprentices. But the real idea of a collection of drawings emerges only in the sixteenth century with Giorgio Vasari. A painter, draughtsman, architect and historian, and one of the founders of the Accademia del Disegno in Florence (1563), Vasari gathered together the first collection of drawings known to us. He was also the first person to regard drawing as an expression of the artist's intimate personality. He therefore built up a collection representative of the Italian artists who were his contemporaries and predecessors, and of the different trends they reflected; his point of view was didactic, non-élitist, completely modern. He did not confine himself to drawings by painters, but tried to give an account of artists' activity as a whole, as universal as his own. He looked on drawing as a link between the three major arts of painting, sculpture and architecture. His *Libro de' Disegni* was a parallel to his historical and biographical work, *Le Vite de' più eccellenti Architetti, Pittori e Scultori italiani da Cimabue…,* published in 1550. In the 1568 edition of his *Lives* Vasari gives references to the drawings he owned. His collection began with Trecento drawings and covered three centuries of Italian art: Botticelli, Lorenzo di Credi, Peruzzi, Beccafumi, Andrea del Sarto, Giulio Romano, Primaticcio, Schiavone, etc. Vasari

Artist collectors

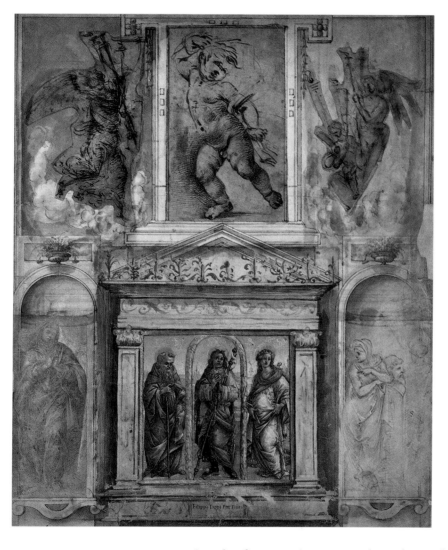

Sheet from Giorgio Vasari's "Libro de' Disegni" ▷ on which are mounted four drawings by Filippino Lippi and Raffaellino del Garbo, enclosed in an architectural setting by Vasari.
Recto. (Overall size 555 × 445 mm.)
Devonshire Collection Chatsworth.

Sheet from Giorgio Vasari's "Libro de' Disegni" on which are mounted six drawings of the Florentine school, enclosed in an architectural setting by Vasari.
Verso. (Overall size 560 × 450 mm.)
Devonshire Collection Chatsworth.

was also the first to give some thought to the actual presentation of a drawing, and attributed an altogether novel importance to mounting and framing. In the famous *Libro*, the drawings, presented on large album pages, are arranged chronologically in five volumes. Smaller drawings are put together on one page, linked by frames and decorative borders, all different, which Vasari himself drew with brush and brown wash or pen and brown ink, adapting the design to each drawing. He often added between drawings a little cartouche or scroll in which he wrote the name of the artist; thus on the recto of the sheet reproduced here he wrote *Filippo Lippi Pitt. Fior.* (i.e. *pittore fiorentino,* Florentine painter). Recent criticism (A. E. Popham) has recognized the drawing at the top of the page as a probable work by Raffaellino del Garbo, and the three other drawings as by Filippino Lippi. Six drawings are mounted on the verso of the sheet. The study for an altar picture, bottom centre, also has a scroll with the name Filippo Lippi inside, but this too is thought to be by Raffaellino del Garbo (Berenson). During the first half of the seventeenth century the five volumes of Vasari's *Libro de' Disegni* were put up for sale, and their pages were dispersed among various collectors. Among these, in the seventeenth century, were the earl of Arundel, the Florentine prince Leopoldo de' Medici, and the Cologne banker Everhard

Jabach. When the latter sold his collection to Louis XIV in 1671 a large number of drawings which had once belonged to Vasari came to form a nucleus of the collection in the Louvre. In the eighteenth century, other pages came into the hands of the Paris banker Pierre Crozat and of the Paris print-seller Pierre Jean Mariette; and by the end of the same century others again were in London in the possession of the painter Sir Thomas Lawrence. It was not until the seventeenth century that the various European collections showed drawings on separate pages, individually mounted on a protective background of cardboard. Jabach provided the items in his own collection with the finest white mounts with broad gilt borders. In the following century, Mariette used blue mounts with narrow gold borders and scrolls. The collectors through whose hands a given drawing has passed may be identified by means of the mount, annotations, initials and the numbering of the sheet. Another guide is the collector's mark, which may be written, printed or embossed on the surface of the drawing. Such marks seem to have come into use at the end of the sixteenth or the beginning of the seventeenth century; a general register of them was published by the Dutch collector and connoisseur Frits Lugt (*Les Marques de Collections de Dessins et d'Estampes*, Amsterdam, 1921). Until the end of the sixteenth century, collections of drawings were generally brought together and preserved in the form of bound volumes. Vasari's example was followed by the Florentine artist and historian Filippo Baldinucci, who helped Leopoldo de' Medici to form his collection of drawings.

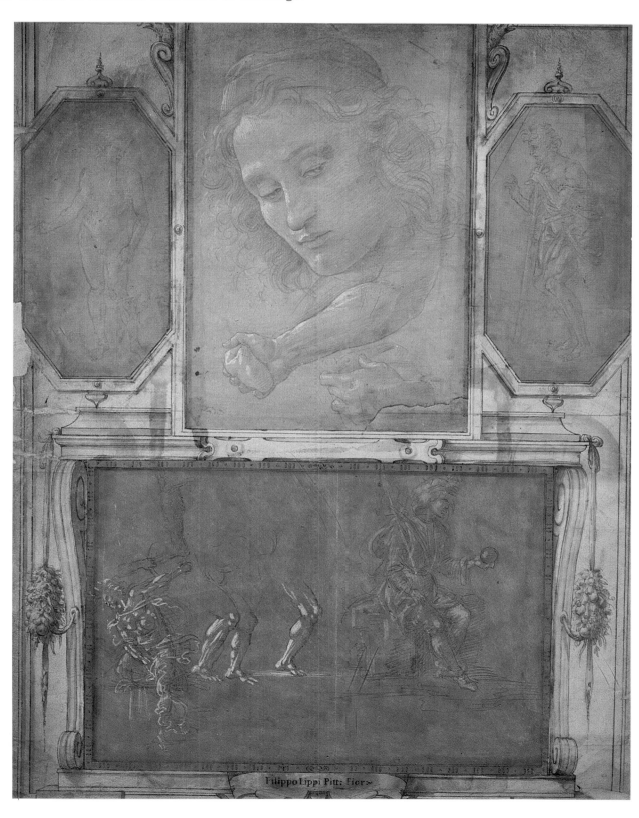

2 DRAWING AND ART THEORY

The medieval treatises, written by monks to begin with and only later by artists, brought together information about artistic techniques and teaching. They were collections of recipes rather than theoretical systems. Being so closely bound up with the other arts and indeed indistinguishable from them, drawing was at first rarely considered for its own sake and only began to assume an independent existence with the geometric treatment of forms. It is thus that it appears in Villard de Honnecourt's pattern book or *Livre de Portraiture* (this latter word meant drawing in medieval French): here drawing was shown in its relation to architectural design and practice. It became one of the fundamental elements of construction, and of the integration of figure sculptures into building structures. At the same time, drawing based on geometry came to be regarded as a science. Towards the end of the fourteenth century Cennino Cennini, in his *Libro dell'Arte,* presented drawing as an essentially intellectual activity: "Lo intelletto al disegno si diletta" (The mind delights in drawing). Cennini distinguished two phases in the act of drawing: conception and execution. At the Renaissance, when art incorporated into its own system such scientific discoveries as Euclidean geometry, the canons of proportions, perspective, anatomy and so on, theory came to predominate over handiwork. In the sixteenth century, treatises laying down rules and principles were nearly always written

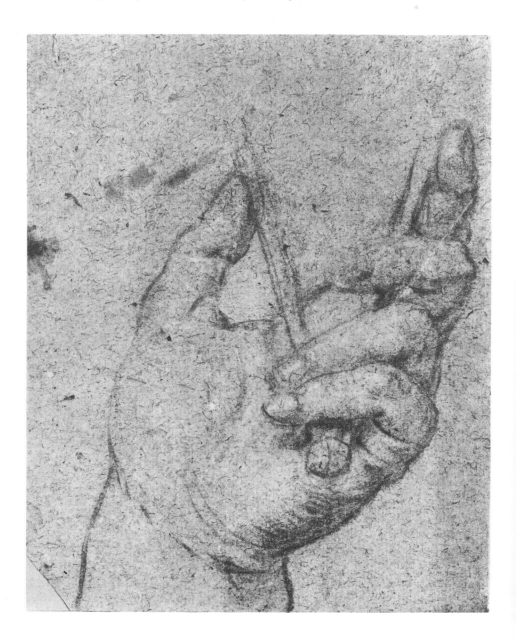

Palma Giovane (1544–1628):
Hand with a Compass.
Black and white chalk. (193 × 154 mm.)
Museum Boymans-van Beuningen, Rotterdam.

16

DRAWING AS REFLECTED IN TREATISES ON ART

by artists, and written with a didactic purpose. Later, such texts were addressed to humanists rather than to practitioners. Leonardo saw painting as a science of knowledge, and drawing as a method of inquiry. His researches were based on an experimental method novel in its positivism. Made from direct study of things and people, his drawings went beyond *a priori* concepts and models. His manifold curiosity attracted him to every possible field—anatomy, perspective, motion, proportion, values, colours, volume and so on. For him, drawing, more significantly than writing, brought out the primacy of the visual over the theoretical. His treatises, preserved in manuscript, were not published in his lifetime; hence they were known to only a few of his contemporaries.

During the Mannerist period almost all artists were theoreticians, and it was then that the Academies came into existence. Drawing was recognized as an art in its own right, among the other liberal arts. It was seen as the tangible form of the idea, of the inventive act which produces a work of art, and the idea was given primacy over manual execution. For the Florentine painter Giorgio Vasari, thought to be the first man to attempt a history of creative artists, drawing acquired a new importance. It was the fundamental basis of the three major arts—architecture, sculpture and painting. Drawing was "padre delle tre arti nostre, architettura, scultura e pittura," he said. His view was that drawing, while of course a technique, should also be an *ideazione*: "Esso disegno altro non sia che una apparente espressione e dichiarazione del concetto che si ha nell'animo" (Drawing is nothing else but a visible expression and declaration of the concept we have in our mind), he wrote in *Della Pittura*, a supplement added to the 1568 edition of his *Vite de' più eccellenti pittori, scultori ed architettori*. "In Vasari's writings on art, as in the theories of the Florentine Academy, which was called the Accademia del Disegno, *drawing*, as the initial expression of artistic conception and the record of all research, was the root and foundation of the arts" (Roseline Bacou). The painter Federico Zuccaro (1543-1609), founder of the Academy of St Luke in Rome, took over Vasari's notion of the dual significance of drawing, in which he distinguished between *disegno interno* (idea) and *disegno esterno* (technique). The same notion appears in Lomazzo's *Trattato dell'arte della pittura* (1584), and the duality thus postulated seems to have had direct practical consequences in the years to come. For in the seventeenth century some artists confined themselves to designing the work in the form of a sketch or *bozzetto*, and once this was done they left the execution entirely to their assistants: such was the primacy of the idea over the technique and execution. In the seventeenth century, theoretical texts were usually the work of historians and critics, among them Giovanni Pietro Bellori (1636-1696), whose views are those of a literary man rather than a practising artist. But for Filippo Baldinucci (1624-1696), a Florentine antiquarian and author of *Notizie de' professori del disegno da Cimabue in qua* (from 1681), which contains some six hundred biographies of artists, "the teachers of drawing, i.e. the artists who belonged to and handed down the Florentine tradition, were the only people capable of judging a work of art and appreciating it fully" (Jacob Bean). In France, it was not until the seventeenth century that the history of art began to be written: "The first history of painting to take account of French art is André Félibien's *Entretiens sur les Vies et les Ouvrages des plus excellents Peintres anciens et modernes*, published between 1666 and 1688, more than a hundred years after Vasari's *Vite*. To begin with, Félibien's intention was undoubtedly to vie with the *Vite*. But the French taste of his time led him to choose the more fashionable form of conversations. And the faults ascribed to Vasari, and above all the circle in which Félibien himself moved—a circle of collectors whose knowledge of drawing and still more of prints gave them an unusual breadth of view—prompted Félibien to aim not at a revised version of Vasari, even supplemented with subsequent writers, nor at an equivalent of the *Vite* devoted to French artists, but at a comprehensive history of painting conceived on an international scale, including foreign as well as French painters" (Jacques Thuillier). Drawing, gaining in importance throughout the seventeenth century, was then recognized, in accordance with the classical and academic conception, as the basic element in the making of a work of art. In France, the rational theories of classicism are exemplified in the work of the painter Charles Le Brun, who represents the official taste

LES
PRINCIPES
DU
DESSEIN;
OU
METHODE COURTE ET FACILE
Pour aprendre cet Art en peu de tems.
PAR LE FAMEUX
GERARD DE LAIRESSE.

A AMSTERDAM,
Chez DAVID MORTIER.
M DCCXIX.

Gérard de Lairesse, *Les Principes du Dessein,*
Amsterdam, 1719, title page
and plate 12.

of the Académie Royale de Peinture et de Sculpture, founded in 1648. In the drawings illustrating his lecture on the expression of the passions delivered at the Académie Royale in 1668, Le Brun kept to a strict idealization of figures, these amounting in fact to an anthology of type-expressions. Henri Testelin (1616-1695), in his treatise on the *Sentiments des plus habiles peintres sur la pratique de la peinture et sculpture mis en table de préceptes* (Paris, 1680 and 1696), followed up the ideas of Le Brun. According to the French classicists, drawing was superior to colour. Drawing, being rational and intellectual, delineated form in its unchanging reality, whereas colour, being material and empirical, was merely a subjective adjunct. In the last resort, drawing was self-sufficient and did not need colour. This widening cleavage and rivalry between the two was reflected in the quarrel between the Ancients and Moderns and subsequently between "Poussinists" and "Rubenists." André Félibien (1619-1695) defended drawing, while Roger de Piles (1635-1709), author of the *Dialogue sur le coloris* (1699), argued in favour of colour, following Giovanni Paolo Lomazzo (1538-1600) and Marco Boschini (1613-1678), for whom "il disegno senza colore è un corpo senz'anima" (drawing without colour is a body without a soul). The painters of the Académie Royale in Paris were similarly divided. Philippe de Champaigne gave precedence to drawing, Jacques Blanchard to colour: "Anyone who despises colour… is attempting to imitate sculpture rather than nature."

In England, where a reaction against academic ideas was already under way in the seventeenth century, the decision went in favour of the imagination rather than logic, of inspiration rather than rules, thus foreshadowing innovations yet to come. In the eighteenth century Sir Joshua Reynolds declared for colour as against drawing, while William Hogarth proposed his "precise serpentine line or *line of grace*" as the best means of representing the human figure, thus referring back to Michelangelo and Lomazzo.

The year 1719 saw the publication in Amsterdam of *Les Principes du Dessein* by Gérard de Lairesse, which was followed in 1740 by Charles A. Jombert's *Nouvelle Méthode pour apprendre à dessiner sans maître.* By now drawing had really assumed a new importance, and connoisseurs,

artists and antiquarians emphasized its role in their writings. For example, the Paris print-dealer
P. J. Mariette (1694–1774) wrote: "I think I may say that as drawing is what gives form to things
represented, so no proper use can be made of the different elements of painting if drawing is
in any way neglected. On the contrary, drawing in itself is enough to express things readily,
so that they may be understood by the spectator. Whatever one wishes to represent may be
made recognizable by a single stroke of the pen or charcoal" (quoted by J. Dumesnil, Paris, 1858).
In the second half of the eighteenth century the antagonism between drawing and colour, by
this time traditional, was the central theme in the widening debate which soon came to oppose
the two great movements, in this aspect contradictory, of Neo-classicism and Romanticism.
Throughout Europe the classical ideal of rational thought stood opposed to the romantic ideal
of unreasoning spontaneity stemming from the uprush of feeling.

In his impassioned reviews of the Paris Salons, the encyclopedist Denis Diderot is all for emotion
and artistic freedom untrammelled by set rules, thus paving the way for modern criticism. In
the nineteenth century, treatises on art became few and far between and almost disappeared.
From now on, ideas about art would be expressed in uncodified form, in the writings of poets,
novelists and dealers. Artists themselves aired their views more readily in their letters, musings
and diaries. This abandonment of theory arose from the new conviction that art is a spontaneous
creative impulse, not a mode of research lending itself to codification. Delacroix gave priority
to colour; Ingres set store by drawing and extolled line. "The pure draughtsmen are naturalists
endowed with excellent sense, but they draw by reason, whereas the colourists, the great
colourists, draw by temperament, almost unawares" (Baudelaire, *Salon of 1846*). With the advent
of realism which in 1848, with Courbet, marked a break with academic form, art seemed to be
liberated from the didactic tradition. Impressionism widened the gap between art and instruction
still further. Art now aimed at being only the transcription of a sensation, of an essentially
subjective and individual perception. Drawing merged with the touch of paint, the patch of
colour. Drawing had become colour.

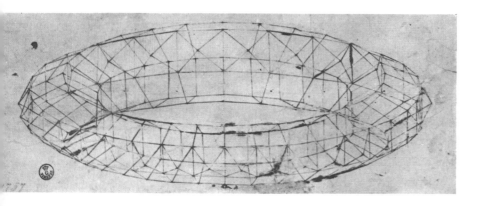

Paolo Uccello? (1397–1475):
Head Pad ("Mazzocchio").
Metal point and pen and ink. (103 × 267 mm.)
Uffizi, Florence.

Piero della Francesca (c. 1410/20–1492):
Building seen in Perspective, drawn to
illustrate "De prospectiva pingendi," before 1482.
Pen and brown ink. (327 × 227 mm.)
Biblioteca Ambrosiana, Milan.

In comparison with ancient and medieval drawing, the geometrical drawings of Paolo Uccello and Piero della Francesca put forward a completely novel organization of perspective space. Uccello, in Florence, was one of the first painters to take up the study of perspective. He drew geometrical figures whose shapes were taken from real objects: chalices, cups, spheres bristling with spikes, and the curious wood or wicker supports for the headdresses worn at that time (mazzocchi). Uccello drew all the perspective lines of these shapes, breaking each object down into many facets whose prolongations meet in a central vanishing point. This kind of geometrical motif with foreshortening effects was also to be found in Florence from the 1440s in marquetry, inlaid work (intarsia) and cabinet making, and these reveal "the handicraft origins and experimental character of perspective constructions" (André Chastel).

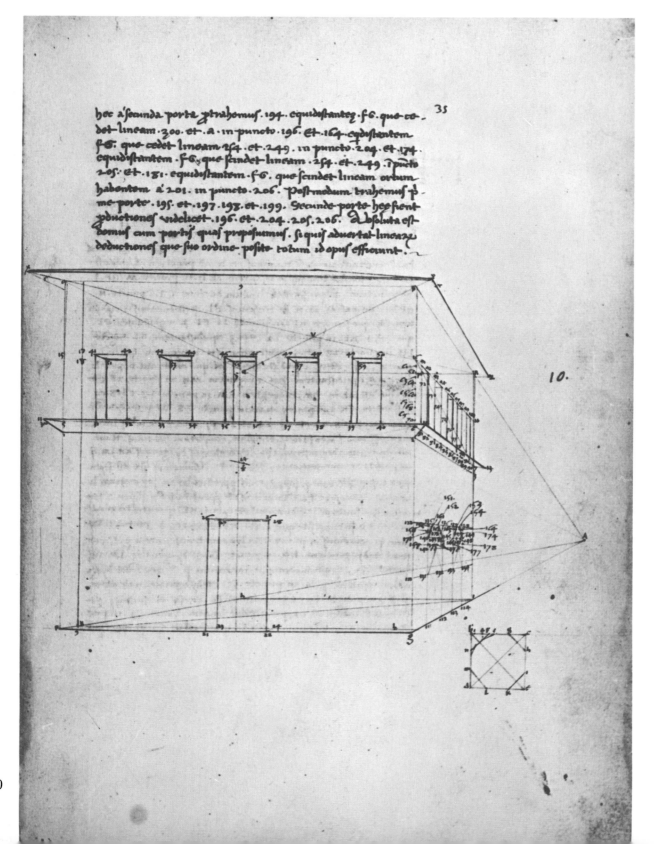

Geometry
and
perspective

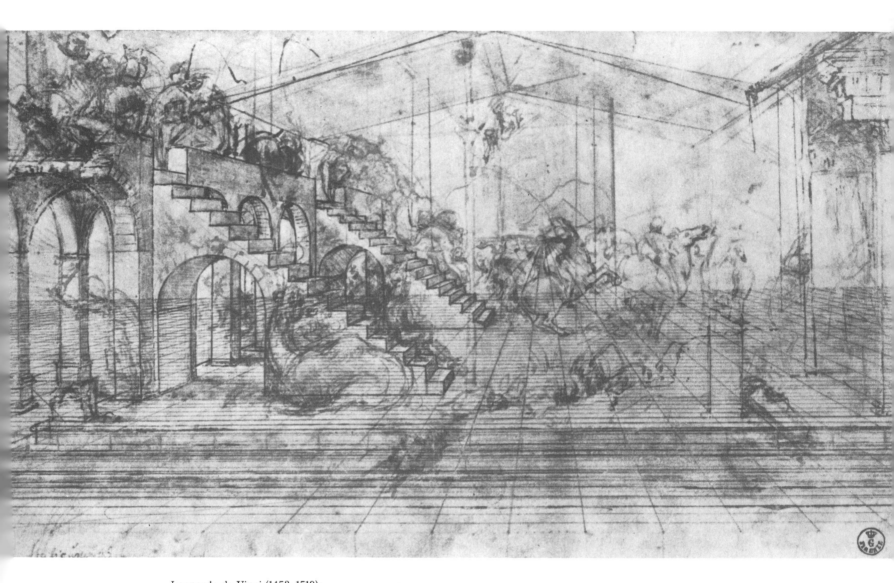

Leonardo da Vinci (1452–1519):
Study for The Adoration of the Magi, c. 1481.
Pen and brown ink, brown wash, heightened
with white. (165 × 290 mm.)
Uffizi, Florence.

Piero della Francesca illustrated his treatise on perspective, *De prospectiva pingendi,* with several engravings based on his own drawings (studies of human proportions, and buildings and objects seen in perspective); the original drawings are preserved in a manuscript codex in the Biblioteca Ambrosiana, Milan. Designed to provide useful models for painters, this Latin codex and the Italian version of it in the Biblioteca Palatina, Parma, contain the only known drawings by Piero della Francesca. Bernhard Degenhart thinks that the drawings in the Milan manuscript were done first, and that those in the Parma version are holograph duplicates. The practice by which all draughtsmen used ruler and compass for their geometrical drawings resulted in an impersonal style which makes it difficult to identify a given artist's hand. Leonardo da Vinci made use of perspective in the linear lay-out of his pictures; in the famous preliminary study for the *Adoration of the Magi,* his vanishing lines meet at a point which is slightly off-centre in relation to the composition as a whole. But Leonardo always fills out the linear scheme underlying the perspective conception with shaded effects of chiaroscuro and atmosphere *(sfumato)* and with colour, thus going beyond the purely graphic abstraction of theoretical perspective.
"By redefining the material surface of the drawing or painting as immaterial planes of projection, perspective–even if imperfectly mastered to begin with–gives an account not only of what is seen but also of the manner in which that reality is seen in particular conditions… It is natural that we *should see perspective as a technique belonging only to the two-dimensional arts"* (Erwin Panofsky).

Treatises
on
perspective

Ein andre meynung.

Vrch drey feden magst du ein yetlich ding das du mit erreychen kanst in ein gemel bringen/
auf ein dafel zuuerzeychnen/dem thu also.
Pist du in einem fal fo schlag ein groffe nadel mit einem weyten or die darzu gemacht ift in
ein wand/vnd feh fur das fur ein aug/dardurch zeuch einen ftarcken faden/vnd henck vnden ein pley ge
wicht daran/darnach feh einen tifch oder tafel fo weyt von dem nadel or darinn der faden ift alß du
wilt/darauf ftell ftet ein aufrechte ram zwerchs gegen dem nadel or hoch oder nider auf weliche fey
ten du wilt/ die ein turlein hab das man auf vnd zu mug than/ diß thurlein fey dein tafel darauf du
malen wilt.Darnach nagel zwen feden die als lang find als die aufrecht ram lang vnd prept ift oben
vnd mitten in die ram/vnd den anderen auf einer feyten auch mitten in die ram vnd laß fie hangen.
Darnach mach ein eyfen langen fteft der zu forderft am fpit ein nadel or hab/darepn feden den lan
gen faden der durch das nadel or an der wand gezogen ift/ vnd far mit der nadel vnnd langen faden
durch die ram hinauß/vnd gib fie einem anderen in die hand/vnd wart bis du die anderen zweyer feden
die an der ram hangen. Nun brauch diß alfo/leg ein lauten oder was dir funft gefelt fo ferr von der
ram als du wilt/vnd das fie vnuerzuckt peleyb fo lang du jr bedarffft/vnd laß deinen gefellen die nadel
mit dem faden hinauß ftrecken/auf die nottigiften puncte der lauten/vnd fo oft er auf einem ftill helt
vnnd den langen faden anftreckt/fo fchlag alweg die zwen feden an der ram kreuzweyß geftrackt
an den langen faden/vnd kleb fie zu peden orten mit einem wachs an die ram/vnd heyß deinen gefel
len feinen langen faden nachlaffen. Darnach fchlag die turlein zu vnnd zeychen den felben puncten
da die feden kreuzweyß uber einander gen auf die tafel/ darnach thu das turlein wider auf vnd thu

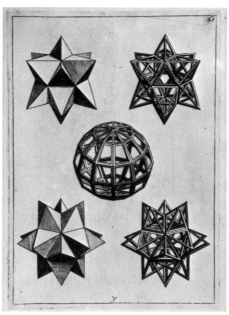

1 Albrecht Dürer, *Underweysung der Messung mit dem Zirckel und Richtscheyt in Linien, Ebnen und gantzen Corporen,* Nuremberg, 1525.

2, 3 Daniel Barbaro, *La Pratica della Perspettiva,* Venice, 1569, title page and page 102.

4, 5 Lorenzo Sirigatti, *La Pratica di Prospettiva,* Venice, 1596, title page and plate 65.

6, 7 Wenzel Jamnitzer, *Perspectiva Corporum Regularium,* Nuremberg, 1568, title page and engraving by Jost Amman.

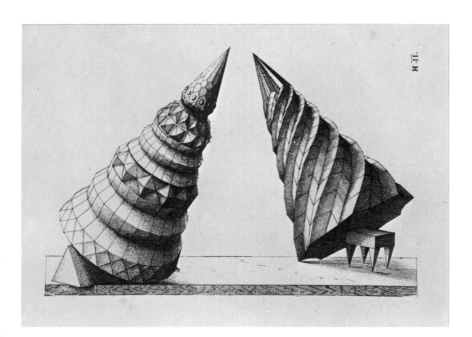

1	2-3
	4-5
6	7

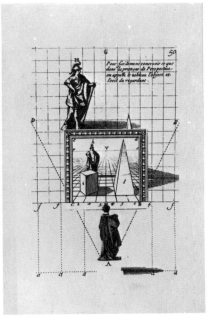

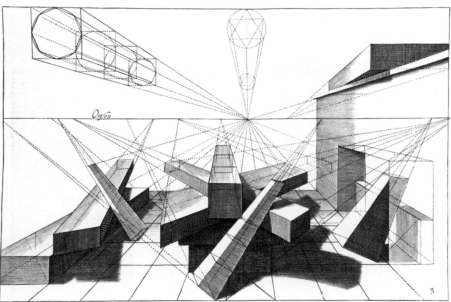

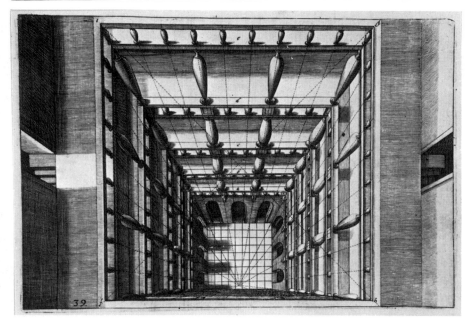

1, 2 Abraham Bosse, *Traité des pratiques géométrales et perspectives*, Paris, 1665, frontispiece and plate 50.

3, 4 Sébastien Le Clerc, *Discours touchant le point de veue*, Paris, 1679, title page and plate 15.

5 Jan Vredeman de Vries, *Perspective, Pars altera*, Leyden, 1605, plate 3.

6 Samuel Marolois, *Perspective contenant la Théorie, et Practicque, d'icelle*, The Hague, 1614–1615, plate 39.

7, 8 Edmond-Alexandre Petitot, *Raisonnement sur la perspective, Pour en faciliter l'usage aux Artistes*, Parma, 1758, title page and plate 4.

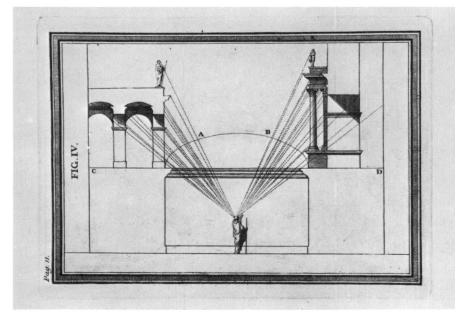

1–2	3–4
5	
6	
7	8

Human
proportions

To study more fully the relation between the human figure and the world in which it moves, it was necessary to define the place of man in the space which the artists and theoreticians of the Renaissance had contrived to organize and control by inventing the system of perspective. The body was studied in terms of its measurements and proportions. It was framed, enclosed and divided up in diagrams, geometrical schemas, ciphers and numbers. The same hankering after geometry was evident in the various codes and canons of human proportion worked out all over Europe, in particular by Piero della Francesca, Leonardo da Vinci and Dürer. A proportional drawing inserted the human figure into a geometrical outline with a grid of lines and measurements. One of the earliest draughtsmen to do this was Villard de Honnecourt, whose studies of human and animal figures were inscribed within triangles, circles and rectangles; he thus brought their constructional patterns into relation with his own architectural practice. Some drawings by Piero della Francesca show that he used linear and geometrical grids to study the proportions of face and skull. It was one of his pupils, the mathematician Luca Pacioli, who in 1509 published a treatise entitled *De divina proportione*; according to Pacioli, the perfect and ideal proportion is that of the Golden Section, and numbers have a mystical significance.

Leonardo da Vinci (1452–1519):
Proportions of the Human Face.
Pen and brown ink, heightened
with watercolour. (343 × 245 mm.)
Gallerie dell'Accademia, Venice.

Hans Holbein the Younger (1497/98–1543):
Sheet of Studies of Heads and Hands.
Pen and black ink. (128 × 192 mm.)
Kupferstichkabinett, Kunstmuseum, Basel.

Leon Battista Alberti, using the rules established by Vitruvius, examined the relations between proportion and perspective. Leonardo da Vinci also sought to establish a relationship between the proportions and motions of the human figure and the perspective system. Dürer, whose researches were also based on those of Vitruvius, stressed the symmetry and schematization of the body. He adopted the Vitruvian canon of proportion, by which the head represents one eighth of a man's total height. But he calculated and imagined various other possible canons of proportion, departing from the traditional pattern of ideal beauty. In the 1520s he was particularly interested in schematic studies of the human figure, and some of the forms he arrived at are like a presentiment of Cubism. His treatise on proportion, *Vier Bücher von menschlicher Proportion,* was not published until 1528, after his death. At the end of the Renaissance, with Michelangelo, we already see a certain departure from the ideal canon, manifesting itself in deliberate distortion and lengthening of the human figure. This subjective tendency, in contrast with mathematical objectivity, developed further with Mannerism and Baroque, when effects of musculature, facial expression and movement were of more interest to artists than the rules of harmony. With the exception of certain draughtsmen like Luca Cambiaso, who used articulated wooden models for drawing the human body in terms of geometrical volume, the importance accorded to proportion as a system lessened at the same time as anatomical studies increased.

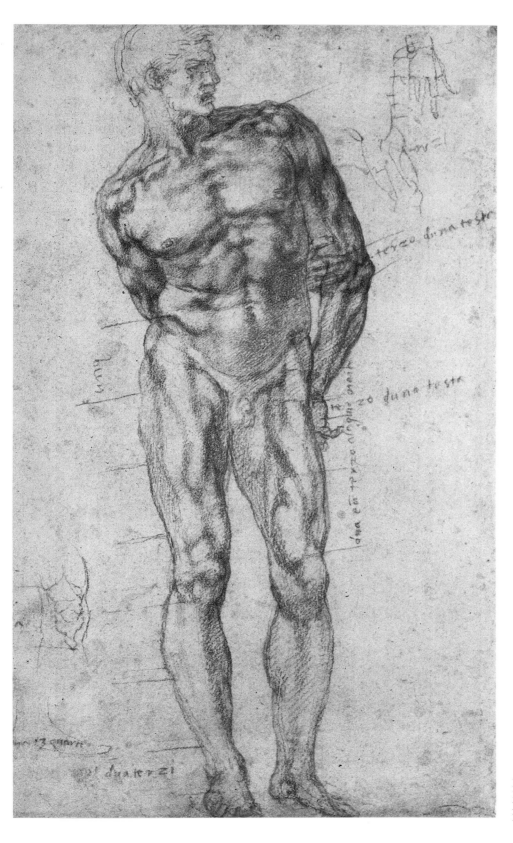

Michelangelo (1475–1564):
Male Nude with Proportions Indicated, c. 1516.
Red chalk. (289 × 180 mm.)
Royal Library, Windsor Castle.

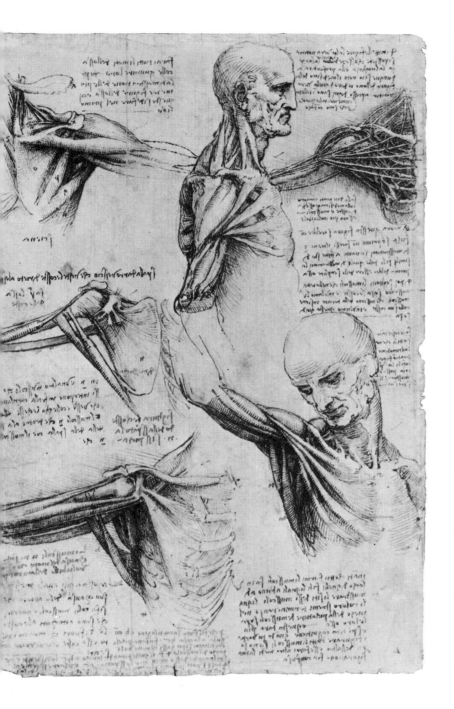
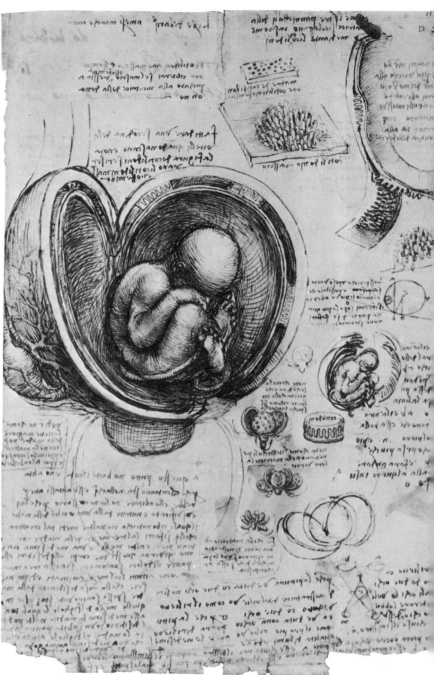

Anatomy

The Renaissance brought with it a new curiosity not only as to the external appearance of the human body but also about its interior, the organs it contained and their functioning. Although dissection was banned up to about 1540, it was practised in Europe as early as the thirteenth century and yielded results which encouraged the scientific development of anatomy. Leonardo da Vinci occupies an outstanding place in this field, and explored all its possibilities. He was the first scientist to depict the inner life of the body and some of its mechanisms; he made drawings, for example, of copulation and gestation. His systematic delineations of all aspects of anatomy make him a precursor both in his scientific thinking and as a draughtsman. He intended to write a treatise on anatomy, but it was never finished. In these two anatomical sheets, Leonardo studies the neck and shoulder muscles of an old man, before and after the skin is removed. In the notes accompanying the drawings he dwells on "the nature and number of the veins," the movements of the neck and the articulation of the shoulder. The drawing on the reverse of this sheet presents a study of every shoulder muscle after dissection; on the right side of it, Leonardo represents the muscles diagrammatically, reducing them to cords and thus extrapolating mere descriptive analysis into an imaginary drawing of forms in their geometrical and mechanical aspect. Other Italian artists—Mantegna, Pollaiuolo, Verrocchio, Signorelli, Michelangelo, Raphael and Baccio Bandinelli—took an interest in anatomy and the human figure long before the publication of *De corporis humani fabrica* (1543) by Andreas Vesalius, a scientific study of human anatomy based on dissections: it summarized and illustrated all the experimental knowledge acquired up to that date.

Interest in anatomy reached it highest point at the Renaissance and in the baroque period. Closer collaboration between artists and anatomists resulted in compilations of anatomical models designed to be used for teaching purposes. This drawing by Alessandro Allori is entirely imaginary: the flayed man walks towards the left, his arm raised; the unreality of the image accentuates the morbidity of the subject. The precision and stylization found in such écorché drawings are fascinating in that they represent an extreme limit of figurative art. For a long time they were regarded as no more than tools for use in the studio, and they were collected and engraved for the convenience of draughtsmen. Anatomy is the scientific study of the body in the form of an écorché (the removal of the skin reveals the muscles, joints, etc.). Morphology is the study of the outer structure of a living creature.

Alessandro Allori (1535–1607):
Anatomical Figure Study: Ecorché walking in side view, with left arm raised. Black chalk. (441 × 285 mm.)
Cabinet des Dessins, Louvre, Paris.

Leonardo da Vinci (1452–1519):

◁ ◁ Studies of the Muscles of the Shoulder and Neck, c. 1510.
Pen and brown ink with wash modelling over black chalk. (292 × 199 mm.)
Royal Library, Windsor Castle.

◁ Babe in the Womb, c. 1510–1512.
Pen and brown ink with wash modelling over black and red chalk. (305 × 220 mm.)
Royal Library, Windsor Castle.

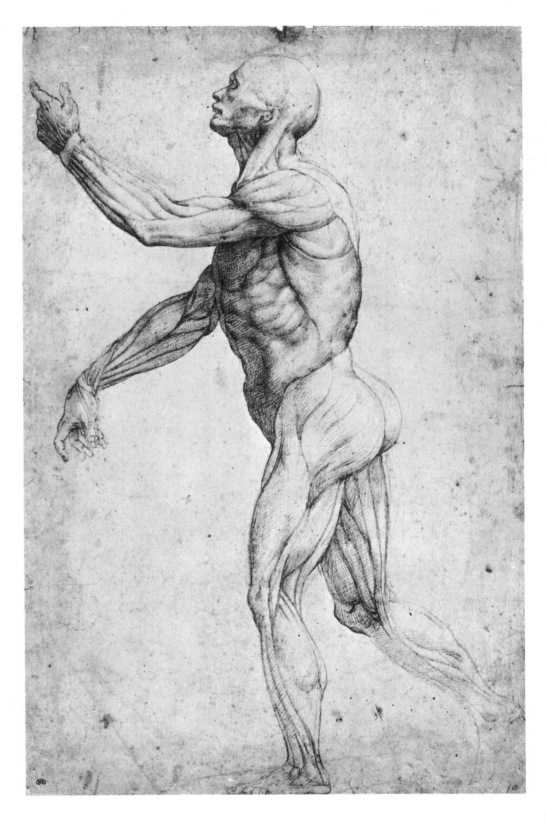

Proportions
and anatomy
in treatises on art

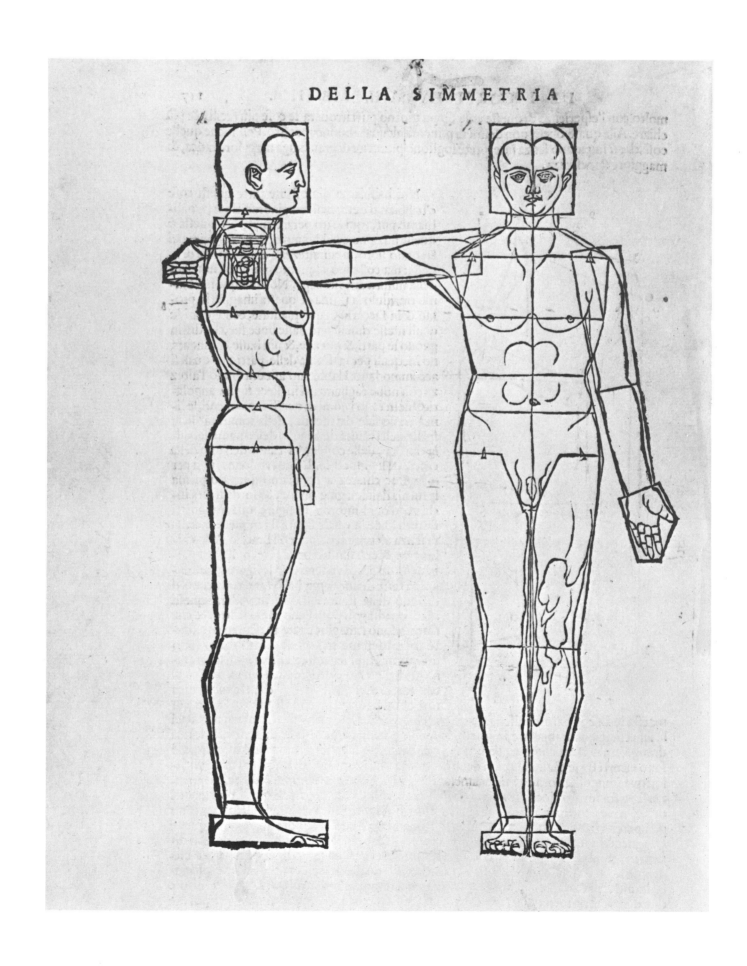

DELLA SIMMETRIA

Albrecht Dürer, *Della Simmetria dei corpi humani,*
Libri Quattro, Venice, 1591, plate from Book IV.

1

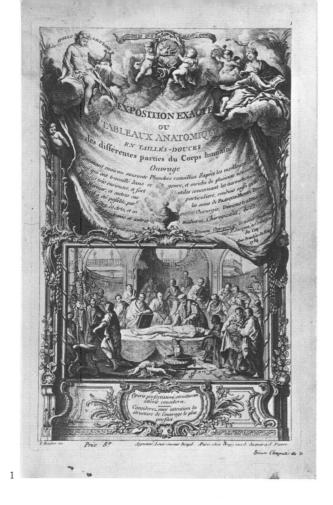

2

3

1, 2 François-Michel Disdier, *Exposition exacte ou tableaux anatomiques en tailles-douces des différentes parties du Corps humain,* Paris, 1784, title page and plate 25.

3 Jacques Gamelin, *Nouveau recueil d'ostéologie et de myologie,* Toulouse, 1779, plate with écorché figure.

4, 5 Charles Monnet, *Etudes d'anatomie à l'usage des peintres,* Paris, n.d., title page and plate 27.

4

5

29

THE STUDY AND TEACHING OF DRAWING

The word Academy denotes both the place where the model is studied and the work which results from this study. It derives from the classical age in Greece, when it referred to the olive grove of Academe outside Athens, where informal meetings were held of humanists and philosophers, including Plato. The term was taken up again in Italy in the fifteenth century to mean the place (a studio or some patron's palace) where artists and scholars met to study the theory and practice of art. According to Wackernagel, the first private art academy was the one which began meeting in the sculptor Bertoldo's studio in Florence around 1490. One of the best known academies was that opened by the sculptor Baccio Bandinelli in Rome about 1530, then continued in Florence about 1550. But it was not until the second half of the sixteenth century that an academy emerged as an institution. On 13 January 1563, in Florence, Cosimo de' Medici officially founded the Accademia del Disegno, whose moving spirit and organizer was Giorgio Vasari. Its dual purpose was to train artists and to reform art education by basing it firmly on drawing. From the beginning, lectures were provided on anatomy and geometry, and we may speculate on the part played by drawing from the living model. Judging from a text by Federico Zuccaro, asking for a teaching reform at the Accademia del Disegno which would provide for a room to be set aside once a week for drawing from life, it seems that a need was already being felt to develop the practical side of the teaching. The idea of such art schools soon spread to the North. Prompted by what he had seen in Italy during his stay there in 1573-1577, Carel van Mander joined Cornelisz van Haarlem and Hendrick Goltzius in setting up an academy in Haarlem, in 1583, where artists could draw from the model. In Rome, on 14 November 1593, the Accademia di San Luca was opened; its first president was Federico Zuccaro, and its purposes and practice were more comprehensive than those of Vasari's academy in Florence. The educational role of this academy covered not only drawing but also painting, sculpture and architecture. Teaching included study from the living model, for which a "life room" was set aside; copying from collections of casts brought together for the purpose; theoretical lectures and study tours in North Italy. From the Renaissance on, drawing and sketching *dal naturale,* from the living model, were regarded in Italy as an indispensable part of the artist's training. As for terminology, it was in Bologna, perhaps already in the studio of the sculptor Baldi, but certainly at the Accademia degli Incamminati founded by the three Carracci about 1586, that the notion of the nude model and that of the (private) academy merged. Count Malvasia, in his book on the Bolognese painters (1678), refers to the room in which the model, male or female, undressed. The use of female models in an art school was a novelty at that date. In Milan, at the Biblioteca Ambrosiana, an academy was set up in 1620, with a syllabus laid down by its founder, Cardinal Federico Borromeo. The students drew from the living model and copied casts of the Farnese Hercules, the Laocoon and the Apollo Belvedere. In Paris the Académie Royale de Peinture et de Sculpture was founded by a decree of Louis XIV dated 20 January 1648. Here, as in Rome, the teaching was based on theoretical lectures

plus drawing from life. There were twelve teachers, and the teaching was divided into three stages: copying from master drawings, drawing from sculpture, drawing from life. The academies had their own collections of drawings for the use of their students. This pattern of progressive imitation seems to have been common to almost all academies. In Paris the Académie de Saint-Luc, a private rival to the Académie Royale, practised the study of the living model, with twenty-four teachers (including Simon Vouet, whose role was very important) and two models instead of the single one available at the Académie Royale. After various quarrels and negotiations, the two academies merged in 1651. In 1655 the Académie Royale stressed the importance of the model by claiming this study as its own monopoly. Models were thenceforward forbidden to pose outside the Académie, even in private studios. An exception was made for members of the Académie itself, who were allowed to work from the model in their own studios in the presence of their pupils. In 1666 the Académie de France in Rome was founded; in 1676 it merged with the Accademia di San Luca, whose president, Charles Errard, was a Frenchman. Zanotti reports that in Rome about 1686, in the public academy held at the studio of Francesco Ghislieri, "anyone might draw and *rittrare* both the male and the female nude." It was not until a century later that the Académie Royale in Paris allowed female models to pose for the students. Until then they were taboo both in Rome and Paris. Having emerged as institutions in the sixteenth century, the academies became subject to well-defined rules in the seventeenth, and new ones were founded in the eighteenth. It has been estimated that by 1720 there were nineteen art academies in Europe, and thereafter they steadily increased in number: 1724, St Petersburg; 1735, Stockholm; 1738, Copenhagen; 1750, Antwerp; 1768, London; 1795, the Columbianum Academy in Philadelphia; and so on. The growth of such art schools ran parallel to the neo-classical movement, one of whose theorists, J. J. Winckelmann, said: "It is easier to copy the beauty of Greek statues than the beauty of nature."

With the spread of art academies, there began to be a reaction against academic teaching amongst both artists and writers, including Schiller and Voltaire. In a letter dated 30 November 1735, the latter wrote: "No work, in any genre, which is called academic has ever been a work of genius." This was the harbinger of a change of attitude, culminating in 1790 with the founding of a group of revolutionary artists headed by David, who demanded the dissolution of the Paris Academy. On 4 July 1793 the "Commune des Arts" was recognized as the only official association of French artists, and in August of that year the existing academies were abolished—only to reappear in another form on 25 October 1795, with the founding of the Institut de France. Academic teaching was now to be dispensed at the Ecole des Beaux-Arts, where study from the female model was not allowed until 1863. At the beginning, the reputation of the Ecole des Beaux-Arts was eclipsed by that of David's studio, first housed in the Louvre, then at the Institut de France, where students did no less than six hours' drawing from life every day; Gros later took charge of the studio. The private studios of leading artists played an important role in France in the nineteenth century. In the first half, the most famous were those of Delacroix, Delaroche, Ingres and Cogniet; in the second half, those of Bonnat, Gleyre and Couture. The nineteenth century opened up new paths by vaunting the genius of inspiration and imagination. "No longer to copy, but to invent," as Kleist said in *Penthesilea*.

Ciro Ferri (1634–1689):
A Drawing Academy.
Black chalk. (198 × 336 mm.)
Nationalmuseum, Stockholm.

Michelangelo (1475–1564):
The Consecration of the Carmine
Church (copy after Masaccio).
Pen and brown ink. (294 × 201 mm.)
Albertina, Vienna.

Peter Paul Rubens (1577–1640):
Copy after Michelangelo's "Night"
in the Medici Chapel, Florence.
Black chalk, pen and brown ink, heightened
with yellow and white gouache. (245 × 350 mm.)
Fondation Custodia, Institut Néerlandais, Paris.

Copying from the Masters

The instruction given in artists' studios has always been based on the practice of copying the works of the Master. As early as the fourteenth century, as we know from Cennini's *Libro dell'Arte,* young artists, from the beginning of their apprenticeship, were set to copying their Master's drawings. One can imagine the rapt attention with which the young Michelangelo copied Masaccio, his awe and wonder at the monumental power of the human figure as represented in Masaccio's fresco cycle in the Brancacci Chapel of Santa Maria del Carmine, Florence, painted in 1426-1428: a key date for Florentine painting, a decisive moment in the new expression of space. Down to the nineteenth century, copying was considered one of the best means of teaching. Indeed some artists made it a lifelong practice to copy works they admired. Witness Rubens' copies after the antique and after the Italian Renaissance masters (Leonardo, Michelangelo, Raphael); during his years in Italy (1600-1608) he made for himself a large collection of such copies, which he used for reference. When Rubens copied Michelangelo, he was intent on bringing out the sculptural forms, as shown by this sheet of studies after the statue of *Night* in the mortuary chapel of the Medici family in the church of San Lorenzo, Florence (1524-1531), in which the reclining figure is studied from three different angles. Rubens must have drawn it first during his stay in Florence in the spring of 1603; later he added certain details, such as the left hand of *Night,* which Michelangelo had left unfinished. The other two studies of the figure as seen from behind were incorporated into several of his paintings. This sheet of studies exemplifies the process by which the copy is assimilated, interpreted and later re-employed by an artist conscious of the affinities between the style of a master and his own temperament.

Presentation drawings

Michelangelo (1475–1564):
Portrait of Andrea Quaratesi, c. 1530.
Black chalk. (411 × 292 mm.)
British Museum, London.

The high finish of what Johannes Wilde in 1953 called "presentation" drawings, those meant to be submitted to a patron or given to a friend, are the equivalent of *modelli*, although they are ends in themselves. These "arrested drawings," as P. J. Mariette called them in his *Abecedario*, which are very elaborate and usually signed, mark the culmination of a completely executed work and are works of art in their own right. Among the most famous examples are the drawings Michelangelo did for his friend Tommaso Cavalieri: they include portraits and religious and profane allegories (*The Fall of Phaeton* has been interpreted as a symbol of Michelangelo's own presumption, and failure, in his passion for Tommaso, to whom he gave the drawing in 1533). Other examples are drawings by Parmigianino, Ribera, Piazzetta, Boucher. Strangely enough, the artist often uses a single medium like black or red chalk for such works, preferring descriptive objectivity to any attempt at more sophisticated effects.

José de Ribera (c. 1590–1652):
Woman holding an Arrow.
Red chalk heightened with
white on buff paper. (310 × 206 mm.)
Christ Church, Oxford.

Copying
from the Antique

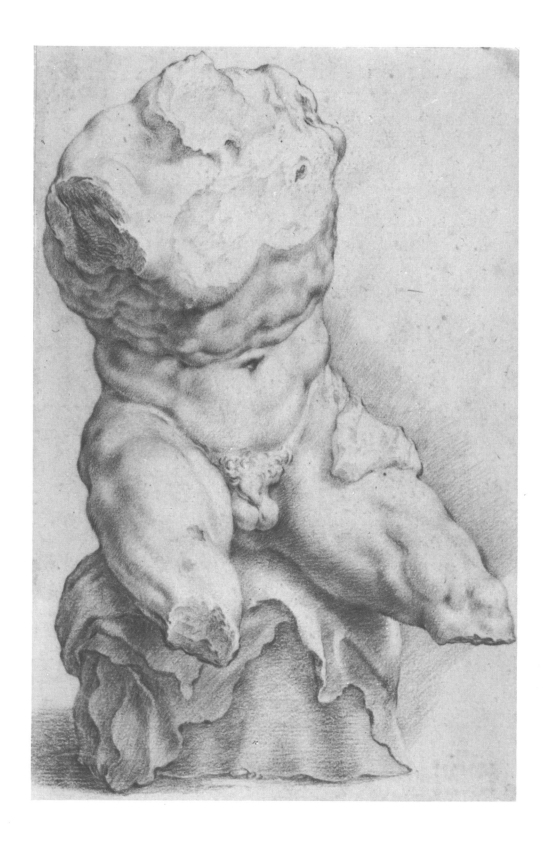

Hendrick Goltzius (1558–1617):
Copy after the Torso Belvedere in the Vatican.
Red chalk. (255 × 166 mm.)
Teylers Museum, Haarlem.

Copying from the antique has been a traditional prac-
tice in the teaching of drawing. Such drawings are
usually done in black chalk or charcoal. This sort of
study has three aims: to acquaint the student with the
human body, to develop his skill in modelling and in
rendering light and shade. Surprising as it may seem,
this most classical discipline and schooling was assid-
uously followed even by those artists whose formal
inventions, in the late nineteenth and early twentieth
century, broke most decisively with the art of the past:
Seurat, Cézanne, Matisse, Picasso. Schooled in this
way, like all the art students of his time, Seurat copied
the Parthenon friezes, the statues of Praxiteles and
Hellenistic sculpture. But not content with a purely
linear drawing, he builds it up in planes, thus indicating
his desire for geometrical simplification and a reduc-
tion of form to its most significant masses.

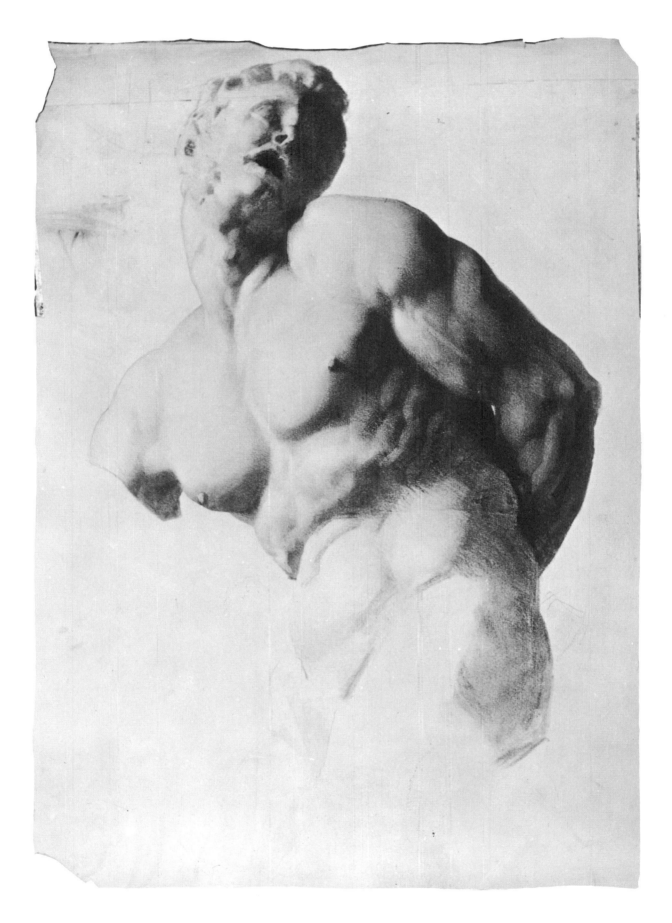

Georges Seurat (1859–1891):
Copy after Puget's "Milo of
Crotona" in the Louvre, c. 1877–1879.
Pencil. (660 × 480 mm.)
Private Collection, Paris.

Life studies

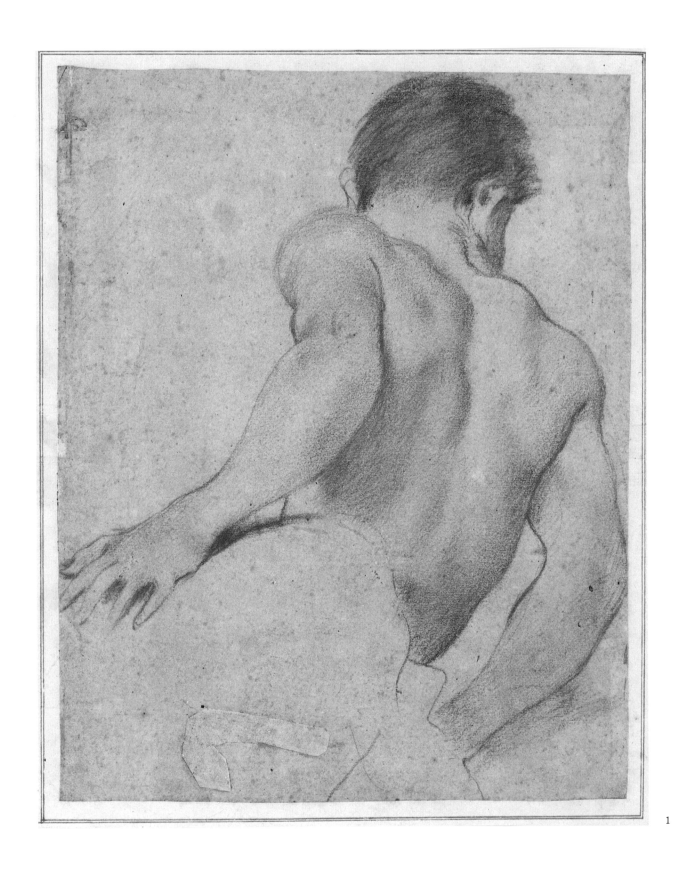

1

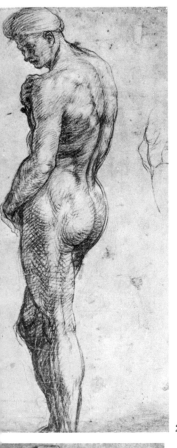

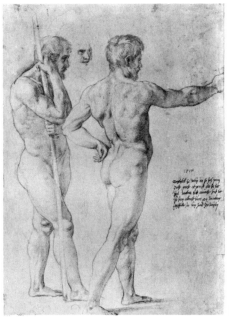

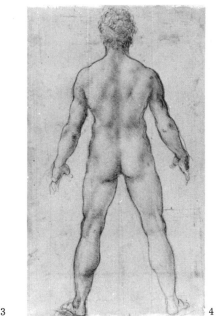

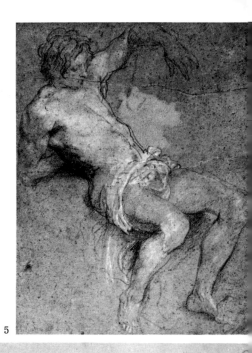

5

6

1. Annibale Carracci (1560–1609).
2. Andrea del Sarto (1486–1531).
3. Raphael (1483–1520).
4. Leonardo da Vinci (1452–1519).
5. Sir Anthony van Dyck (1599–1641).
6. François Le Moyne (1688–1737).
7. Eustache Le Sueur (1616/17–1655).
8. Antonio Canova (1757–1822).
9. A.L. Girodet-Trioson (1767–1824).
10. Pierre-Paul Prud'hon (1758–1823).
11. Vincent van Gogh (1853–1890).
12. Henri Matisse (1869–1954).

2

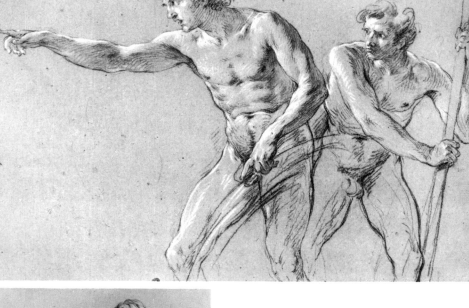

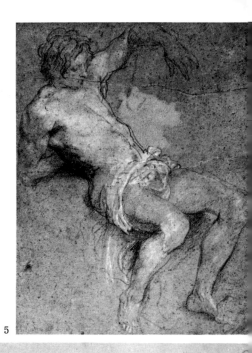

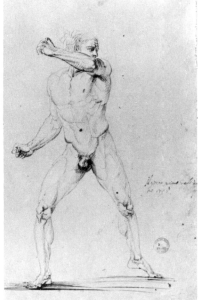

7

8

10

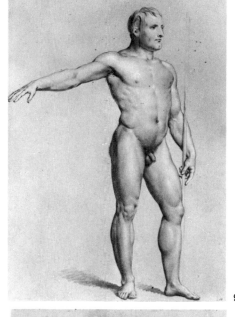

9

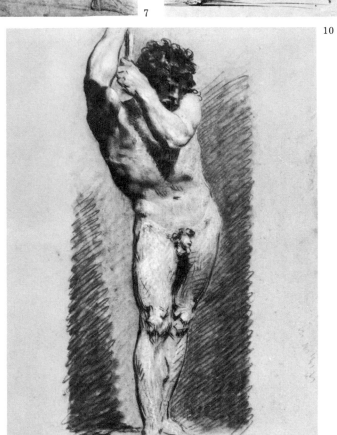

11

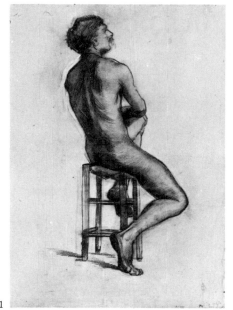

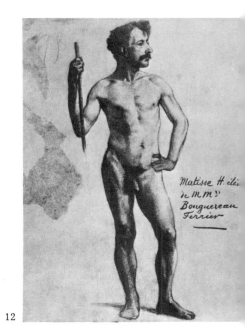

12

THE BASIC
TECHNIQUES
OF DRAWING

The ambiguity of drawing techniques and the difficulty of interpreting them can never be sufficiently stressed. At one and the same time the viewer has to identify the blend of different media and try to make out the order in which the artist used them, going back through successive strata to the drawing's starting point, i.e. to the line or stroke which represents the artist's "first idea." The best method is to begin by noting the predominant, and therefore the most visible, technique. Then one proceeds to the techniques used for the earlier strokes, and lastly the accents and emphases used to heighten the drawing. Starting with a few basic techniques, drawing offers an endless variety of permutations, ranging from the use of different media for laying in the initial lines (by means of stylus, pencil, or pen dipped in inks of various colours), through different kinds of paper (prepared or washed or rubbed with coloured chalks or crayons), to the choice of pen, wash or varnish for the final touches. Error is possible, for example, in trying to distinguish between black chalk and charcoal, where the first has become so dry that it looks as powdery as the second (Titian); or, again, in trying to distinguish between charcoal and black pastel when the former has been pressed down so hard that it has the smooth brilliance more characteristic of the latter. On the other hand, it is comparatively easy, in a raking light, to tell the mark of black chalk from that of graphite pencil (shiny grey) or Conté crayon (a more shiny black). To describe techniques one has to take three contributory factors into account: media, tools and grounds. Media may be divided into two categories: solid (black, red and other chalks, pastel, charcoal, Conté crayon, graphite, greasy crayons, coloured crayons, etc.) and liquid (inks, washes, watercolour, tempera, gouache, etc.). Tools include metal points, pens, brushes, stumps and erasers. Grounds or supports fall into four main categories: tablets, cloth, parchments, papers and cardboards (see Pierre Lavallée, *Les Techniques du Dessin,*

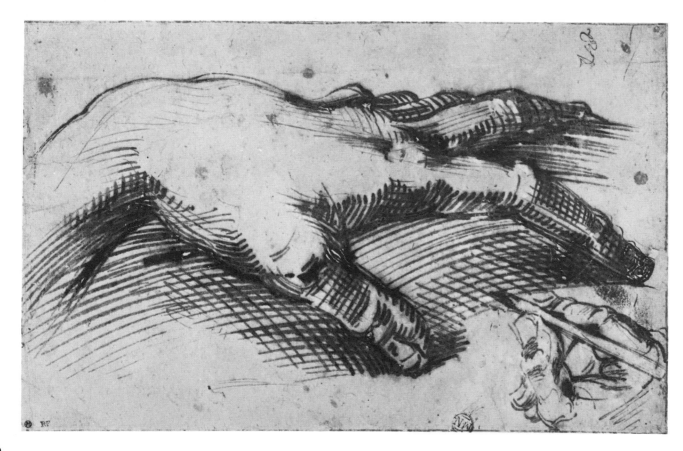

Bartolomeo Passerotti?
(1529–1592):
Study of Hands.
Pen and brown ink.
(180 × 290 mm.)
Cabinet des Dessins,
Louvre, Paris.

Paris, 1949, and Joseph Meder, *The Mastery of Drawing,* translated and revised by Winslow Ames, New York, 1978). Drawing tablets, of which very few examples survive, were made in the Middle Ages of polished wood covered with a layer of powdered bone or a layer of parchment prepared with gesso and white lead. The cloth surfaces most commonly employed were linen and silk, on which the artist drew with brush and wash or pen and ink. Parchment (Greek *pergamene,* from the ancient city of Pergamum in Asia Minor) is dressed animal skin (goat or sheep). Vellum is parchment made from calfskin. Both parchment and vellum were used before the appearance of paper, whose discovery in 105 A.D. is attributed to Ts'ai Luen, director of the imperial workshops in China. The paper-making process was transmitted from China to Central Asia in the fifth century, then to India in the sixth; it reached Baghdad in 793, Egypt in the tenth century, North Africa and Spain in the eleventh, and appeared in Italy at Fabriano in 1276 and in France at Troyes in 1348, thereafter spreading all over Europe. The close-meshed wire mould, dipped in the pulp in the course of paper-making, left wire-marks on the sheets. It was not until the late seventeenth century that paper free of wire-marks was produced through new systems of manufacture. The watermark is produced by a raised design in the mould or roll. It is visible when the paper is held up to the light. The watermarks on drawings can be readily identified when the latter are done on loose sheets, i.e. not backed, pasted down or mounted on cardboard; even then the mark can sometimes be detected in a raking light. As watermarks differ according to the factory, they sometimes permit us to trace the old paper-mills; they also characterize different sizes of paper. The same design, figure or device may give rise to many variants. A common design, for example, is a bunch of grapes, of which some 200 variants are recorded in the standard catalogue of early watermarks (C. M. Briquet, *Les Filigranes,* Geneva, 1907). In addition to the watermark, the sheet of paper usually shows the maker's countermark or monogram. These marks, then, can tell us where the paper was made and when. And so they may be very helpful in dating a drawing or fitting it into the chronological sequence of an artist's work (though of course in all periods the artist may have obtained paper from other times and places than his own); they are helpful above all in reconstituting a sketchbook whose leaves have been dispersed. A distinction needs to be made between "prepared" paper, covered by the artist with a coloured priming coat (indispensable for metal point), and coloured paper dyed with colouring matter while still in the pulp stage. Blue was the first of the coloured papers, appearing in Venice at the end of the fifteenth century; then came grey, brown and buff papers; in time the colour shades and surface textures were refined to an infinite variety.

Almost all the basic techniques of drawing were known by the first half of the sixteenth century, though they may not have reached their fullest development till later. The early inventions were followed by a continuous stream of others, and the expressive powers of even the oldest techniques were ceaselessly renewed. Examples of this are the reappearance of metal points in the later nineteenth century in the hands of Degas and Legros; of watercolour with Géricault and Delacroix; of pastel with Redon, Manet and Renoir. The "mixed media" arise out of inventive combinations, "recipes" personal to each artist. Some of these verge on other fields than that of pure drawing. Some are almost impossible to classify, like the drawings of Giovanni Benedetto Castiglione, who in the seventeenth century drew on paper with a brush dipped first in oil, then in coloured pigments (red, brown, blue, ochre), which he heightened with brown wash or broad strokes of the pen; or those works of Degas in which he mixed and super-imposed tempera, oil and pastel, or laid in pastel and gouache over a monotype. This summary of the main techniques of drawing deliberately excludes those which really belong to painting: oil sketches on paper (e.g. the *bozzetti* of Veronese. Castiglione and Rubens) and grisaille (monochrome painting in grey). Also excluded are techniques belonging to the field of print-making, such as counterproof and monotype.

Pen and ink

Pen and ink, commonly employed for writing, were used for some of the oldest drawings, and have continued to be used for this purpose ever since. Hand-cut quills of birds (swan, goose, raven) are recorded as early as the sixth century; the use of plant quills (reed), which are square-cut and less flexible and give a wider stroke, appeared later. Metal pens manufactured industrially did not come into general use until the nineteenth century. Inks are the result of the widest possible range of mixtures, each artist choosing his own. One of the most common, which can take on a brown colouring, comes from gall-nut, a growth found on oak leaves: to a decoction of the nuts is added vitriol, gum arabic and oil of turpentine. Black ink with a carbon base (lamp-black), which includes so-called Indian ink, can be diluted with water to produce every variation of grey. By using a bird quill cut very fine, Pisanello could reproduce every detail of the surface of a horse's head. With great narrative freedom, Leonardo da Vinci lets his pen flow in easy waves: some of the oblique strokes show that he drew with his left hand.

◁ Pisanello (c. 1395–c. 1450):
Two Studies of a Horse's Head.
Pen and brown ink. (291 × 185 mm.)
Cabinet des Dessins, Louvre, Paris.

Leonardo da Vinci (1452–1519):
Arno Landscape, 1473.
Pen and ink over metal point,
reworked in darker ink. (195 × 281 mm.)
Uffizi, Florence.

44

Metal point

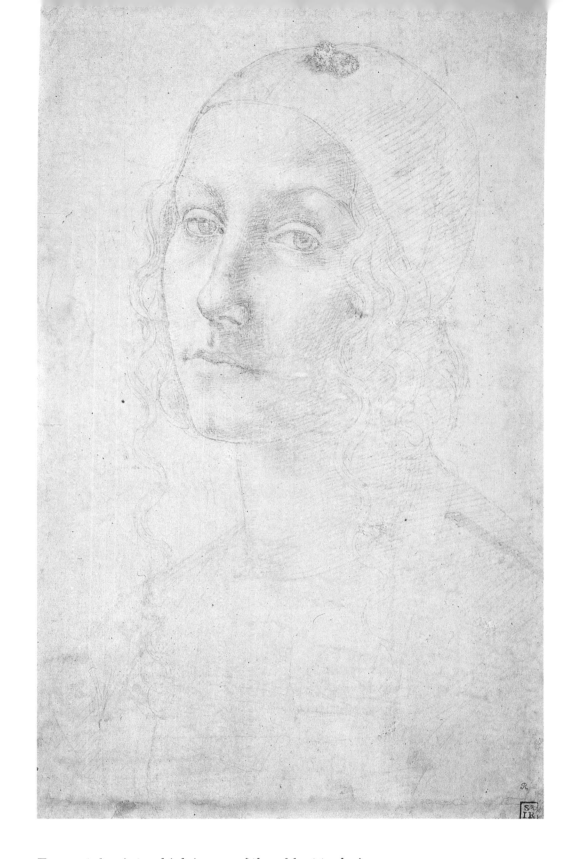

Perugino (c. 1445–1523):
Head of a Young Woman.
Metal point and faint wash on
grey prepared paper. (377 × 243 mm.)
British Museum, London.

◁ Lorenzo di Credi (1456–1537):
Head of an Old Man with a Skull-Cap.
Metal point heightened with white on
paper prepared in grey, then in pink.
(298 × 211 mm.)
Cabinet des Dessins, Louvre, Paris.

For metal point, which is one of the oldest techniques,
the artist uses a metal stylus (gold, silver, lead or cop-
per) which leaves a mark on the sheet and, in the case
of silver point, a trace of matter which becomes
slightly shiny when oxidized by time. The paper has
first been covered with a layer of coloured preparation
applied with the brush and made up of such ingredients
as Spanish white, gypsum, or powdered bone and
colour, bound with size. Several layers may be super-
imposed one upon the other, after each has dried and
been smoothed. Metal points, which leave a furrow on
the surface, can only be used on the prepared paper
known in Italy as *carta tinta*. There is an inexhaustible
variety of shades available for the preparation – every
tone of blue, grey, green, pink, mauve and yellow.
Metal point technique, which was used as early as the
fourteenth century by such northern artists as Jan
van Eyck, Rogier van der Weyden and Gerard David,
was employed with particular virtuosity by the Ger-
man draughtsmen of the following generation (Dürer,
the Holbeins) and also the Florentines.

Lucas Cranach the Elder (1472–1553):
Two Dead Waxwings hanging from a Nail, c. 1530.
Watercolour and gouache. (346 × 203 mm.)
Staatliche Kunstsammlungen, Dresden.

Watercolour and gouache

Albrecht Dürer (1471–1528):
Alpine Landscape in the South Tyrol
("Wehlsch pirg"), c. 1495.
Watercolour and gouache. (210 × 312 mm.)
Ashmolean Museum, Oxford.

Watercolour is a mixture of coloured pigments and transparent gum (gum arabic, from the Latin *arabicus,* "which comes from Arabia"; derived from a species of acacia), diluted to a greater or lesser degree with water, with no white added. The white of the paper, which thus needs to be left bare in certain places, shows through everywhere to some extent according to the amount of dilution.

Watercolour is frequently used for light heightening in drawings made as designs for decorative work (costumes for pageants and ballets, objets d'art, painted façades). It is also a technique which is perfectly suited to still lifes, in which it is able to transcribe all the nuances (Cranach, Dürer). The use Dürer made of this technique, from the late fifteenth century on, was exceptional at the date; a striking example is the series of some fifteen landscapes, recording his crossing of the Tyrolean Alps, which he drew on his way back to Nuremberg from Venice.

In this landscape, foregrounds are sketched broadly with brush and watercolour, while the mountain in the middle is very delicately depicted in watercolour, with some touches of gouache for greater detail. Gouache (from the Italian *guazzo,* distemper), also known as body colour, is a preparation in which the colouring matters are thinned with water, with size and white added, which makes it opaque whereas watercolour is transparent.

Luca Signorelli (c. 1445–1523):
Two Male Nudes Wrestling, c. 1513.
Black chalk. (283 × 163 mm.)
Royal Library, Windsor Castle.

Black chalk, also called Italian chalk, is in its natural state a close-grained slate which can be cut into sticks, varying in tone from black to grey. It came into use in Italy at the end of the fifteenth century, especially in Florence, where it was well suited to the new researches into volume and modelling which were necessary for the study of the nude (Pollaiuolo and Signorelli). It remained a favourite medium for drawing the human figure, whether nude or draped, single or in groups. It is chiefly to be found among the preparatory drawings for paintings made in the fifteenth and sixteenth centuries (Leonardo da Vinci, Michelangelo, Fra Bartolomeo, Lorenzo Lotto, Raphael, Sebastiano del Piombo, Titian). During the seventeenth century, most European artists continued to use it for their preparatory studies and also for portraits; and in the eighteenth century for landscape. In time, the strokes of black chalk may become so dry that it is hard to distinguish them from charcoal. Towards the beginning of the nineteenth century, charcoal and graphite pencil began to replace black chalk.

Titian (c. 1490–1576):
Jupiter and Io.
Black chalk and charcoal (?)
on blue-grey paper. (252 × 260 mm.)
Fitzwilliam Museum, Cambridge.

Red chalk

michel. ange.

Pontormo (1494–1556): ▷
Study of Three Male Nudes.
Red chalk. (400 × 267 mm.)
Musée des Beaux-Arts, Lille.

Michelangelo (1475–1564):
Pietà.
Lead point, black chalk and red
chalk on brownish paper. (404 × 233 mm.)
Albertina. Vienna.

This is one variety of an iron oxide called haematite (from the Greek *haimatites*, bloodlike), which exists in the form of a slab or a stick or as powder. Cennino Cennini in his *Libro dell'Arte* (Florence, c. 1390) describes it, in the first two forms, as a stone which is "very strong and solid, dense and perfect." Ranging in colour from orange-red to purplish-brown red, it is sometimes called sanguine (from the Latin *sanguis, sanguinis,* blood). First used for the preparatory tracing of frescoes, red chalk was applied directly to the plaster ground on the wall to be painted. This underdrawing was called a sinopia (from the ancient town of Sinope in Asia Minor where haematite came from). Not until the late fourteenth century did red chalk become a technique of drawing proper, and it was then used on paper, either in its solid form (the mark left by the stick) or in liquid form (the slab or powder being mixed with water to form a wash applied with either brush or pen). It was often laid in over other media, such as pen and brown ink, black chalk or white chalk. The use of red, black and white chalk together is known as the "three crayon" technique. Because its colour and luminosity fit it perfectly for rendering flesh tints, red chalk is a favourite for portraiture and studies of the nude. The most masterly examples come from the Tuscan artists: Leonardo da Vinci, Michelangelo, Pontormo. In the seventeenth century and even more in the eighteenth, it continued to be used for figure studies from the living model, but in the second half of the eighteenth century Fragonard and Hubert Robert freed it from this restriction, and instead of using it for nudes alone adopted it as almost the sole medium of their landscapes. In the nineteenth century the Impressionists (Renoir, Berthe Morisot, Manet) resumed the traditional use of red chalk for portraits.

53

Mons^{r.} Le Gran escuyer Galiot

Jean Clouet (c. 1475–1541):
Jacques Ricard, known as Galiot,
Seigneur de Genouillac, c. 1520–1525.
Black and red chalk. (263 × 196 mm.)
British Museum, London.

54

Coloured chalks

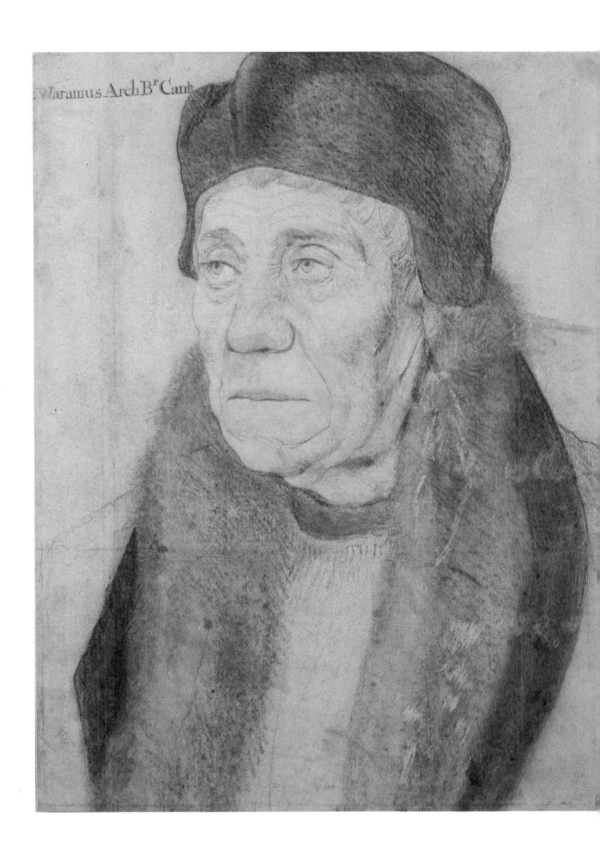

Hans Holbein the Younger (1497/98–1543):
William Warham, Archbishop
of Canterbury, c. 1527-1528.
Black, red, yellow and brown chalk.
(401 × 310 mm.)
Royal Library, Windsor Castle.

Coloured chalks offered a composite medium much
favoured for portraits, of which the most celebrated
examples are to be found in the sixteenth century,
with the Clouets and the Holbeins. This tradition of
colour in the art of portrait drawings was continued
by such artists as the Zuccares, Hendrick Goltzius,
Rubens and Van Dyck; it culminated in the early
eighteenth century with Watteau's extraordinary sheets
of head studies. The so-called three crayon technique
(black, red and white chalk) was used both for portrait
studies and for the preparatory sketches for decora-
tive paintings in eighteenth-century palaces and
mansions. Much appreciated by French artists (La
Fosse, the Coypels, the Boullongnes, the Mignards,
Lancret, Pater, Boucher), the three crayon technique
reappeared in the late nineteenth century.

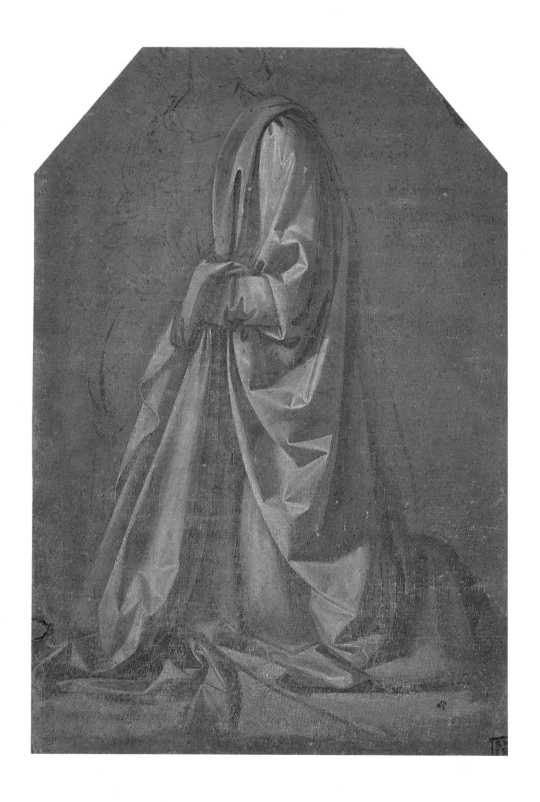

Leonardo da Vinci (1452–1519):
Study of Drapery for a Kneeling Figure.
Pen and brown ink and wash heightened with
white on grey-tinted linen. (280 × 190 mm.)
British Museum, London.

Perino del Vaga (1500–1547): ▷
Study for a Wall Decoration in the Sala
della Giustizia in the Castel Sant'Angelo, Rome.
Pen and brown ink and grey wash on light brown
paper, heightened with white (305 × 353 mm.)
Royal Library, Windsor Castle.

Daniel Marot the Elder (1663–1752): ▷
Design for a Ceiling Decoration.
Pen and brown ink and grey wash heightened
with yellow and red. (308 × 385 mm.)
Kupferstichkabinett, Staatliche Museen,
Berlin.

Grey wash is Indian ink diluted with water and applied with the brush; it is generally heightened with white gouache. It appeared in a special form in Italy in the second half of the fifteenth century, when it was applied to fine linen and so elaborately worked up that it resembled painting. Mantegna used it in this way, sometimes laying the grey wash over a coloured camaieu or monochrome base, this latter technique belonging strictly to painting. Grey wash—brush and Indian ink—should not be confused with grisaille, monochrome painting in grey. As a pupil in Verrocchio's workshop in Florence, Leonardo used brush and grey wash with white heightening for his drawings of draperies, executed as follows: "He made clay figurines which he covered with a soft worn linen dipped in plaster, and then set himself to draw them with great patience on a particular kind of fine Rheims cloth or prepared linen" (Vasari).

Colour washes result from the use of inks of various tones diluted in water and applied with a brush. The colours most frequently used are indigo blue, derived from the leaves of the indigo plant; red, from haematite or mercuric sulphide (cinnabar); and green, from a mixture of verdigris and saffron. Colour washes made from ink are used in much the same way as water-colour: they often serve to heighten drawings destined to be used as architectural designs or projects for decorative paintings. The most abundant examples are supplied by the Mannerist generation, whether the Italians (Perino del Vaga, Parmigianino, Bernardo Buontalenti, Ludovico Cigoli, Giovanni Biliverti), the French (Jacques Bellange), the Dutch (Carel van Mander, Abraham Bloemaert, Joachim Wtewael, David Vinckeboons) or the Flemings (Bernaert van Orley, Bartholomeus Spranger).

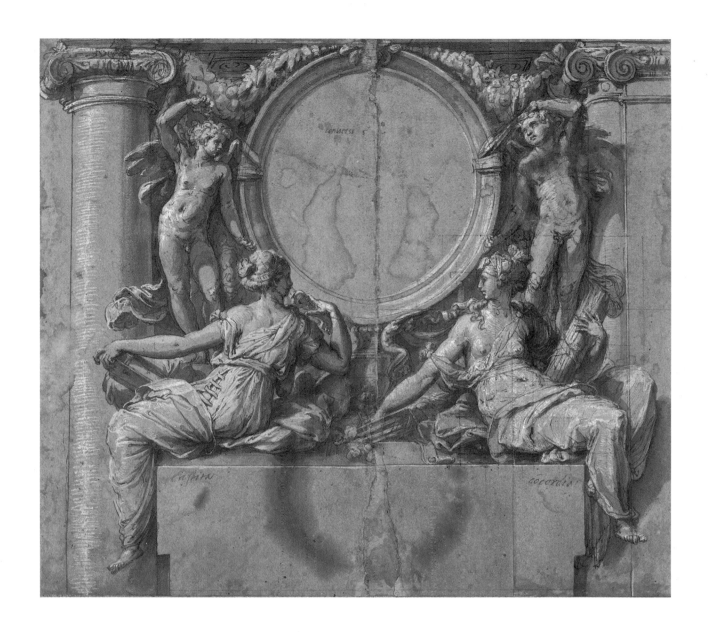

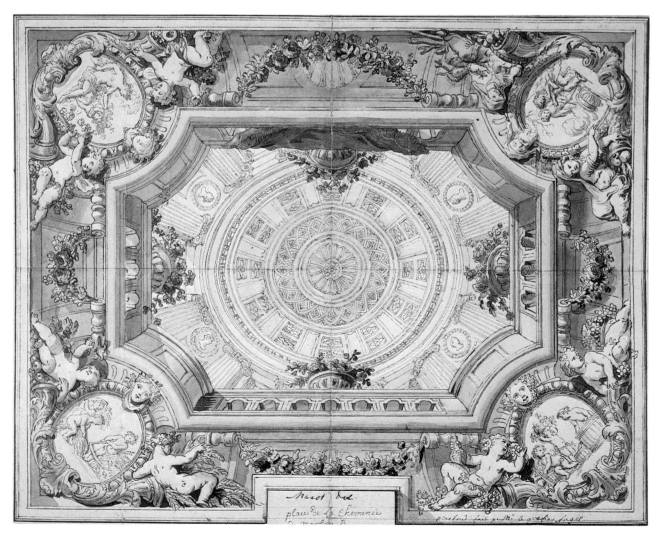

Watercolour
on vellum

Georg Hoefnagel (1542–1600):
Vase of Flowers surrounded by
Insects, Fruit and Flowers, 1594.
Watercolour on vellum. (161 × 120 mm.)
Ashmolean Museum, Oxford.

Vellum is so smooth and satiny a support that it enhances the delicacy of watercolour. It has therefore been used, with a technique akin to that used for illumination and miniatures, and often with gold heightening or borders, for small-scale studies connected with books on natural science (plants, flowers, fruits, animals) or ornaments. It produces an almost photographic accuracy, a sort of trompe-l'œil. In the sixteenth century many artists all over Europe developed this way of imitating reality with a parallel study of animals, insects and plants: the Hoefnagels and the de Gheyns were at once miniaturists, draughtsmen and engravers. Common to all their work is the idea of transcribing something as light, fine and transparent as the wings of an insect, a fly or a butterfly. In addition to this painstaking study of detail they also showed great skill in lay-out and harmony of design. This technique was used for the great sets of plant drawings commissioned in France in the seventeenth century by Gaston d'Orléans and later by Louis XIV. In the case of the royal collection, the drawings were done by a number of different miniaturists, including Nicolas Robert, in collaboration with the botanists of the Jardin des Plantes, who chose the plants to be reproduced and supervised the accuracy of the work. With their high finish and threefold purpose (scientific, encyclopedic and aesthetic), these vellums are a special case among drawing techniques, on the boundary between drawing and illumination, drawing and manuscript, drawing and album adapted for engraving. A vellum often has gold borders or edges, by way of a trompe-l'œil imitation of plates from herbals.

Jacques Lemoyne de Morgues (?–1587):
Dog Roses, 1585.
Watercolour on vellum. (213 × 143 mm.)
British Museum, London.

The techniques
of brown wash
and brown ink

Nicolas Poussin (1594–1665):
Woodland Scene.
Pen and brown ink, brown
and grey wash. (255 × 185 mm.)
Albertina, Vienna.

The washes most frequently met with are executed
in brown ink, the colours ranging from the lightest
bronzes (Parmigianino and Niccolò dell'Abbate) to the
darkest browns (some of the wash drawings of Poussin and Claude Lorrain, those of Rembrandt, Goya
and Fuseli). Wash may be used in small light touches
to heighten pen and ink drawings, as well as in large
flat tints without any preliminary drawing in pen or
pencil. See, for example, this landscape by Guercino,
rapidly and with the utmost virtuosity set down with
the whole width of the brush on a blue-grey paper
which contrasts with the brown of the wash. This
swift landscape sketch by Rembrandt, drawn with
similar economy of means and comparable brio, is
executed in brown ink with a very wide-cut reed
pen–not to be confused with a brown wash done with
a brush. A reed pen produced a stroke of various
widths depending on the way it was manipulated.

Guercino (1591–1666):
Landscape with a Volcano.
Brush and brown wash on
blue-grey paper. (258 × 372 mm.)
Janos Scholz Collection,
The Pierpont Morgan Library, New York.

Rembrandt (1606–1669):
Farm among Trees, c. 1641.
Reed pen and brown ink. (183 × 326 mm.)
Staatliche Kunstsammlungen, Dresden.

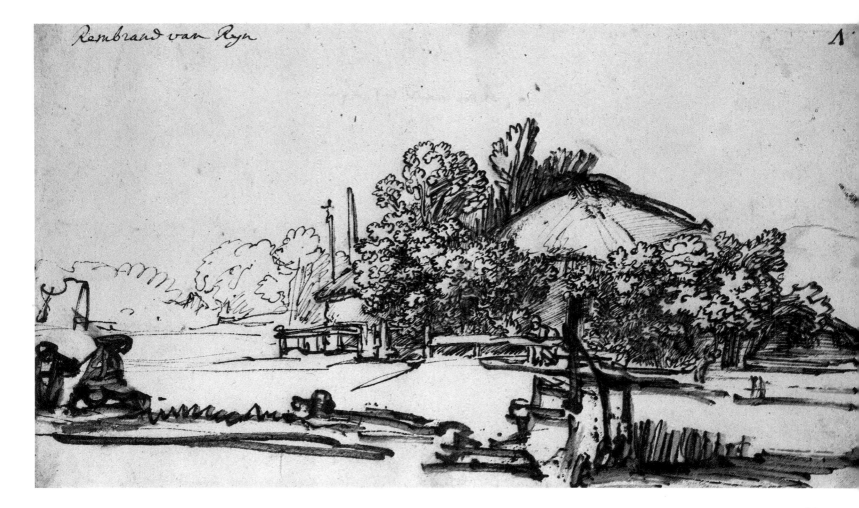

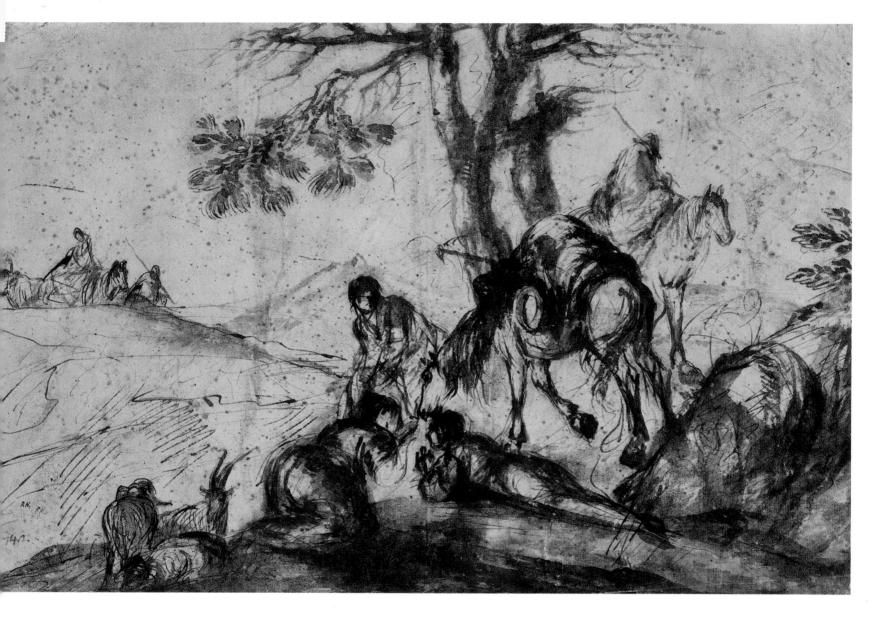

Giovanni Benedetto Castiglione (c. 1610–1665):
Travellers Resting under a Tree.
Pen and brush, dark brown ink and wash,
on yellowed white paper. (273 × 403 mm.)
Janos Scholz Collection, New York.

It is comparatively rare to find techniques used
entirely unmixed, as was the case with Guercino and
the brush and Rembrandt and the pen. Usually the
two techniques are found closely intermingled on the
same page, the pen and ink defining the lines and
contours of the figures while the brush and brown
wash, with their large flat tints, modulate the tones
and shadows. There is no law about which should
come first, the pen or the brush: each artist is free
to follow his own ideas. Among the most creative of
artists in this respect is Giovanni Benedetto Casti-
glione, sketching his composition rapidly with the
brush and then going over it with wide stripes of the
pen. In this drawing by Salvator Rosa, on the other
hand, the spirited patches of brown wash seem to
complement the stroke of the pen, encircling the
draped male figure and freezing him in that position.

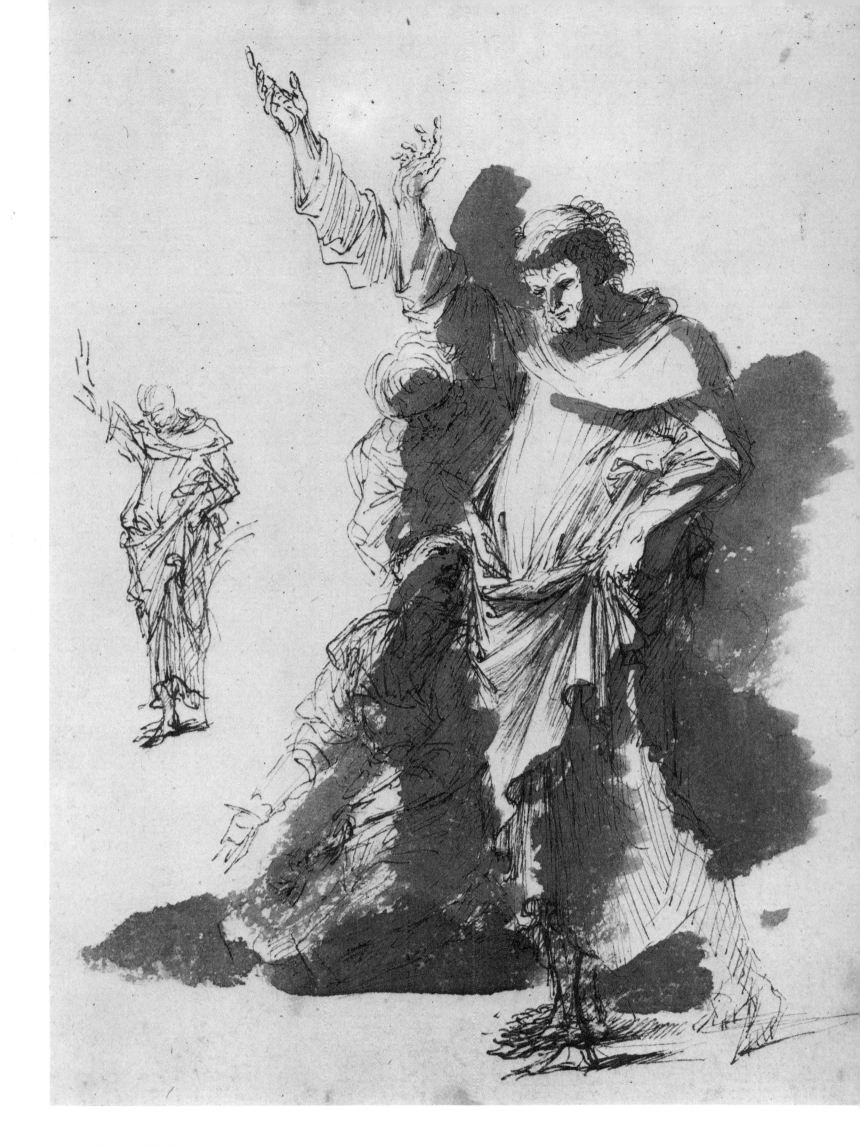

Salvator Rosa (1615–1673):
Studies of a Standing Male Figure with Raised Arm,
with a Kneeling Supplicant Female and Another Figure.
Pen and brown ink and brown wash. (198 × 151 mm.)
The Art Museum, Princeton University, Princeton, New Jersey.

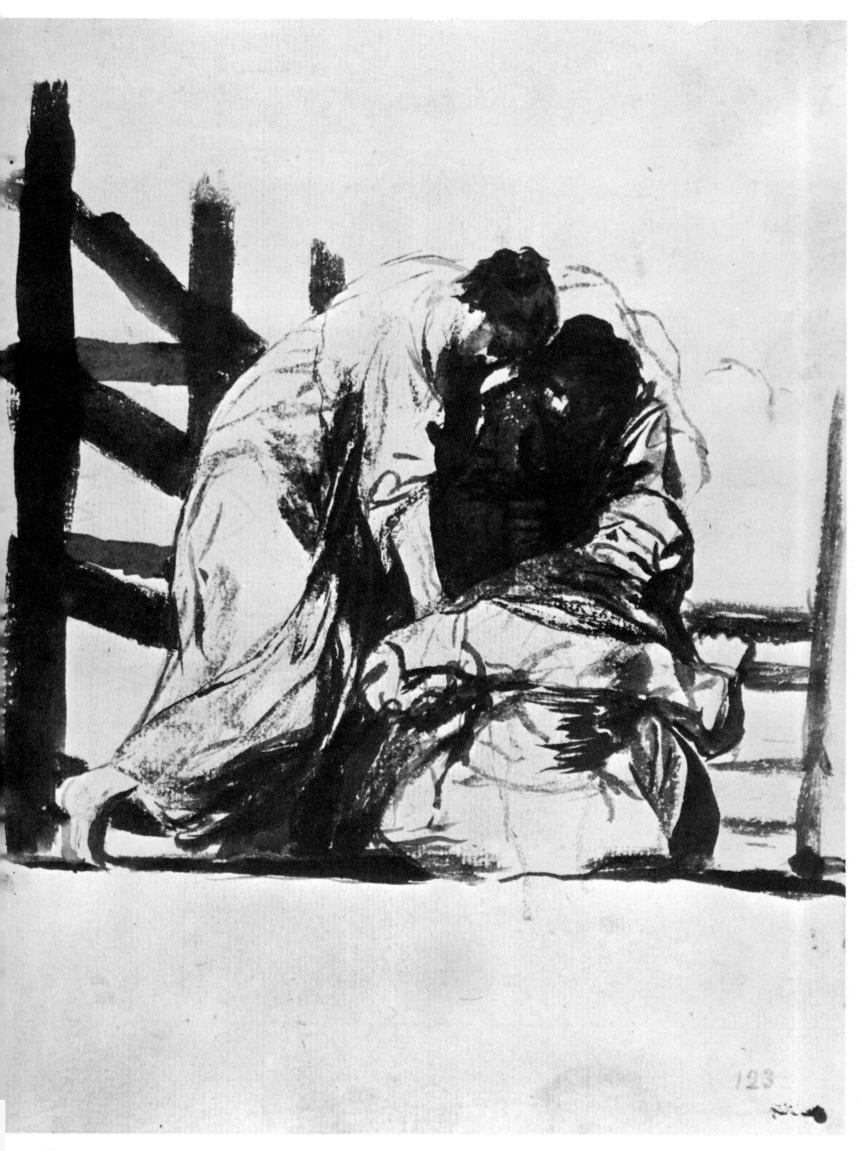

Brush and brown wash is one of Goya's commonest techniques, lending itself to his violent contrasts of light and shade and to his simplification of figures. These he depicts with a minimum of detail since he is chiefly concerned with the expressiveness of their attitude, which he often distorts. A very dark wash matches the tragic nature of his favourite subjects, torture and death, and reminds us that Goya is essentially a painter more accustomed to handling a brush than any other tool at the draughtsman's disposal. In his often enigmatic scenes, the brush becomes a marvellous vehicle for conveying a new visionary power, with all the force of the imagination. Something of the same power is found in George Romney, William Blake and Fuseli. Fuseli's subjects were the anguished images of dream and the unconscious.

◁ Francisco Goya (1746–1828):
 Help, c. 1812–1823.
 Brush and brown wash. (206 × 145 mm.)
 Prado, Madrid.

John Henry Fuseli (1741–1825):
Kriemhild sees the Dead Siegfried in a Dream, 1805.
Brush and brown wash heightened with
watercolour and gouache. (385 × 485 mm.)
Kunsthaus, Zürich.

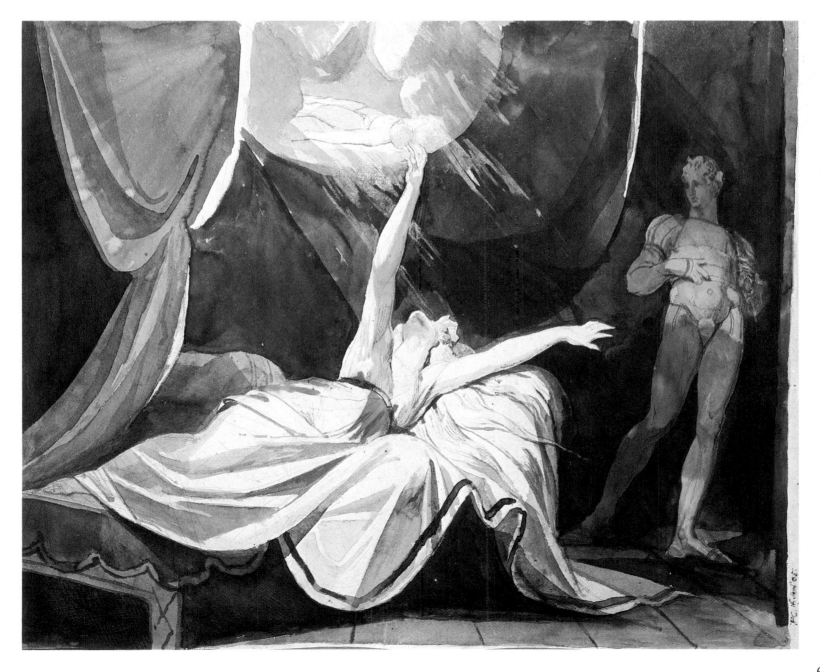

Pastel is obtainable in little sticks made from various ingredients. Dry powdered colours, either pure or mixed with a proportion of white according to the desired intensity, are kneaded up in a paste with size, gum arabic, and sometimes honey or milk, and allowed to set in little cylindrical moulds. Pastel is applied to a support of paper or cardboard which is usually tinted (grey-blue, grey-beige, buff) and more or less grainy. Parchment or primed canvas may also be used. The support is usually stuck on to a frame covered with canvas, and then itself framed in order to avoid rubbing. The great problem is to prevent the powder left on the paper by the pastel from dropping off or smudging, so the whole surface of the work is sprayed with a fixative, formerly with a gum arabic base but now with a base of spirit and transparent resin (shellac). The etymology of the word pastel (*pastello*, from *pasta*, paste) seems to suggest an Italian origin; but according to a note written by Leonardo da Vinci (folio 247 of the *Codex Atlanticus*, Biblioteca Ambrosiana, Milan), this technique, which he calls "the way to draw with dry colours," was introduced to him at the end of the fifteenth century by a French artist, Jean Perréal, who came to Milan in 1499 with Louis XII. Throughout the sixteenth century, pastel was used for heightening portrait drawings with a few touches of colour: in France, those of

Jean-Etienne Liotard (1702–1789):
Portrait of Mademoiselle Lavergne, 1746.
Pastel. (521 × 419 mm.)
Rijksmuseum, Amsterdam.

Pastel

Maurice Quentin de La Tour (1704–1788):
Head of Mademoiselle Puvigné.
Pastel. (320 × 240 mm.)
Musée Antoine Lécuyer, Saint-Quentin.

François Quesnel, Daniel Dumonstier, and Jean and François Clouet; in Italy, those of Jacopo Bassano and Federico Barocci; and in Holland, those of Hendrick Goltzius. In the seventeenth century pastel emerged as an independent technique perfectly suited to the art of the portrait, and Charles Le Brun, Robert Nanteuil and Joseph Vivien prepared the way for the great period of pastel in the eighteenth century, with Rosalba Carriera, Nattier, Louis Vigée, Liotard and Boucher. Among the greatest exponents of pastel were Maurice Quentin de La Tour, Jean-Baptiste Perronneau and Jean-Baptiste Siméon Chardin.

Being mat and opaque, this medium is well suited to rendering flesh tints by an interplay of cool and warm tones. Unless diluted and applied with the brush, pastel does not have the covering power of oil paints; according to the intensity or the lightness of the artist's touch, the underlying tones may show through to some extent. It affords a wide variety of handling: fine or full-bodied hatchings, interwoven or blurred strokes. A further advantage made it ideal for commissioned portraits: the ease and rapidity with which facial expression could be caught without the necessity of long sittings; in this way the head alone of important figures could be drawn from the model on a small sheet, and then fitted into the picture afterwards in the studio.

The revival of watercolour

Thomas Girtin (1775–1802):
Above Bolton: Stepping Stones
on the Wharfe, 1801.
Watercolour. (322 × 521 mm.)
Mr and Mrs Tom Girtin Collection, London.

The revival of watercolour to depict landscape drawn from nature occurred in England in the second half of the eighteenth century, with artists such as Girtin, Cotman, Turner, Constable, Bonington and Fielding. In their watercolours they keep to a rather sombre range of colours (greens, blues and ochres) applied in large flat tints covering the whole of the paper without any spaces left blank. Theirs was a decisive influence, not only on the following generation of French romantic artists like Géricault and Delacroix, but also for the Impressionists who used watercolour in their study of landscape in the open air. Cézanne, outstripping all previously discovered technical possibilities, used watercolour as a field for experiment. He invented new effects of transparency and superimposed colours, breaking natural objects down into numerous facets foreshadowing Cubism, the notion of the unfinished picture and abstraction.

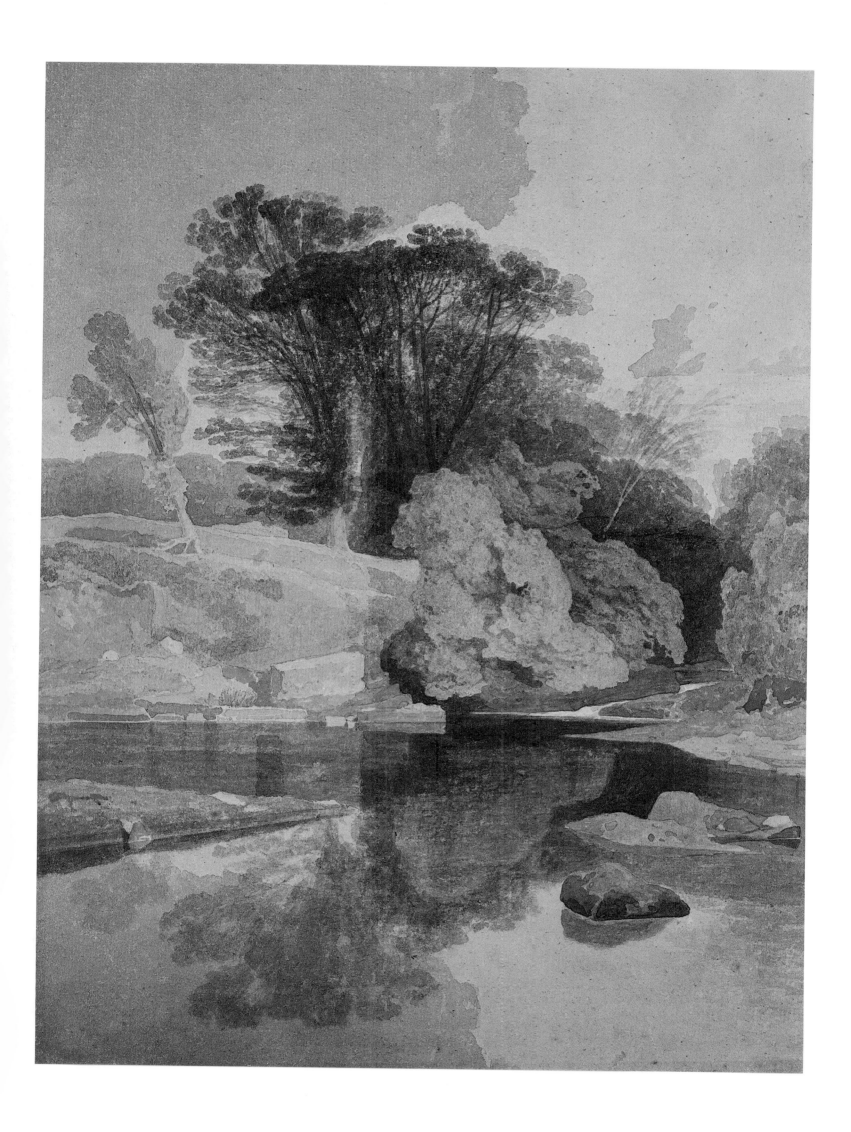

John Sell Cotman (1782–1842):
The Shady Pool, where the Greta
joins the Tees, 1805.
Watercolour. (455 × 355 mm.)
National Gallery of Scotland, Edinburgh.

70

Pencil

Sir Edward Burne-Jones (1833–1898):
Head Study for one of the Graces
in "Venus Concordia," 1895.
Pencil. (370 × 315 mm.)
Kunsthalle, Hamburg.

◁ Jean Auguste Dominique Ingres (1780–1867):
Portrait of Madame d'Haussonville, c. 1842–1845.
Pencil on thin white wove paper,
squared for transfer. (234 × 196 mm.)
Fogg Art Museum, Harvard University,
Cambridge, Massachusetts.

This is a small stick of graphite made of almost pure
crystallized carbon, also called plumbago, which
forms the central part of the ordinary pencil intro-
duced at the beginning of the nineteenth century. It
leaves a shiny mark on the paper and this helps to
distinguish it from the much duller mark made by
black chalk. The sharpness, purity and flexibility of
the pencil line made it the favourite instrument of the
great nineteenth-century draughtsmen, such as
Burne-Jones, Ingres, Corot, Delacroix, Chassériau
and Degas. In his portraits, Ingres uses graphite with
such mastery that it adds to their effect of distance.
The line is so fine that it delimits only the outer shell
of the people portrayed, so that despite the fact that
they gaze fixedly at the artist or spectator, they seem
to lack both physical density and real life. This tech-
nique reached its culmination in the twentieth century
in the drawings of Modigliani, Bellmer and Picasso.

Charcoal and Conté crayon

Odilon Redon (1840–1916):
Fantastic Head, 1891.
Charcoal on buff paper. (505 × 364 mm.)
The Metropolitan Museum of Art, New York.

Charcoal is a friable carbon made from the wood of the spindle tree. Because the powdery residue it leaves is so volatile, it needs spraying with a fixative. Even more than black chalk it permits strong contrasts between the ground of the paper and the most intense blacks, obtained by pressing hard on the charcoal and superimposing one stroke on another. Charcoal enabled Odilon Redon to find expression for his "researches into chiaroscuro and the invisible." He always used it on coloured paper, usually buff or blue, "thus indicating the trend of my art, or the premisses in the matter of colour in which I was later to delight." No one before Redon had ever achieved such depth in the range of blacks. This medium, through which shapes are no longer decipherable, is a perfect vehicle for his ambiguous and visionary art.

This is a soft black crayon manufactured industrially and named after its inventor, the French scientist Nicolas Jacques Conté. It is a shiny deep black, as distinct from charcoal, which is duller and more sooty. Conté crayon resembles charcoal, however, in the intensity of the blacks it produces and the contrast between these and the paper support. Seurat used Conté crayon exclusively, applying it on coarse-grained white paper so as to produce an endless range of greys and blacks, and leaving the grain visible. The glitter of light is suggested by leaving parts of the paper blank or "*en réserve,*" though here, unusually, they are heightened with white chalk to intensify the effect of luminosity. The figures in Seurat's drawings are almost never represented in terms of contour, but bodied forth by encircling areas of shade, which seem to be gradually enveloping them.

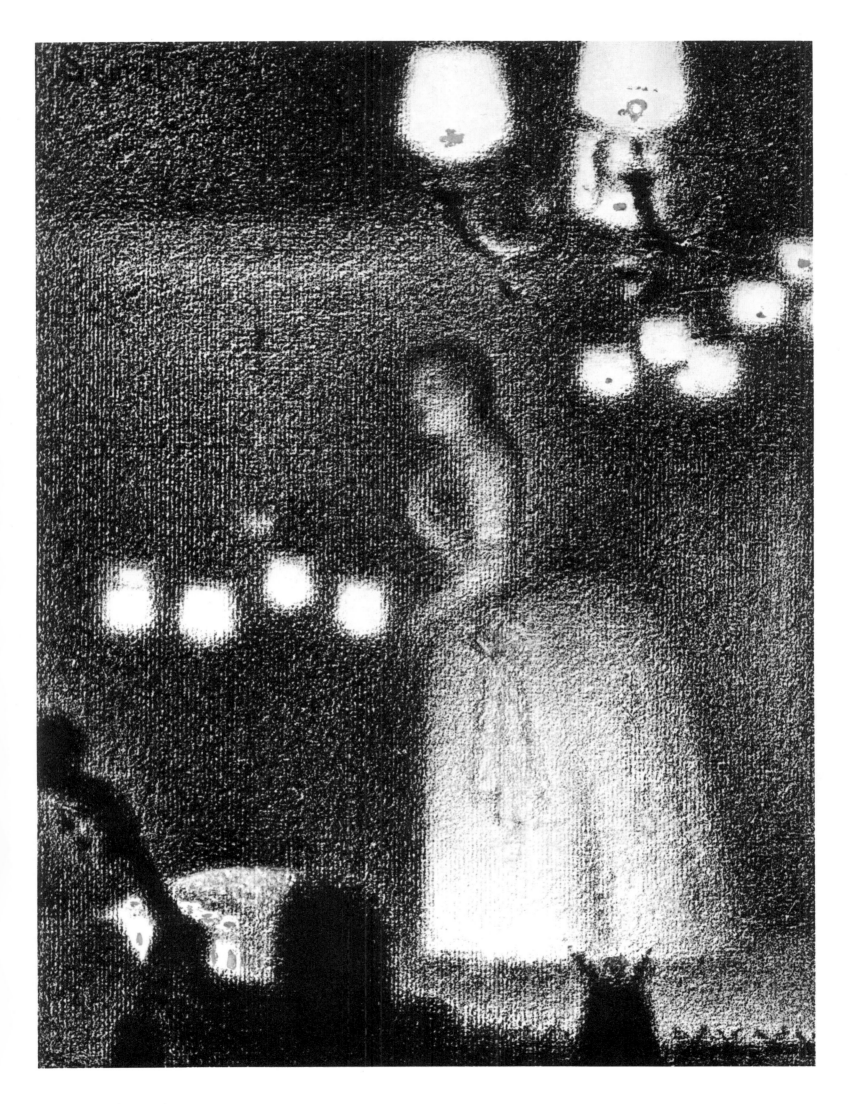

Georges Seurat (1859–1891):
Eden Concert: Singer on the Stage, 1887.
Conté crayon heightened with white chalk
and gouache on Gillot paper. (295 × 225 mm.)
Rijksmuseum Vincent van Gogh, Amsterdam.

Fernand Khnopff (1858–1921):
Nude Study, c. 1910.
Coloured crayons. (325 × 185 mm.)
Private Collection, Brussels.

Coloured crayons

Gustav Klimt (1862–1918):
Reclining Woman, 1909–1910.
Pencil and red and blue crayons
heightened with white. (370 × 560 mm.)
Private Collection, Austria.

Coloured crayons, which began to be produced industrially towards the end of the nineteenth century, are harder and finer than pastel, and easier and quicker to use, while offering the same infinite variety of shades. Their introduction coincided with the revival of colour. The Impressionists used them for their landscape studies, and they made it possible for Toulouse-Lautrec to capture with the utmost swiftness the artificiality of the characters he chose to depict. Coloured crayons enabled both Toulouse-Lautrec and Klimt to produce a trompe-l'œil rendering of the exaggerated make-up of the women who fascinated them. The symbolists used the strange colours this new medium made available to underline the gap between their images and the real world. The Belgian artist Fernand Khnopff intermingled fine strokes of different coloured crayons to produce the most unusual colour effects.

Pastel and the resurgence of colour

Edgar Degas (1834–1917):
After the Bath.
Pastel. (622 × 655 mm.)
Cabinet des Dessins, Louvre, Paris.

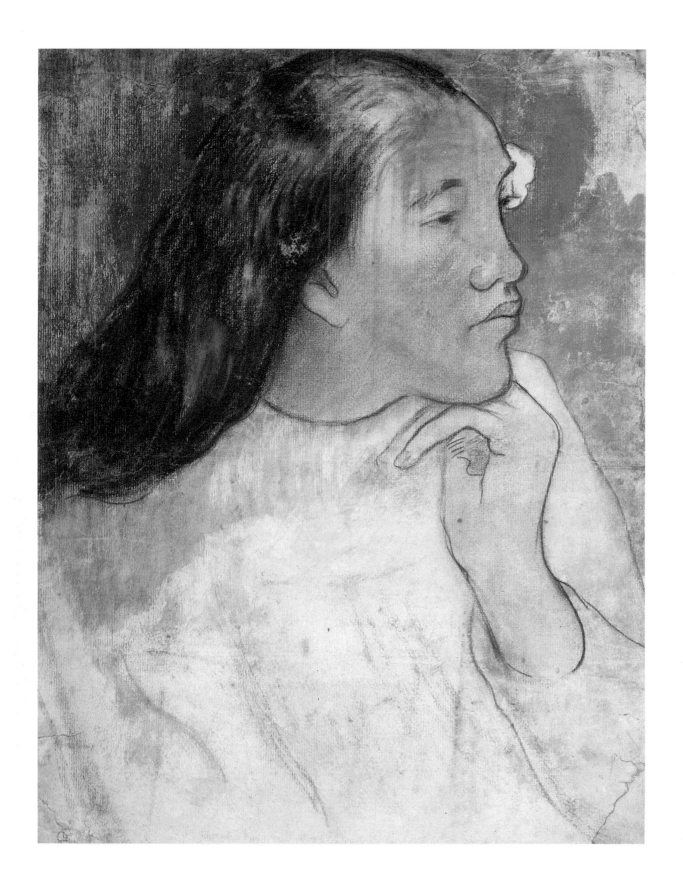

Paul Gauguin (1848–1903):
Tahitian Woman, 1891–1893.
Pastel and gouache. (400 × 310 mm.)
The Metropolitan Museum of Art, New York.

At the end of the nineteenth century pastel again played an important role, when the dazzling resurgence of colour reached its climax in the field of drawing. From 1877 on, Degas began to use pastel in a most inventive manner, from the point of view of colour, treatment and composition alike. The bold palette he uses here already belongs to the art of the twentieth century. Gauguin mixed pastel with gouache to represent the bright colours he lived amongst in Tahiti. For the symbolists, pastel was no longer a medium for representing reality, but must suggest the idea of inner feeling. Odilon Redon, rediscovering colour in about 1895 after his black and white period, adopted pastel as one of his favourite techniques.

4

DRAWING

AND

ITS PURPOSE

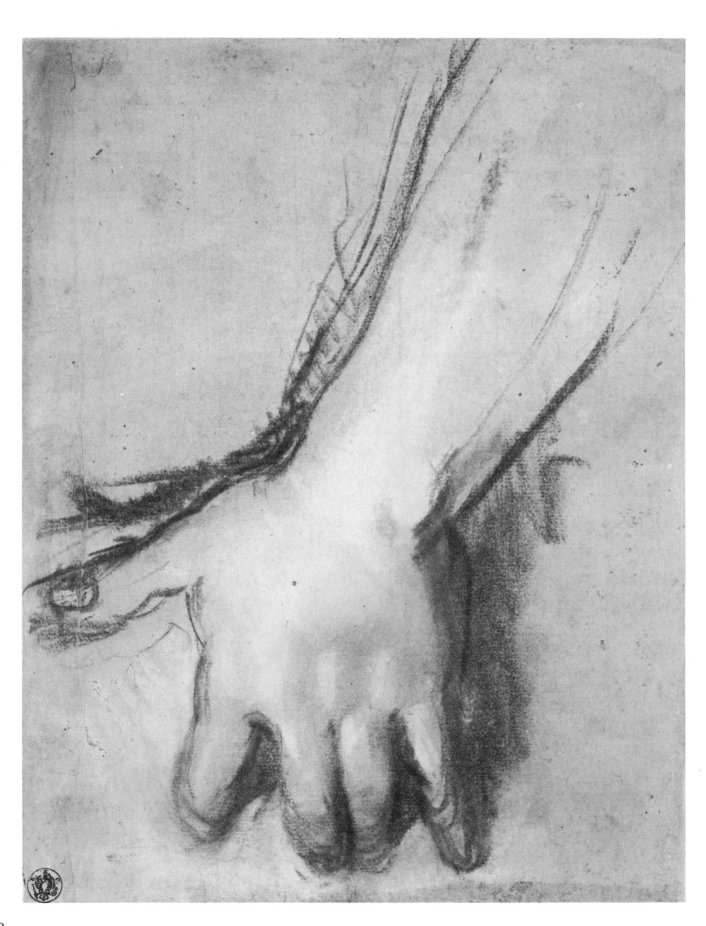

FROM DRAWING TO FINISHED WORK

Drawing may be seen as the ideal means of showing the creative process behind a work of art in all its spontaneity, revealing the various stages of its conception from the very "first idea" (Italian *pensiero*) onward. Several series of preparatory drawings survive which each lead up to a single composition, and study of these shows that most artists follow the same sequence. A rapid sketch of the first idea is worked up into a general disposition of the composition. Individual parts are then studied in detail, followed by the squaring up of the whole, and then the *modello*, a full and accurate drawing which is a smaller version, more or less identical, of the finished work. It is often executed in media akin to those of painting (grisaille, *bozzetto*) and indicating all the necessary values. The cartoon, which has the same format as the final painting, is the last stage preceding it.

For the first part of this chapter, Federico Barocci's *Visitation* has been chosen as an example of the unfolding of this process. The second part brings together examples of preparatory drawings for different kinds of work (fresco, painting on panel or canvas, engraving, sculpture), all instances in which the artist himself carries out each of the necessary stages from conception to final realization (though he may have help from others in certain works of monumental proportions). The drawing is thus placed in the context of its purpose. Examples of comparisons between drawings and final works have been selected from among artists who are at the same

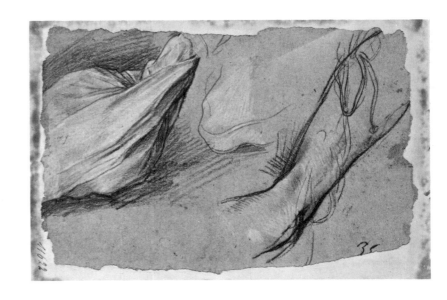

Federico Barocci (c. 1528–1612):

◁ Study for the Virgin's left hand.
Black and white chalk on green paper. (251 × 186 mm.)
Kupferstichkabinett, Staatliche Museen, Berlin.

Studies for St Joseph's right arm and his bag. Verso.
Black chalk heightened with white
on blue paper. (283 × 420 mm.)
Uffizi, Florence.

time most representative of their age and particularly inventive and productive in the realm of painting, engraving or sculpture. The choice was necessarily limited, but it aims at bringing out in each case the key moments of the artist's work as a draughtsman. In many cases the drawing is closely linked to the "conceptual" aspect of the painting, but it should be remembered that this aspect is strangely absent from the work of such artists as Vermeer, Hals, Velazquez and Chardin, who were so essentially painters that they worked directly on canvas or panel without passing through the intermediary stage of drawing. The third part of the chapter attempts to distinguish between the kind of preparatory drawing designed to lead to a specific work, and the kind which is "planned" to be executed by other hands than that of the draughtsman himself. The latter corresponds to the English term *design*: something drawn by an artist but put into effect by a whole team of other practitioners: builders and engineers in the case of architecture, weavers in that of tapestry, goldsmiths for jewellery and objets d'art, and the relevant specialized executants for wallpaper, stage scenery, ballet costumes, etc. In such cases the drawing is a point of departure for all kinds of transformation and interpretation, depending on the contributions made by all those involved in the execution.

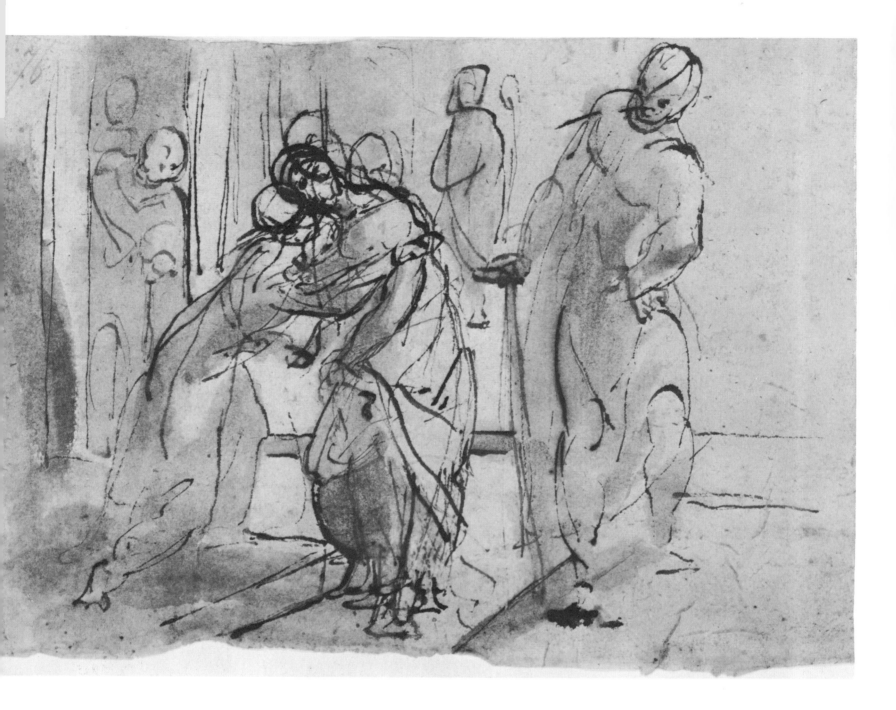

First idea

First idea.
Pen and brown ink and grey wash. (117 × 166 mm.)
Rijksmuseum, Amsterdam.

The working out
of Barocci's *Visitation*

Federico Barocci was born in Urbino about 1528 and died there in 1612. He carried out many commissions both for his native town and for others (Bologna, Genoa, Perugia, Rome, Senigallia) and made a large number of preliminary drawings for his paintings: "The studies for one picture are multiplied to such an extent that it is hard to imagine a man persevering enough to pursue his work so far" (P. J. Mariette, *Catalogue de la vente Crozat,* Paris, 1741). Barocci's work is well known thanks to Harald Olsen's monograph (*Federico Barocci,* Copenhagen, 1962) and the catalogue of the Barocci exhibition held in 1975 at the Museo Civico in Bologna. The *Visitation* was commissioned in 1582 by the Oratorian Order, who were active diffusers of Catholicism, for the chapel of the Visitation in the Chiesa Nuova in Rome; the patron of the chapel was Francesco Pozzomiglio. The long

and painstaking work was carried out between 1583 and 1586 in Barocci's Urbino studio. Surviving documents show that the artist's clients complained about his slowness, hesitations and delays. As soon as the picture was finished in Urbino in 1586 it attracted great attention, even before being transported to Rome and put into position in July 1586. Its fame spread thanks to prints and painted copies. The first engraving of it, with a dedication to Cardinal Aldobrandini, the future Clement VIII, was made by Gysbert van Veen in 1588; two further printings of it followed in 1589 and 1594. It was subsequently engraved by Philippe Thomassin, Philippus Galle and Aegidius Sadeler. Barocci's initial working out concerned the action and setting of the figures. The "first ideas," in pen and brown ink, are lay-outs of the composition, with the meeting of the Virgin and St Elizabeth set in the centre. The format,

Schematic drawing
for the overall composition. Recto.
Pen and brown ink and wash. (270 × 176 mm.)
Statens Museum for Kunst, Copenhagen.

Schematic drawing

◁ Schematic drawing
for the overall composition. Verso.
▽ Two schematic drawings
for the overall composition. Recto.
Pen and brown ink and brown wash
over black chalk (327 × 219 mm.)
Fondation Custodia, Institut Néerlandais, Paris.

Sheet of studies

Sheet of studies: The Virgin
and St Elizabeth. Recto.
Pen and brown ink and wash.
(281 × 205 mm.)
Nationalmuseum, Stockholm.

at first square, later becomes an upright rectangle and
remains so in the final painting. The artist's chief
concern is how to organize the background of the
scene, which takes successive forms: an open space
in the Amsterdam drawing; a doorway opening on to
the cathedral square in Urbino, with a glimpse of the
cathedral steps on the right (Copenhagen drawing);
a schematic view with several buildings (Fondation
Custodia, verso). Finally, on the recto of the Custodia
drawing is the sequence of semicircular arches open-
ing on a landscape; these arches reappear, with
assurance and precision, in the sheet of studies in
Stockholm in which the flight of steps where the
meeting takes place is now clearly defined. The Stock-
holm sheet is important as showing the moment at
which the artist studies as a unified group the two
central figures of the Virgin and St Elizabeth, both

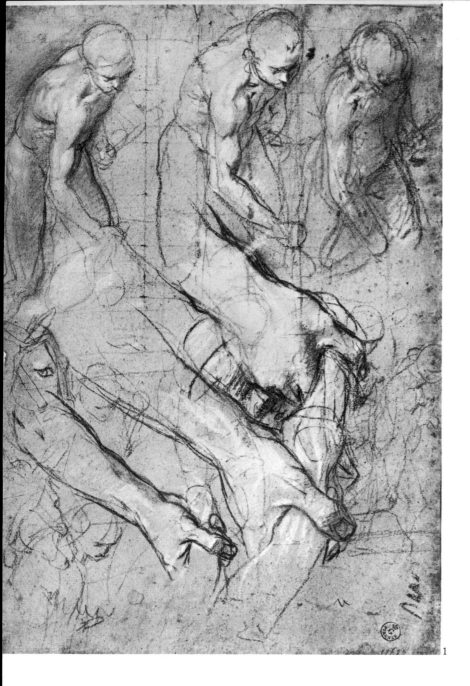
1

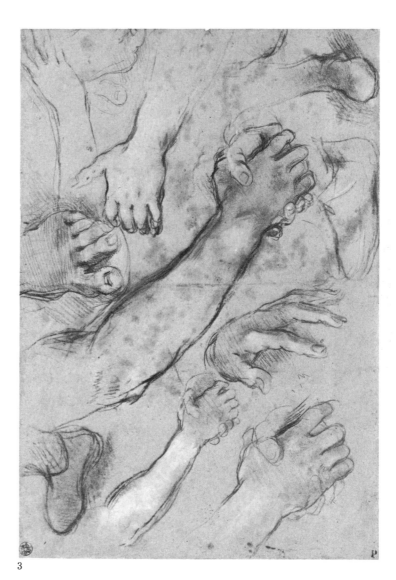
2

Sheet of studies

1. Nude studies for St Joseph. Recto.
 Black chalk heightened with white
 on blue paper. (420 × 283 mm.)
 Uffizi, Florence.

2. Sheet with studies of St Zacharias.
 Black and red chalk heightened with
 white on blue paper. (401 × 283 mm.)
 Uffizi, Florence.

3. Studies for the hands of the Virgin
 and St Elizabeth.
 Black and white chalk on
 blue paper. (274 × 409 mm.)
 Kupferstichkabinett, Staatliche Museen, Berlin.

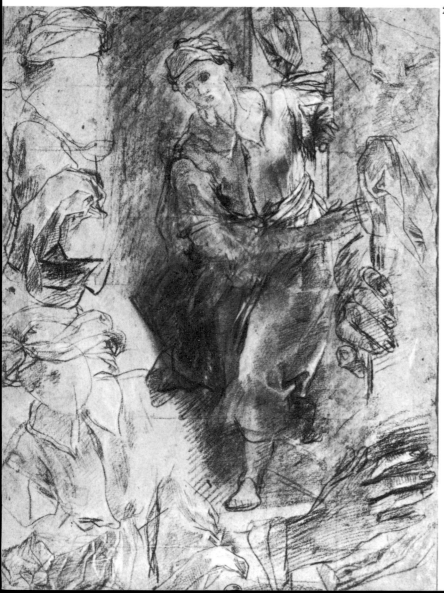
3

clad in draperies. At the foot of the sheet he twice
repeats this figure group, but reversing it and drawing
the two figures schematically in the nude. From now
on, right down to the finished painting, he keeps to
this reversed pose; the background will also be revers-
ed in order to emphasize the way in which the compo-
sition hinges on the diagonal running down from the
upper right corner. Having thus set the picture
elements in place, Barocci made many further studies
in black and red chalk, working out in detail the atti-
tude of each figure, drawn first in the nude, then
draped, first in full length, then half length. After this
analysis of each figure taken singly, he recomposed
the scene as a whole in its definitive shape in a squared
drawing (disegno compito) ready for transfer to the
final canvas. It is worth noting the elaborate technique
of this Edinburgh drawing: black chalk, pen and

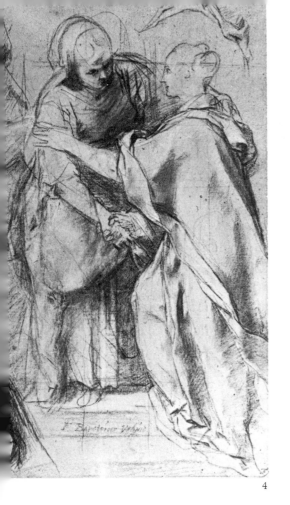

4 5 6

Single figures

7

-5. Study for the Virgin
 and St Elizabeth. Recto.
 Study for the Virgin. Verso.
 Black chalk heightened with white
 on blue paper. (381 × 253 mm.)
 Devonshire Collection Chatsworth.

6. Study for the Virgin.
 Black chalk heightened with
 white on blue paper. (414 × 222 mm.)
 Uffizi, Florence.

Squaring

7. Squaring of the composition.
 Pen, brown ink and wash over black
 chalk heightened with white on blue
 paper squared in pen and black
 and red chalk. (463 × 316 mm.)
 National Gallery of Scotland, Edinburgh.

Study for the head of St Elizabeth.
Oil on brown paper. (397 × 278 mm.)
The Metropolitan Museum of Art, New York.

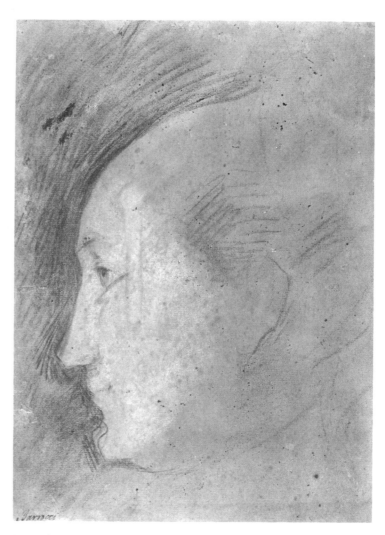

Study for the head of the Virgin.
Pastel. (307 × 227 mm.)
Statens Museum for Kunst, Copenhagen.

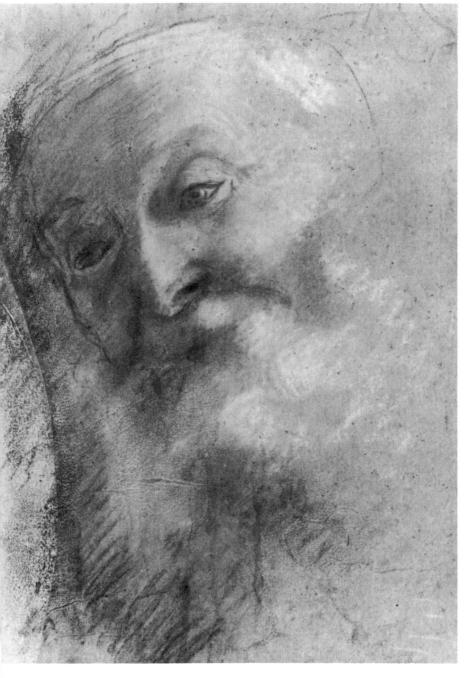

Study for the head of St Zacharias.
Black, red, white and coloured chalk
on blue paper. (343 × 232 mm.)
Albertina, Vienna.

Single figures

brown ink, brush and brown wash, heightened with white gouache; lines drawn in with stylus and compass, reworked with red chalk and squared with pen and black chalk. But even after this apparently definitive stage, some details were yet to be modified. Principally affected were the attitudes of the heads and the angles at which they were inclined; once adjusted, these points of detail gave the painting a remarkable harmony, not only in the sequence of planes in space and the effect of recession, but also in the distribution of lights, illuminating each face but most intense on the profile of the Virgin (almost at the centre of the canvas). The squared drawing in Edinburgh anticipated the large-size cartoon, of which only a fragment has been preserved (Florence). Before the actual execution or possibly in the course of it, Barocci tackled the problem of colour in some studies of heads – in pastel for the

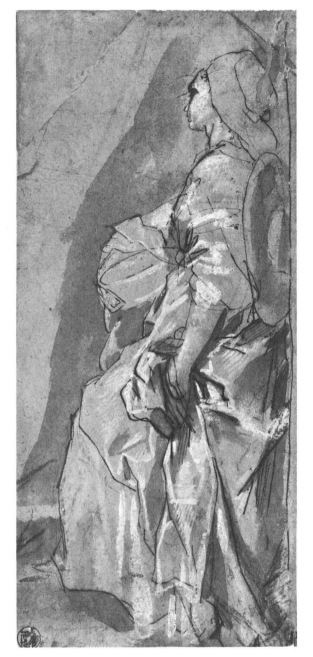

Study for the woman on the right.
Pen and brown ink heightened with
white on blue paper. (275 × 123 mm.)
Kupferstichkabinett, Staatliche Museen, Berlin.

Final painting

The Visitation, 1583–1586.
Oil on canvas. (3 × 2.05 metres)
Cappella Pozzomiglio, Chiesa Nuova, Rome.

Copy of the final painting.
Pen and brown ink and brown wash
heightened with white over black
chalk on blue paper. (396 × 283 mm.)
Royal Library, Windsor Castle.

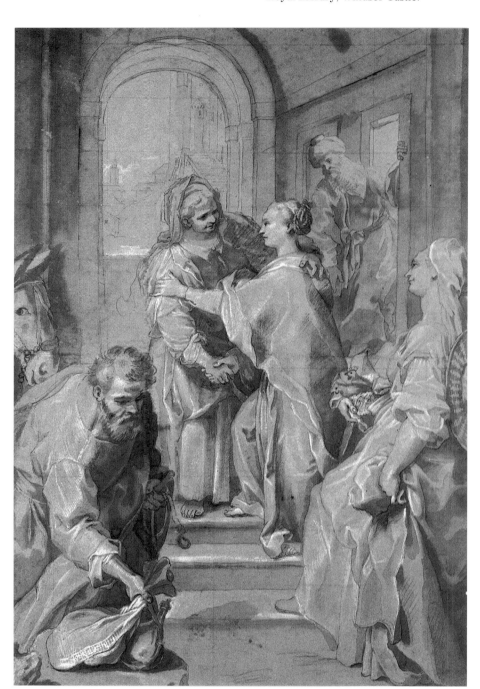

head of St Zacharias, in oils for that of St Elizabeth.
Here, as Edmund Pillsbury notes, Barocci defines form
in terms of colour, and even the tone of the paper
itself–brown–plays a part in the formulation of the
design. He treats this religious scene with a strong
sense of narrative, showing aspects of everyday
domestic life. In the most unconventional way, the
central group is accompanied by three figures, two of
them with animals (a donkey standing on the left
and chickens brought in by the maidservant on the
right). By this directness of feeling, Barocci marks
a break with the prevailing Mannerist style and the
traditional expression of religious sentiment. By the
dynamism of his composition, tellingly accentuated
by the lighting effects, he gives an anticipatory glimpse
of some of the features which were to characterize
the Baroque.

Key stages
in the
preparatory work

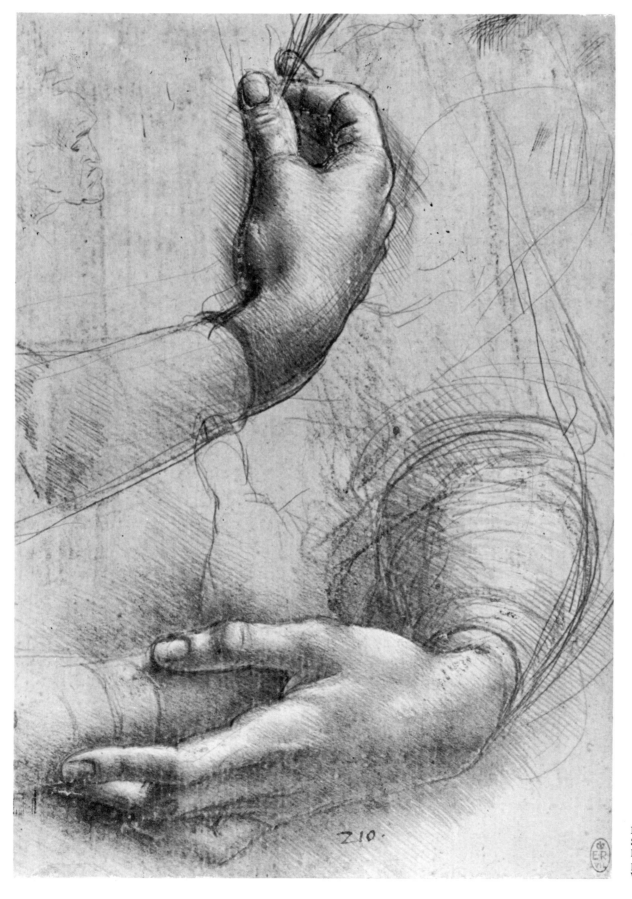

Leonardo da Vinci (1452–1519):
Study of Hands. Metal point
heightened with white on pink
prepared paper. (210 × 145 mm.)
Windsor Castle, Royal Library.

Sinopia: Ambrogio Lorenzetti

The first idea: Fra Bartolomeo and Carpaccio

Pentimenti: Botticelli, Filippino Lippi, Pontormo, Parmigianino

Pricked cartoons: Domenico Ghirlandaio and Verrocchio

An example of preparatory studies: Michelangelo

Squaring: Raphael and Tintoretto

The draughtsman's and engraver's line: Dürer

The modello: Veronese and Jordaens

Schematic drawings: Rubens and Poussin

Figure study for a sculpture: Bernini

Three preparatory stages for Le Brun's "Battle of Arbela"

The draughtsman's and engraver's line: Rembrandt

Sheets of head studies: Lanfranco, Boucher, Watteau

Two preparatory sketches: Giambattista Tiepolo

The draughtsman's and engraver's line: Goya

The importance of line: David and Ingres

The final stages in the preparatory work: Ingres and Puvis de Chavannes

Sinopia

◁ Ambrogio Lorenzetti (active 1319–1348):
The Virgin of the Annunciation,
detail of the right side.
Sinopia. (240 × 172 mm.)
Oratory of San Galgano, Montesiepi (Siena).

Ambrogio Lorenzetti (?) and the Master of Montesiepi:
The Virgin of the Annunciation, detail of
the right side. First half of the 14th century.
Fresco.
Oratory of San Galgano, Montesiepi (Siena).

A sinopia is a drawing made on a wall by way of preparation for a fresco. The name comes from the city of Sinope in Asia Minor which was the source of a brick-red iron oxide (haematite). The powder was mixed with water to produce a wash which was applied directly to the plaster of the wall to be painted. Several coats of plaster (intonaco) could be used one on top of the other if the artist wished to replace or correct his first drawing. A fresco may thus reveal several layers of sinopie, each corresponding to a different stage of composition of a given figure. In this sinopia, a detail from the right-hand side of Ambrogio Lorenzetti's *Annunciation*, the artist's brush has rapidly depicted the attitude of the Virgin as she falls to her knees, overwhelmed with emotion at the apparition of the angel Gabriel: she supports herself by throwing her right arm round a pillar. The right-hand part of the original fresco contained slight modifications, and soon after it was finished it was changed into a much more conventional image, with the Virgin's hands folded over her bosom. The historian Millard Meiss explains: "To carry out this variation the painter (in my opinion, someone very close to Pietro, Ambrogio's brother) cut out a piece of the original intonaco and replaced it by fresh plaster, on which he painted *a fresco* (using the usual technique) a new head and another pair of hands for the Virgin… The fresco and the sinopia were removed by Leonetto Tintori in 1966 and transferred to a support of polyester and fibre glass" (from the catalogue to the exhibition *Frescoes from Florence,* Paris, Petit Palais, 1970). Apart from his sinopie, drawn on walls, we have no other drawings from the hand of Ambrogio Lorenzetti, one of the greatest Tuscan painters of the first half of the fourteenth century.

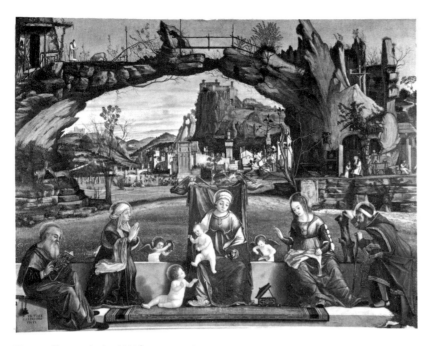

First idea

Fra Bartolomeo (1472–1517):

Study for The Risen Christ (Salvator Mundi). ▷
Black chalk on pink ground. (210 × 170 mm.)
Musée Condé, Chantilly.

The Risen Christ (Salvator Mundi), 1516. ▷▽
Oil. (282 × 204 cm.)
Palazzo Pitti, Florence.

Vittore Carpaccio (c. 1460/65–c. 1526):

Sacra Conversazione, c. 1500.
Tempera on panel. (98 × 127 cm.)
Musée du Petit Palais, Avignon.

Schematic drawing for the Sacra Conversazione.
Pen and brown ink and wash. (197 × 250 mm.)
Uffizi, Florence.

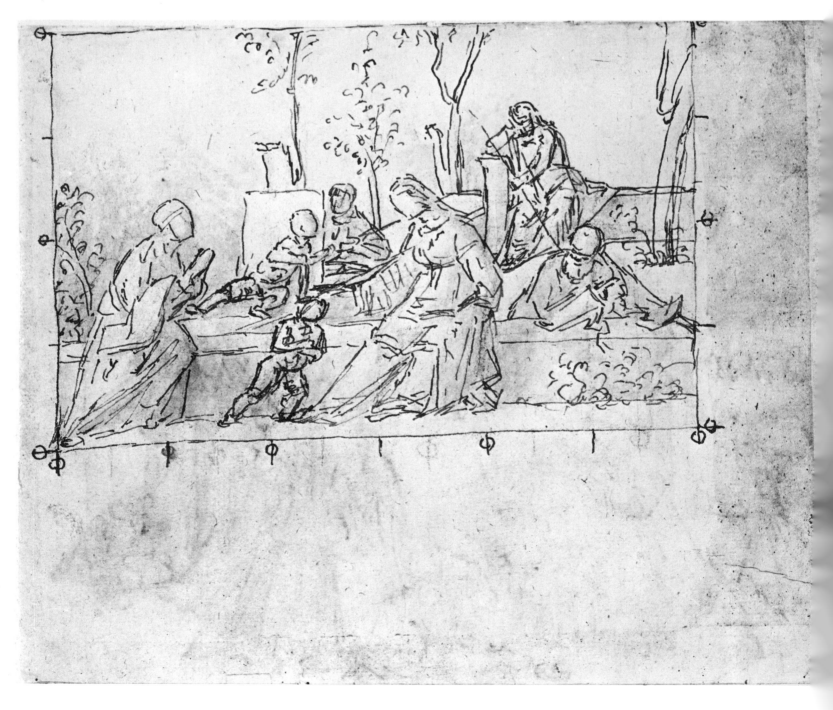

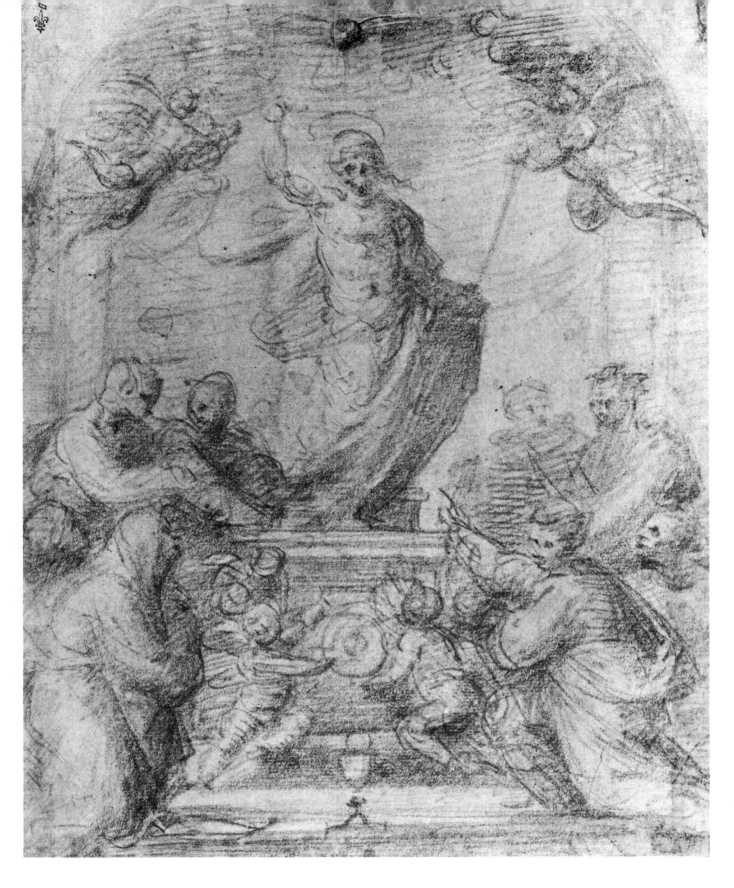

The "first idea" or *primo pensiero* may be a few diagrammatic strokes indicating more or less geometrically the lay-out of various elements in the composition; or there may be a tangle of interrelated strokes setting out its main lines of force. This rough initial sketch was usually small, and the media most frequently employed were pen and ink or red chalk, because of their flexibility and speed. The "first idea" represents the moment in which the work was conceived, with all that moment's inventiveness, effervescence and spontaneity reflected in the energy and excitement of the style. This sketch usually shows many variants with respect to the final painting, containing as it does the sometimes contradictory ideas that went to the working out of the composition. It represents the first and quickest phase of the preparatory drawing.

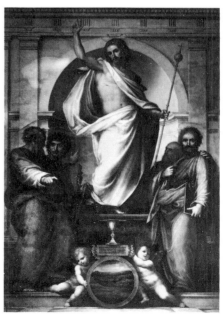

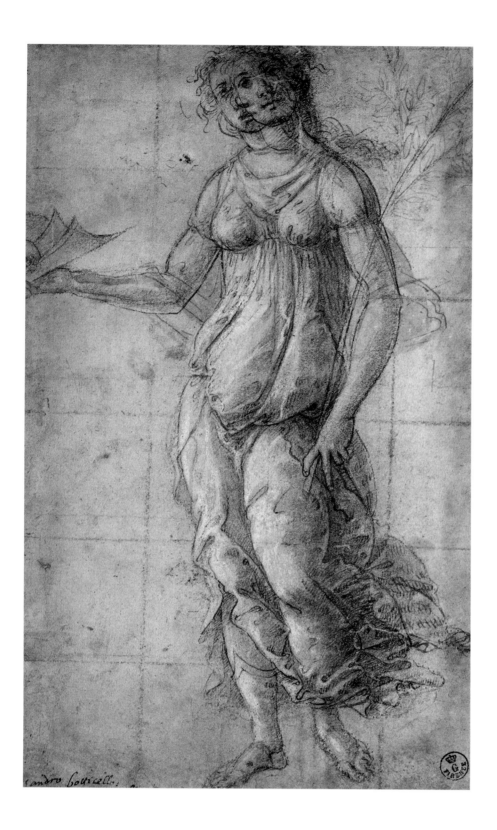

Sandro Botticelli (1445–1510):
Minerva, study for the tapestry
of Guy de Beaudreuil, after 1490.
Black chalk, pen and brown ink, brown
wash, white heightening, pink watercolour.
Squared in black chalk. (222 × 139 mm.)
Uffizi, Florence.

As he is in the process of drawing a whole composition
or a single figure, a draughtsman may hesitate between
two ideas as to how to place an element in space:
a pentimento is his correction or change. It may be
a change in the inclination of a head, as is the case in
these drawings by Botticelli and Filippino Lippi. In
the latter, the pentimento concerning the attitude of
the Virgin, who now bends over the Christ lying in
her lap, increases the harmony of the relation between
the figure of Mary and the other figures in the com-
position. Most examples of pentimento relate to the
positions of arms and legs. Among the artists who
have allowed their "repentances" free rein, not trying
to conceal or cover them up, as if they like to preserve
all possible alternatives, are Pontormo, Andrea del
Sarto, Raphael, Parmigianino and Niccolò dell'Abbate.
Notable in the nineteenth century are the extraor-
dinary drawings by Ingres in which there may be as
many as three pentimenti for one arm.

Filippino Lippi (c. 1457–1504):
Pietà with Saints and Angels, after 1495.
Pen and brown wash over black chalk, (251 × 182 mm.)
Fogg Art Museum, Harvard University,
Cambridge, Massachusetts.

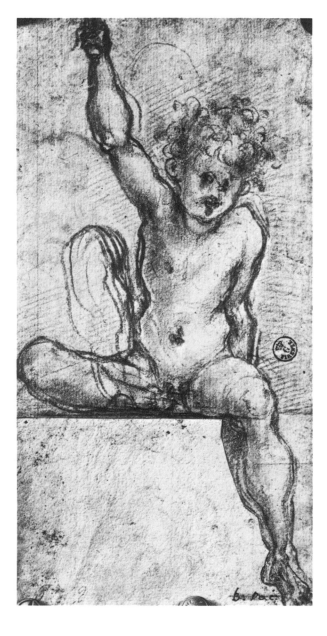

Pontormo (1494–1556):
Putto sitting on a Wall.
Black chalk. (220 × 110 mm.)
Uffizi, Florence.·

Parmigianino (1503–1540): ▷
Studies of Putti and a Seated Boy, c. 1524.
Red chalk on white paper. (191 × 159 mm.)
Janos Scholz Collection,
The Pierpont Morgan Library, New York.

93

Pricked cartoon

The actual execution of paintings and frescoes was preceded by a final stage in the drawing consisting of the study of the most important details, such as heads. They were drawn in black chalk or charcoal on a support of heavy paper, on the same scale as the final composition. The cartoon was pricked out with a pin or a perforating wheel, depending on the sort of line to be traced. Then it was sprinkled with a black or other coloured powder (Italian: *spolvero*) which passed through the paper, transferring the drawing on to the wall, canvas or panel beneath. These cartoons might be used as a "pattern" either once or several times. This explains why the few surviving examples are mostly in a poor state of preservation. This curly head was used by Andrea del Verrocchio

Domenico Ghirlandaio (1449–1494):
Head of a Woman.
Black chalk or charcoal, outlines
pricked for transfer. (366 × 221 mm.)
Devonshire Collection Chatsworth.

Domenico Ghirlandaio (1449–1494):
The Birth of the Virgin, detail
of the left side, after 1485.
Fresco.
Santa Maria Novella, Florence.

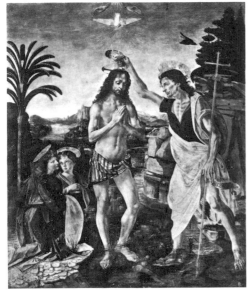

—helped, according to tradition, by his pupil Leonardo da Vinci—for the second angel on the left in the tempera painting on panel of the *Baptism of Christ*, in the Uffizi in Florence. The cartoon by Domenico Ghirlandaio was used for the head of the woman standing on the left, by the stairs, in the fresco of the *Birth of the Virgin* in the church of Santa Maria Novella in Florence. On the reverse of this sheet there is a full-length figure of a woman which also served as a study for a figure in the same fresco, which was commissioned as a whole from Domenico and Davide Ghirlandaio in 1485. In these two cartoons, although the function of the lines is of primary importance since it is they which have to be transferred to the support, in both cases the modelling and values are perfectly suggested by means of black chalk (or charcoal), heightened, in the Verrocchio cartoon, with brush and brown wash.

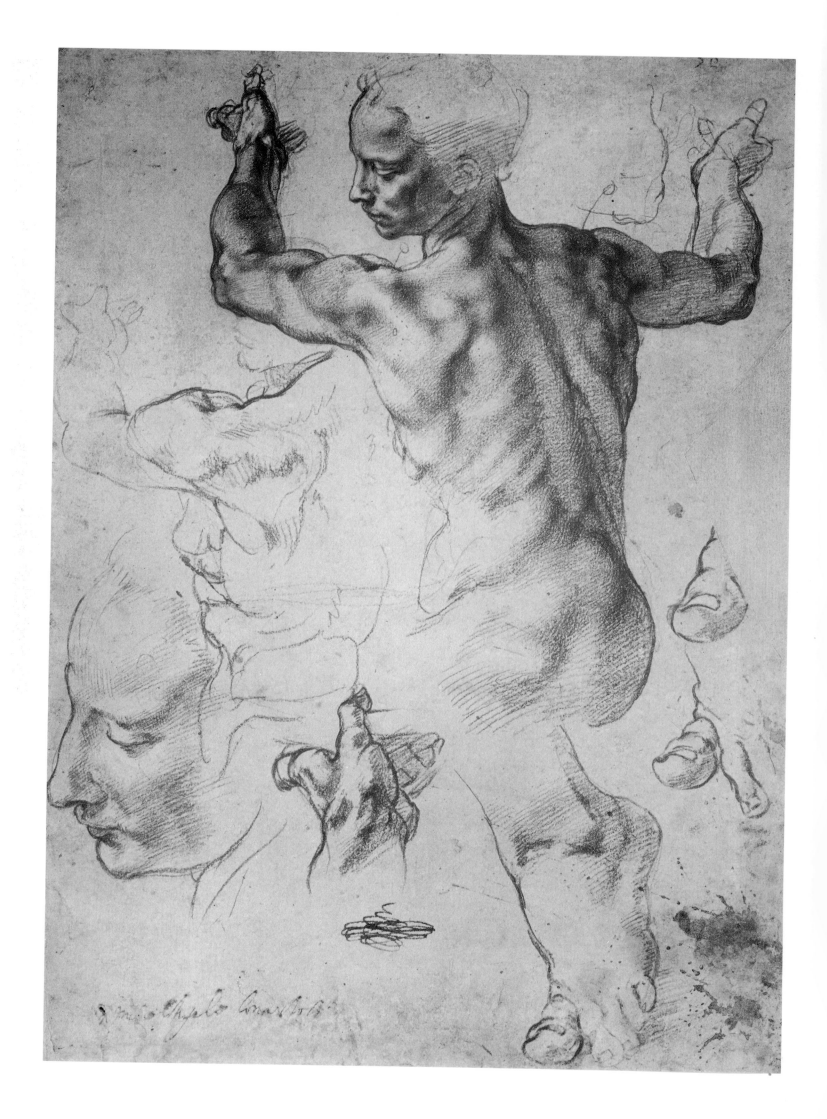

Michelangelo (1475–1564):
Studies for the Libyan Sibyl.
Red chalk. (289 × 214 mm.)
The Metropolitan Museum of Art, New York.

Michelangelo
An example of
preparatory
studies

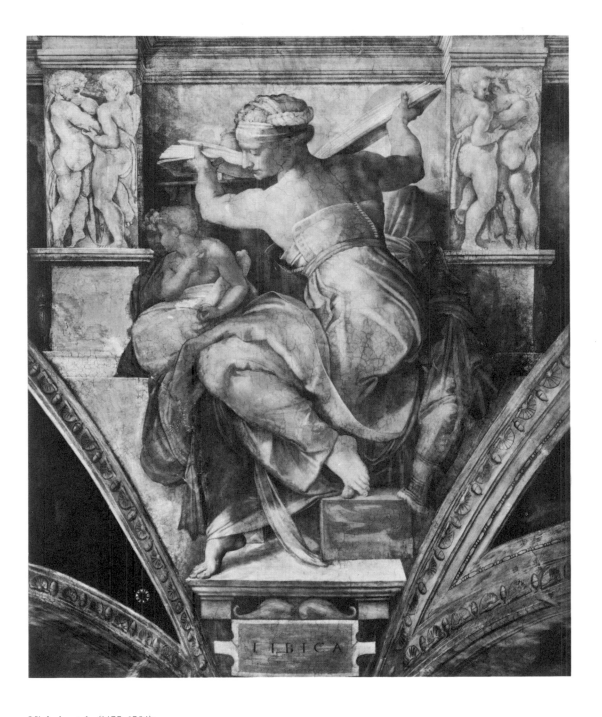

Michelangelo (1475–1564):
The Libyan Sibyl, 1508–1512.
Fresco.
Vault of the Sistine Chapel. Vatican.

The sheet of studies may bring together, set down in apparent disorder as needed, various parts and details of one or more figures which, from their sequence on the sheet, afford some insight into the stage of development reached by the composition and the points of detail being worked out. This red chalk drawing by Michelangelo shows the turning figure from behind, the raised arms supporting an undefined object (seen, in the fresco, to be a large open book). From this central figure, Michelangelo went on to study certain chosen details, shifting them to the left of the figure as he worked over them anew: the right forearm, the musculature of the left side and shoulder, the head (now slightly enlarged), the left hand with thumb and fingers outstretched to grasp the book, and finally (on the right) the left foot and the toes of the same foot. One thus follows, as if at the artist's side, the glancing eye of Michelangelo as he continually refers back to the central figure between two sketches of detail. The composition of this sheet is set out along a broad diagonal running from the lower left to the upper right. This diagonal is crossed by two obliques, one of them running along the spinal column of the Sibyl, whose body is given a double twisting movement (contrapposto), the shoulders turning to the right, the head to the left. When he came to paint the final work—the *Libyan Sibyl* on the vault of the Sistine Chapel whose vast series of frescoes were commissioned from him in 1508 and finished in 1512—Michelangelo modified this movement by tilting the figure further forward. He also elaborated on the details of the headdress and added a flowing drapery to the figure. Form and values are fully worked out in this drawing. It conveys, much more than the fresco, the intense realism of a study drawn directly from the nude male model, which in the final work was transmuted into a woman.

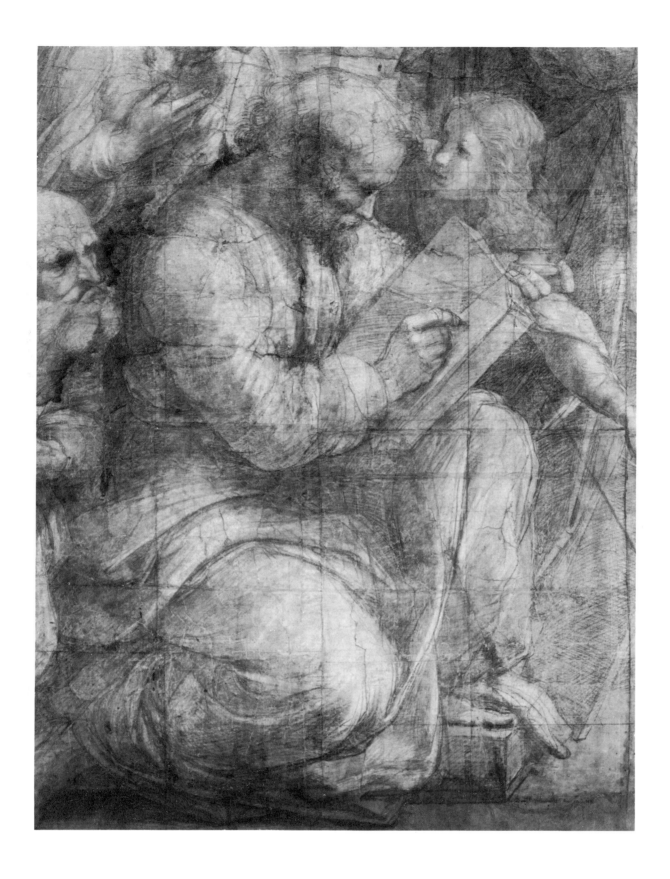

Raphael (1483–1520):
Preparatory cartoon
for the School of Athens
in the Stanza della Segnatura, Vatican:
Detail showing Pythagoras, 1509.
Charcoal over red chalk.
(Entire cartoon: 2.85 × 8.04 m.)
Biblioteca Ambrosiana, Milan.

A grid of lines, usually right-angled, may be super-imposed on a finished drawing for the purpose of transferring it to another surface, usually on a larger scale. Squaring is sometimes done in the same medium as the drawing itself, but the grid is often drawn in another medium in order to stand out better. The Raphael cartoon is a study for the left-hand part of the *School of Athens* in the Vatican Palace, and gives a partial view of the group of three people surrounding Pythagoras, who is kneeling and writing in a ledger. The figure of Pythagoras, which is more massive in the cartoon, is bent forward slightly less in the painting, probably so as to harmonize better with the other figures. Only very slight changes, however, seem to have been made in the draperies.

Cartoon
and
squaring

Tintoretto's method of squaring was all his own: his grids were incomplete and uneven, and instead of using the edges of the paper as parallels were drawn on a diagonal pattern creating a rhombus in the centre of the sheet. This study of a man (representing an angel) was used, with some variations in the pose, for the painting of the *Last Judgment* (Santa Maria dell'Orto, Venice), in which he appears, top right, bent further forward, and with the left arm, holding the trumpet, in a different position. This diagonal squaring is in accord with the oblique lines of the composition, which brings out the depth of the space into which the figures tumble from the clouds. One is led to wonder whether the squaring here is merely an aid to the transfer of the drawing, or whether it is not also intended to help integrate the figure into the linear scheme of the composition as a whole.

Tintoretto (1518–1594):
Flying Angel Blowing a Trumpet,
study for The Last Judgment
in Santa Maria dell'Orto, Venice.
Charcoal on brownish paper,
squared. (285 × 225 mm.)
Hermitage, Leningrad.

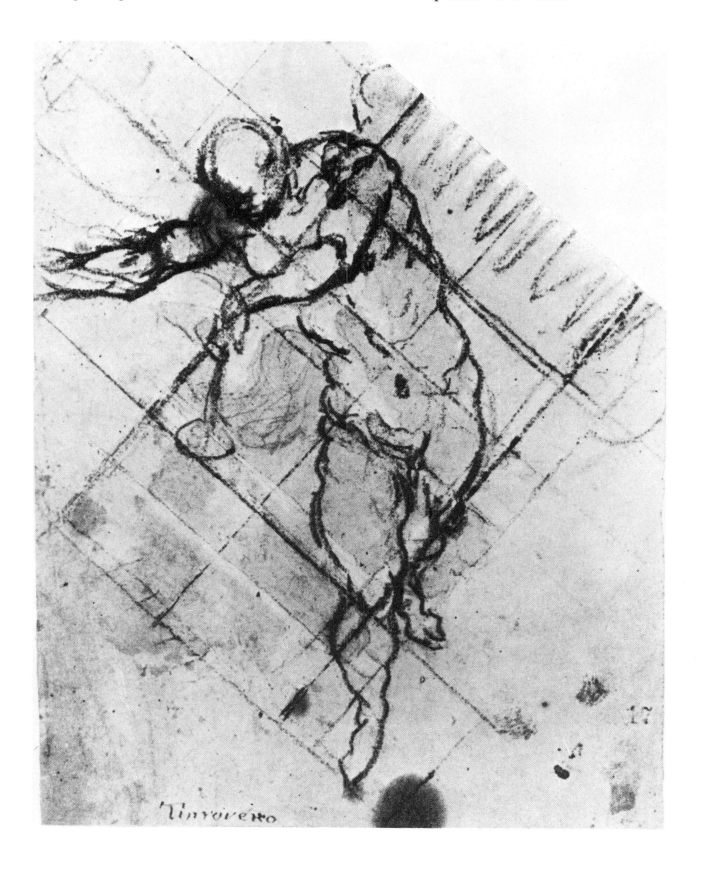

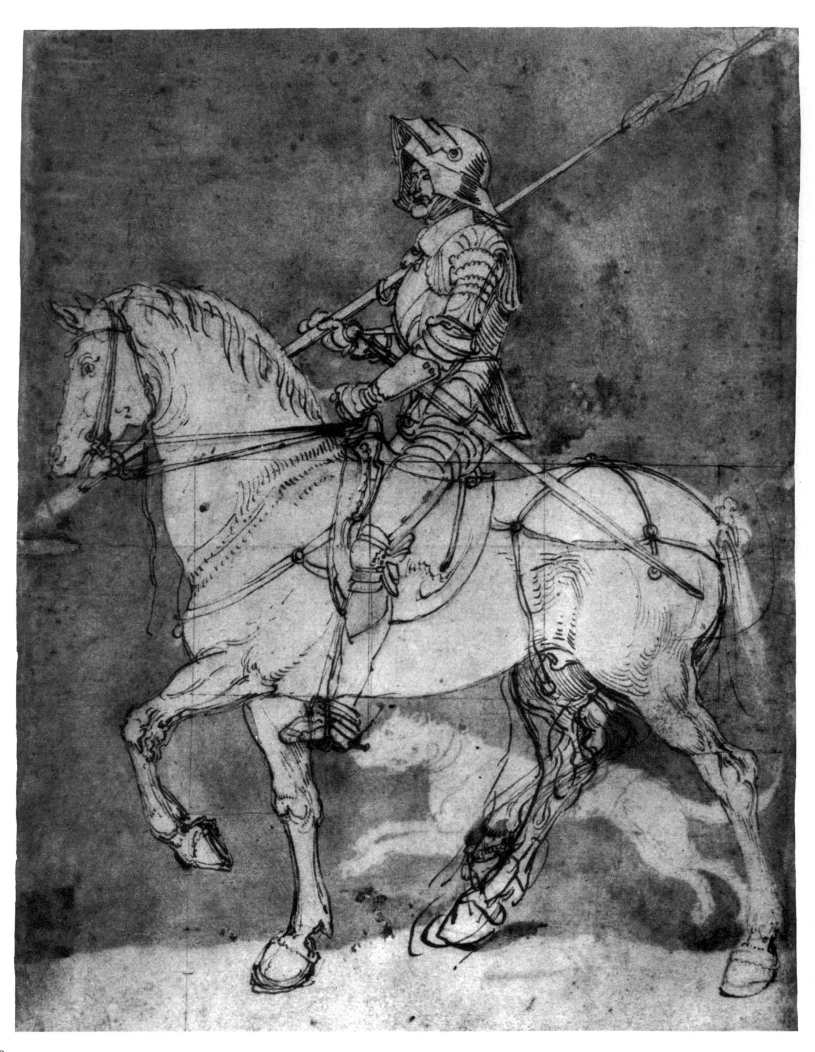

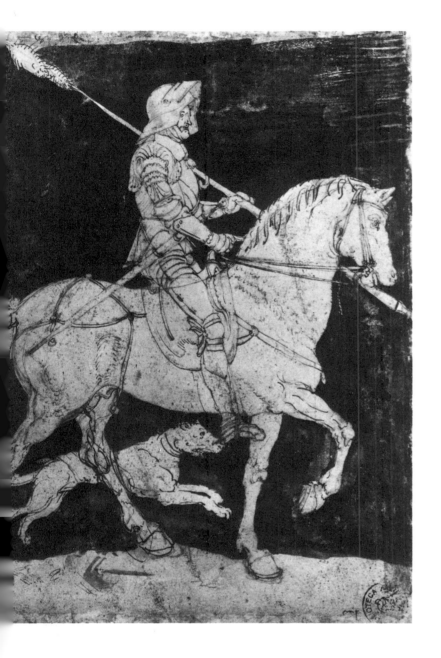

In these two preparatory drawings, one on either side of the same sheet, Dürer studies the motif of a knight on horseback: that this represents the outcome of some research into proportions is evidenced by the preparatory network, still visible on the recto, of straight lines crossing at right angles. In the drawing of the knight facing left, the position of the horse's right hind-leg was changed (pentimento): resting at first on the ground, the hoof was then redrawn in the air. In the second drawing on the verso (traced from the recto), Dürer blacked in the background with brush and brown wash, thus setting off the hound and the mounted knight with his lance. The engraving based on this drawing, once it is printed, shows the subject in reverse. On the lower left of the engraving is a small scroll with the date, 1513, and Dürer's monogram. The theme of the knight leaving for or returning from war often appears in Dürer's woodcuts and engravings. Here the knight is accompanied by Death and the Devil, symbols (according to Erasmus) of the vain phantasms which are powerless to frighten the Christian knight.

Albrecht Dürer (1471–1528):

Knight on Horseback, facing left. Recto.
Pen and brown ink. (246 × 185 mm.)
Biblioteca Ambrosiana, Milan.

Knight on Horseback with Dog, facing right. Verso.
Pen and brown ink and brush. (246 × 185 mm.)
Biblioteca Ambrosiana, Milan.

Knight, Death and the Devil, 1513.
Copperplate engraving. (246 × 190 mm.)
Bibliothek Otto Schäfer, Schweinfurt.

Modello

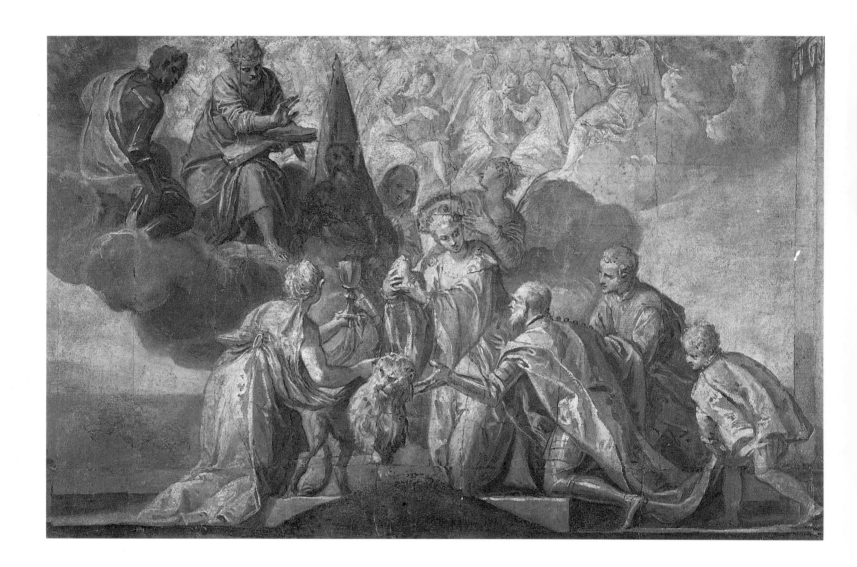

Paolo Veronese (1528–1588):
The Battle of Lepanto, 1571–1581.
Oil sketch in chiaroscuro on
prepared red paper. (297 × 470 mm.)
British Museum, London.

A modello is a highly finished drawing similar in every way (lay-out, contours, colours and values) to the final work, of which it is a reduction. More accurate and elaborate than the ordinary composition sketch, it was often made to be shown to the patron who was to commission the work, and in the case of large-scale works the modello actually formed part of the contract between the patron and the artist. After being submitted for initial approval, it might be modified and recast in some respects by the artist before he proceeded to the final work, but usually there would be no major change except as regards the medium. It thus represents the last and most elaborate phase which a drawing might reach as part of the process of creation. A modello was sometimes sketched in oil, using a technique taken directly from painting, as in the case of Veronese's *Battle of Lepanto,* where the modello is closely related to the painting in the Sala del Collegio in the Ducal Palace in Venice. Some changes were made in the upper part, and to the figure of Agostino Barbarigo, the Venetian proveditore killed in the sea-battle with the Turks at Lepanto in 1571. The Flemish master Jordaens probably remembered the rich colouring of the Venetians when he produced his modelli, which include this *Martyrdom of St Apollonia,* made in preparation for the painting commissioned by the Augustinian order for their church in Antwerp and completed in 1628. Certain changes were made between the modello and the final canvas; they concern the colour of the horses, the presence of the kneeling executioner, the pose of the priest and the number of angels in the sky.

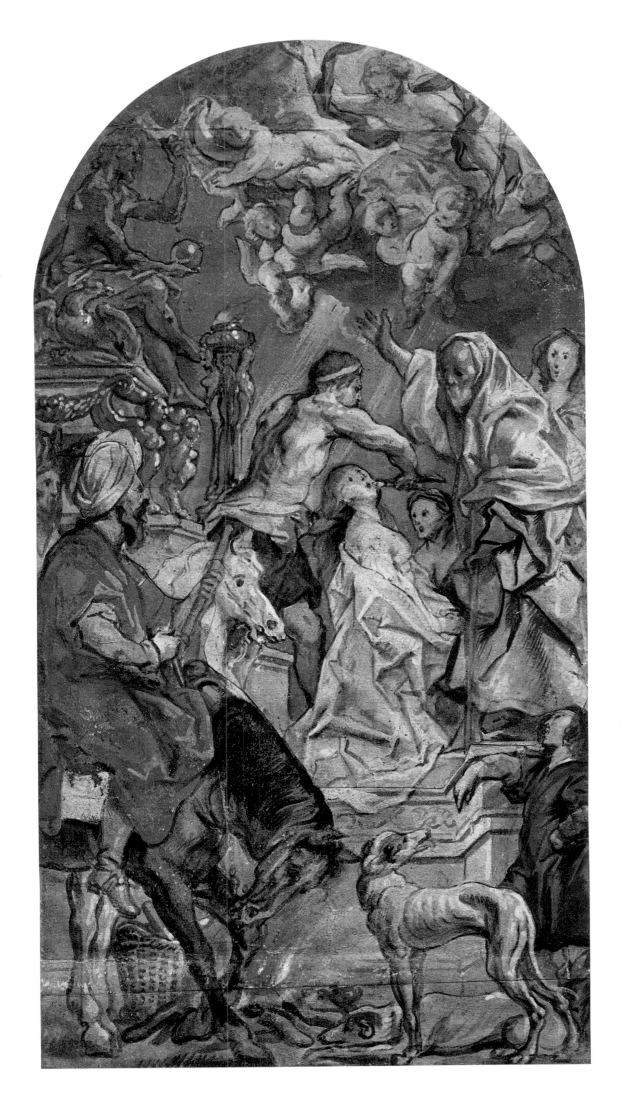

Jacob Jordaens (1593–1678):
The Martyrdom of St Apollonia, before 1628.
Pen, brown wash, watercolour and gouache
over some traces of black chalk. (510 × 275 mm.)
Museum Plantin-Moretus, Antwerp.

Schematic drawing

Peter Paul Rubens (1577–1640):

Hero and Leander, c. 1605–1606.
Oil. (85.8 × 128 cm.)
Yale University Art Gallery,
New Haven, Connecticut.

Hero and Leander, 1601–1605.
Pen and brown ink and brown wash. (204 × 306 mm.)
National Gallery of Scotland, Edinburgh.

Nicolas Poussin (1594–1665):

The Massacre of the Innocents. ▷
Pen and brown ink and brown wash. (146 × 169 mm.)
Musée des Beaux-Arts, Lille.

The Massacre of the Innocents, c. 1625–1626. ▷ ▽
Oil. (147 × 171 cm.)
Musée Condé, Chantilly.

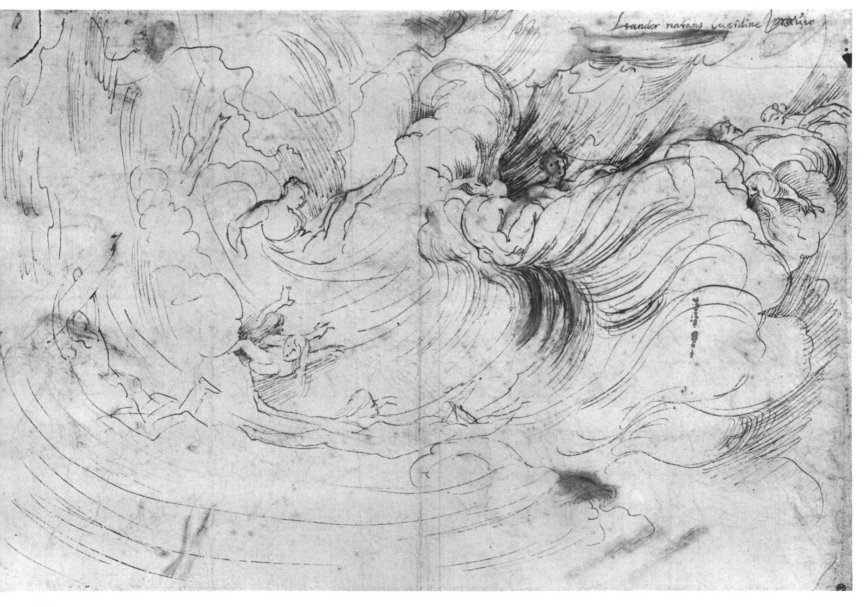

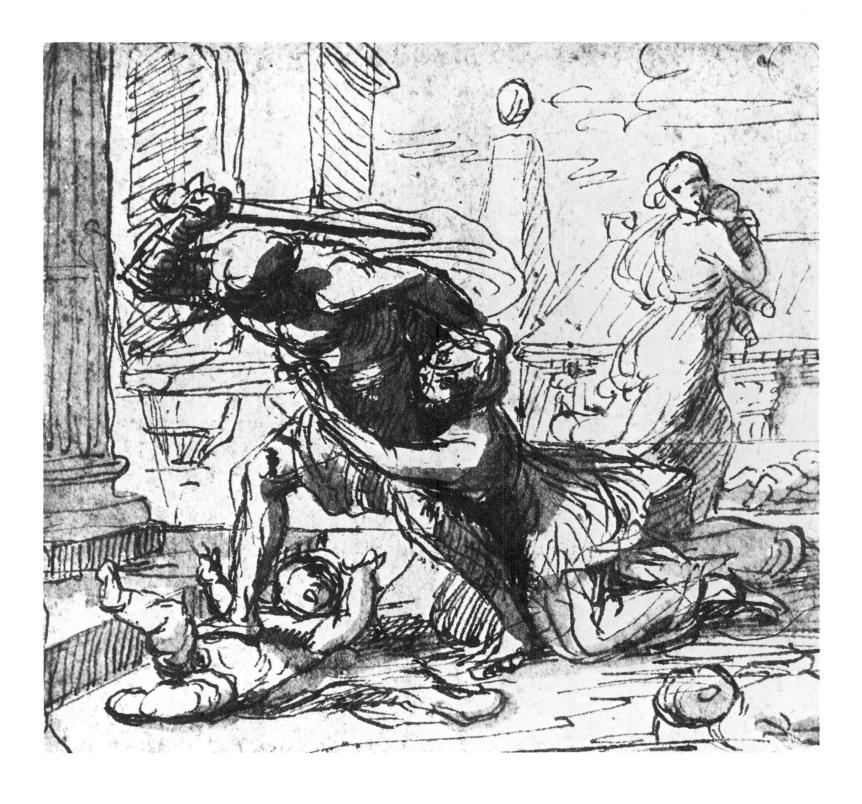

Rubens used a few strokes with a swift and flexible pen to produce this first idea for the painting of *Hero and Leander*. The idea of the storm and its huge curling waves may have been inspired by Leonardo da Vinci's drawings of *The Deluge,* which Rubens had seen in Milan; on the reverse of the same sheet Rubens made a copy of Leonardo's *Battle of Anghiari.* Poussin uses the rapidity of pen and brown ink in this small drawing to set down with great energy the lay-out of his final composition; touches of brown wash suggest the shadows. The vigour of the handling is in accordance with the violence of the scene: the pen manages to indicate the desperate writhings of the child lying on the ground, and his mother's attempts to stay the murderer's arm. This study was in preparation for a large canvas (147 × 171 cm.) painted around 1625–1626, perhaps for the Marquis Vincenzo Giustiniani, one of the great Roman art patrons.

Gian Lorenzo Bernini (1598–1680):
Study for the Nile, one of the statues
of the Fontana dei Fiumi, Piazza Navona, Rome.
Red chalk heightened with white
on buff paper. (522 × 406 mm.)
Uffizi, Florence.

Figure study
for
a sculpture

Gian Lorenzo Bernini (1598–1680):
Terracotta model for the figure
of the Nile. (Height 42 cm.)
Galleria Giorgio Franchetti
alla Ca' d'Oro, Venice.

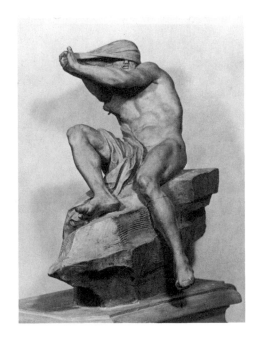

Gian Lorenzo Bernini (1598–1680)
and Jacopo Antonio Fancelli (1619–1671):
The Nile, one of the four statues of the
Fontana dei Fiumi, Piazza Navona, Rome,
1648–1651. Marble.

For a sculpture, the preparatory drawings approach the final work from different angles and aim at conveying the idea of the third dimension. In Bernini's drawings for the fountain in the Piazza Navona, Rome, the sculptor made separate studies for each of the four figures symbolizing four great rivers (Nile, Ganges, Danube, Rio de la Plata). He drew the "Nile" as seen from below (da sotto), just as the figure would appear, when finished and set up, to people crossing the square. He forcibly indicated the contrasts of light and shade, the volumes, movements and sweep of the draperies. The four figures of Rivers form an interlocking whole, but each is developed in a different direction. This colossal marble, with its illusionist effects of movement and emphatic theatrical character, is one of the masterpieces of baroque sculpture.

Charles Le Brun (1619–1690):
The Battle of Arbela, before 1669.
Black and red chalk, gone over with pen and
black ink, heightened with grey wash. (268 × 425 mm.)
Cabinet des Dessins, Louvre, Paris.

When planning his great historical canvases, Charles Le Brun, faithful to the Renaissance tradition, made many preparatory studies: they ranged from studies for the overall composition to studies of groups of figures and details of single figures or single heads. This first idea for the central section of the *Battle of Arbela* indicates the general lay-out, the distribution of groups and the dynamic lines on which the final painting is based (it is now in the Louvre, and measures 4.70 × 12.65 metres). The armies of Alexander (on the left) confront those of Darius, seated in a monumental chariot (on the right): Le Brun organized these large figure groups with great lucidity. The squared-up drawing represents a detail in the far left of the painting, showing a masked horseman lifting his sword and seizing one of the enemy by the hair. The figures were studied in the nude so that the artist might analyze their movements better; they were clothed afterwards. The study of a head expressing terror corresponds closely to the head of the Persian soldier running away in the foreground of the painting.

Charles Le Brun (1619–1690):
Detail of a Battle Scene, before 1669.
Black chalk on buff paper, squared
in red chalk. (272 × 353 mm.)
National Gallery of Scotland, Edinburgh.

First idea,
squaring,
figure study:

three stages for
the *Battle of Arbela*

Charles Le Brun (1619–1690):

Head of a Persian Soldier, 1660–1668.
Black chalk on buff paper. (369 × 250 mm.)
Royal Library, Windsor Castle.

The Battle of Arbela: Alexander
victorious over Darius, 1669.
Oil. (4.70 × 12.65 m.)
Louvre, Paris.

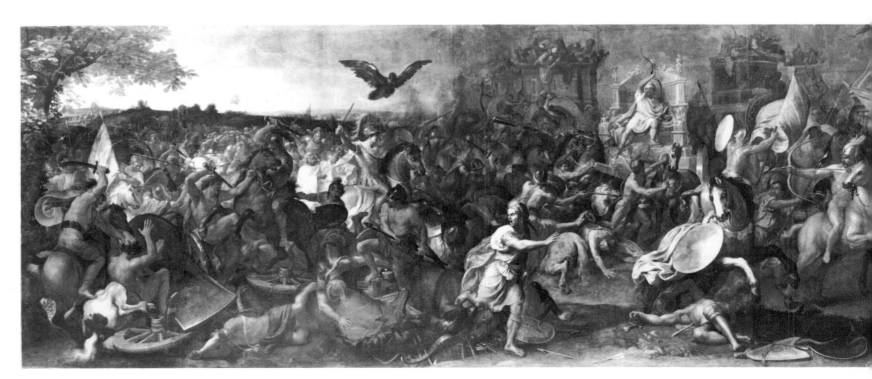

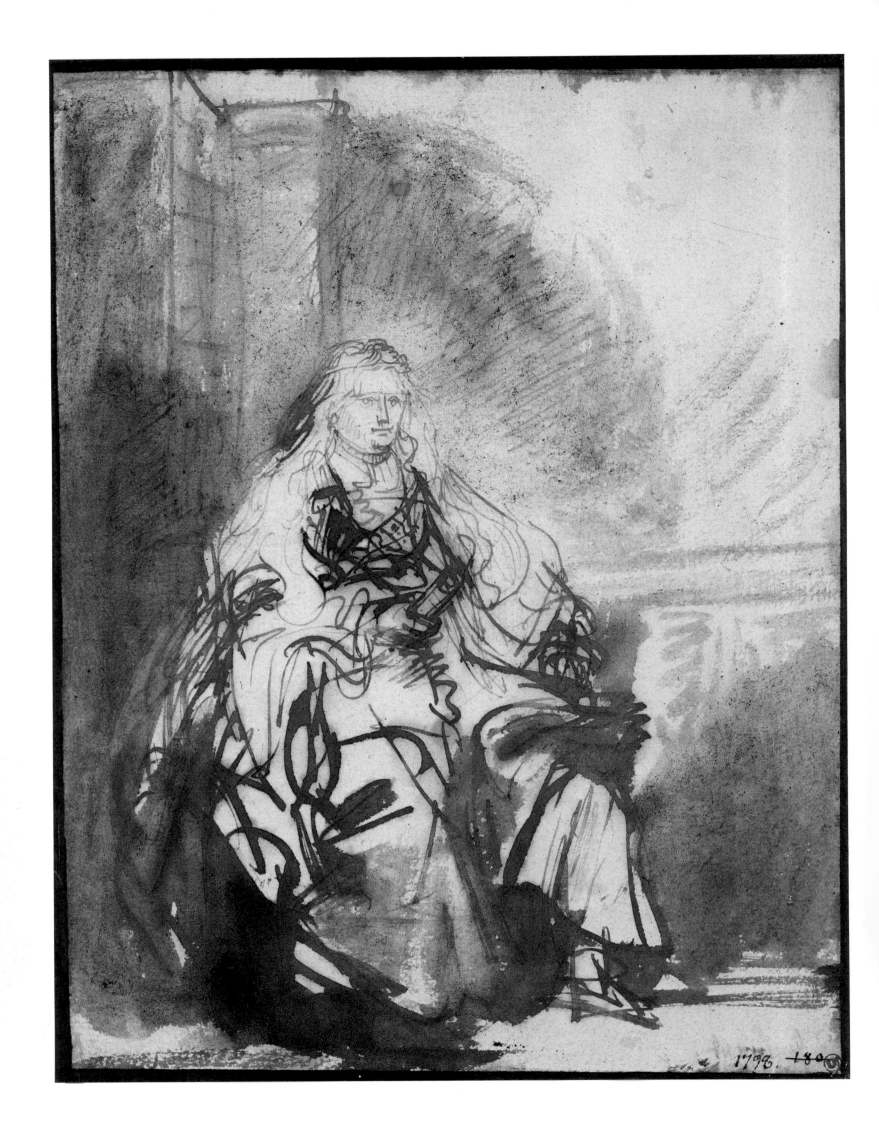

Rembrandt (1606–1669):
Study for The Great Jewish Bride, c. 1635.
Pen and Indian ink and wash. (241 × 193 mm.)
Nationalmuseum, Stockholm.

110

This drawing is thought to be a preparatory study for the etching in which the woman appears in reverse. The rough sketch underlying the drawing is indicated by large areas of shadow corresponding to touches of brown wash later reworked vigorously with what seems to have been a reed pen. The luminous parts are produced by areas of paper left blank. The idea of a window diffusing a pale halo (in contrast with the dazzling light which falls on the central figure) is already present in the drawing, but the proportions are modified in the etching: this example is a second-state proof of which only seven impressions are known. Rembrandt etched only the upper half of the copper plate, concentrating on the face and the long and abundant hair which frames it, and defining all the 'modulations of the background lighting. The model has sometimes been identified as Saskia, Rembrandt's first wife.

Rembrandt, the draughtsman's and engraver's line

Rembrandt (1606–1669):
The Great Jewish Bride, 1635.
Etching. (219 × 168 mm.)
Dutuit Collection,
Musée du Petit Palais, Paris.

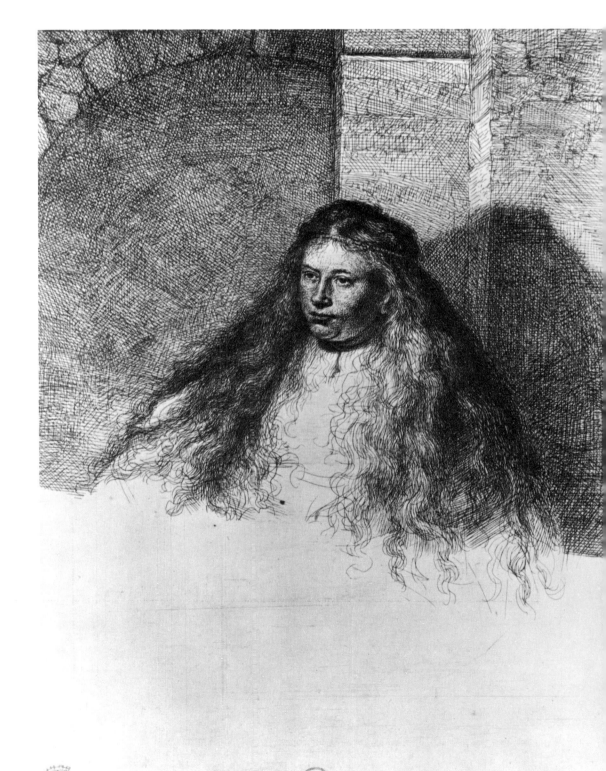

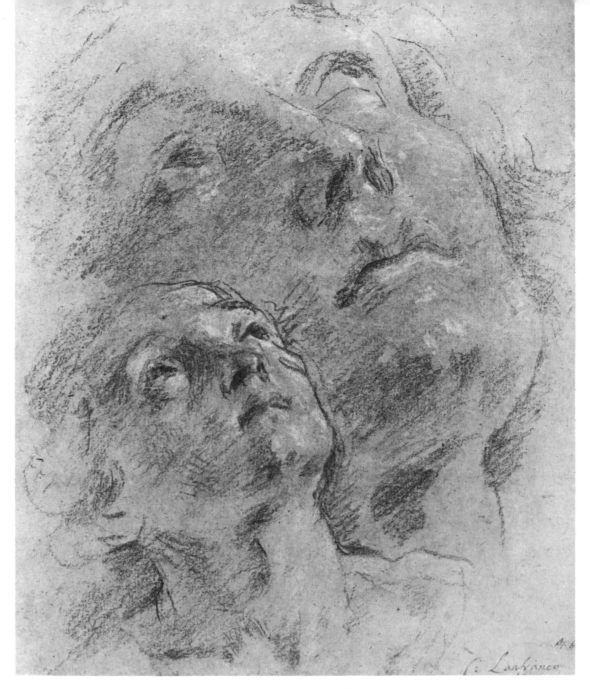

Giovanni Lanfranco (1582–1647):
Two Studies of a Head, c. 1636.
Black chalk heightened with white
on buff paper. (268 × 221 mm.)
Janos Scholz Collection,
The Pierpont Morgan Library, New York.

François Boucher (1703–1770):
Three Heads of Roman Soldiers.
Black chalk heightened with white
on buff paper. (228 × 305 mm.)
Private Collection.

112

Sheets
of head studies

Sheets of head studies, where the artist repeats the details of a face in close-up as if he were drawing nearer to his model, are common to the preparatory work of many artists. They bear witness to the draughtsman's unwearying quest for truth, changing the model's pose and examining all the resulting differences in lighting. In these drawings by Lanfranco and Boucher, the faces are seen from the same angle, with close-up details placed on the same axis. In the case of Watteau the same head is studied from three different angles, producing a much stronger dynamic effect and marvellously suggesting the rapid head movements of the youthful model.

Antoine Watteau (1684–1721):
Three Studies of a Young Negro.
Black and red chalk heightened with white,
with a few touches of wash, on buff paper. (244 × 270 mm.)
Cabinet des Dessins, Louvre, Paris.

Some of the drawings of Giambattista Tiepolo may be related to his paintings (canvases or frescoes), as is the case with these two washes, *Apollo in his Chariot* and *River God with Nymph and Putto*, which are thought to be studies for the ceiling fresco in the Clerici palace in Milan. But there are also groups of drawings by Tiepolo—about three hundred of them, formerly bound in three volumes—which are called *Sole Figure per Soffitti* (Single Figures for Ceilings) and form a sort of repertoire of flying figures, executed without any particular end in view but used by Tiepolo or his workshop when a ceiling needed to be decorated. They are now dispersed in Europe and the United States. All these figures, seen in low angle shot, have been executed in light, airy, transparent wash, later heightened with accents of dark wash applied with the tip of the brush to indicate the shadow of a foot, a knee, an armpit or a chin.

Giambattista Tiepolo (1696–1770):

Reclining River God with Nymph and Putto.
Pen and brown ink and brown wash
over black chalk. (235 × 235 mm.)
The Metropolitan Museum of Art, New York.

Ceiling of the Palazzo Clerici (detail), 1740. ▷
Fresco.
Palazzo Clerici, Milan.

Apollo Standing in his Chariot. ▷
Black chalk, pen and brown wash.
(241 × 243 mm.)
The Metropolitan Museum of Art, New York.

Tiepolo,
examples of
preparatory
sketches

Goya used brush and Indian ink, from which he derived a very varied range of greys and blacks, in his preparatory drawings for etchings and aquatints. The technique of aquatinting, in black or in colour, was used in the eighteenth century for genre scenes and "pleasing" subjects. Goya completely renewed this technique, which he used to produce novel effects, as in his series of *Caprices*. This drawing was transposed, with some slight variations, into the etching entitled *Caprice 17: Bien tirada está*. There are several versions of this scene, in which a young woman is pulling up her stocking in the presence of an old procuress who is seated. The interpretations of it offered by Goya in the various proofs of the etchings include some scenes which are very circumstantial and other versions which are more transposed. Published in 1799 with eighty plates, the *Caprices* can be divided into three main themes: social satire, erotic subjects and scenes of witchcraft.

Goya,
the draughtsman's
and engraver's
line

Francisco Goya (1746–1828):

Young Woman pulling on her Stocking, 1796–1797.
Brush and Indian ink wash. (173 × 101 mm.)
Prado, Madrid.

Caprice 17: It is well pulled up
("Bien tirada está"), 1799.
Etching and aquatint. (186 × 127 mm.)
Cabinet des Estampes, Geneva.

Francisco Goya (1746–1828):
She is waiting for him to come, 1796–1797.
Brush and Indian ink wash. (237 × 150 mm.)
Prado, Madrid.

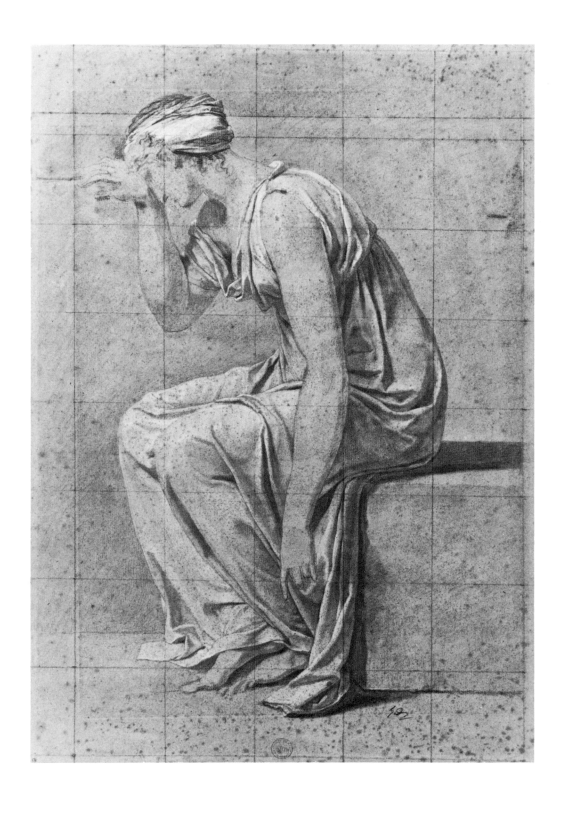

Jacques-Louis David (1748–1825):

Seated Woman in side view, facing left.
Black chalk and wash, heightened with
white chalk on buff paper, squared
in black chalk. (505 × 350 mm.)
Musée Bonnat, Bayonne.

The Oath of the Horatii (detail), 1784.
Oil.
Louvre, Paris.

Towards the end of the eighteenth century, with neo-
classical drawing, there was a clear return to tradition,
and the importance accorded to preliminary studies
is well illustrated by the working method adopted by
David. In this highly finished drawing in preparation
for the figure of Camilla in the far right of the painting,
the *Oath of the Horatii*, he defines the pose of the
character (who leans further forward in the painting),
shows the fine folds and modelling of the draperies,
and accentuates the effects of the side lighting (parallel
to the surface of both the sheet and the canvas). The
squaring, done according to the traditional grid to
facilitate the transfer of the figure to the canvas,
further intensifies the linear rigour of the study.
David's synthesis of the emphasis on modelling and
the necessity of line was carried further by Ingres and
later by Degas.
Ingres carried out many preliminary studies for the
Martyrdom of Saint Symphorian, a painting commis-
sioned in December 1824 by the bishop of Autun for

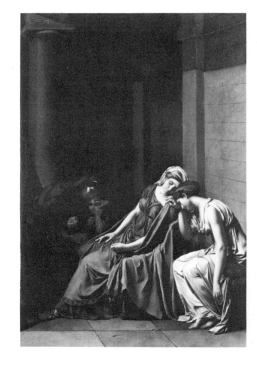

the cathedral there. Ingres worked on it until 1834, making over two hundred drawings now preserved in the Ingres Museum at Montauban, and others dispersed in various other museums (Fogg Art Museum, Cambridge, Mass.; Musée Bonnat, Bayonne). In this sheet of studies of horsemen, the main drawing was modified in the final painting. The figure of the Roman centurion pointing his finger is studied here, bottom right, enclosed in a small partial squaring. The same figure is to be seen again in an oil sketch preserved in Montauban, centred in the same way as the squaring; the detail occupies the centre of the painting. There is a great distance between the free, spacious preliminary

Jean Auguste Dominique Ingres (1780–1867):
Three Men on Horseback, c. 1827–1834.
Black chalk on paper. (544 × 413 mm.)
William Rockhill Nelson Gallery of Art
and Mary Atkins Museum
of Fine Arts, Kansas City.

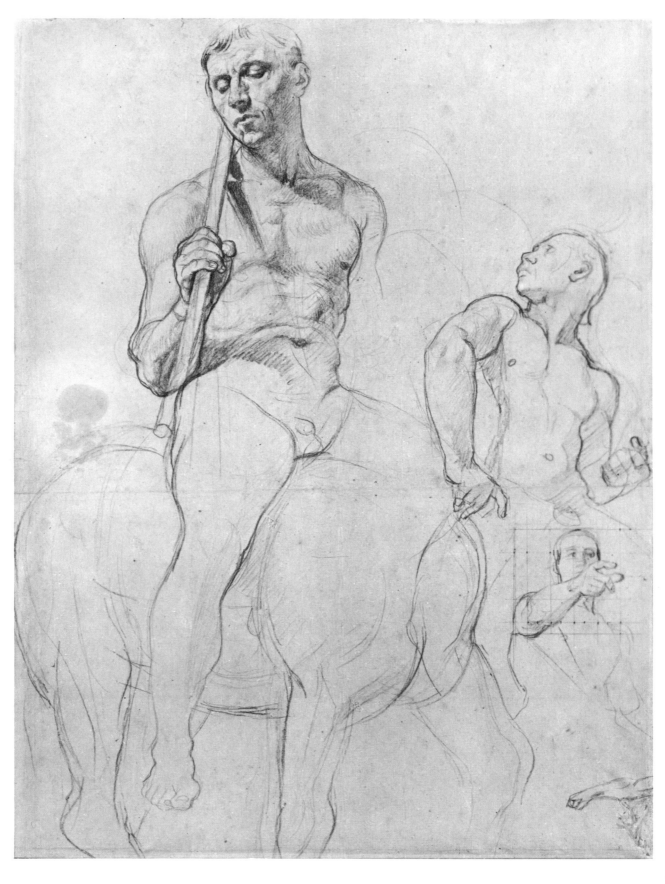

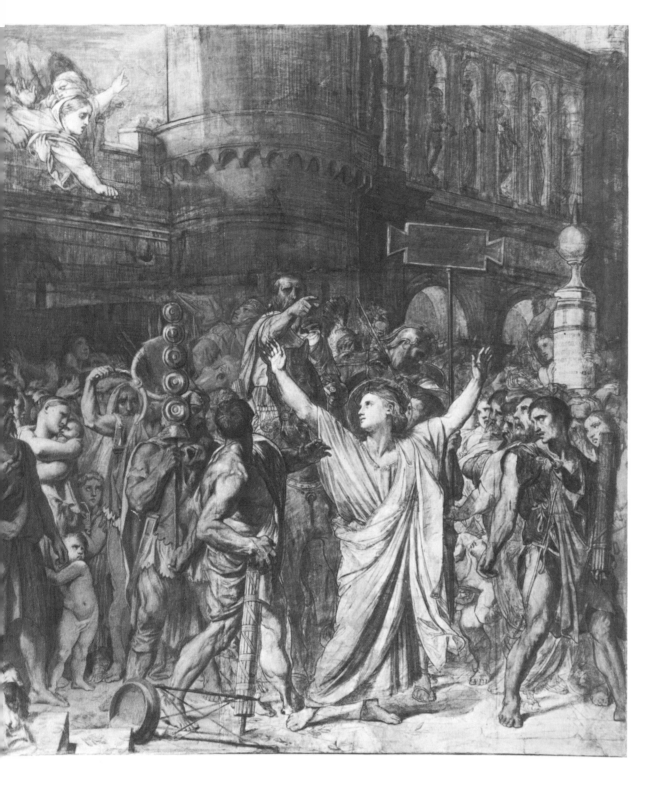

Jean Auguste Dominique Ingres (1780–1867):

The Martyrdom of St Symphorian, 1834.
Tracing made from the squared drawing.
Pen and brown ink, black wash, heightened
with white, over black chalk. (680 × 595 mm.)
Musée Bonnat, Bayonne.

The Martyrdom of St Symphorian, 1834.
Oil on canvas. (4.07 × 3.39 m.)
Cathedral of Saint-Lazare, Autun.

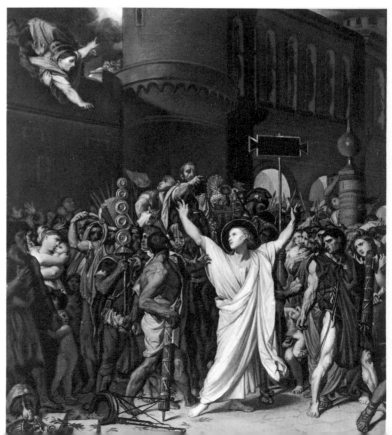

drawings and the final work, which is crowded with
figures. These drawings, some of which contain many
pentimenti, bear witness to the artist's unflagging
efforts at elaboration. But the painting met with a very
cool reception at the Salon of 1834, and the artist left
Paris for Rome, where he was later appointed director
of the Académie de France.

This large cartoon by Puvis de Chavannes for the *Family of Fishermen* represents the final preparatory stage for the large painting (2.60 × 2.18 metres) exhibited in Paris at the 1875 Salon. Acquired by the Dresden museum in 1901, the painting was destroyed in 1945; it is known from the smaller replica painted by the artist in 1887 and now in the Art Institute of Chicago. In the cartoon Puvis is still working out the position of the child, shown here standing, though beneath it one can detect a faint sketch showing the child seated as it appeared in the painting of 1875 and the replica of 1887.

Pierre Puvis de Chavannes (1824–1898):
Cartoon for Family of Fishermen, c. 1875.
Sienna mixed with solvent on canvas.
(2.44 × 2.17 m.)
Musée Saint-Nazaire, Bourbon-Lancy
(Saône-et-Loire).

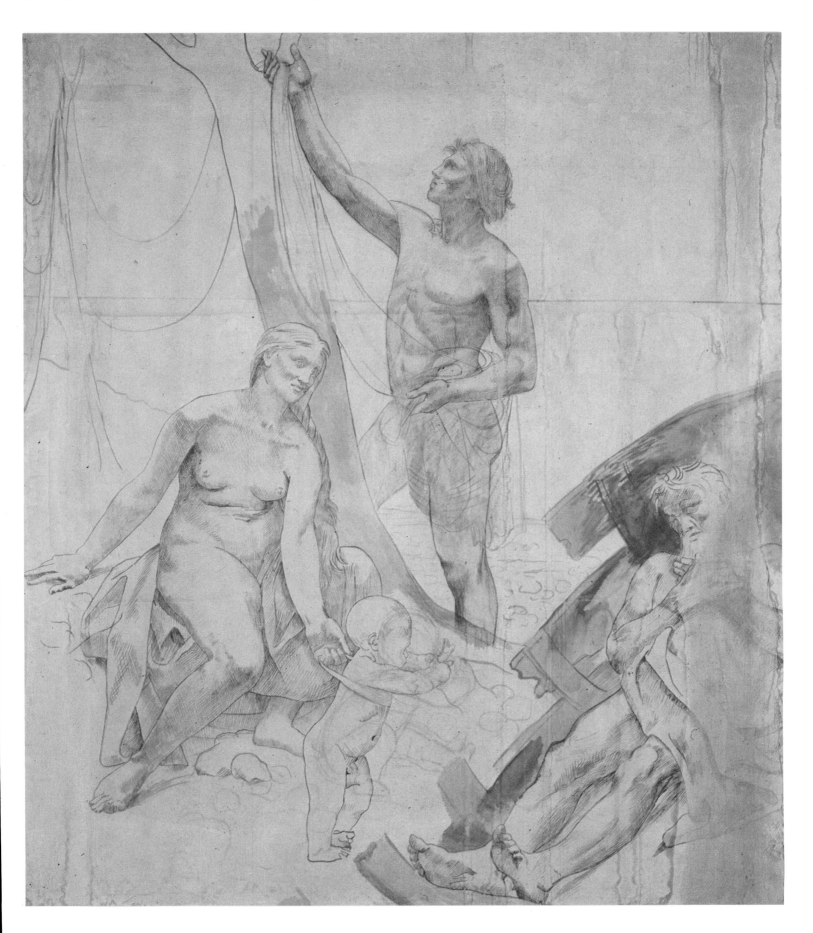

ARCHITECTURAL DRAWING

Architectural drawing needs to be read according to a different code from those with which we interpret other forms of graphic expression. The viewer has to decipher a plan, an elevation, a cross-section or a profile of a building, and then reconstruct them in his mind and relate them to the building as a whole. Among the great variety of forms taken by architectural drawing, two diverging tendencies may be selected. The first covers drawings made with an actual project in view; they are drawn with ruler and compass and usually indicate scale. They may be sketches showing the architect's first idea as to the placing of the main constituents of the building, or they may be analytical studies (plans, cross-sections, profiles, elevations) which form part of the ultimate realization of the project. Such drawings sometimes call for the collaboration of the architect's workshop or office; not every drawing is necessarily by the architect's own hand, for he is backed up by various assistants who may work out the whole project, to be given the final touches by the architect if necessary. One feature of architectural drawing is that it puts forward alternatives on the same page, so that the patron may choose between them. The second type of architectural drawing includes those belonging to the realm of the imagination, the visionary, the irrational. This trend dates from the sixteenth century with its decorative profusion of designs for feasts and

triumphal entries, and the seventeenth, with the illusionist perspectives characterizing one aspect of baroque architecture. The work of the Italian stage designers—the Bibienas, Juvarra, Vanvitelli, etc.—was one result of this form of expression, making great play with ever-receding perspectives. In most of their drawings, these architects give free rein to the most extravagant imagination. In both types of architectural drawing, however, the structure is usually three-dimensional. Drawings are generally minutely rendered with shaded tints of wash or watercolour. A somewhat chilly precision distinguishes such work from the more emotional treatment found among painters. An architectural drawing is to show off a design, and the main factor is its relation to the final work and not the personal touch of the artist. Some of the functions of architectural preliminary drawings appear in this selection, which concentrates on examples of plans, façades, elevations, cross-sections and trompe-l'œil. Other applications of architecture, such as settings for the theatre and public and private celebrations, have given rise to a large output of drawings. In the second half of the eighteenth century, with Piranesi and the generation of artists influenced by him, a new sense of emotion appeared in architectural drawings, foreshadowing the imaginary exercises of the visionary architects. The new "pre-romantic" atmosphere was created largely by light and shade effects and by setting the buildings against a background of cloudy skies (an architectural design was usually presented against an empty, neutral background). With the visionary draughtsmen, technique evolved towards an increasingly controlled style and a chilly treatment of monochrome washes. The large size of these drawings foreshadows the megalomaniac tendency of the competitions for academic prizes and the sketches sent back to France from Rome; this sort of drawing was executed with an increasingly sophisticated technique. A return to precise, functional drawing took place in the first half of the nineteenth century with the designs of the architect-engineers. From then onwards the drawings of architect-designers remained utilitarian, exact and descriptive, as was shown by the creations of Art Nouveau around 1900. This chapter has not tried to deal with designs for wallpapers, textiles, china, carpets, vases, furniture, picture frames, book illustrations, and so on. These designs, though sometimes carried out by the artist himself, were usually put into execution by anonymous craftsmen following the instructions either of the artist or his executive. The frontiers between architecture, decoration and design were however crossed by the most inventive draughtsmen. This was a practice which continued from the Renaissance, when draughtsmen interested themselves in all the decorative arts, down to the early twentieth century, when out of a desire for architectural unity the architect himself might design the façade of the building, the interior decoration, the furniture and even the crockery. Architectural fictions have deliberately been excluded, together with imaginary ruins such as those of Natoire, Pannini, Clérisseau, Hubert Robert, Vernet and Servandoni, in which architecture is only an incidental motif. Illustrations have been chosen from the drawings of the builder-architects, including the most utopian among them.

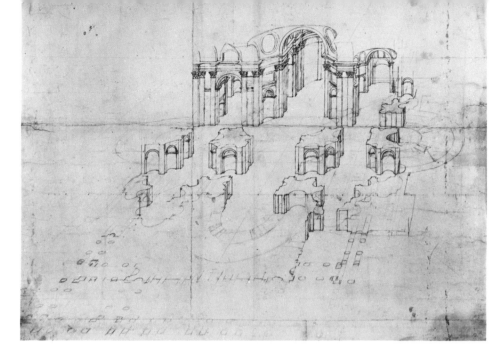

Baldassare Peruzzi (1481–1536):
Axonometric Drawing of St Peter's, Rome.
Pen and ink and red chalk over
black chalk. (539 × 679 mm.)
Uffizi, Florence.

Bramante (1444–1514):
Plan of St Peter's in Rome, 1505.
Pen and brown ink and red chalk.
(471 × 684 mm.)
Uffizi, Florence.

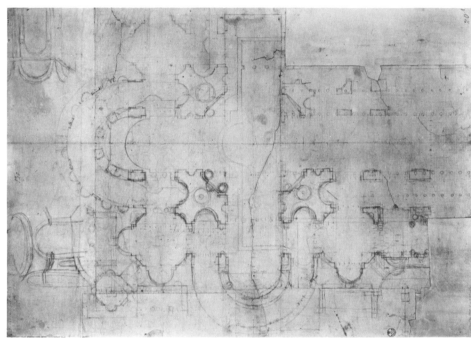

Michelangelo (1475–1564):
Studies for the Dome of St Peter's,
Rome, c. 1546.
Black chalk. (399 × 235 mm.)
Teylers Museum, Haarlem.

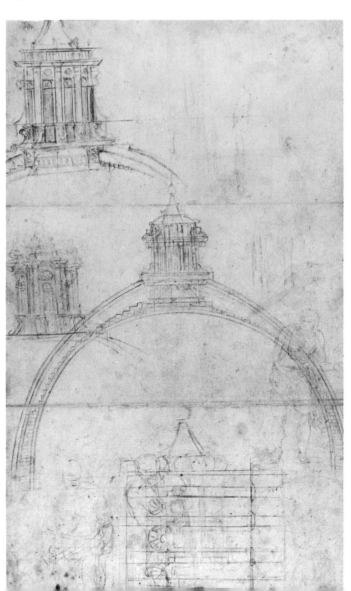

In 1505 Pope Julius II commissioned Bramante to build the new Basilica of St Peter, of which a plan is shown here. Work was suspended in 1513 when Julius died. In this plan the dome is the focal point of the building, with all the other parts arranged round it. Bramante seems to have planned two campaniles at the entrance, opposite the dome, the latter resting on pillars which, being thought too slender, were strengthened in the plans later drawn up by Antonio da Sangallo and Michelangelo. The axonometric drawing by Baldassare Peruzzi, Bramante's collaborator and successor, proposed a Greek cross design with a narthex added at the entrance. It was not until 1547 that Michelangelo took over responsibility for St Peter's and drew up plans for the dome. It was begun, but remained unfinished at his death. The illustration shows Michelangelo's cross-section of the dome and lantern. Until he finally completed a model of the dome (1558–1561), Michelangelo hesitated between two alternative heights for it, though he seems to have decided ultimately on a hemispherical vault rather than a slightly raised arch. After his death the work was completed, between 1586 and 1593, by Giacomo Della Porta and Domenico Fontana, who reverted to the earlier solution (a higher, less hemispherical vault), with some modifications.

Building designs in the 16th century

Andrea Palladio (1508–1580):
Design for the Proscenium of the
Teatro Olimpico, Vicenza, 1580.
Pen and brown ink and grey wash
over black crayon. (420 × 895 mm.)
Royal Institute of British Architects, London.

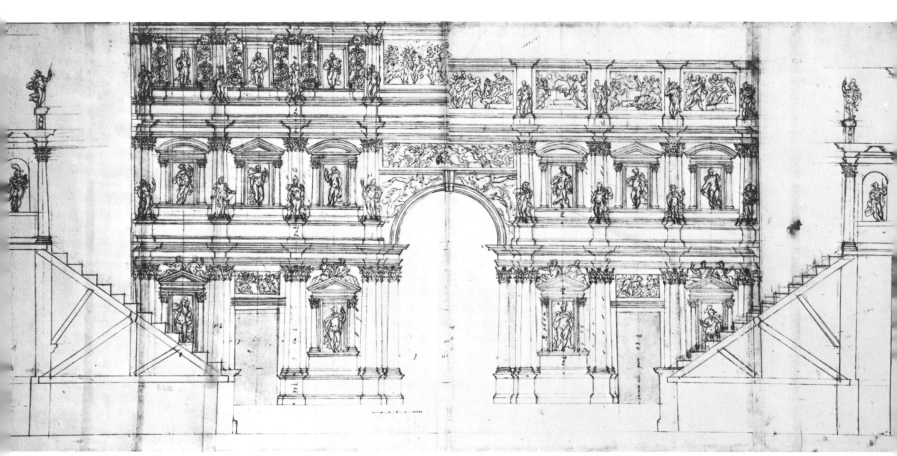

After early training as a stone-cutter (which accounts for the precise indications about construction which he set down on his designs), Palladio adopted the repertoire of antique forms (the triangular pediment, the pronaos, etc.) as the point of departure of his buildings. In Vicenza, where he had grown up, and throughout Venetia, he erected public buildings, palaces and villas. In Venice he designed the convent of the Carità and the churches of San Francesco della Vigna, San Giorgio Maggiore, and Il Redentore (1577). His extant designs include some thirty sheets in the Museo Civico, Vicenza, and about 250 sheets in London (Royal Institute of British Architects) brought back from Italy by Inigo Jones in the early seventeenth century. Most of Palladio's drawings are incised with the stylus and worked over in pen and ink. Some of the corrected and annotated sheets are closely related to buildings which he actually erected. In the design for the Palazzo Valmarana, built in the centre of Vicenza, Palladio shows simultaneously the exterior and interior of the building. Six high, imposing, composite pilasters run across the façade, imparting to it a strong vertical tension further emphasized by statues (eliminated in the end) which stand in the Attic manner in the extension of the columns. Palladio often resorted to this colossal order of half-columns and pilasters. This classical "purism" is especially characteristic of his early designs. But at the end of his life the proscenium of the Teatro Olimpico in Vicenza, which was his last project, shows an "intense poetic vibration" (Renato Cevese). In this drawing Palladio develops the proscenium over the whole width of the stage, whose architectural scope was something quite new. Finished after his death by his son Scilla and by Vincenzo Scamozzi, the theatre opened in 1585. A designer and builder, Palladio published *I Quattro Libri dell'Architettura* (Venice, 1570), illustrated with plans, elevations and details largely based on his own work. This important book, one of the first of its kind in the history of architecture, goes far to explain the wide diffusion of the Palladian style, or Palladianism as it is called, characterized by rhythmically designed façades, classical austerity, and purism of lines and forms derived from the antique.

The artists of the sixteenth century carried out their preparatory drawings with the same facility whether they were to be used for gold and silverwork, furniture, objets d'arts or tapestries. They found no difficulty in making the transition from one scale to another, producing designs for a piece of jewellery as easily as for a vast wall-hanging. Their wide range of activities explains why the same repertoire of odd, hybrid motifs (mascarons, grotesques, festoons) is to be found both in the borders of tapestries and in gold and silverwork. Giulio Romano, a painter who decorated the Palazzo del Te in Mantua, made drawings for gold and silverwork, chimney-pieces and tapestries (the *Triumphs of Scipio*).

Hornick, who came from Antwerp, worked in Nuremberg, Ulm and Augsburg, which were important centres for gold and silverwork. Throughout Europe in the sixteenth century, this was one of the most

Ornamental designs

Giulio Romano (1499–1546): ▷
Design for a Gold Girdle, c. 1530.
Pen and brown wash over light black chalk.
(265 × 378 mm.)
Christ Church, Oxford.

Agnolo Bronzino (1503–1572):
Truth and Justice defending Innocence.
Cartoon for a tapestry.
Biblioteca Ambrosiana, Milan.

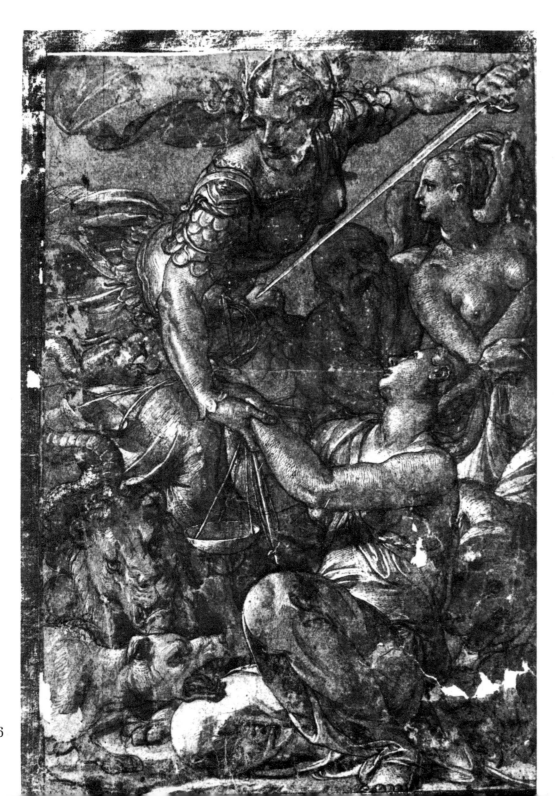

Jacques Androuet Du Cerceau (c. 1515–1585):
Studies for Two Tabernacles.
Pen and black ink and Indian ink
wash on vellum. (237 × 180 mm.)
Ecole des Beaux-Arts, Paris.

Erasmus Hornick (?–1583):
Design for a Salver on a Stem
with a separate drawing of its interior.
Pen and ink, grey and yellow wash. (415 × 200 mm.)
National Gallery of Canada, Ottawa.

characteristic expressions of court art. Most draughtsmen were called upon to produce designs to cope with all the plate, trophies, weapons and pieces of jewellery that were commissioned: among them were Hans Holbein, Lucas van Leyden, Hans Sebald Beham, Peter Flötner, Wenzel Jamnitzer, Etienne Delaune and the Du Cerceaus. J. A. Du Cerceau produced designs for ornaments and goldsmith's work which he executed with great delicacy in pen and wash, usually on parchment. Bronzino, a colleague of Pontormo's, collaborated in all the decorative work commissioned by the Medici court, producing not only frescoes and portraits but also cartoons for tapestries to be made in the Medici factory in Florence. It was this factory, founded in 1545 by Cosimo I de' Medici, which accounted for the greatest output of tapestries, surviving to the eighteenth century, together with other workshops turning out mosaics, glass, gold and silverwork and cabinet work. Among the artists who designed outstanding tapestries were Salviati, Stradanus, Sustris and Alessandro Allori. The cartoons usually give very precise indications of outline and depth, to be faithfully translated in terms of coloured silk or wool. This cartoon showing *Truth and Justice Defending Innocence* is part of a series of tapestries on the *Story of Joseph*. The scene here is in reverse with respect to that of the finished tapestry. This is the case for most of the cartoons which served as a model for the heddlers, for the latter worked on the reverse side of the tapestry; after weaving, they turned the piece over and the scene then appeared in reverse. The scale of the figures here is unusually large in relation to the setting of the composition, whose monumentality is thus emphasized.

Illusionist drawings

◁ Domenico Beccafumi (c. 1486–1551):
Designs for Frescoed Façades of Houses, c. 1545–1550.
Pen and brown ink, wash, watercolour
and white heightening. (189 × 198 and 138 × 198 mm.)
Royal Library, Windsor Castle.

Tommaso Sandrini (1575–1630):
Design for a Coffered Ceiling, 1625.
Pen and brown ink and brown wash heightened
with watercolour, gouache and gold. (904 × 481 mm.)
Cabinet des Dessins, Louvre, Paris.

Painted façades imitating architecture or representing narrative scenes appear to have originated in fifteenth-century Italy, and few vestiges of them have survived. In the sixteenth century the drawings of Perino del Vaga, Polidoro da Caravaggio, Domenico Beccafumi, Pordenone and Lelio Orsi provide excellent designs, sometimes heightened with watercolour, for such fresco decorations. They produce an impression of simulated sculpture, painted in trompe-l'œil. Almost at the same time, in German Switzerland and South Germany, other designs for painted façades were being made by Hans Holbein and Tobias Stimmer.

In all these examples of trompe-l'œil the imaginary architectural framework plays a leading part, defining the surface areas in which the various motifs are organized. The same is true of ceiling designs, like those of Tommaso Sandrini, in which he creates the illusion of a balustraded gallery with a coffered ceiling; the simulated relief of the brackets casts a semblance of shadow which heightens the illusion of depth and recession in space.

129

L'archo del [...] la [...] fatti
nella notte dell'arciduchessa

Triumphs and pageantry

For processions and triumphal entries, draughtsmen designed ephemeral creations to last no longer than the occasion which produced them: drawings of chariots, costumes and decorations for the city gates through which the processions would pass. In Florence the architect Buontalenti played a leading part in organizing displays: he built the Uffizi theatre and produced most of the sets, costumes and machinery for all the city's theatrical performances in the latter part of the sixteenth century. His costume designs show the same attention to detail as his architectural drawings. His pupil Cigoli, a painter as well as an architect, designed a large number of triumphal arches for the Entries which took place in Florence in the early years of the seventeenth century, including those erected for Cosimo II de' Medici's marriage to the archduchess Maria Magdalena of Austria. The triumphal Entry into Florence on 18 October 1608 was followed by a variegated series of balls, theatrical

performances and banquets lasting until 5 November. Jacques Callot was clearly influenced by the designers of such spectacles in Florence, which he visited several times. He collaborated in an account of the Tournament of the War of Love *(Guerra d'Amore)* commissioned by Cosimo II to celebrate the arrival in Florence of the Duke of Urbino (1615-1616). The celebrations were organized by Giulio Parigi. Callot made reversed engravings of three drawings recording the festivities and depicting Indian costumes, exotic beasts, camels and elephants. In the years that followed, the tradition of processions and cavalcades was kept up both in Florence and Rome, as is shown by the many drawings of Stefano della Bella. In England, in this first half of the seventeenth century, Inigo Jones performed the same office for King James I. This drawing of an elephant with a castle on its back must relate to the celebration, on 24 March 1610, of the anniversary of the King's accession to the throne.

◁ Ludovico Cigoli (1559–1613):
Design for an Arch of Triumph.
Pen and brown ink and blue watercolour over black chalk. (384 × 346 mm.)
Uffizi, Florence.

Jacques Callot (1592–1635):
Studies for the suite "Combat à la barrière."
Pen and brown ink washed with brown on buff paper. (255 × 390 mm.)
Devonshire Collection Chatsworth.

Inigo Jones (1573–1652):
Design for a Masque: An Elephant, 1610.
Pen and brown ink washed with brown. (290 × 206 mm.)
Devonshire Collection Chatsworth.

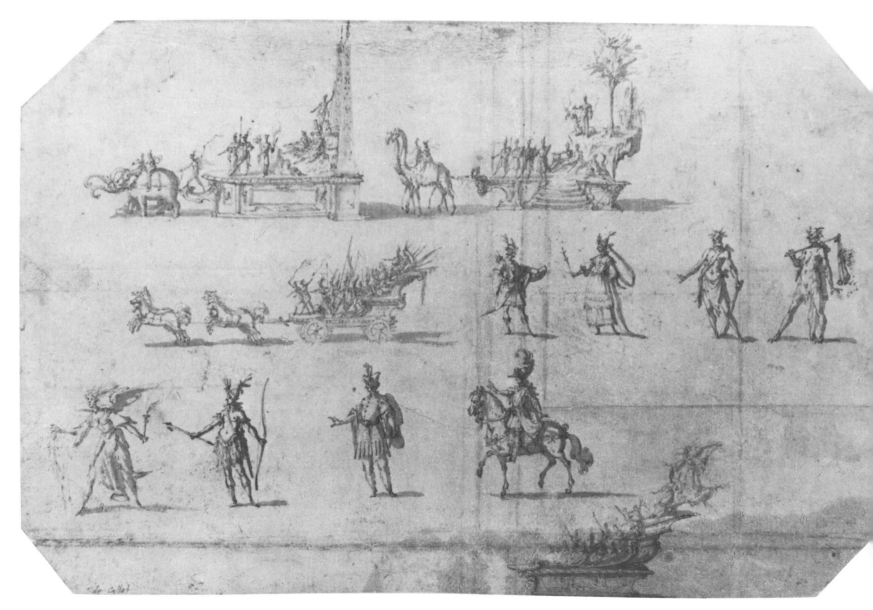

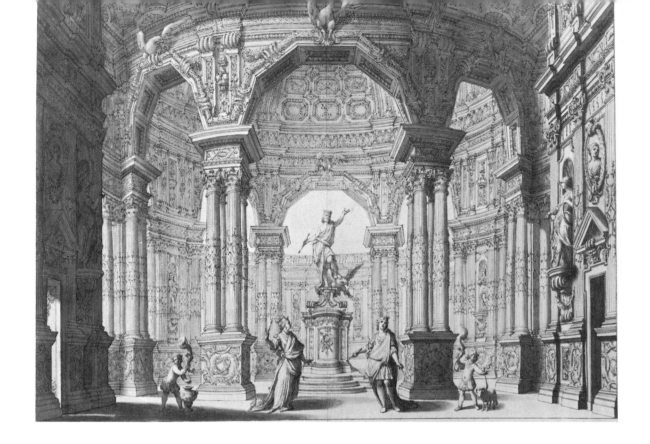

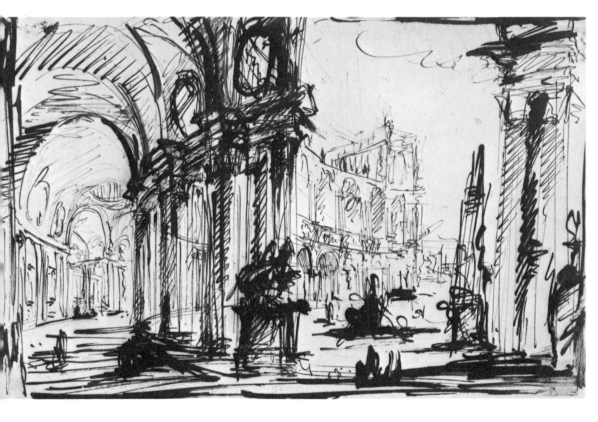

△ Attributed to Giuseppe Bibiena (1696–1756):
The Temple of Jupiter, c. 1720-1740.
Pen and brown ink with brown
and blue wash. (353 × 508 mm.)
The Pierpont Morgan Library, New York.

Giovanni Battista Piranesi (1720–1778):
Architectural drawing from Juvarra's stage
set for "Teodosio Il Giovane."
Pen and brown ink. (266 × 410 mm.)
British Museum, London.

The art of stage design played an essential role in the introduction of formal innovations into architecture, decoration and pictorial space in Parma and Bologna, from the early eighteenth century on. The Bibiena dynasty covered three generations and included eleven people, working as a team and travelling all over Europe to build theatres and design sets. The two major personalities in the family were Ferdinando, architect, stage designer, painter and author of a treatise on *Architettura Civile* (1711); and his son Giuseppe. Their drawings show a profusion of variants, and endless reworking of the same motifs; they range from single architectural details to elaborate studies for complete stage sets. The Bibienas created their own style, a genuine family tradition, so that it is difficult to assign single works to individuals. Moreover, they sometimes drew the architectural part of the design themselves and left their assistants to add the figures. This highly developed drawing for the *Temple of Jupiter* is a good example of the illusionist effects of perspective: the porticoes and galleries radiate from a central vanishing point on the pedestal of the statue. Among the Bibienas' scenic innovations was the use of angular construction, an idea taken up by Juvarra and later by Piranesi. A great builder and prolific draughtsman, Juvarra designed the basilica of the Superga in Turin (1717-1731) and, outside the city itself, the castle at Rivoli and the Stupinigi palace commissioned by the Prince of Savoy (1729-1733). In 1735 Juvarra drew up plans for Philip V's Palacio Real in Madrid and the summer palace of La Granja near Segovia. His work was highly varied and included palaces, churches, chapels, private houses, and designs for pageants, stage sets, objets d'art and

ornaments. The same variety of subject is found in most of the stage designers. This design for the play *Teodosio Il Giovane,* performed in Rome at the Ottoboni theatre in 1711, is part of a volume of stage drawings made by Juvarra in Rome between 1708 and 1712. Two rough sketches at the bottom show a plan of the stage and a detail of a staircase. The main drawing is based on an angular effect which gives a dual diagonal perspective. The style is free and spirited, using contrasting light and shade to accentuate depth of perspective. The astonishing facility of Juvarra's pen, in his hands so rapid and sure, anticipates Piranesi.

Unlike the Bibienas, Piranesi designed vast architectural spaces devoid of any functional purpose and indeed not even constructible; they were meant as capriccios or fantasies, even though he had been trained in stage design and perspective in Venice, under Zucchi and Valeriani. This drawing is connected with the opera *Teodosio,* for which Juvarra did the sets. For the Bibienas and their contemporaries, technical knowledge and the study of perspective outweighed all other research. For Piranesi's generation, language and style had become essential, and his bold and forcible drawings are the expression of an independent activity rather than preparatory studies. His inspiration stems from a romantic, sometimes frenzied imagination. His style is to be seen in all its baroque fantasy in the series of *Invenzioni Capricciose di Carceri* (1745), in which he conjures up a space which is distorted, dilated, surreal, and modifies the proportions of the architectural elements so as to give them a "new fantastic dimension" (Rodolfo Pallucchini).

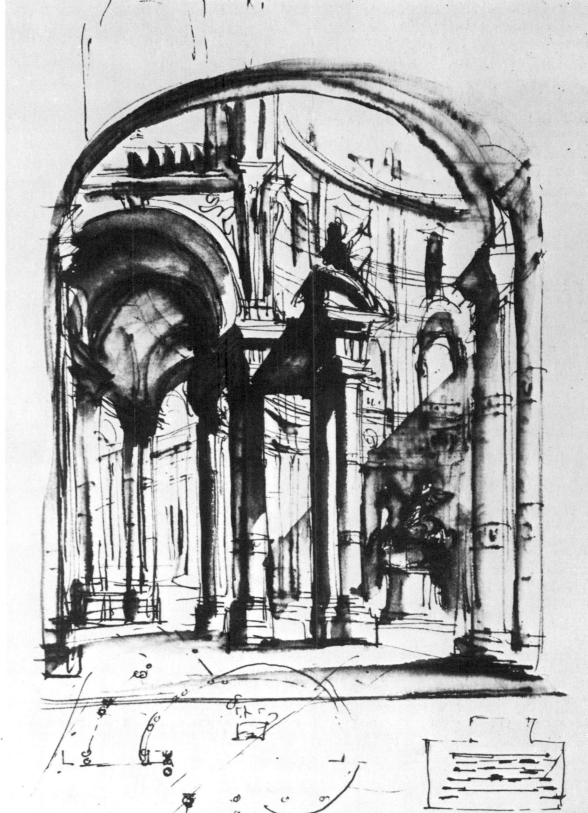

Filippo Juvarra (1678–1736):
Sketch for the stage set for
"Teodosio Il Giovane,"
Rome, 1708–1712.
Pen and brown ink and watercolour.
(270 × 175 mm.)
Victoria and Albert Museum, London.

François Mansart marks a sharp break in France with Italian art (he never went to Rome). Following in the line of Philibert de L'Orme and Salomon de Brosse, he stands out as one of the creators of French classicism in architecture. A large number of designs for his essential buildings have come down to us: the church of the Visitation and that of the Val-de-Grâce in Paris; the Orléans wing of the Château de Blois, and the châteaux of Maisons and Balleroy; and private houses built in Paris (Chavigny, Tubeuf, Guénégaud, Jars, La Vrillière, Carnavalet and Condé). These drawings, often symmetrical in their lay-out and scrupulously accurate in their linework, sometimes show the elevation and plan on the same sheet. The many surviving designs for the eastern wing of the Louvre (Bibliothèque Nationale, Paris, and Nationalmuseum, Stockholm) are in pen and brown ink, with sketches in black chalk; some of them bear strokes in red chalk corresponding to the foundations of the wing built by Le Vau from 1661. Le Vau's work had been suspended in 1664 by Colbert, who then invited other architects, both Italian (Bernini, Candiani) and French (Mansart, Le Brun), to enter into competition. In 1667 the commission was restored to Le Vau who, departing from his previous designs, erected a façade with an open colonnade. This fifth and last elevation by Mansart shows the entire façade with, on either side of the central axis, two alternative designs for it. The large square units at either end derive from a sketch already figuring on the third elevation combined with further modifications. The absence of a dome in the centre reduces the bulk of this east wing. The style of François Mansart was continued by his great-nephew Jules Hardouin, who took the name of Mansart and became architect to Louis XIV in 1675.

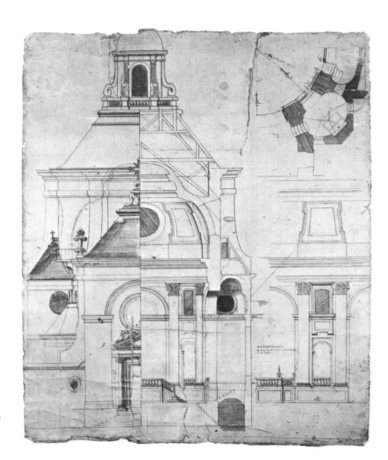

François Mansart (1598–1666):

Half-elevation, half-section, quarter-plan,
and quarter internal elevation of the church
of Sainte-Marie de la Visitation, Paris, 1632-1633.
Pen and brown ink over black chalk. (770 × 640 mm.)
Archives Nationales, Paris.

Elevation of the East Wing of the Louvre, Paris, c. 1666.
Pen and brown ink. (228 × 799 mm.)
Cabinet des Estampes, Bibliothèque Nationale, Paris.

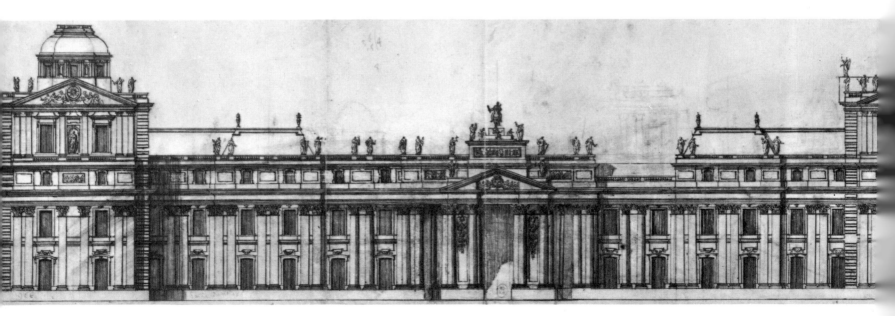

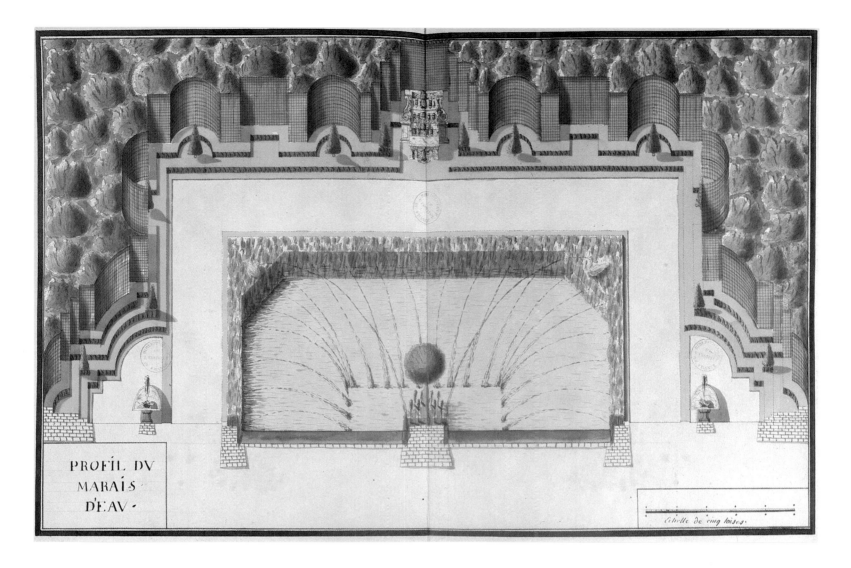

PROFIL DV
MARAIS
D'EAV -

Eschelle de cinq toises.

André Le Nôtre (1613–1700):
Perspective drawing of the Marais d'Eau
at Versailles.
Pen and black ink, grey wash, blue
and green watercolour. (526 × 800 mm.)
Bibliothèque de l'Institut de France, Paris.

The strict design
of French classicism
in the 17th century

In 1637 Le Nôtre took over his father's position as chief gardener of the Tuileries. From 1656 on he planned and laid out gardens, grottoes and cascades for the château of Vaux-le-Vicomte, before becoming "garden designer to the King." Always harmonizing with the architectural setting, his gardens were an integral part of all the royal residences: Saint-Germain-en-Laye, Chantilly, Meudon, Saint-Cloud, Sceaux. At Versailles, from 1662, they found their most perfect expression. There was close cooperation at every stage between the architect, the engineer of waterworks and fountains, the gardener, the marble mason who executed the edges of the ornamental basins, and the king's first painter, Charles Le Brun, who designed the decorations and set out the sculptures amid the trees, shrubbery, basins, jets of water and *parterres d'eau*. This latter term was coined in 1672 when the ornamental basins were transformed. The flower-beds laid out by Le Nôtre are often surrounded by a raised terrace bordered by lawns planted with yew trees. This drawing is one of a series of designs for the gardens of Versailles and Saint-Germain-en-Laye whose authenticity was established by A. Marie and M. Charageat (1954), thanks to inscriptions in Le Nôtre's hand visible on certain sheets. The design for the Bosquet du Marais is based on strictly geometric forms: rectangular basin, semicircular shrubberies, yew trees carved in triangles. This perspective view indicates the lay-out of the ground around the rectangular basin, with an artificial oak in the centre of it. The optical effects of the shrubberies are deftly enhanced by shading.

135

Oppenord was one of the creators of the Rococo style, whose fanciful informality marked a real innovation in architectural design. He worked for the Duc d'Orléans, Regent of France from 1715 to 1723, for whom he built a part of the Palais Royal which was demolished in 1748 during the construction of the Comédie Française. This longitudinal section of an opera house, designed in 1734 but never built, shows the curtain on the right. The different levels of the section were indicated on the ground plan by dotted lines. The section is an important element of architectural planning, showing as it does the structures and the depth of certain details; it affords the draughtsman a pretext for spectacular effects by revealing the interplay of solids and voids, rendered by the contrast between dark washes and the lighter tints of watercolour.

The church of Sainte-Geneviève, Paris, is Soufflot's chief building; he worked on it for over twenty years, till his death in 1780. Begun in 1757, the church was completed in 1813 by his successors: his nephew Soufflot le Romain, Rondelet, the engineer L. P. Baltard and the theorist Quatremère de Quincy. The dome rising at the centre of the cruciform plan, where the four naves meet, is the distinctive feature of the building. Soufflot took inspiration from Bramante's dome for St Peter's in Rome (1505) and Wren's dome for St Paul's in London (1675-1709). Between 1756 and 1777 Soufflot made six designs for his dome, whose final form influenced

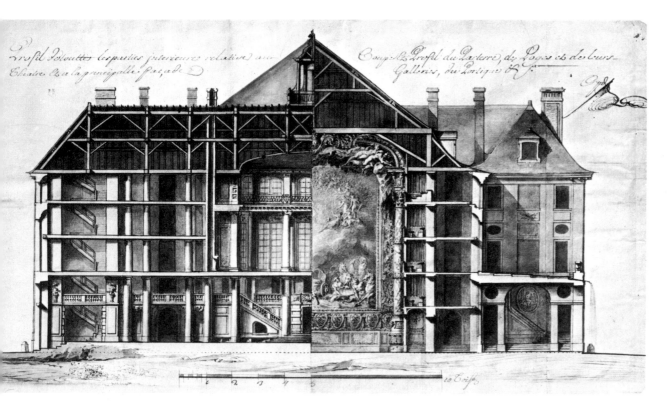

Gilles-Marie Oppenord (1672–1742):
Longitudinal section
of an Opera House, 1734.
Pen and Indian ink and wash.
(530 × 600 mm.)
Ecole des Beaux-Arts, Paris.

Charles de Wailly (1729–1798): ▷
Longitudinal section
of the drawing room
in the Palazzo Spinola,
Genoa, 1771-1773.
Pen and brown wash.
(133 × 161 cm.)
Musée des Arts Décoratifs, Paris.

Germain Soufflot (1713–1780): ▽
Longitudinal section of the new
church of Sainte-Geneviève, Paris.
Pen and brown ink, grey and brown
wash, heightened with watercolour.
(610 × 940 mm.)
Archives Nationales, Paris.

many foreign architects, despite the controversy aroused by the appearance in 1776 of fissures in the pillars, due to the instability of the ground but imputed to the weight of the dome. Soufflot aimed at combining the regular order of the Antique (fluted columns, entrance portico with hexastyle colonnade supporting a huge triangular pediment) with the lightness and clarity of Gothic architecture. In 1791 this church was converted into a hall of fame, the Panthéon, where the ashes of France's great men were interred. The interior space was now completely modified, all the low windows of the four naves being walled up to provide the surface for an extensive series of murals by Bonnat, J. P. Laurens, Cabanel and Puvis de Chavannes.

A painter, architect and decorator, Charles de Wailly built castles and private houses both in France and abroad. With Joseph Peyre he built the Odéon theatre in Paris and designed projects for the theatre in Brussels and the opera house in Paris; with J. A. Gabriel he took part in the construction of the Versailles opera house. As a town planner he drew up plans for the Odéon and Opéra quarters in Paris, the new town of Port-Vendres and the centre of Brussels. His style as a draughtsman is colourful and pictorial, marked by a profusion of motifs more closely related to Baroque than to the frigid design of Neo-Classicism. De Wailly was fond of spectacular light effects which he distributed in broad sweeps to animate his sections and elevations. This design for the large drawing room in the Palazzo Spinola, Genoa, was carried out by de Wailly in 1771-1773, with the collaboration of the painter Antoine François Callet, who decorated the oval ceiling, and of Philippe de Beauvais who did the sculptures in gilt stucco (caryatids on the ceiling and bas-reliefs under the architrave). This highly ornate setting, whose theatrical effect is enhanced by mirrors creating an illusion of perspective, harmonizes well with the style of this Genoese palace.

A painter and designer of ornaments, Gillot brings together in this design for a wall decoration various aspects of his style: trompe-l'œil, arabesques and the Commedia dell'Arte (represented here by the figure on the right). Each side of this attractively asymmetrical drawing offers a different solution, the patron being free to choose between them. In Gillot's studio worked the young Watteau, who imbibed his master's taste for arabesques, decorative panels and *chinoiseries*. Introduced in France about 1715, the so-called Chinese style provided an inexhaustible source of inspiration for many artists: Pillement, J.B. Huet, Huquier, Oppenord, Pineau, Meissonnier, Lajoue, Boucher, C. Huet, the Audrans, J.B. Oudry and J.F.

Charm and fancy of 18th-century designs

Nicola Fiore (second half of the 18th century):
Mural decoration for the antechamber of the Queen's bathroom in the Palazzo Reale, Caserta, 1775.
Pen and black ink, watercolour, gouache. (623 × 545 mm.)
Cooper-Hewitt Museum of Decorative Arts and Design, New York.

Desportes. It was subsequently taken over, with a
free play of fancy, in all fields of decorative art, in
particular textiles, wallpapers and book illustration.
The Chinese style only came into vogue in Italy in the
later eighteenth century, notably in the work of
Nicola Fiore, painter to King Ferdinand I of the Two
Sicilies, and in that of Francesco Guardi.

A prolific draughtsman, Robert Adam with the help of
his brother James made a large body of designs for
architecture and decorative art (furniture, mirrors,
candlesticks, iron fittings): some 8,000 drawings are
in the Sir John Soane's Museum, London. Adam trans-
formed the conception of interior decoration. He
adapted the monumental style, usually reserved for
external decoration, to his interior elevations, which
recall the elegant geometry of Palladio's façades.

Claude Gillot (1673–1722):
Design for a Wall Decoration.
Pencil, pen and brown ink, brown
wash. (204 × 342 mm.)
Print Room, Rijksmuseum, Amsterdam.

Robert Adam (1728–1792):
Section of the Great Room
for Great Saxham House, Suffolk.
Pen and grey ink and grey wash. (520 × 950 mm.)
The Metropolitan Museum of Art, New York.

Dream
projects

Etienne-Louis Boullée (1728–1799):

Project for a Metropolitan Church, 1781-1782.
Pen and grey ink, grey and brown wash. (578 × 829 mm.)
Lodewijk Houthakker Collection, Amsterdam.

Cenotaph in the Egyptian Style.
Pen and brown ink and wash. (44.5 × 107 cm.)
Cabinet des Estampes, Bibliothèque Nationale, Paris.

CÉNOTAPHE DANS LE GENRE ÉGYPTIEN

Etienne-Louis Boullée was more of a designer than a builder, and received his first training as a painter. The gigantic, almost unrealizable specimens of architecture he conjured up earned him the name "utopian." His designs, strange in their formal rigour, were rarely carried out. He drew geometrical forms (pyramids, cubes, spheres and cylinders), bringing out their symbolic significance in relation to building. He had a partiality for circular edifices (designs for an opera house in the Place du Carrousel, Paris, for circuses, and for a cenotaph for Newton). His drawings, especially after 1778, are imaginary visions, like this wash depicting the central area of a Metropolitan Church in which Corpus Christi would be celebrated. According to Boullée, "this temple should present the grandest and most striking image of existing things: if that were possible, it should seem the universe." He was probably influenced by the Panthéon: he worked on its completion after Soufflot's death. Boullée sought after the effect of smooth surfaces devoid of ornament. He stressed shadow effects which suggested a better articulation of form. Here the visionary aspect is introduced by the vastness of the building and the clouds floating within the dome. He was very interested in the theoretical side of his art, and wrote a *Traité sur l'Architecture*; the manuscript is preserved in the Bibliothèque Nationale in Paris, and the work was published in 1953.

Jean-Jacques Lequeu (1757–c. 1825):
The Isle of Love and Fisherman's Rest.
Pen and brown ink and watercolour. (356 × 513 mm.)
Cabinet des Estampes, Bibliothèque
Nationale, Paris.

Jean-Jacques Lequeu was an inventor of designs rather than a constructor. His visionary style links him to his two contemporaries Ledoux and Boullée, with whom he forms a kind of "trilogy" since their recent rediscovery by Emil Kaufmann (1952). Lequeu, whose imagination was often motley in its heterogeneity, was interested in all styles—antique, Gothic, Middle and Far Eastern. His over-complex drawings differ in their excess from the simplicity and rigour of Boullée and the harmonious proportions of Ledoux. Lequeu, a theorist, gave a highly didactic definition of "the science of natural shadows and wash" in his *Traité d'Architecture Civile*. As media for their drawings the visionaries used grey or brown wash; the monochrome tints added to the drama of designs often destined for mausoleums, tombs and temples underlines the morbidity of the images.

Félix Louis Jacques Duban (1797–1870):
Tomb of Cecilia Metella, Via Appia, Rome.
Grey wash and watercolour. (254 × 400 mm.)
Ecole des Beaux-Arts, Paris.

Eugène Viollet-le-Duc (1814–1879):
The Salle Synodale at Sens.
Watercolour. (650 × 985 mm.)
Caisse Nationale des Monuments
Historiques et des Sites, Paris.

The teaching system at the Ecole des Beaux-Arts in Paris, founded in 1819, was based on a tradition going back to the early eighteenth century, the tradition of the old Academy of Architecture, which closed in 1793. The system rested on a hierarchy of different competitive awards: as well as monthly prizes, there was the Prix de Rome, which sent the winner to the French School in Rome (Villa Medici) to study the ancient monuments. When he returned to France he usually entered on an "official" career. The first Prix de Rome competition took place at the Academy of Architecture in 1721, and the prize was awarded annually from then till May 1968. The subjects proposed were generally monumental edifices such as palaces, museums, public buildings, libraries, embassies, exhibition halls, schools, universities, military academies, lawcourts, cathedrals, mausoleums; always some national building which might be commissioned by the state. The student architect had to produce a general plan, a detailed plan, a cross-section and an elevation, never any perspective drawings or model. The medium used was wash drawing and watercolour–with a riot of colour between 1850 and 1880. From this period dates Lambert's design for a water tower. The cruciform plan is perfectly symmetrical and stands out against an abstract background. In Prix de Rome drawings, the place where the proposed edifice was to be built remained vague, ideal, utopian. Reduced to the function of "presentation," architectural drawings developed towards an ever more sophisticated and aesthetic technique, at the expense of the study of actual structure. "Rendering" was more important than the basic realities of building. All the designs which won the First Grand Prix de Rome, and some of those which won the Second and Third, are preserved in Paris in the collections of the Ecole des Beaux-Arts. The monthly competitions which began in 1763 offered a sort of training for the Prix de Rome, based on limited subjects, such as fountains, schools, chapels and small

private buildings. The successful student, once in Rome, was expected to send a number of sketches of ancient monuments back to the Institute every month. His progress was judged by the quality and size of his sketches, which grew steadily larger in scale. A purely technical exercise, the sketch drawing was followed by an archaeological exercise, the "reconstruction," which called for imagination as well as archival research. Together the sketch and the reconstruction formed an essential part of the teaching syllabus in so far as it consisted of pastiche. The earliest surviving restoration is that of Trajan's Column in Rome made by Charles Percier in 1788. Before his restoration of the Portico of Octavia, Duban, who won the Prix de Rome in 1823, drew many monuments in the Roman Campagna, including this elevation of the Tomb of Cecilia Metella, a standard point of reference for all architects studying in Italy. Labrouste took over the frieze of this tomb almost unaltered for the façade of the Bibliothèque Sainte-Geneviève, Paris. Such drawings played a major part in the work of Viollet-le-Duc, whose main restoration campaigns included the Sainte-Chapelle (1840-1849), Notre-Dame and Saint-Merri in Paris, the Madeleine in Vézelay, and the old town of Carcassonne. His work as a restorer is more important than his actual building, and most important of all is his work as a theorist, chiefly in the *Entretiens sur l'Architecture*. He sought to widen the student's usual horizon by introducing a taste for medieval architecture. He thus represents a different trend in teaching from that of the Ecole des Beaux-Arts.

Noël-Marcel Lambert (1847–?):
Ground Plan of a Water Tower.
Prix de Rome 1873.
Pen and Indian ink and watercolour.
(3.64 × 2.63 m.)
Ecole des Beaux-Arts, Paris.

Functional designs
of the
architect-engineers

Jacques-Ignace Hittorff (1792–1867):
Project for the Gare du Nord, Paris:
Perspective View of the Main Hall, 1862-1863.
Pencil. (503 × 965 mm.)
Wallraf-Richartz Museum, Cologne.

The first constructions in iron were mostly bridges, for which some designs have survived, executed in watercolour in different tints bringing out the play of shadows and rendering with the utmost precision the assemblage of interlocking ironwork. Henri Labrouste was one of the first architects to use new materials like iron and cast iron, not merely functionally but also for their aesthetic qualities, letting them show in his constructions and even underlining their structural effects. This makes him a pioneer of functional architecture and one of the first "architect-engineers." In 1838 he was appointed architect to the Bibliothèque Sainte-Geneviève in Paris, which he began rebuilding in 1844 and completed in 1851. The reading room is divided into two long bays by cast-iron colonnettes supporting iron arcading. After the success of this library, Labrouste was entrusted with various projects for the Bibliothèque Nationale (1854-1875). In the big ground-floor reading room the nine spherical domes, their pendentives decorated with glazed faience, are supported by tall cast-iron colonnettes which take up the least possible space while letting in the maximum amount of light. This idea of pendentives continuing the line of pillars is taken from the portico of Brunelleschi's Spedale degli Innocenti in Florence. The technique of metal construction calls for extreme delicacy in joining and shaping, an extreme rigour and accuracy which are found in Labrouste's drawings: every detail, drawn in pen or finest graphite, is worked out and ready for execution. Victor Baltard also used an iron framework in building the Halles Centrales, Paris (1854-1856), these market halls probably being inspired by the first railway stations of 1835; and again in the church of Saint-Augustin, Paris (1860-1871), in which the nave arcading is supported by iron colonnettes. Following the example of Labrouste

Jean-Baptiste Philippe Canissié (1799–1877):
Project for an Iron Bridge, 1824.
Pen and Indian ink, grey wash, pink
and blue watercolour. (66.5 × 209 cm.)
Ecole des Beaux-Arts, Paris.

Henri Labrouste (1801–1875):
Construction details of the attic of
the Bibliothèque Sainte-Geneviève, Paris.
Pen and black ink over pencil, heightened
with watercolour. (66.3 × 101 cm.)
Cabinet des Estampes,
Bibliothèque Nationale, Paris.

and Baltard, Hittorff used an iron framework for the
Gare du Nord, Paris (1862–1863), which was one of his
most important achievements. Many other architect-
engineers deserve mention: Hector Horeau, whose
prize-winning competition design for the Crystal
Palace, London, was not used; L. A. Boileau; Gustave
Eiffel, who built the Galerie des Machines in the
Champ de Mars for the Paris World's Fair of 1867,
followed by the famous Eiffel Tower for the 1889
World's Fair; Anatole de Baudot; and Louis Dutert.
The use of iron in architecture marked the beginning
of the industrialization of building materials, and of
prefabrication.

Hector Guimard (1867–1942):

◁ Longitudinal section of the Humbert
de Romans Concert Hall,
Paris, c. 1898-1900.
Pen and Indian ink. (610 × 950 mm.)
Musée des Arts Décoratifs, Paris.

▽ Design for a stained-glass window
in his office on the ground floor of
the Castel Béranger, 14 Rue La Fontaine,
Paris, 1898.
Pencil, red ink and watercolour
over tracing. (396 × 385 mm.)
Musée des Arts Décoratifs, Paris.

Horta, a disciple of Viollet-le-Duc, was the first to
make use of iron in private houses: the Hôtel Tassel
(1892-1893) and the Hôtel Solvay (1895-1900) in Brus-
sels, the most significant of his houses in the Art
Nouveau style. He took inspiration from plants and
flowers in creating the patterns of coiling and inter-
lacing lines which occur in most of his architectural
motifs. The large façades of his buildings are marked
by a novel combination of metal and glass. After a stay
in the United States (1916-1919) he moved towards a
stricter, more austere design; and giving up his sinuous
lines based on floral motifs, he reverted about 1928 to
the use of straight lines.

Van de Velde too used the curves and counter-curves
characteristic of Art Nouveau, but he tried to stylize
them in order to achieve a greater simplicity of line.
A painter, illustrator and furniture designer, he aimed
at an overall harmony between the external design,

◁ Victor Horta (1861–1947):
Study for the pavilion of the Congo Free
State at the 1900 World's Fair, Paris, 1898.
Pen and Indian ink. (64 × 124 cm.)
Musée Horta, Saint-Gilles, Brussels.

◁ Henry van de Velde (1863–1957):
Perspective study for the Louise
Dumont Theatre near Weimar, 1904-1905.
Watercolour. (390 × 539 mm.)
Bibliothèque, Fondation
Isabella Errera, Brussels.

1900:

Structure
and
ornament

Joseph Maria Olbrich (1867–1908):
Project for the Exhibition Hall of the
Vienna Secession: Perspective View, 1897–1898.
Pencil, pen and Indian ink, watercolour
and gouache. (187 × 116 mm.)
Kunstbibliothek, Staatliche Museen
Preussischer Kulturbesitz, West Berlin.

internal arrangement and furnishings of a house. This new sense of ornament was common to all the artists of this "1900" generation: ornament had become as important as the architecture in which it was perfectly integrated.

Considered as the master of Art Nouveau, Hector Guimard handled the repertoire of flexible plant and floral forms more skilfully and inventively than anyone, without recourse to the principle of symmetry. His imagination played not only with forms but with materials, which he liked to mix with eager fancy. Thus some of his Métro entrances in Paris (1899–1904) combine cast-iron railings with wood, ceramic tiles and stained glass. Guimard is one of the few who kept to the Art Nouveau style after it lapsed about 1909: he practised it until about 1928.

Mackintosh, the leading exponent of Art Nouveau in Britain, built the Glasgow School of Art (1898–1909) in a severe and functional style unexampled at the time. So keen was his interest in decorative art that after 1913 he limited himself to designing furniture and fabrics. In his trend towards a greater rigour of structure, based on the straight line, he has something in common with the Chicago School and may be regarded as a precursor of the rational architecture of the twentieth century.

J. M. Olbrich in Austria was a pupil of Otto Wagner. Together with Josef Hoffmann, he was the founder in 1897 of the Vienna Secession, whose style is a synthesis between Belgian or French Art Nouveau and the geometric stylization begun by Mackintosh. Olbrich and Hoffmann were also active as designers of fabrics, wallpaper, posters, jewellery, rugs, illustrations and books. From now on architects took a wider, more searching view of their role, and their drawings came to express a more personal aesthetic vision.

5 DRAWING AS A RECORD OF OBSERVATION

Drawing is a special way of apprehending the reality which the artist chooses to observe. He sets down certain details of his subject spontaneously, without necessarily having in mind any ultimate realization of this image, without seeing it as part of the creative process leading up to a finished work. Thus the drawing is no longer merely a step in the direction of something else, but an independent work in its own right, although the artist may refer to it later and even use it, changed or as it is, in some other creation.

Drawing is a habit, something the artist does every day, and acts as the first phase of knowledge. It can be the record of something seen in nature (rocks, trees, plants, animals, insects), of an event, of something experienced during a journey (places, architecture, costumes, faces), of the impression made by a landscape. It is at one and the same time a proof of perception and an instrument of memory.

The draughtsman, observing reality at a given moment, may become the chronicler of a happening (ceremonies, feasts, processions), the witness of a season or of an atmospheric change (a storm, for example), or the spectator of some instant whose fleeting image he is able to fix for ever on the page. Among drawing's special characteristics is the power to translate instantaneity by means of a few strokes of the pen or brush.

The choice of subject and the way it is placed on the page reflects the artist's personality, his individuality and the uniqueness of his way of seeing. So too do the variations in the distance he decides to set between himself and his subject: sometimes it is seen from very close to, with some details treated separately, in close-up, so that they may be analysed more fully; sometimes the artist takes a general or panoramic view.

Vincent van Gogh (1853–1890):
Study of Hands for "The Potato Eaters," 1885.
Black crayon. (300 × 330 mm.)
Rijksmuseum Vincent van Gogh, Amsterdam.

REALITY: STUDIES, SKETCHBOOKS

In his sketchbook or on larger pages, loose or bound, the artist sets down his rough, fragmentary notations as they occur. Often there is no connection between the various sketches put down in no particular order; different motifs may even overlap on the same page. This lack of organization may reflect the speed at which these notations from life have been transcribed on to the paper. In many cases the artist uses one page to study a single motif from various angles or distances, circling around it and showing it simultaneously from the front, in profile, in three-quarter profile, from close to and from far away. A page of studies reflects the agility of the artist's eye, its curiosity, its vitality. The drawing is the overall result of his countless explorations in quest of the essence of the subject, observed in the intensest possible manner.

Some artists, including some of the greatest (Pisanello, Leonardo, Rembrandt, Watteau, Delacroix, Degas), find perfect expression in their sketchbooks and sheets of studies. In the very moment of spontaneous notation they consciously or otherwise arrive at a perfect lay-out, combining the finest analytical perception with the most comprehensive conceptual synthesis. Their knowledge of composition and placing is reinforced by the rhythmic interaction between the drawings and the areas of the page left blank. At this stage of representation the idea of space is not yet involved; the various elements exist on the page on different planes; the only space is that marked out by the four edges of the paper.

REALITY: SCENES, LANDSCAPES

Here we are concerned not with fragmentary studies but with a single composition carefully placed, in which the scene is depicted in a definite and coherent setting. The page acts as a window opening on to a part of the world. Space is suggested by means of the traditional system of perspective (ground configuration, vanishing points, horizontals).

STUDIES OF SUBJECTS TAKEN OUT OF THEIR CONTEXT

Some very finished drawings are studies of isolated subjects seen in their entirety but cut off from their setting: without surroundings or background, without ground or horizon. All that matters is the most detailed and rigid representation of the subject. Are such drawings images taken from reality, or copied from the masters, or purely imaginary? Or are they a synthesis of all three? Paradoxically, a copy based on the masters may create the admirable illusion of having been made from a living model. Any reading of such images is bound to be subjective, and their interpretation varies in accordance with the viewer's skill, erudition and imagination.

THE TRANSFORMATION OF REALITY

At what stage of observation does the process of interpretation begin, whereby that which is seen is transformed? How is one to distinguish between drawings from life and those noted down from memory and then retranscribed in the evening by the artist in his studio, or, if he is travelling, in his room at the inn? At what point does imagination intervene? What part does memory play in imagination?

Even the most direct of drawings partakes of this duality between reality and imagination. The artist's activity alternates constantly between notations from life and the records of the mind: just as on the plane of chronological evolution the great trends alternate, realism with romanticism, impressionism with symbolism.

Curiosity about the world

Leonardo da Vinci was a pioneer in every field: ideas, subjects, techniques. His vast intelligence and unbounded curiosity made him approach all the problems of drawing as if drawing were a special instrument of observation. He thus initiated a systematic investigation of the world, an attempt to define the internal and external structure of things, beyond appearance. His drawings were accompanied by manuscript notes, some purely scientific, others essentially literary texts. To understand Leonardo's special role in the fifteenth century we have to remember earlier studies by other draughtsmen (such as Pisanello, Giovannino de' Grassi, Gentile da Fabriano) who since the fourteenth century had been making detailed analyses of nature (trees, plants, flowers, animals, birds, fishes, insects) while still remaining close to the ornamental and decorative approach of medieval court art and

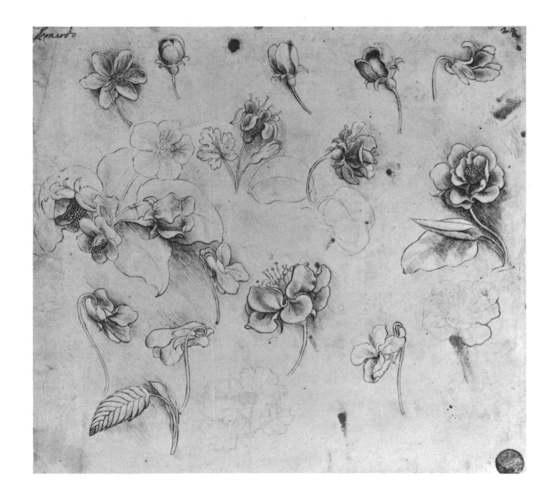

Leonardo da Vinci (1452–1519):
Studies of Flowers, c. 1483.
Pen and brown ink over metal
point on brownish paper. (183 × 203 mm.)
Gallerie dell'Accademia, Venice.

illuminated manuscripts. The range of Leonardo's curiosity is so wide that it covers not only all these aspects of nature, but also the elements (water, earth, air and fire) and atmospheric phenomena (clouds, storms, floods, avalanches, tidal waves and volcanic eruptions). He is as interested in what is infinitely large (mountain ranges, precipices, valleys—he also drew maps) as in what is infinitely small (the pistils of flowers, the arteries and capillaries of the human body—he was the first artist to make anatomical drawings, having studied dissection with Marcantonio della Torre, the greatest anatomist of that time). All Leonardo's drawings are pieces of sustained research in their own right, but despite the limitlessness of their thematic repertory they have one aim in common: the discovery of new knowledge. Not all of them are necessarily linked to his work as a painter, but all bear witness to his prodigious creativeness as a universal

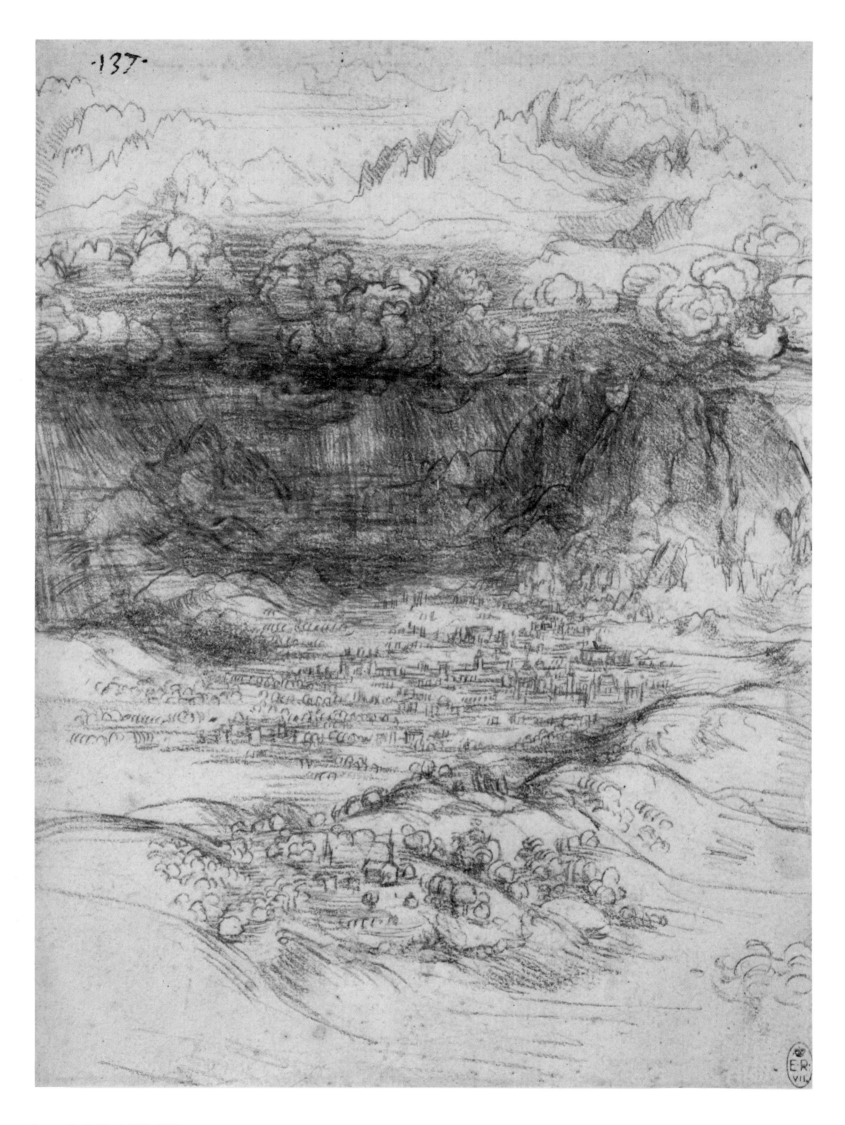

Leonardo da Vinci (1452–1519):
Storm over a Valley in the Alps, c. 1506.
Red chalk on white paper. (220 × 150 mm.)
Enlarged reproduction.
Royal Library, Windsor Castle.

draughtsman. His interest in botany is shown on this sheet of *Studies of Flowers*, drawn from nature and showing various stages in their budding and blooming: the angles of the stems dictate the pattern of the layout on the sheet. Metal point, a favourite technique of Leonardo's between 1478 and 1490, here touched up with pen and ink, permits perfect accuracy of detail. Modelling and shadows are rendered by fine parallel lines drawn obliquely from right to left and reminding us that Leonardo was left-handed (in all his drawings both the strokes and the handwriting tend to the left). The composition also follows the pattern of diagonals slanting upwards to the left. The very naturalistic drawing of a *Storm*, either a direct record or one done from memory, may have been executed at the time when Leonardo left Milan for Venice after the French occupation (late 1499-early 1500) or after May 1506,

Leonardo da Vinci (1452–1519) :

Studies for the Head of Leda, c. 1509–1510. ▷
Pen and brown ink over black chalk
on white paper. (200 × 162 mm.)
Royal Library, Windsor Castle.

Study for a Cataclysmic Deluge, c. 1515.
Pen and brown and yellow ink
over black chalk. (162 × 203 mm.)
Royal Library, Windsor Castle.

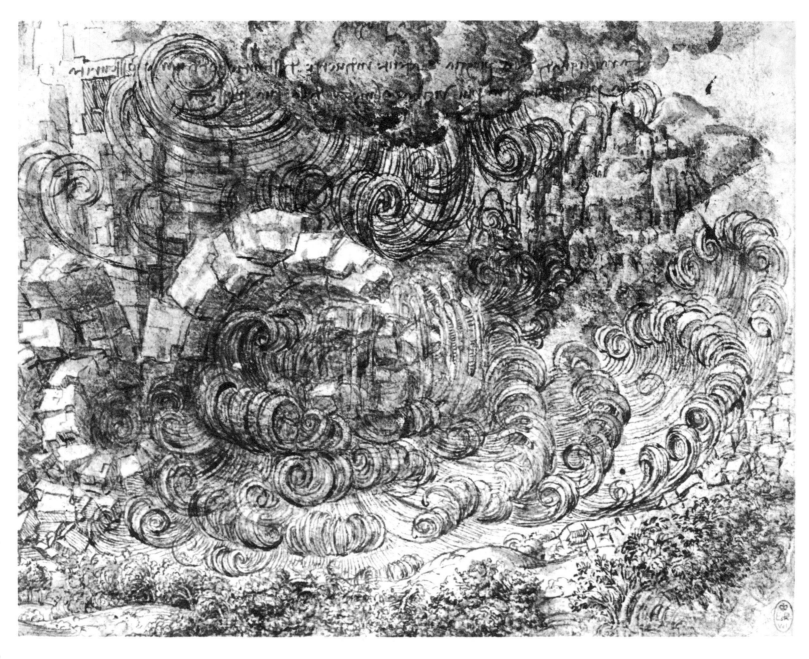

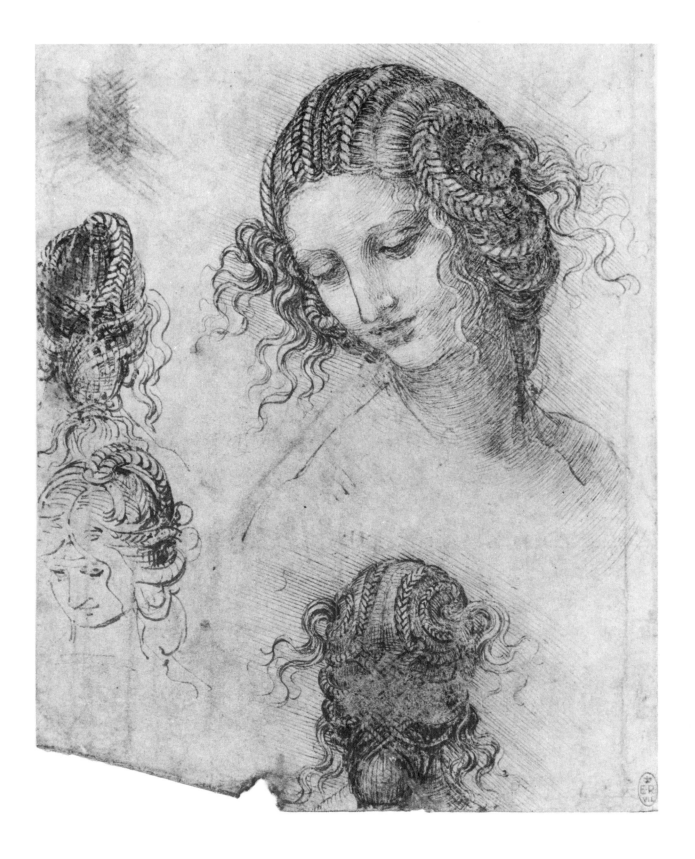

when he left Florence to return to Milan. The second
date is that most generally accepted. Leonardo uses
very fine lines to represent the rain falling from the
clouds. Water was a theme which fascinated him, and
he made drawings of its manifold manifestations,
including the formation of water in motion and whirl-
pools (his manuscripts note the analogy between the
movement of water and wave-forms in hair). These
studies formed part of his research in connection with
engineering commissions: in Tuscany, about 1502, he
produced a plan for a dam on the Arno, and in France,
about 1507, one for the canalization of the Loire. In
scenes showing floods, and in deluges especially,
emphasis and stylization predominate over accuracy
and naturalistic representation: Leonardo shows, for
example, huge water-spouts bursting out of dark
clouds about to sweep down on wooded hills.

The elder Holbein's close observation is clearly seen in the Oxford sheet of studies on which the head and shoulders of the woman in a cap are first seen from two different angles, profile and front, then supplemented with three details of hands. The drawing suggests the painstaking accuracy characteristic of the northern schools, both German and Flemish, since Jan van Eyck. The few surviving sheets from this period are almost all executed in this metal-point technique, and are generally portraits executed with great elegance, typifying the transition from the Gothic style to the early Renaissance. The delicate modelling is achieved by means of the fine parallel lines left by the metal point in the velvety preparation applied to the paper. This drawing probably dates from quite early in Holbein's work. His style later became more fluid.

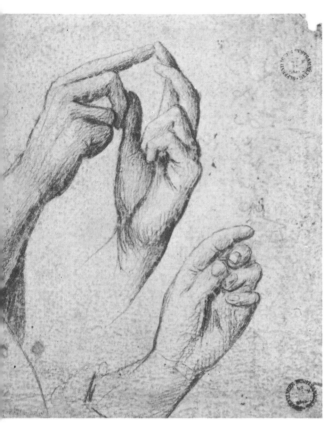

Hans Holbein the Elder (c. 1460/65–1524):

Studies of Three Hands.
Silver point. (97 × 81 mm.)
Kupferstichkabinett, Kunstmuseum, Basel.

Two Studies of the Head of a Woman
and Three of Hands.
Silver point on grey prepared paper. (146 × 212 mm.)
Christ Church, Oxford.

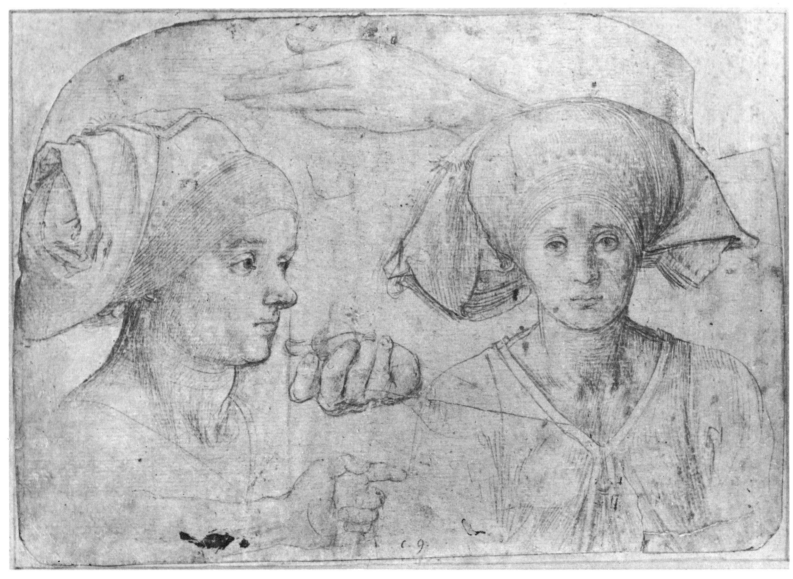

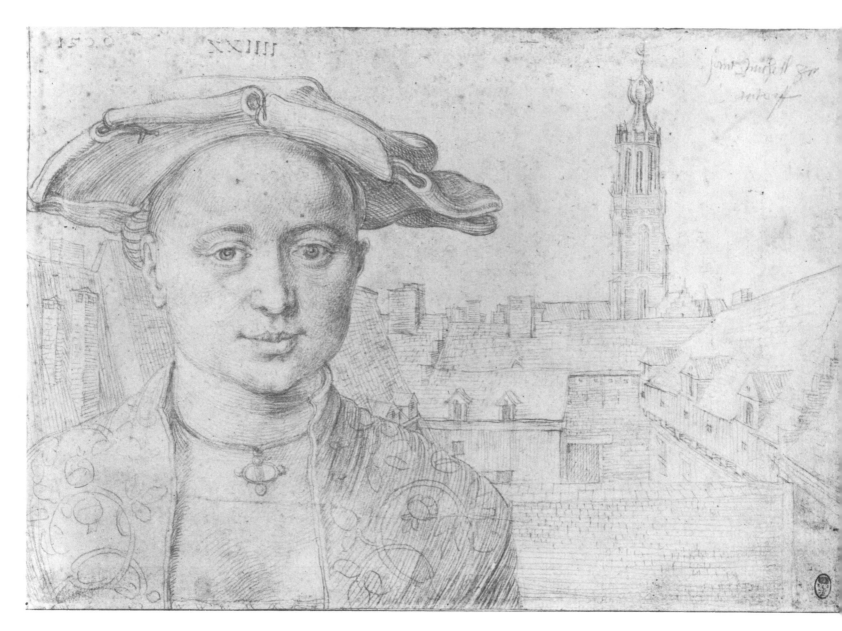

Albrecht Dürer (1471–1528):
Portrait of a Man of Twenty-Four
and St Michael's Abbey in Antwerp, 1520.
Silver point. (133 × 194 mm.)
Musée Condé, Chantilly.

All the drawings made by Dürer in the course of his travels, whether in the watercolours or in the little sketchbooks, are works containing the most minute delineation of natural features. He was one of the first Northern artists to make the journey to Italy, visiting Venice in 1494-1495. From his native Nuremberg he went via the Tyrol, passing through Innsbruck and over the Brenner, and he drew some fifteen or so watercolour landscapes on the way. By introducing colour he brought in a new feeling for atmosphere, capable of reflecting a single moment or a whole season, while remaining faithful to the utmost detail of representation. A new quality of light appears in these watercolours, perhaps through the influence of the painting and luminosity of Venice. In 1505-1506 Dürer went back to Venice and on to Bologna. In 1519 he visited Switzerland, and on 12 July 1520 he again set out from Nuremberg on a long journey to the Netherlands which lasted until July 1521. We can follow Dürer's itinerary in a travel diary he kept, part of which is preserved in the archives in Nuremberg, while the rest is in the library in Bamberg. We learn that Dürer drew numerous portraits on the way: his hosts, the officials of the cities he passed through, celebrities such as the Dutch philosopher Erasmus and King Christian II of Denmark, and the painters he met. "Moreover, to please people, I here and there did many sketches and other things, but for the most part I was paid nothing for my work," he noted in his diary. In addition, he travelled with a sketchbook, whose leaves are now scattered in different museums (Chantilly, Berlin). He filled it with delicate silver-point drawings whose sharp lines depict landscapes, buildings and faces encountered by chance on the road through Brussels, Ghent and Zeeland.

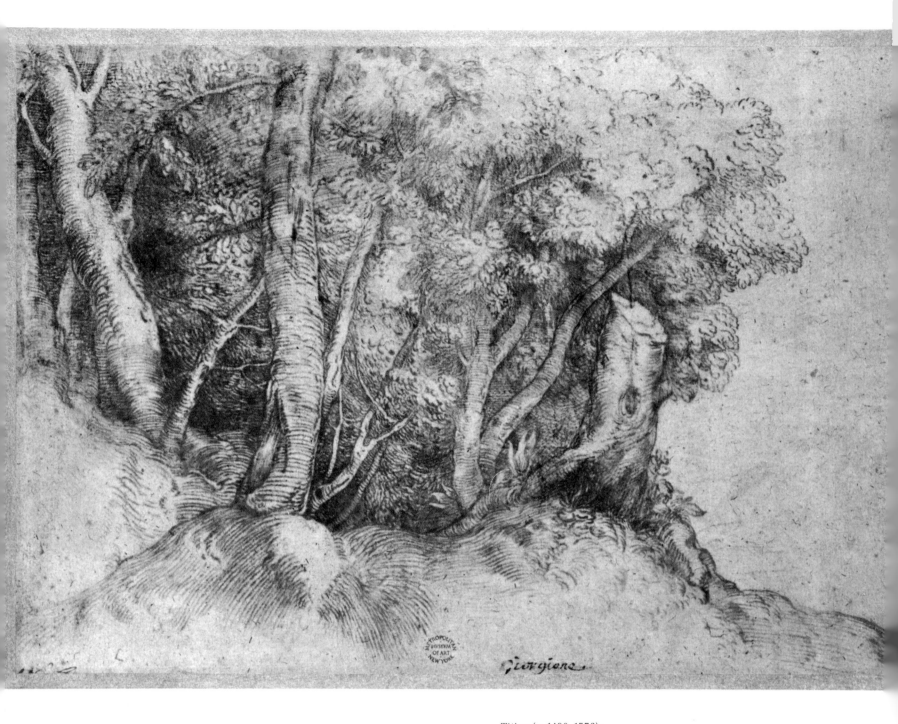

Titian (c. 1490–1576):
Group of Trees, c. 1513–1514.
Pen and brown wash. (217 × 319 mm.)
The Metropolitan Museum of Art, New York.

Titian's landscape drawings from nature are among the finest made by any artist. In 1741 P.J. Mariette, the famous Parisian connoisseur, collector and print-dealer, wrote: "That pen of his, as mellow as it is expressive, served Titian well when he drew landscapes; and it would appear that he enjoyed drawing them, for he produced some very fine ones. Apart from his excellent, quite unmannered way of depicting foliage and his truthful expression of the different kinds of terraces and mountains, and of singular buildings, he also discovered the art of making landscapes interesting through the choice of site and the distribution of light, even though he introduced no figures. Such great parts have caused Titian to be regarded, and rightly regarded, as the greatest of draughtsmen" (catalogue of the Crozat Sale, Paris, 1741). Mariette admired Titian's skill with the pen, the simplicity with which he recorded the beauties of nature, and the role played by light in his drawings (even though there were no figures), as if light were only one element in imparting life to a scene. It is clear that in Mariette's day pure landscape was still regarded as a rarity. Yet the novelty of Titian's approach lay primarily in his sensitive rendering of light, and in his very direct notation of this or that feature of the landscape before him, in this case a group of trees on a steep hillside: the rich texture of the bark, the sturdiness of the tree-trunks and vitality of the leafage are conveyed with searching precision. Some other drawings, still more detailed and precise and long considered to be among Titian's fundamental works, are now ascribed to his younger contemporary Domenico Campagnola, who was in close contact with Titian in Venice, especially between 1513 and 1515. The style of Campagnola's landscapes seems harder and more monotonous, and the workmanship "slow and somewhat mechanical" (Rearick).

Parmigianino seems to have been influenced by Venetian landscapes, especially some of Giorgione's known to us through prints. But when he drew features of nature from life (plants, shrubs, tree-trunks) with his swift, light touch, hatching certain details with shadows and making the air seem to move among the leaves, Parmigianino emerged as a great innovator. In the first third of the sixteenth century this perception of nature was quite new. In the years to come, it developed in the direction of deft, cursive, immediate notation. During the second half of the sixteenth century, a similar rendering of nature was to be found in the work of both Italians, such as Muziano, Barocci and Annibale Carracci, and of Flemish artists who visited Italy. On this common basis they invented new trends in the observation of nature which were to become more clearly defined during the seventeenth century.

Parmigianino (1503–1540):
Study of Plants at the Foot of a Treetrunk, c. 1524-1530.
Pen and brown ink on yellowish paper. (165 × 240 mm.)
Uffizi, Florence.

Pieter Bruegel (c. 1525–1569):
Alpine Landscape with a Mountain
Stream flowing into the Valley, 1553.
Pen and brown ink. (236 × 343 mm.)
Cabinet des Dessins, Louvre, Paris.

Bruegel, in 1552, was one of the first Flemish artists to make the journey to Italy (after Lambert
Sustris in 1545 and Stradanus about 1550), thus marking the beginning of a steady migration
southwards which would last for at least two centuries. Some northern artists settled in Italy
and stayed there for years. Strangely enough, what especially attracted the Flemings were the
mountain views, the crags, precipices and waterfalls, all the dramatic departures from the level
horizon lines of their own flat country. Crossing the Alps as Dürer had done half a century
earlier, Bruegel went to Italy by way of France and returned, in 1553–1554, through the Tyrol
and Switzerland. In the beautiful series of pen drawings he made of the mountains and valleys
through which he passed, he records both the minute details of landscape and its panoramic
sweep. His view is objective, reflecting a certain aloofness from inner impressions and a desire
to take in and synthesize the whole of nature without favouring any one feature of it. Mountains,
trees, rocks and pebbles are all in the same key, forming a coherent and harmonious whole in
which man has a place (he is absent from the landscape drawings of Leonardo, Dürer and
Titian). Bruegel's realistic observation of the world around him was shared by the new generation
of artists from the North: Jacob de Gheyn II, David Vinckeboons, Roelandt Savery, Abraham
Bloemaert. Savery, who travelled widely and worked as court painter for Rudolf II in Prague
(c. 1605–1610), was commissioned by the emperor to record from life the most remarkable sites
in the Tyrol. The result was the series of drawings large in size and new in scope to which this
imposing view of an Alpine valley belongs. The receding valley is depicted in great detail
(rivers, trees, houses, fields, hedges, cattle), lying between steep mountains with, to the left,
an artist at work drawing, with a gun and sword beside him.

Roelandt Savery (1576–1639):
Mountain Landscape with Artist Sketching, c. 1604–1610.
Pen and brown ink. (515 × 483 mm.)
Cabinet des Dessins, Louvre, Paris.

Curiosity
about
the human figure

Roelandt Savery (1576–1639):
Three Hungarian Foot-Soldiers, c. 1605–1610.
Pen and brown ink with light touches
of watercolour. (194 × 302 mm.)
British Museum, London.

Pieter Bruegel (c. 1525–1569):
A Seated and a Standing Peasant, c. 1559–1563.
Pen and brown ink over black chalk. (170 × 178 mm.)
Kupferstichkabinett, Staatliche Museen, Berlin.

Bruegel's boundless curiosity about the human figure
is evident in all his drawings, whether satirical des-
criptions or peaceful notations of the Flemish people
at work or amusing themselves (peasants, artisans,
waggoners)–all are eyewitness accounts of the life
surrounding him. Jacob de Gheyn's passionate scru-
tiny is so marked that his realism, one of the usual
elements in Northern art, sometimes borders on
distortion, caricature, dream or fantasy. In this sheet
of nine head studies the artist has examined his model
with the most ardent exactness, making him adopt
different positions in the same light coming from the
left. At that date, 1604, such truthfulness in the search
for instantaneity is remarkable. On a different note,
Savery gives an accurate description of the costumes
of Polish or possibly Hungarian foot-soldiers, drawn
during his stay in Prague around 1605–1610.

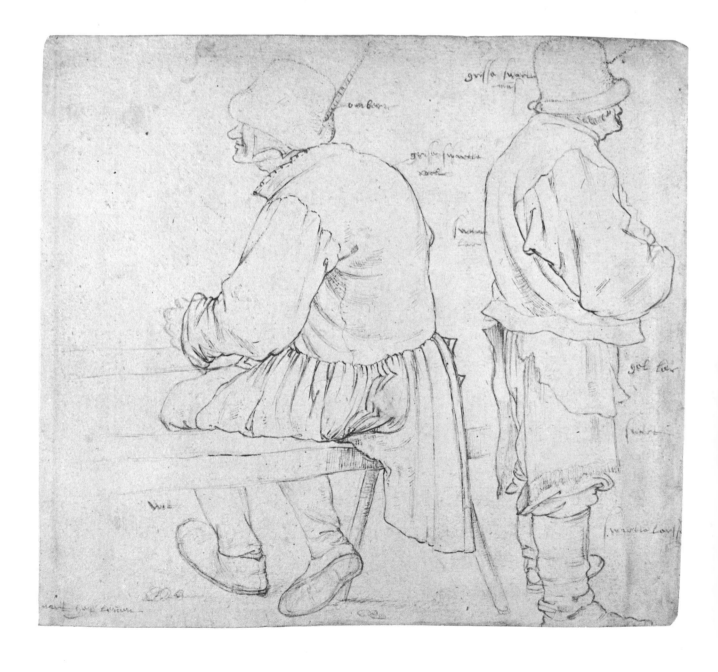

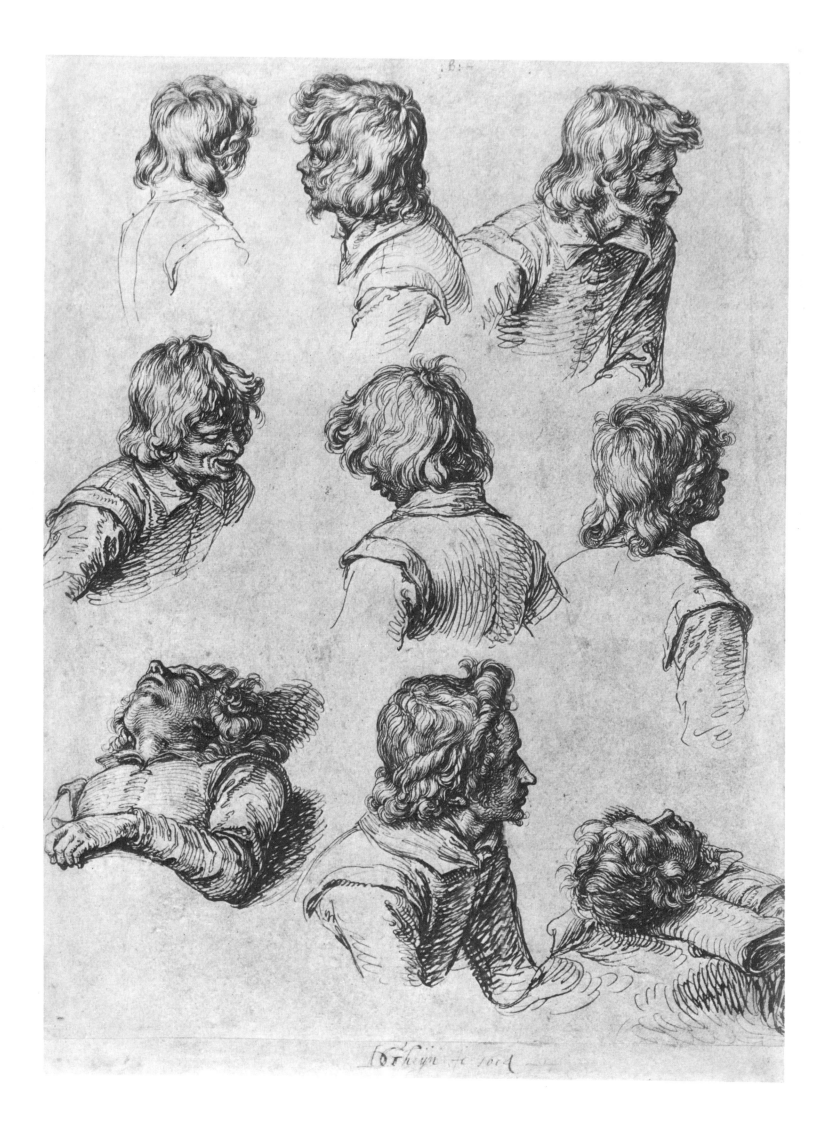

Jacob de Gheyn II (1565–1629):
Study of Nine Heads, 1604.
Pen and brown ink. (362 × 260 mm.)
Kupferstichkabinett, Staatliche Museen, Berlin.

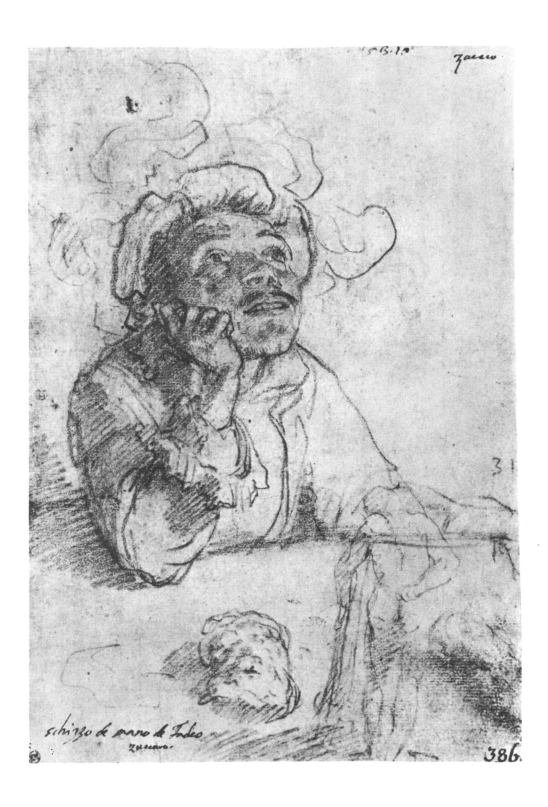

Taddeo Zuccaro (1529–1566):
Man in a Plumed Hat Sitting at a Table.
Black and red chalk. (254 × 171 mm.)
Nationalmuseum, Stockholm.

While Flemish realism sometimes produced scenes of great satirical verve, the realism of certain Italian draughtsmen reflects a definite penchant for the grotesque. Leonardo da Vinci, with his drawings of *Profile Heads*, was the first to open up this path. The starting point was direct observation of an expressive, animated, slightly disproportionate face, as in the case of this drawing by Taddeo Zuccaro, to which is added some strange detail, some distortion of the body or some item of dress. Thus caricature was born, and was developed by Annibale Carracci on the basis of the crudest realism. Often regarded as the inventor of caricature in the modern sense of the word, Annibale Carracci enjoyed drawing the monsters or deformed creatures he met by chance in street or tavern; he used a very free style which contrasted with the preparatory drawings he made for his great decorative compositions. The vivacity and lightness of the forms Guercino set down from life are a striking anticipation of the work of Giambattista Tiepolo and his son Giandomenico. By the beginning of the seventeenth century, Italian influence was having a marked effect on foreign artists, including the Frenchman Jacques Callot. Callot was fascinated by the characters of the Commedia dell'Arte—musicians, clowns, dancers, singers—usually represented in the grotesque guise of hunchbacks, gnomes or dwarfs. A whole line of draughtsmen and engravers in Italy among whom it is sometimes difficult to distinguish were to take up the art of caricature: Gianlorenzo Bernini, Pier Francesco Mola, Cesare Gennari, Pier Leone Ghezzi, Antonio Maria Zanetti. "The attribution of caricatures, with their often purposely child-like technique, is more difficult than any other class of drawings" (Rudolf Wittkower, *The Drawings of the Carracci in the Collection of Her Majesty the Queen at Windsor Castle*, London, 1952).

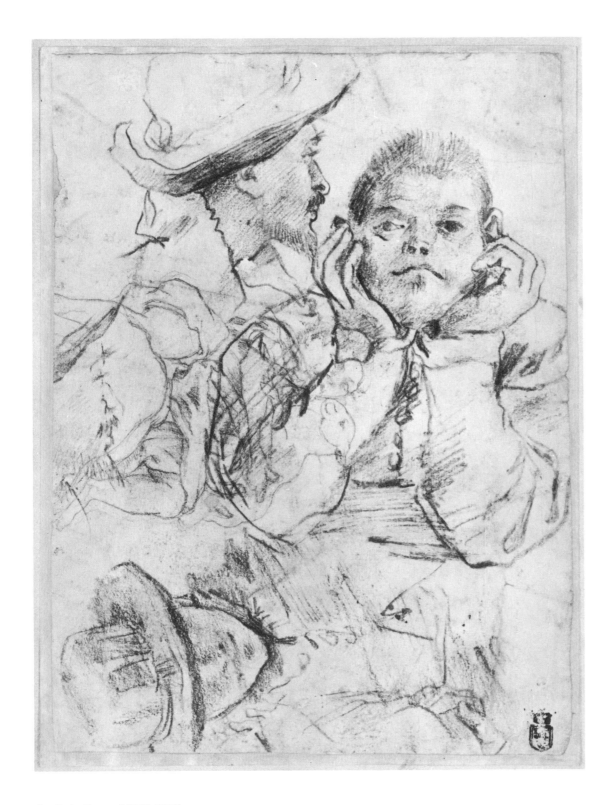

Guercino (1591–1666):
Caricature of a Boy Wearing
a Broad-Brimmed Hat.
Pen and brown ink and brown wash. (163 × 121 mm.)
Art Museum, Princeton University.

Annibale Carracci (1560–1609):
Three Studies of Men.
Black chalk. (278 × 204 mm.)
Private Collection, Paris.

Jacques Callot (1592–1635):
Two Dwarfs with Mandoline and Flute.
Pen and brown ink on yellowish paper. (108 × 144 mm.)
Album Mariette, Louvre, Paris.

Annibale Carracci (1560–1609):
Portrait of a Young Man (Self-Portrait?), c. 1580.
Black chalk heightened with white
on grey-green paper. (380 × 250 mm.)
Royal Library, Windsor Castle.

In the second half of the sixteenth century, the development of a new composition of the art of portraiture coincided with a steady trend towards an ever more direct observation of people and things. In Italy, first in his native Bologna, then in Rome where he settled in 1595, Annibale Carracci was one of the first to draw so many portraits with such telling spontaneity in the simultaneous expression of the features of a face, the gaze of the eyes, the mobility of the head turned straight towards the spectator. What is new in these portrait drawings is their immediacy, the impression of life, presence, movement, and the fact that the faces are generally seen from in front and from very close, as if silently conversing with the artist who is drawing their likeness. In this chalk drawing of a young man, possibly an early self-portrait, observation is concentrated on the tender, searching eyes, the faint smile lurking about the lips, and the partial modelling of the face, seen half in the light and half in the shade.

In the next generation, in Flanders, we encounter a similarly simple and direct approach in the analysis of a face. These drawings, which often have a high degree of finish, are sometimes works in their own right, not preliminary studies for paintings commissioned officially. As well as such drawings, Rubens also did off-the-cuff studies, warm, natural and sunny, of the people around him. He painted at least seven portraits of Susanna Fourment and drew several others, including this one, dating from about 1625, shortly after her marriage to Arnold Lundens, a friend of the artist's. In 1630, at the age of sixteen, her sister Hélène Fourment became Rubens' second wife. Rubens uses a pictorial and illusionist technique when he touches up with red chalk those parts of the face (lips, nostrils, ears and eye-lids) where the skin is thinnest and the blood nearest the surface. Watteau was to imitate this use of the "three crayon" technique.

Peter Paul Rubens (1577–1640):
Portrait of Susanna Fourment,
the Artist's Sister-in-Law, c. 1625.
Black and red chalk heightened with white
chalk and gone over with pen and brush
in brown ink. (344 × 260 mm.)
Albertina, Vienna.

Light in terms of line and space

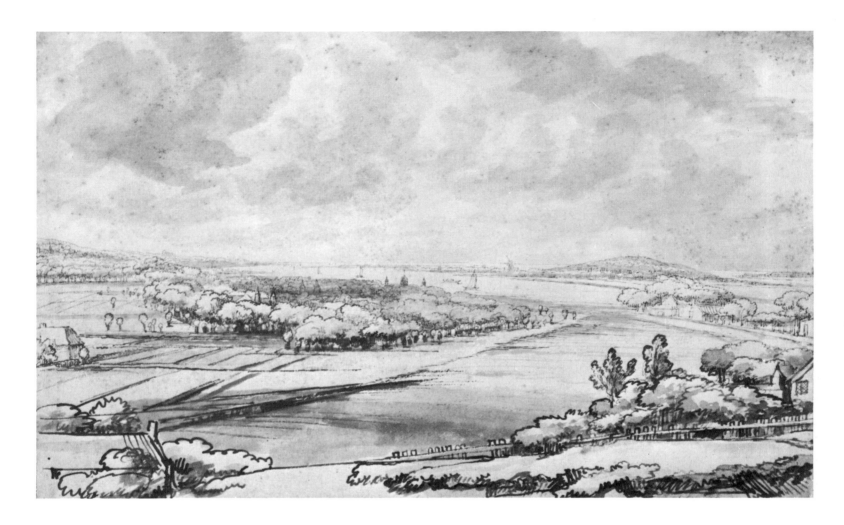

Philips Koninck (1619–1688):
River Landscape, c. 1650–1653.
Pen and Indian ink and brown wash. (194 × 310 mm.)
Fondation Custodia, Institut Néerlandais, Paris.

Jan van Goyen, a lifelong observer of the Dutch countryside and above all of the sea and shore, devoted innumerable small drawings to an attempt to transcribe these scenes in their entirety. With a touch that is staccato without being schematic, he gives a precise rendering of site, vegetation, figures, buildings, boats, and even the gulls wheeling in the sky. An early harbinger of the impressionist movement, he even contrives to suggest the sough of the wind. Rembrandt, on the other hand, was a fervent student of every aspect of the world around him. He draws Holland's level fields and thatched cottages, its rivers and canals; he seems never to have travelled outside his native land. He notes down from life both street scenes and scenes of home life. Even in his most rural landscapes, such as those depicting milkmaids, his method is still magisterially synthetic, great simplifying lines being used to construct the scene without ever lapsing into anecdote or excess of detail, yet remaining true to reality. This sheet of nine studies shows how fascinated Rembrandt was by a telltale attitude or expression, by picturesque details of dress or headgear. The sketches are laid out on the sheet in a perfect *mise en page* of two concentric circles: the circumference is formed by the outer contour lines, while the centre is the old man's hand holding a handkerchief. Like Rembrandt, who influenced him, Philips Koninck represents nature in its familiar aspects, bathed in sunlight, which he conveys by leaving parts of the paper blank in contrast to the darker areas worked over by pen or brush. He too seeks to create an impression of the immensity of space stretching away to the horizon line. These fields bounded by a river were probably observed from the top of a tower; hence the panoramic effect of the composition.

Jan van Goyen (1596–1656):
On the Seashore, 1652.
Black chalk and grey wash
on white paper. (120 × 195 mm.)
Fogg Art Museum, Harvard University,
Cambridge, Massachusetts.

Rembrandt (1606–1669):
Studies of Heads and Figures, c. 1636.
Pen and brown ink and brown wash
over red chalk. (220 × 233 mm.)
Barber Institute of Fine Arts, Birmingham.

167

Jacques Callot (1592–1635): △
Landscape with a Village, c. 1630.
Brush and brown wash over black
chalk. (171 × 337 mm.)
Nationalmuseum, Stockholm.

Claude Lorrain (1600–1682): ▷
Road through a Wood, c. 1640–1645.
Pen and brown ink, brush and dark
brown wash. (312 × 218 mm.)
British Museum, London.

Bartholomeus Breenbergh (c. 1599/1600–1657):
In the Grounds of the Castle of Bomarzo, 1625.
Pen and brown ink, brown and grey wash.
(407 × 280 mm.)
Fondation Custodia, Institut Néerlandais, Paris.

At the beginning of the seventeenth century a new notion entered into and transformed the conception of landscape. The importance of the part played by light, with its effects of contrast and chiaroscuro, directed the analytical study of nature towards a more subjective, a pre-romantic vision. Light, that most changeable of all elements, made possible a rendering of nature that was both accurate and lyrical. There thus reappeared the duality already noticed between precise observation and imaginative interpretation, or a continual oscillation between those two poles. The earliest examples of night pieces and twilight scenes are the work of the German Adam Elsheimer and the Dutchmen Breenbergh and Poelenburgh, followed by Callot, Claude Lorrain and Rembrandt. These three drawings have several features in common: their theme, which is pure landscape, without any anecdote or pretext; their object, which is to convey a sensation of space, shadows and lights; their medium, brush and brown wash; their treatment, in broad areas of flat wash.

Nicolas Poussin (1594–1665):
The Ponte Molle near Rome.
Pen and brown ink, brush and brown
wash over preparatory drawing
in lead point. (187 × 256 mm.)
Albertina, Vienna.

It was in Italy, and chiefly in Rome, that landscape developed and the idea of painting out of doors was established. For several generations Rome was a Mecca for artists from all over Europe, among them the two Frenchmen Claude Lorrain and Nicolas Poussin. The migration of northern artists to Rome had got under way in the early sixteenth century, with Jan van Scorel (1520) and Maerten van Heemskerck (1532), followed by Paul Bril (about 1575). The German Elsheimer went there about 1600, followed in the years 1605–1607 by the Dutchmen Pynas, Lastman and Goudt. Claude Lorrain went to Rome for the first time in 1613, as a mere boy, and finally settled there in 1627, after the Dutchmen Poelenburgh and Breenbergh. Poussin did not go to Italy until 1624, at the same time as the Dutchman Swanevelt, one of the first to introduce figure subjects into his landscape drawings, thus marking the evolution towards a more decorative style, which was to be accentuated with Jan Both and

Jan Asselyn in the next generation. Claude Lorrain's observation of the Roman Campagna is infinitely varied in range, from the simple notation of a site or a detail of a tree or a valley full of grazing cattle, via the transcription of a fleeting impression, say of the setting sun, right through to elaborate drawings reflecting a total investigation of nature. This can be seen in the woodland drawing reproduced here, in which the bark of the trees is modelled by brush and white gouache, a technique reminiscent of Adam Elsheimer's night pieces. Poussin is less concerned with transcribing a detail or impression than with using great alternate planes of light and shade to convey the structure of a landscape and its disposition in space. Poussin usually employs brush and pure brown wash without heightening, exploiting the contrast with the blank areas of the paper as Jacques Callot had already done.

Claude Lorrain (1600–1682):
Clearing in a Wood, c. 1645.
Pen and brown ink and brown, grey
and pink wash heightened with white
on blue paper. (224 × 327 mm.)
British Museum, London.

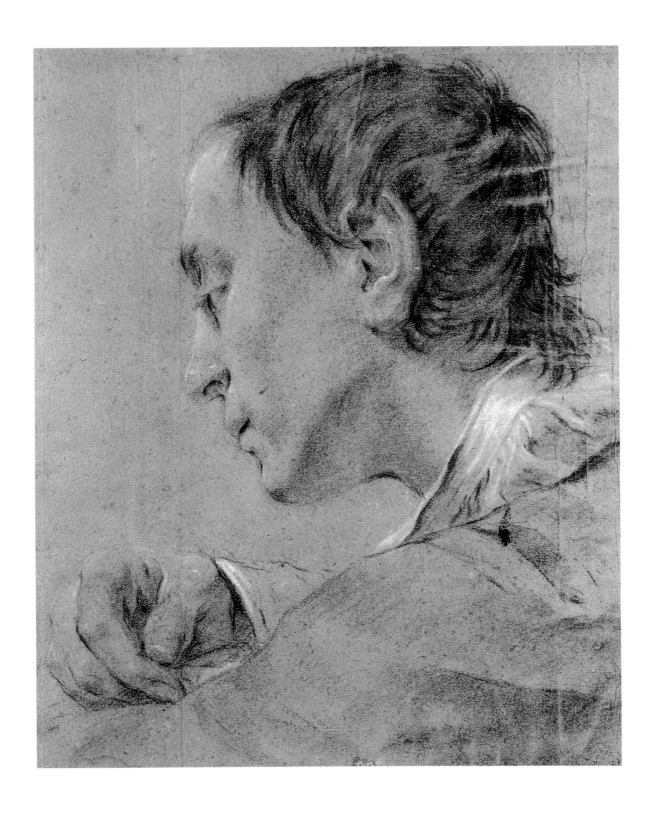

When the Venetian artist Piazzetta drew from the life his various series of young men's heads, life size, he (like his French contemporary Chardin, and perhaps before him) was depicting people who, instead of posing, are engrossed in some activity of their own (reading, drawing or thinking). His aim was to capture something of the intensity of their concentration rather than to portray them as individuals or reproduce their features. He usually shows their faces in full or three-quarter profile, partially illuminated: the effect is that of a play of mirrors between the observing artist and the model who in turn contemplates an invisible world of his own. In his sheets of studies Piazzetta swiftly transcribes the sort of figures, movement or slightly theatrical gesture which draughtsmen of the next generation were to develop in order to reflect the evanescent scenes of Venetian life, with its feasts, masquerades and round of carnivals.

In the two drawings by Pannini and Tiepolo (the first probably done in Rome, the second in Venice), there is the same translation of a momentary, spontaneous gesture, but it is recorded by means of completely different techniques. Pannini, using brush and transparent brown wash, has deftly indicated the area of shadow cast over the upper part of the face, and the graceful outline of the young man standing in broad sunlight, his figure chequered by shadows. Tiepolo, with much more intensity, has made a close-up study of a young woman's head as she holds her left hand to her brow; he uses broad strokes of red chalk to hatch the darker parts of the face and bring out the sharp contrast with the brightly lit hand, heightened with white. This drawing is one of a series of studies in red chalk on blue paper; the attribution of them to Giambattista Tiepolo or his son Giandomenico is in many cases still a matter of controversy.

A momentary gesture or attitude

Giovanni Paolo Pannini (1691/92–1765):
Young Gentleman holding up his Hat
to shade his Eyes from the Sun.
Brush and brown wash over
black chalk. (216 × 106 mm.)
The Metropolitan Museum of Art, New York.

Giovanni Battista Piazzetta (1682–1754):

△ Sheet of Figure Studies, c. 1736–1738.
 Black crayon. (208 × 130 mm.)
 Fondazione Giorgio Cini, Venice.

◁ Portrait of a Young Man, c. 1730.
 Black and white chalk on
 grey-pink paper. (520 × 398 mm.)
 Museo Correr, Venice.

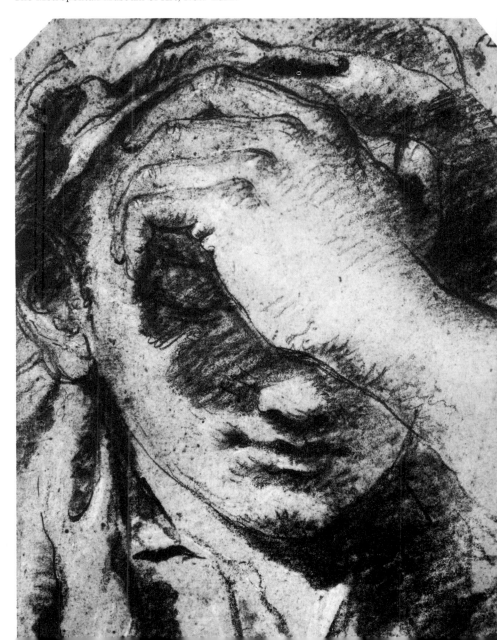

Giambattista Tiepolo (1696–1770):
Head of a Young Woman with
her Hand over her Eyes.
Red chalk heightened with white
on blue paper. (255 × 200 mm.)
Staatliche Kunstsammlungen, Weimar.

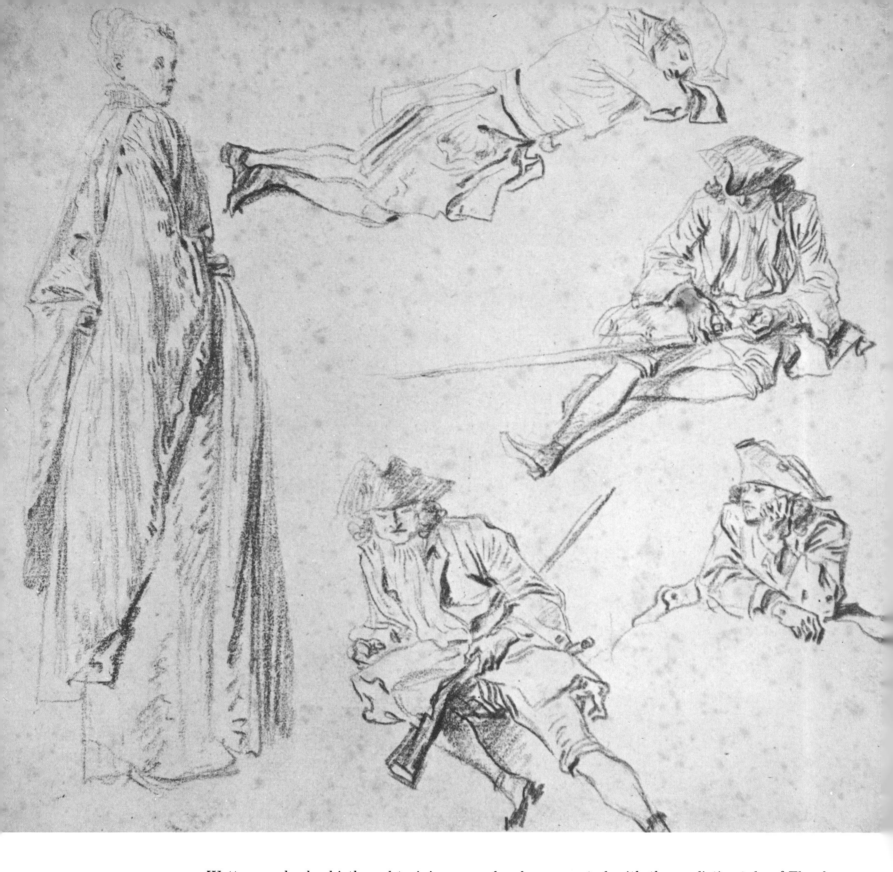

Watteau, who by birth and training was closely connected with the realistic style of Flanders, made many studies from life, starting with his earliest drawings of the wars troubling northern France in the early eighteenth century. In his youth he established what was to become his usual working method by making numerous drawings of soldiers which he would afterwards incorporate in his paintings as needed. From the real life of his day, he brought together a repertory of direct notations of attitudes and moving figures, setting down side by side at random various elements chosen from different people who came to his notice. Later he would go back to these studies, picking out details to transpose on to canvas. He often used the same figure in several different pictures on different themes, painted years apart, because a certain pose or attitude pleased him and fitted in with a particular composition. These drawings of soldiers were taken up and used in the *Recreations of War* and the *Baggage Escort*. Apart from such military scenes, Watteau was almost entirely intent on such subjects as *Fêtes Galantes, Concerts* and *Serenades in a Park*, thus founding a whole new school of French painting; Pater, Lancret, Quillard and Boucher took over the same subjects and drew similar, well-observed figure studies, including many of musicians.

In this sheet of figure studies by Piranesi, the gestures are carried to an extreme of expressiveness and almost distorted in their energy. In addition to the intense impression of life which it conveys, it also puts forward another feeling for space: it appears to be not so much a composition as a telling juxtaposition of three separate studies made directly from life.

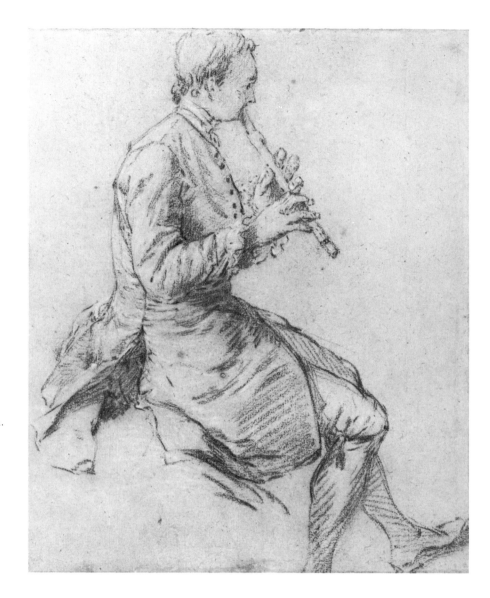

◁ Antoine Watteau (1684–1721):
Sheet with Five Figure Studies:
A Young Woman Standing and Four
Soldiers Resting, c. 1700–1709.
Red chalk. (180 × 198 mm.)
Museum Boymans-van Beuningen, Rotterdam.

Nicolas Lancret (1690–1743): ▷
Seated Man playing a Flute.
Black chalk heightened with white
on grey-maroon paper. (252 × 209 mm.)
Edward Croft-Murray Collection, London.

Giovanni Battista Piranesi (1720–1778):
Sheet with Three Figure Studies.
Pen and brown ink. (173 × 278 mm.)
Ecole des Beaux-Arts, Paris.

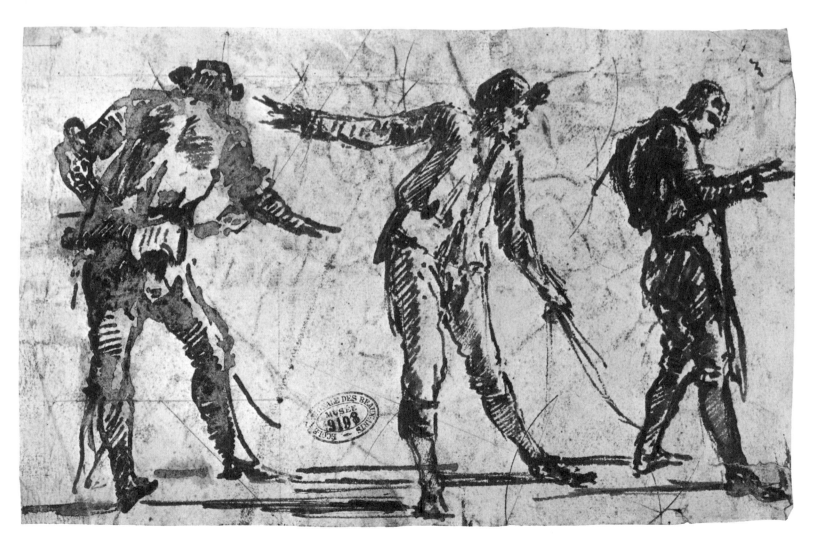

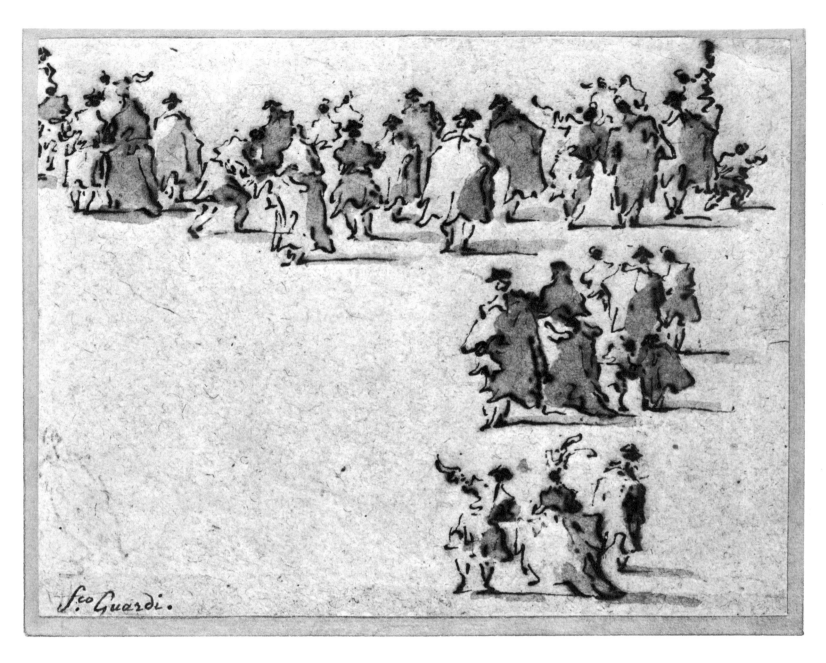

Francesco Guardi (1712–1793):
Sheet with Groups of Figures, c. 1780.
Pen and brown ink and brown wash
on blue paper. (171 × 217 mm.)
The Metropolitan Museum of Art, New York.

◁ Giambattista Tiepolo (1696–1770):
Man in a Cloak, seen from behind.
Red chalk heightened with white
on blue paper. (343 × 200 mm.)
Graphische Sammlung der Staatsgalerie, Stuttgart.

In the second half of the eighteenth century, especially in Venice, the predominating factors were personal interpretation, the free play of fancy and imagination. It was in Italy that the *Capriccio* was born – an invented landscape or townscape made up of partly real, partly imaginary buildings, the figures being indicated with such rapid, glancing touches of the tip of the brush that they were called *macchiette* or little spots. Pietro Longhi, the Tiepolos and above all Francesco Guardi all made highly abbreviated drawings of people walking about in the vibrant light of Venice, their shapes hidden in ample cloaks, stepping lightly through the city squares. Guardi succeeded in transcribing two evanescent impressions at one and the same time: the fleeting appearance of a figure about to pass out of sight, together with the gleaming play of sunlight, suggested by means of a zigzag linework all his own.

Francesco Guardi (1712–1793):
Capriccio: Inner Porch of a Church, c. 1770–1780.
Pen and brown ink, brush and brown wash on white paper.
(195 × 148 mm.) Enlarged reproduction.
Museo Correr, Venice.

Jean-Honoré Fragonard (1732–1806):
The Grand Cascade at Tivoli, from
below the Bridge, 1760–1761.
Red chalk. (488 × 361 mm.)
Musée des Beaux-Arts, Besançon.

Hubert Robert (1733–1808):
Arch of Triumph in Rome, probably
the Arch of Gallienus near Santa
Maria Maggiore, c. 1760–1761.
Red chalk. (465 × 630 mm.)
Museum Boymans-van Beuningen, Rotterdam.

In the eighteenth century Italy was still, as it had been for some two centuries, the centre of attraction for foreign artists. Rome was the great showplace of the art of antiquity, and the fascination of its ruins exerted a profound influence on many artists, including the Frenchmen who came to study at the Villa Medici as inmates of the French Academy in Rome. Of the many generations of artists who were trained there, perhaps Charles Natoire, Hubert Robert and Fragonard best express in their drawings some of the most faithfully observed aspects of the Roman Campagna. Hubert Robert has left the most accurate rendering of ancient monuments. Fragonard prefers landscapes to ruins, but often includes the latter, enveloped in waving leafage or overgrown with vegetation. The two artists were friends and worked side by side, especially during the summer of 1760, when thanks to their patron, the Abbé de Saint-Non, they lived at Tivoli in the Villa d'Este. Their styles are sometimes difficult to distinguish when they used red chalk, at that time still an unusual medium for landscape. Apart from a few previous examples in red chalk among the Mannerists, landscape drawings were normally done in media more obviously suited to create the illusion of nature: watercolour, gouache, pen and brown ink, brown wash. But when red chalk was used by Robert and Fragonard, the discrepancy between it and the real colour of the landscape underlined the artificiality of their vision and its deliberate distancing from reality. Their purposeful use of this medium may be seen as one of the first moves away from observed reality towards a reinterpretation of nature through the artifices of technique and imagination.

Mood
and
atmosphere

The renewal of the direct observation of nature, which laid the foundations of modern landscape painting and sowed the seeds of the impressionist movement, began in England towards the end of the eighteenth century. Alexander Cozens rendered the slope of a hill with a few simplifying strokes of pen or brush, creating the distant impression of a range of mountains. Gainsborough gives his landscapes an emotional glow by suggesting the mood of the people in them: this pre-romantic atmosphere was to inspire such artists as Prud'hon, Gros and Delacroix, and even later Corot. Gainsborough used watercolour and gouache in a very painterly manner, with broad fluid strokes already foreshadowing the flickering touch invented by the Impressionists. Constable still kept to soft flat tints within a muted range: his colour had not yet taken on the vigour and intensity of his later watercolours of 1820-1825.

Alexander Cozens (c. 1717–1786):
Landscape with Distant Mountains.
Brush and Indian ink. (157 × 193 mm.)
British Museum, London.

John Constable (1776–1837):
A Bridge, Borrowdale.
Watercolour. (187 × 270 mm.)
Victoria and Albert Museum, London.

Thomas Gainsborough (1727–1788):
Lovers in a Country Lane.
Black chalk and grey wash heightened
with white, gone over with pen and
black ink. (352 × 244 mm.)
Cabinet des Dessins, Louvre, Paris.

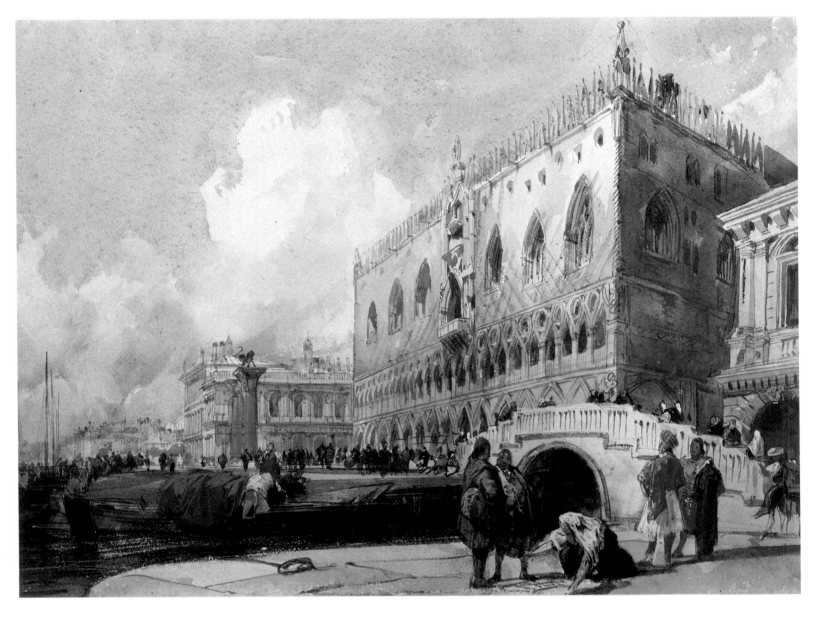

Turner's discovery of Venice was so important for him
that he altered his whole technique in order to adapt
it to the expression of this unique city rising from the
waters. He uses large areas of pure, very diluted
watercolour applied directly to the paper without any
underdrawing, producing the misty evanescence so
characteristic of Venice and, henceforward, of Turner's
own style. During his first visit in 1819 he began to use
the tachist effects which separate distances from one
another and accentuate the impression of motion be-
tween sea and sky. Bonington's vision of Venice
follows a more traditional descriptive pattern. He
gives a precise definition of the city's principal sites,
establishing a model for topographical watercolours
which was to be continued by other English artists
like Callow and Holland, followed during the nine-
teenth century by a long succession of imitators.

This rapidly improvised set of sketches from life of Oriental riders on rearing horses was made soon after Géricault had finished his famous painting of a *Cavalry Officer Charging* (1812). The sketches treat separate battle-scene motifs which foreshadow the *Wounded Cuirassier* (1814), but they should be regarded rather as spontaneous exercises out of which the ideas for this latter picture soon arose. The sinewy line corresponding to the speed with which these notations from life were made is impulsive and romantic, in complete reaction against the classical rules according to which composition and idealization were more important than study from nature and the search for expressiveness. Géricault's fluid tangle of lines perfectly suggesting movement represented an innovation in French drawing, preparing the way for the cursive linework of Daumier and Toulouse-Lautre.

Théodore Géricault (1791–1824):
Sketches of Oriental Horsemen, 1813–1814.
Pencil. (174 × 230 mm.)
The Art Institute of Chicago.

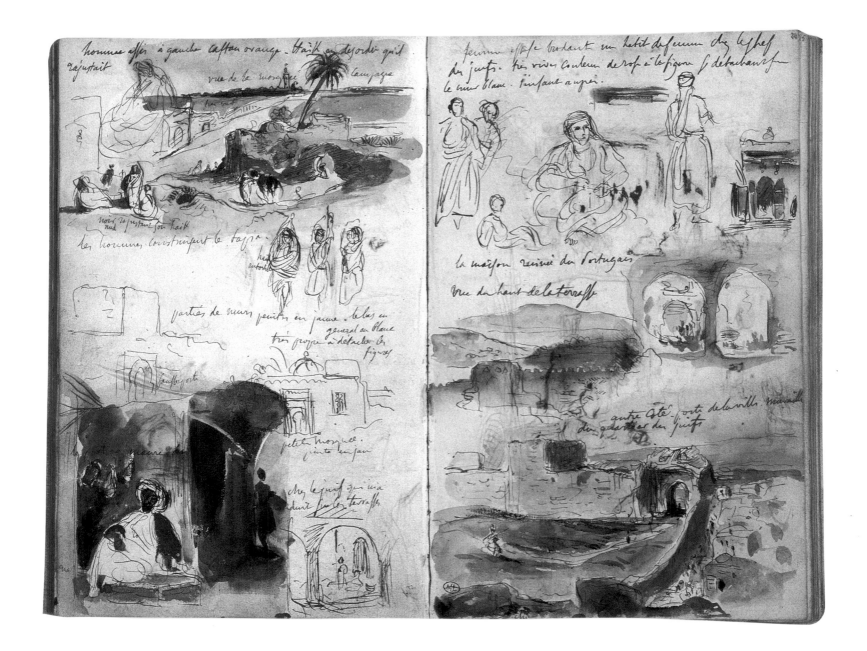

Eugène Delacroix (1798–1863):
Double page from the Notebooks of the
Journey to Morocco: Meknes, 1 April 1832.
Pen and watercolour. (Each page 193 × 127 mm.)
Cabinet des Dessins, Louvre, Paris.

Delacroix's line is equally fluid and mobile, leaving the forms open. When in 1832 he went to Morocco with the diplomatic mission of Count Charles de Mornay, sent by Louis-Philippe to the court of the Sultan Muley Abd Er Rahman, Delacroix used his sketchbooks as a kind of diary. From day to day he notes down dates, places and sights. He sketches the mountain landscapes, the route itself, the abrupt descents, recording his impressions of the light and hygrometric variations in the atmosphere. He conveys the sense of motion he felt, travelling along on horseback. For Delacroix this journey to North Africa was a discovery of colour: the green of a valley or a palm-tree; the blue of distant mountains, of a wadi or a burnous; the orange glint of a cliff, the red of a saddle, a turban, a banner; the yellow of a wall. He sets the colour down in small intermittent touches to punctuate an interior or a costume, in broad flat tints to recreate the landscape. Some pages contain just pencil drawings, with notes on colour to jog the artist's memory when, later in his Paris studio, he will work up the sketches into watercolours or large paintings. Delacroix's originality in the Moroccan sketchbooks resides chiefly in the new brightness given to tones through watercolour, and also in the close relationship between pictures and text, the latter organizing the lay-out of the scenes in a series of registers extending vertically over the page. The alternation of writing and drawing produces an overall image of unusual homogeneity. Ranging from one to three lines, the writing respects the images and at the same time fuses them together. The idea of co-ordinating writing and drawing was to be developed further in France round about 1890, in the work of Gauguin, Emile Bernard and Van Gogh, under the influence of Far Eastern art. It reached its fullest expression in the twentieth century, in Klee, Braque and Picasso.

Camille Corot (1796–1875):
A Wooded Stream at Civita Castellana, 1826–1827.
Pencil. (310 × 420 mm.)
Cabinet des Dessins, Louvre, Paris.

Camille Corot (1796–1875):
Boy lying in a Landscape
overlooking the Sea, probably 1830–1834.
Pen and brown ink over pencil sketch. (241 × 375 mm.)
A.K.M. Boerlage Collection, Baarn, Holland.

After the studied precision of his early drawings of rocks and trees, Corot began to transpose and interpret the scenes of nature which he drew in his maturity, like this landscape with the sea in the distance, where the style is drastically simplified and schematic. The line of the horizon suggests the slow curve of the earth and the immensity of space which invites dreams of distant voyages. The spectator identifies with the introspective mood of the boy lying on the ground, and dreams with him. Corot was even more of an escapist in the large charcoal drawings of his later years, in which nature is felt rather than seen and the gap between observation and imagination stressed. These works foreshadow the next stage, in which Odilon Redon broke the barrier altogether by discarding the notion of reality and substituting representation through symbols.

Théodore Rousseau produces an essentially tactile impression of nature, in contrast to the vision of Corot, which is linear, formal and ethereal rather than precise. Rousseau's mixture of techniques—charcoal, various washes, watercolour—is employed in a highly pictorial way. Hatched lines are superimposed on highlights to produce a texture suggesting earth and vegetation; the web of strokes echoes the lines of the elements portrayed; technique is put to the service of subject. Corot, on the other hand, distances himself from the subject and uses line rather as a vehicle for the imagination. Rousseau employs the colours dictated by his naturalistic rendering, while Corot prefers the monochrome abstraction of a black line on the white sheet. Rousseau, through perspective, gives the spectator the feeling of being inside the landscape; with Corot, the only access is through the imagination. The two artists present an antithesis between a realistic image of nature and one which is ideal and purified of reality.

Théodore Rousseau (1812–1867):
The Chaussée du Roi in Fontainebleau
Forest, 1850.
Charcoal with brown and grey wash
heightened with watercolour. (168 × 335 mm.)
Cabinet des Dessins, Louvre, Paris.

Figures from everyday life

In the 1840s naturalistic representation became more frequent, coinciding with the realist movement in literature. What figure drawings of the period have in common is the frankness and forthrightness of the notation, the desire to achieve exact resemblance to the model, the force of gesture and expression, the violent and contrasted lighting. Predominating themes are concerned with the human figure, shown perhaps for the first time in its daily, working attitudes, through peasants in the drawings of Millet and Pissarro, through workers in those of Courbet, through city-dwellers of various professions in those of Daumier. In the latter's *Two Men*, the contrast between the encroaching shadows and the profiles outlined against the light emphasizes the almost caricatural distortion of the faces; the tumultuous pen-stroke defines form, attitude and expression in the most elliptical possible way. In Millet's double study in close-up of a peasant's

Honoré Daumier (1808–1879):
Two Men in half length, facing left.
Crayon, pen and Indian ink wash. (150 × 190 mm.)
Cabinet des Dessins, Louvre, Paris.

Jean-François Millet (1814–1875): ▷
Two Studies of a Man's Head.
Black crayon. (234 × 183 mm.)
Cabinet des Dessins, Louvre, Paris.

◁ Camille Pissarro (1830–1903):
 Kneeling Peasant Woman, seen from behind, c. 1878.
 Charcoal on cream paper. (620 × 465 mm.)
 Cabinet des Dessins, Louvre, Paris.

◁ Gustave Courbet (1819–1877):
 Self-Portrait with a Pipe, c. 1848.
 Charcoal. (280 × 210 mm.)
 Wadsworth Atheneum,
 Hartford, Connecticut.

head the light, which comes from the left, illuminates
only a part of the face, soberly drawn in black crayon
with a somewhat rough simplicity. In Courbet's *Self-
Portrait*, the darkness of the intensely black charcoal
predominates over the areas which are lit: the face
and the front of the shirt stand out brightly as if to
accentuate the illusion of presence. Pissarro's *Kneeling
Peasant Woman* uses charcoal and an assured stroke to
give strong definition to the contours of the figure. At
this point Pissarro almost merges with the realists, and
in so doing brings out the basic principles of the Impres-
sionists, among whom he was one of the most active.
Such solidity and sculptural density was never seen
again in impressionist drawings; their mode of transcrib-
ing reality was lighter, more concerned with surface
effects, transparency and reflection.

Jean-François Millet (1814–1875):
Twilight, 1858–1859.
Black crayon and pastel
on yellowish paper. (510 × 390 mm.)
Museum of Fine Arts, Boston.

Vincent van Gogh (1853–1890):
View of La Crau from Montmajour. Arles, May 1888.
Pen and Indian ink, reed pen,
black crayon. (490 × 620 mm.)
Rijksmuseum Vincent van Gogh, Amsterdam.

In his highly finished and carefully composed drawings, Millet moves away from the naturalistic style of his studies of details. With *Twilight*, he suggests the distance that separates the real, everyday scene of peasant life (the flocks returning home at evening) from the scene as evoked in the drawing, with its superadded aura of awe and mystery. Light has become the main subject of the composition: a tenuous, wavering light, suggested by tremulous mobility of the inter-mingled lines marking the leisurely pace of the ghostly shapes moving through the evening shadows. Black crayon strokes alternate with pastel: Millet invents a new textural effect by so closely interweaving one stroke with another, at the same time destroying the frontiers between black and colour. This research into texture was taken up by Seurat, who introduced a further element by drawing on very grainy paper, thus enhancing the notion of interwoven lines and the interplay of light.

Van Gogh, using a different technique whereby he went over the black crayon lines with pen and ink, also introduced a new range of drawing textures. He had long admired and studied Millet's rural subjects, as is shown by a letter of 20 August 1879 in which he asks his brother Theo to lend him some reproductions of Millet's *Labours in the Fields*. When representing some cultivated fields stretching into the distance, Van Gogh differentiates each area of crops by a set of appropriately distinctive touches: dotted lines, hatchings, short parallel strokes, broken lines. To get the different effects he uses two kinds of pen: the wider is a reed quill, while a finer tip is used to accentuate the quality of the texture. Black and white are handled as if to suggest the values and colours of painting. Van Gogh breaks even more decisively than Millet with the traditional distinction between drawing and colour.

191

Fleeting
images
and
impressions

Edouard Manet (1832–1883):
Rue Mosnier, Paris, c. 1878.
Pencil, brush and Indian ink
on buff paper. (278 × 440 mm.)
The Art Institute of Chicago.

An innovator in his direct, open-air studies from nature, Boudin, even before the Impressionists, exercised his hand and eye in jotting down scenes and passing figures in all their immediacy and freshness. Born at Honfleur, on the Channel coast, he was intent all his life on evoking that maritime atmosphere which answered so well to the new researches into light and space. In his watercolours he aptly conveys the sway of an open boat, the rising tide or a brewing storm. With his off-centre, elliptical compositions, he pointed the way to the innovations of the Impressionists. Manet, in this overhead view of the *Rue Mosnier*, drawn from his studio window, successfully captured a fleeting impression of passers-by in a Paris street. With rapid flicks of the brush dipped in Indian ink, he indicated, rather like Boudin, the moving figures as they enter and leave his field of vision as defined by the sheet of paper; the focus is not unlike that of the camera eye.

Claude Monet (1840–1926):
Belle-Ile-en-Mer, Brittany.
Black crayon. (230 × 310 mm.)
Private Collection, Paris.

Eugène Boudin (1824–1898):
Four Figures in a Boat.
Watercolour over pencil
on light blue paper. (86 × 179 mm.)
Cabinet des Dessins, Louvre, Paris.

The new freedom taken by all the Impressionists in using unfamiliar viewpoints and framing (objects and figures sometimes being cut in half by the edge of the picture) corresponds to a "raw" vision of reality, as afforded by the then recently discovered techniques of photography. The influence of Japanese prints, so passionately studied by the Impressionists, may also account for the sudden taste for off-centre compositions, usually based on diagonal lines (as is the case here with Manet). For all the Impressionists and for Monet in particular, sea and sky were a favourite motif, studied on the spot, day in, day out. This theme more than any other offered them the opportunity of capturing the play of reflected light and the impression of ceaseless movement.

Pierre Bonnard (1867–1947):
Study for "Marie."
Pen and Indian ink. (150 × 110 mm.)
Private Collection, Geneva.

Edgar Degas (1834–1917):

Four Studies of a Dancer, 1876–1880. △
Charcoal heightened with white
on buff paper. (480 × 300 mm.)
Cabinet des Dessins, Louvre, Paris.

Edouard Manet at the Races, c. 1864. ▷
Pencil on buff paper. (324 × 248 mm.)
The Metropolitan Museum of Art, New York.

Henri de Toulouse-Lautrec (1864–1901):
Marcelle Lender, 1893.
Red chalk. (170 × 270 mm.)
Mr and Mrs Paul Mellon Collection,
Upperville, Virginia.

A close observer of scenes of various kinds (the race-course, ballet dancers, milliners, laundresses, women at their toilet), Degas was passionately interested in the dynamic aspect of people, in the habitual gestures of their everyday life. He studies his chosen figures in isolation, noting their pose and outline with the swiftest and most fluid of strokes, as in the portrait of *Edouard Manet at the Races*. He likes to draw one and the same figure from several angles. Thus, for his bronze sculpture of a *Fourteen-year-old Dancer* exhibited in 1881 at the sixth group exhibition of the Impressionists, he made four charcoal studies of her on a single sheet; their juxtaposition here in space suggests the idea of movement, from the fact of the girl's facing in four different directions. Degas invented many ingenious ways of breaking up forms, often with the dual purpose of isolating a detail so as to heighten its impact and multiplying the facets of a figure so as to disclose it more fully.

For Toulouse-Lautrec, "only the figure exists, the landscape is and should be only an accessory." In his subject matter he follows the line laid down by Degas. Like Degas, he is fascinated by the transcription of movement, but he likes movement best at its most exuberant and acrobatic (a natural sublimation for an artist crippled by a riding accident). He concentrated on Paris night life, the theatre, music-hall and cabaret, with their various performers, singers and decors; but he also drew members of the audience, both in front and backstage. Much of his work, like that of Daumier, was illustration and conceived as such. His vast output of drawings, lithographs and posters accounts for the untrammelled ease of his style and the facility of his spirited, dishevelled line. Whatever technique he was using–and he tried most–he lays stress on light effects: the glare of the footlights on the rouged cheeks and make-up of actresses and singers as they go through their turn.

Odilon Redon (1840–1916):
The Enchanted Forest, c. 1875.
Charcoal on buff paper. (600 × 500 mm.)
Musée des Beaux-Arts, Bordeaux.

Georges Seurat (1859–1891):
Landscape with Trees, study for
A Sunday Afternoon on the Island
of La Grande Jatte, 1884–1886.
Conté crayon. (619 × 470 mm.)
The Art Institute of Chicago.

Odilon Redon, who broke through the barrier–if there is one–between observation and imagination, used charcoal for his early landscape drawings, which he liked to call his "blacks," and which link him up with Corot's late work. This he himself analysed in a review of the 1868 Salon (for Redon was also a practised writer): "While Corot deliberately expresses his dream through vague jumbles that seem hidden in half-tones, he immediately places beside it a detail which could not be surer or better observed. This is what proves how much he knows: he founds his dream on a seen reality." Similarly in this landscape or forest scene Redon places side by side a group of trees which seem quite close to reality and the ghostly apparition of two purely imaginary figures. He subtly adjusted the proportions between these two worlds united in one image so that his "blacks" often attained the apogee of the visionary, where observation has become no more than a tiny point of departure.

Seurat here depicts a real landscape: the island of the Grande Jatte in the Seine to the west of Paris, the setting of his most famous painting. But there are no figures to be seen, and the spareness and stylization create a great distance between reality and the artist's transcription of it. In both Redon and Seurat the choice of medium–here black strokes of Conté crayon on a white ground–contributes to this distancing by deliberately excluding the colour of the observed world. In his many drawings Seurat kept exclusively to this technique of soft black crayon applied to coarse-grained white paper which held the crayon particles and made possible an infinite range of greys and blacks, blank areas being left for the most luminous parts of the drawing. The idea of letting the grain of the paper show through the crayon inaugurated researches into texture which were to dominate drawing in the early twentieth century, as for example in the work of Max Ernst.

Paul Cézanne (1839–1906):
Le Pont des Trois Sautets, c. 1906.
Pencil and watercolour on white paper. (406 × 533 mm.)
The Cincinnati Art Museum.

Scrupulous study of nature is a constant in Cézanne, who worked from nature and pursued his quest indefatigably until the end of his life. He tries to transcribe a study which is distanced from reality, to express the inner structure of the spaces he is contemplating. Watercolour technique enabled him, especially in the last ten years of his working life, to arrive at some of his most essential discoveries. In the watercolours of his last period he amplifies the interplay of transparency and reflection arising out of a more fragmented vision of nature, broken down into innumerable facets. His geometrical modulation of certain volumes foreshadows Cubism. He uses colour to express variation of values, thus discovering one of the keys which was to liberate the art of painting. Sometimes details in his landscapes or objects in his still lifes seem to be suspended in space; colour is applied in swift brushstrokes one above the other, making no attempt to follow the previously drawn black outline. Cézanne is more concerned with defining the direction of trees, of a rock, or of a bridge, than with creating the illusion of space, and in this he breaks with the traditional system of linear perspective. Moreover, by dissolving a motif in the space surrounding it he breaks yet another barrier—the one that leads towards abstraction, as formulated by Tatlin, Kandinsky, Malevich and the Constructivists. The two special characteristics of watercolour—lightness and transparency—are to be seen in the variations on the theme of the *Mont Sainte-Victoire*, which he studied from every angle: the motif becomes a pretext for variations so numerous that the subject seems lost in the distance. The structure, conceived of in planes, reflects Cézanne's constant quest for simplification and synthesis. Watercolour leaves more and more to the blank paper, patterning the space with a few touches of pigment in a way that reinforces the impression of amplitude and luminosity. Cézanne's research in the field of watercolour influenced his oil-painting technique, which became lighter and more fluid and also let the white of the canvas show. In this too Cézanne broke with the tradition of "finished" art, the only kind then recognized. He foreshadowed the idea of the unfinished and of tachism, which is linked to the notion of destroying the subject or motif.

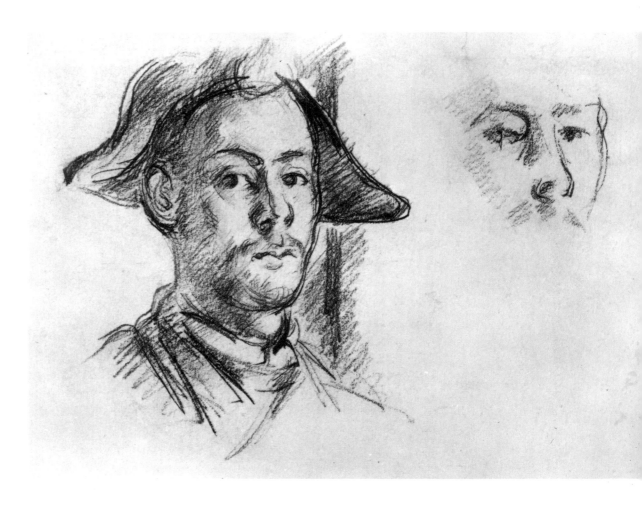

Paul Cézanne (1839–1906):

Head studies for Mardi Gras, c. 1888. ▷
Pencil. (180 × 250 mm.)
Kupferstichkabinett, Kunstmuseum, Basel.

Mont Sainte-Victoire seen
from Les Lauves, 1902–1906.
Pencil and watercolour. (360 × 550 mm.)
The Tate Gallery, London.

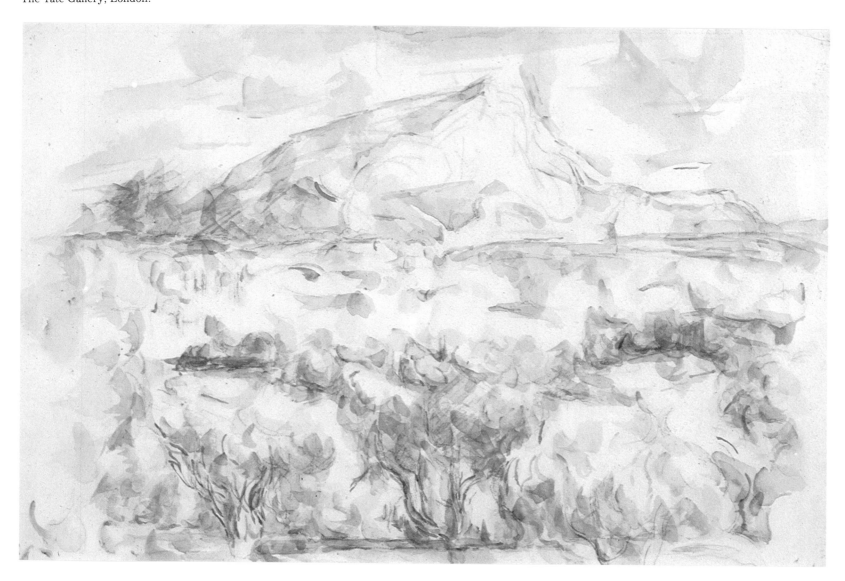

6 A VIEW OF DRAWING TODAY

By the first decade of the twentieth century the role of drawing had become both complex and ambiguous. Cézanne had projected a clear crisis, not simply in the notion of finish but in the whole traditional relationship between painting and drawing. If, as he implied, conception cannot precede execution, since "expressions can never be the *translations* of clear thought"[1] and it is only in the completed work itself that one sees the clear thought, then conception and execution had to be as one; drawing and painting had to become manifestly part of the same work: "Drawing and painting are no longer different factors, as one paints one draws: the more harmony there is in the colors the more precise the drawing becomes..."[2]

Thus, from Cézanne on through the first half of the century, we must trace the role of drawing as it radicalizes itself, even inventing a new form, collage, as it presses into painting, as it incorporates painting modes to itself, as it aspires to function as an equal to painting, as it effects a total rapprochement with painting, and finally as it asserts itself as an independent discipline. From the second part of the century on, we can begin to trace a history of drawing as it begins to once again differentiate the means peculiar to itself as a discipline from those of painting, referring to classical notions of drawing as means for re-investigation, and transforms itself into an independent third major discipline, one distinct from, yet equal to, painting and sculpture.

We must see also that drawing as a discipline thus becomes an integral part of its heritage, joining that heritage as it were to the ongoing concerns of the century; that indeed it plays a core role in the radical innovations which characterize the century, so that by the sixties the new role of drawing is projected as the result of a crisis in the structure of art itself.

The most important structural change in drawing was the introduction of collage into the fine arts by Braque and Picasso in the second decade of the century. A projection from Cubist drawing, it brought to a clear conclusion the break with Renaissance linear perspective and naturalistic illusionism initiated by Cézanne. The most important conceptual change, the projection of line as an autonomous force that led to the invention of abstraction, was proposed by Kandinsky as early as 1910 although it took him several years to reach pure abstraction. Thus one can trace in the early part of the century a kind of story of drawing using several frames of reference as touchstones. The first is that all drawing refers constantly to the new attitudes initiated by Cézanne. Implicit within this first reference is the identification of drawing as it oscillates between two notions that are never rigorously differentiated until quite late and are absolutely identified in the work of Cézanne. One is the notion of drawing as conceptual in that it represents the structural concept of the work (even the idea prior to execution as propounded by the Aristotelians and Mannerists), while it functions on the practical level as the means to rationalize that structure. It is in this sense that we would identify collage as one pole of a dichotomy. On the other hand is the notion of drawing as autographic—indeed biographical—revelation or confession, drawing as the swift envisagement of the artist's first intuitive conception. In this sense drawing is *touch,* the means by which the artist's unique presence was to be recognized. Latent in this is a key concept of early modernism, the presence of the artist's personality made manifest by the very act of making and its concomitant, the idea that finish is subjective, that a work arrives at a finished state as the result of decisions made in the process of working. It is in the notion of line as an abstraction that the two senses of drawing come together. The one identifies line at its very essence as a conceptual abstract; it is non-existent in nature. The other accepts line as a physically generated reality tending toward abstraction as a function of the vitality of the moving hand and its own self-generated energy.

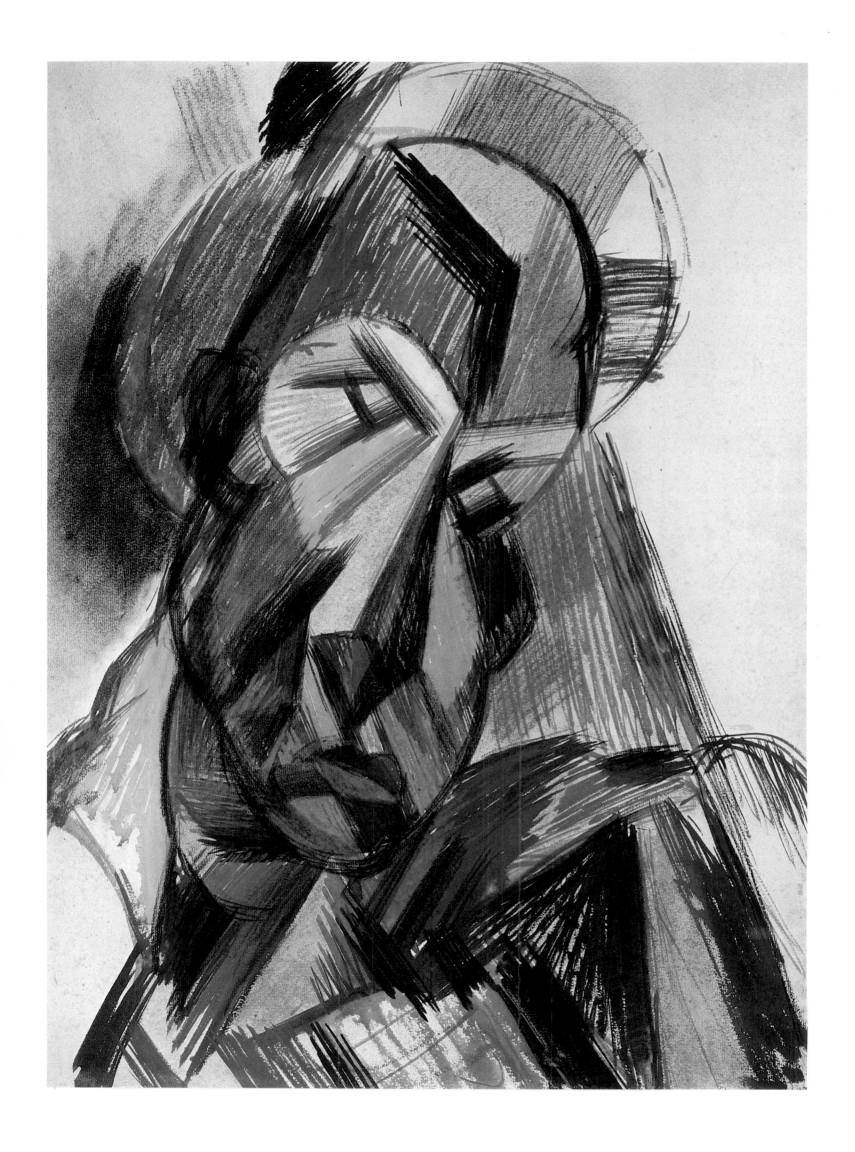

Pablo Picasso (1881–1973):
Head of a Woman, spring 1909.
Black crayon and gouache. (615 × 476 mm.)
The Art Institute of Chicago.

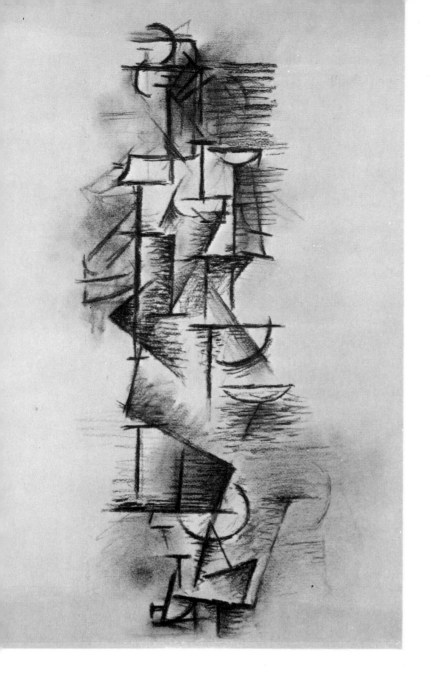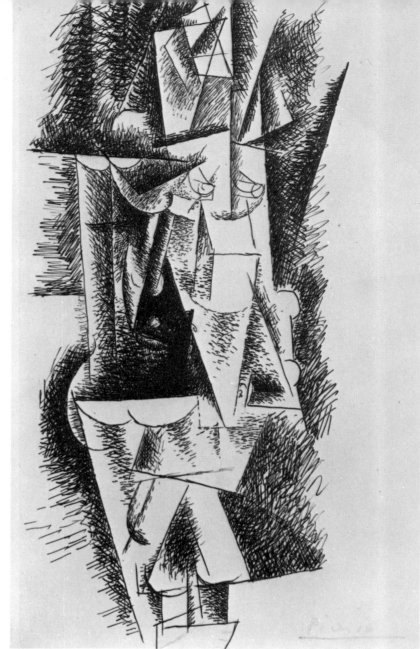

The second referent is to the invention of collage and the development of abstraction which—with their notions of non-illusionistic structure and autonomous line—established new canons, new conventions, so that all drawing had then to refer back to these inventions and be seen as modifications or accommodations of traditional drawing to the newly established canons. Cubism is thus among the first and most important styles of the century in which drawing plays a decisive role.

The two geniuses who dominate the first part of the century, Henri Matisse and Pablo Picasso, were both great masters of drawing. Matisse is the master of the contour line, the line in which gestural expression is reduced to its essence, as opposed to the "impure" line of Kandinsky and the Expressionists in which drawing and painting modes merge to express form which culminates in total abstraction. Picasso would then be the master of conceptual drawing, of drawing as the backbone, the medium for thinking and inventing.

We are here concerned with Picasso's drawing in relation to the developments of the years 1909–1913 when he, with Georges Braque, was involved in the invention of Cubism. In drawing after drawing we can watch Picasso's accommodation of three-dimensional form to the conditions of the two-dimensional picture plane as he made the conditions for the survival of representation progressively more stringent. Picasso worked thematically; he is peculiar in his concentration on one object, confined to the center of the sheet; one form, one object, one figure led to a series of variants, a kind of chain reaction that led into painting, which then extended and continued the process of variability that is the heart of Cubism. Yet Picasso's variations constantly incorporate new ideas about construction, about seeing and knowing form. In Cubism drawing was asserted, not as the means by which a complete clear thought was arrived at or set, prior to the painting, but as part of a process, and was projected finally into the completed work itself in the same manner as a structural armature. The completed work was the culmination of the process, incorporating the final steps itself; it was not a translation from one discipline into another. At the same time it can be seen that many drawings press to function not only as part of the process, but as complete thoughts and separate acts.

A drawing may be described as a structure (or a construction) in which lines and other kinds of marks are arranged in related groupings according to a plan to which the groupings are subordinate, even though the plan may only emerge in the course of the drawing. In traditional drawing

the arrangement of groupings is hierarchical and usually characterized by a broad range of expressive marks variously subordinated to one another as well as to the motif. With Picasso's drawings, we see the beginnings of the use of a simplified range of marks in which the internal relationships of the marks become less hierarchical; they grow more abstract and forms open and broaden in a more equal part to part relationship; they also move art from a centralized composition to cover the support more equally. In this sense Picasso's earliest Cubist drawings are centrifugal, they do not cover the whole sheet; the tendency for Cubist drawing to fade as it approaches the edges of the sheet has to do with the sense of organization as internal and most importantly with forms that are sculpturally conceived within a shallow space just behind the picture plane. These forms, moreover, cannot exist except as conceptual creatures of their creator no matter how tactilely rendered in their shallow space, and therefore they must fade as they move away from the imaginary space that has been hollowed out in the center of the format to accommodate them toward the real edges of the sheet or canvas. This is still the space of naturalism. In this first accommodation to the two-dimensional, the volumes of the individual forms are rendered not as one would see them, but as one might know them by touch. More than one view is given; the form, schematicized, conceptualized, is rendered in facets in order to

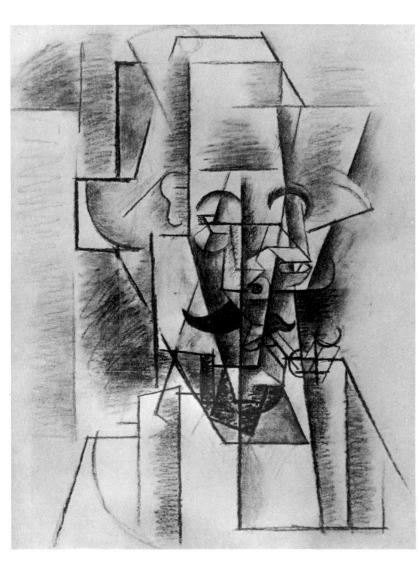

Pablo Picasso (1881–1973):

◁◁ Female Nude, 1910.
 Charcoal. (482 × 310 mm.)
 The Metropolitan Museum of Art, New York.

 ◁ Mademoiselle Léonie, 1911-1912.
 Pen and ink. (318 × 190 mm.)
 Mrs Bertram Smith Collection, New York.

 Man with a Pipe, 1912. ▷
 Charcoal. (625 × 472 mm.)
 Dr and Mrs Israel Rosen Collection, Baltimore.

establish that although the picture plane is flat the object is not. Then as Picasso's drawing opens up and grows more abstract through 1911–1912, it moves closer to the picture plane and relates more to the edges. The internal organization of these drawings is highly peculiar: line both describes and breaks away from form; there are lines that are purely conceptual so that, on the one hand, the line is dissecting and reconstituting form and, on the other, is constituting itself as a separate armature into which individual forms are inserted. I have noted that the forms do not exist and this is precisely because of this ambiguous description, the constant elision and passage of plane passing into plane that, in the early drawings like the Chicago *Head,* is so tactile and sculptural and gives way in high Analytic Cubism to forms in which contour breaks open, letting space flow in and around each plane as the line both constructs and dissolves form in a constant optical transference between object and space. These drawings in pen and ink are projected as an art of reflections, of mirrors and layers. The aim is an accommodation of the three-dimensional object to the two-dimensional picture plane. By stripping down the layers of reality and making the forms transparent to everything but the picture plane, they became the creatures of their own illusion—non-existent creatures of an ideal, private hermetic world. For this reason also, they are not seen in color.

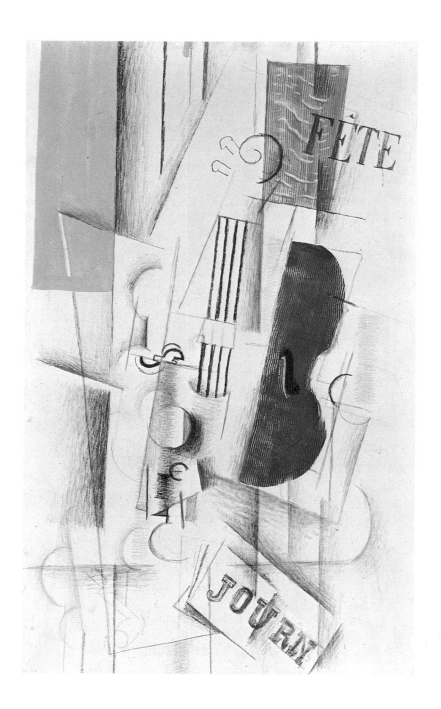

Pablo Picasso (1881–1973):
Violin, 1913.
Pasted paper. (660 × 508 mm.)
Philadelphia Museum of Art.

As the form had opened, the space that had been established originally as a kind of shallow box behind the surface plane grew even shallower. As Clement Greenberg points out, the depiction of the object as a series of small faceted planes had the effect of tautening the surface; the illusionistic dappling of light as it modulated volumes did nothing to dispel the insistent two-dimensionality of the tactile surface; and the drawing constantly reinforced the tautness of the plane.[3] By 1911–1912, it became impossible to insist on the shallow illusionistic space. Here Picasso is dealing with fundamental perceptual problems, problems which are extensions of Cézanne's critical probings of his own art. Despite the shallower space and more linear surface construction, Analytic Cubism retained vestiges of conventional space; to have simply done away with the modulated rendering would have been to create a decorative armature. Picasso turned to construction in three dimensions in his attempt to create a new pictorial synthesis. Actual planar dissection and construction of a cardboard guitar in three dimensions became Picasso's catalyst to resynthesize the fractured forms that had been moving toward abstraction. The physical displacement between the pasted pieces of paper in collage created an optical displacement, the first spatial displacement not dependent on realist illusionism. As Pierre Daix notes, "The difference between the collage materials creates the same discontinuity as that which exists between the different planes in real space."[4] Braque had been the first to introduce collage to the surface of a painting; it was also Braque who in 1910 had stenciled trompe-l'œil lettering onto the surface of the painting. Both were attempts to establish the real surface plane without ambiguity but, more importantly, to establish that a painting is "not a replica, nor a symbol of reality, but possesses a life of its own, oscillating in a precarious equilibrium between the two extremes of illusion and of symbol."[5] Clement Greenberg called it "the pasted paper revolution," and as Daix notes, "The use of collage instituted an investigation into the means of painting itself without precedent in the history of painting."

Now Picasso adopted and extended Braque's devices, asserting the "objectness" of the picture. Documentary photographs of Picasso's studio in 1912 show how, by inserting the pasted paper into the armature of the drawings, he used the drawings as a "springboard" to collage. As both Daix and Greenberg observe, the pasting of newspaper and paper and the letters on the paper itself, like Braque's trompe-l'œil letters, asserted the frontal plane; the scaffolding held the composition together creating an architectonic arrangement of planes and volumes, and integrated the foreground and background, while the forms drawn in on top pushed the pasted forms back into space. The effect is of a constant optical shifting as all the elements of the composition change places constantly with respect to the picture plane, asserting the picture always as an object, always as absolutely frontal. Collage thus stands at the crux between two formal conceptions. The first was an abstraction of forms, the second was the embodiment of a formal concept: the form is a synthetic invention. The first moves away from nature; the second "constructs as nature constructs." From this point, Picasso went on to an ever-enlarging repertoire of collage uses, expanding into full-fledged compositions very like painting, into painting itself, into paintings imitating collages. As Meyer Schapiro notes, Picasso had sacrificed a natural talent for draftsmanship to the discipline of the Cubist investigation. In the years that followed he again returned to practice that astonishing skill: "The Cubist works inaugurate a new era of painting in which representation in its age-old sense is submerged in an art of autonomous construction with discontinuous lines and flecks and a complexity inherent in the most advanced naturalistic compositions. Yet far from holding to his basic invention, he moves freely afterward between a constructed, sometimes grotesque figuration on the one side and an imagery with classic forms and allusions on the other, in frequent oscillation."[6]

Georges Braque (1882–1963):
Violin, 1913.
Pasted paper. (920 × 600 mm.)
Philadelphia Museum of Art.

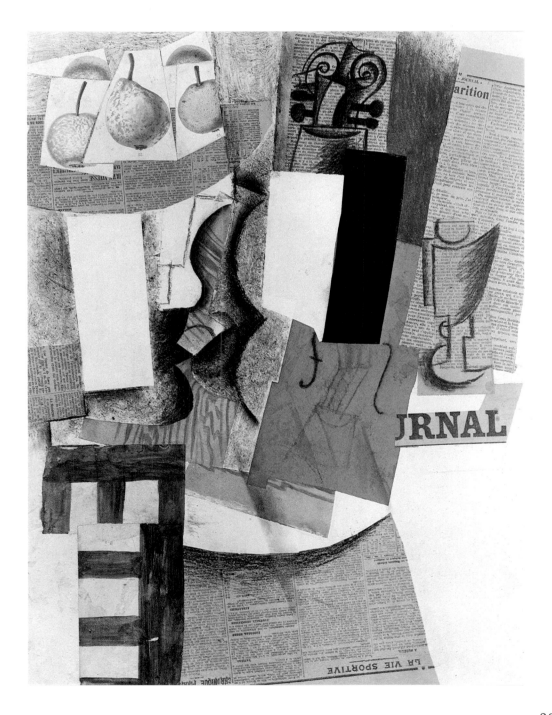

Henri Matisse (1869–1954):
Nude in a Folding Chair, c. 1906.
Brush and ink on paper. (657 × 467 mm.)
The Art Institute of Chicago.

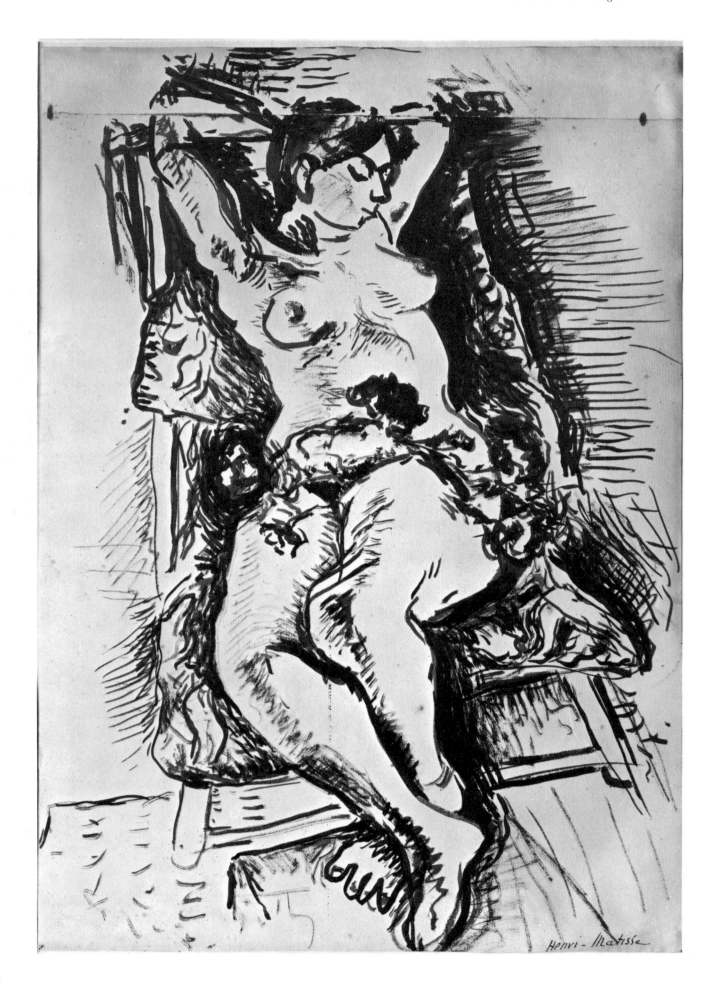

Henri Matisse consistently practiced drawing as a means of expression distinct from his painting. Nevertheless the relationship of drawing to painting in his work is complex and bears directly on his conception of space. Contour is the overriding issue to Matisse, it controls both his drawing and his painting. The link, however, between contour drawing and representation is hard to break and despite a desire to break with traditional illusionism Matisse was unwilling to give up the human form. For Matisse there was "an inherent truth which must be disengaged from the outward appearance of the object to be represented." Contour drawing, simplified and intensified, became the primary means for this disengagement enabling him to break with traditional pictorial illusionism even before Picasso and in a manner at least equally as radical.

His new radical space is first realized in 1909 in a large painting, *The Dance,* a wholly new spatial concept in which contour drawing, tied firmly to the four edges of the support, so effec-

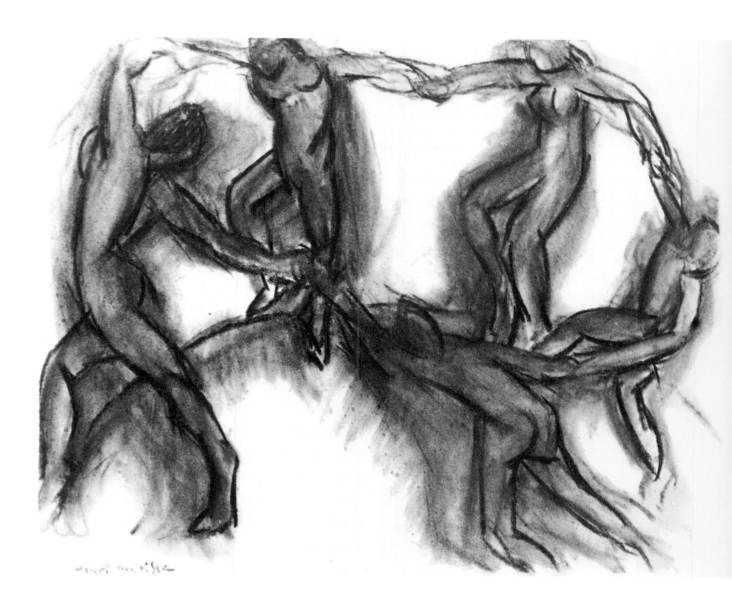

Henri Matisse (1869–1954):
Study for The Dance, c. 1910.
Charcoal on Ingres paper mounted
on cardboard. (480 × 650 mm.)
Musée de Peinture et Sculpture, Grenoble.

tively adjusts volume to surface that in conjunction with non-atmospheric color it excludes any inference of shallow illusionistic space and constitutes a complete break with convention.

It also signifies the kind of formal preoccupation that would stay with Matisse throughout his career: a synthetic unity of form, especially the human female form, and the accommodation of holistic, volumetric form to the flat surface of the picture plane through drawing. This attitude toward edge–the pushing and fitting, adjusting of form and line to the limit of the sheet–is in direct contrast to Picasso's discrete early Cubist drawings with their careful margins.

Matisse, then, can also be seen as addressing himself to the tradition of draftsmanship, which he set out to modify and transform quite as much as he wished to modify and transform painting. Like Picasso, Matisse is an artist whose career encompasses the most radical inventions in the means of drawing itself. While less an inventor of technique, Matisse reinfuses old techniques with new poetry by forcing them beyond convention. As painting came more and more to mean

color, black and white drawing became a refuge, a means of refreshing the eye. Nevertheless Matisse's ambition in drawing was to invest black and white contour drawing with all the nuance of color.

Writing in 1939 he said, "My line drawing is the purest and most direct translation of my emotion. The simplification of the medium allows that. At the same time, these drawings are more complete than they may appear to some people who confuse them with a sketch. They generate light; seen on a dull day or in indirect light they contain, in addition to the quality and sensitivity of line, light and value differences which quite clearly correspond to color."[7]

His drawings exist in a luminous self-sufficient space, a space which is the "generalized equivalent" of the ambiguous, intangible and other-worldly space of his painting. In suggesting that, "As regards perspective: my final line drawings always have their own luminous space and the objects of which they are composed are on different planes; thus, in perspective, *but in a perspective*

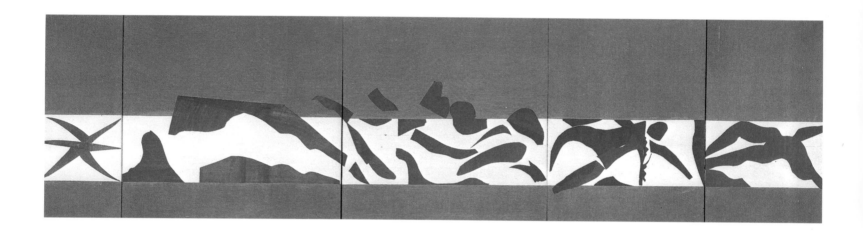

of feeling, in suggested perspective,"[8] we have his essential attitude and an exact description of his radical space and of the nature of his break with Renaissance linear perspective. Yet if his pen and ink line drawings of the 1930s represented a kind of essential finished drawing to Matisse, a summing up, many of his "sketches," works on the way to other works, are more than sufficient drawings to us. Matisse's drawings also tell us of his fascination with his model: a rare Cubist drawing, a large portrait of the violinist Eva Moducci, bears traces of the artist's process even as he moves toward abstraction.

Matisse could become very ambitious with his drawing, and late in 1942 or 1943 he seems to have left as a self-sufficient drawing a charcoal on canvas, *Nymph and Faun with Pipes,* which might have been originally conceived as the preparation for a painting (although there is some evidence to suggest that he may indeed have conceived of it as finished). The first version (preserved in a photograph sent to Etta Cone) in 1935 was reworked into this more monumental and decorative composition,[9] whose drawing is very daring in its form. Sensual erasures and soft smudging of charcoal suggest a hint of atmosphere. Severely though lyrically condensed forms push beyond the boundaries of the canvas to establish the volumes with absolute frontality and the plane as a fact confirmed by its very limitations. This drawing adumbrates the scale of the later *papiers collés,* and, indeed, in several of those, most notably *Acrobats,* the cut-paper drawing is supported by drawing on the canvas in charcoal with erasures. The use of erasures and stump for drawing is one of Matisse's more original and beautiful adaptations of classical vocabulary.

The *papiers découpés* are the culmination of Matisse's life-work. They demonstrate the relation-

ship between line and color, and contour and surface in his work. They are an ultimate confrontation and unification of color and drawing within the conventions of abstraction in twentieth-century art. They are drawing, painting, and sculpting with color. literally constructions in color and contour. "I have now turned toward more mat, more immediate textures, and this leads me to seek out a new medium of expression. The paper cut-out enables me to draw in color. For me this represents a simplification. Instead of drawing the contour and installing the color within it—each modifying the other—I draw directly in color, which is all the more measured since it is not transposed. This simplification guarantees precision in the uniting of the two mediums, which now make one... Cutting into the raw color reminds me of the direct carving of sculptors."[10]

For Matisse the use of collage is distinct from that of Picasso. Taken up in Matisse's maturity, collage now transformed in the sense of cut paper to an organic means, became a question of a new way to discipline material, a new way to link contour and surface in an already coherent and mature style.

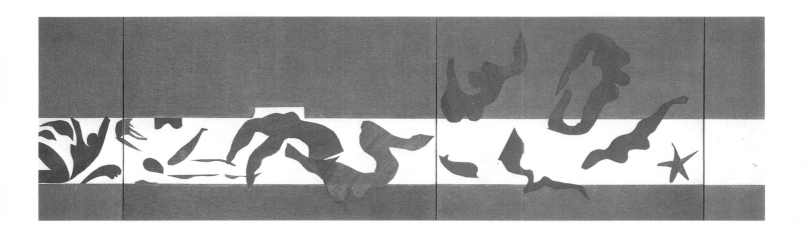

Henri Matisse (1869–1954):
The Swimming Pool, 1952.
Nine-panel mural in two parts.
Gouache on cut-and-pasted paper mounted
on burlap. (2.30 × 8.46 m. and 2.30 × 7.95 m.)
Collection, The Museum of Modern Art, New York.

Papier découpé also made possible a union of the decorative and the expressive that was the fundamental formal theme of Matisse's art throughout his career. Its culmination is the great decoration created for his own dining room, the *Swimming Pool*. It is a summation of the formal and iconographic theme of his entire artistic career and one of the most radical statements in all of modernism. By far the largest of his *papiers découpés*, it is proposed as a discontinuous decorative band around the room. It is the culmination of Matisse's notion of the human figure in motion, and of form brought to life by the action of scissors activating contour. Matisse noted, "The paper as a material remains to be disciplined, to be given life, to be augmented. For me it's a need for knowledge. Scissors can acquire more feeling for line than pencil or charcoal."[11]

The *Swimming Pool* represents a summation of the possibilities of formal and optical metamorphoses between figure-ground relationships, between the notions of solid and void, natural and abstract, as it accommodates the holistic figure to the picture plane and absorbs it totally to the flat yet limitless space. The work is projected as surrounding the spectator; Matisse's illusion of other-worldly space now wholly encompasses the world, and the spectator is drawn into the "constructed" synthetic world of the work.

In Matisse's end we see his beginning, how his drawing so firmly tied to the conception of contour and a simplicity derived from naturalistic sources, was the premise of his exploration of space. We see that color became the embodiment of light in the rendering of a luminous space in which the notion of linear perspective no longer prevails but is replaced by a world constructed wholly by the force of the artist's hand manipulating volumes and contours.

By 1914 the entire Paris milieu was affected by Picasso's innovations in Cubism and Matisse's experiments with color and line. The ramifications of Cubism spread quickly, producing Futurism in Italy, Constructivism in Russia, and non-objective painting in Holland. These styles are among the last in which the traditional relationship of drawing to painting obtains; as might be expected the sculptor's drawings like those of Modigliani and Brancusi retain their traditional relationship to the object; their contour style and monumentality is clearly within the orbit of Matisse's simplifications of form. But the basic reorganization of form had been done, and as Picasso himself

Amedeo Modigliani (1884–1920):
Anadiomena, c. 1915.
Pencil and yellow crayon
on white wove paper. (339 × 265 mm.)
The Art Museum, Princeton University,
Princeton, New Jersey.

Fernand Léger (1881–1955): ▷
Head and Hand, c. 1920.
Pencil. (310 × 200 mm.)
Madame Nadia Léger Collection, Paris.

had moved to an accommodation of his more radical innovations with natural space, so too did most of those affected by the Cubist revolution and expressive abstraction accommodate radical inventions with more conventional usages.

For Fernand Léger, the Cubist rationalization of form proved a concept which he could adapt to a personal style more tied to descriptive contour. As his drawings show, he developed a pictorial vocabulary of volumetric cones and cylinders; the geometric forms repeated throughout the canvas and juxtaposed with more angular forms use the concept of heightened contrast, contrast of color, lights and darks, as well as the forms themselves. Léger's most obvious contrast is that of line and color, of contour and volume. It is necessary to distinguish between drawing and drawings in Léger's work. His drawings, when he wished them to be more than notations, are quite accomplished and in later years frequently very beautiful—the linear

construct of his painting style. While he cannot be accounted as a supple, varied draftsman or an inventor of varied or exciting lines, he must be regarded as a major artist in his painting style and a great artist in the graphic tradition in that the structure of his art is based on the projection of contour drawing. Like Roy Lichtenstein, whom he probably influences in this, the tendency of contour drawing in Léger's work is like Matisse's to simplify and to simultaneously amplify volume, while drawing it up to the picture plane. It creates an extremely architectonic style of great brilliance and clarity and is wholly original while remaining within the Cubist canon.

Fernand Léger (1881–1955):
Contrast of Forms, 1913.
Gouache on yellow paper. (448 × 542 mm.)
Rosengart Collection, Lucerne.

Franz Kupka (1871–1957): ▷
Study in Verticals (The Cathedral), 1912.
Pastel on brown paper. (406 × 225 mm.)
The Museum of Modern Art, New York.

213

Piet Mondrian (1872–1944): ▷
Sea and Starry Sky (Pier and Ocean), 1914.
Charcoal and watercolour. (88 × 112 cm.)
The Museum of Modern Art, New York.

◁ Robert Delaunay (1885–1941):
Study for The Eiffel Tower, 1910.
Pen and ink on paper. (632 × 470 mm.)
Musée National d'Art Moderne,
Centre Pompidou, Paris.

It may seem peculiar to characterize Léger's as a draftsman's style but not to so characterize Piet Mondrian's, which is even more linear, especially as Mondrian's line is so wholly abstract that for the first time in the twentieth century it is possible to discuss a network of independent lines. But Mondrian's paintings are constructions. They are not composed by means of draftsmanship, even in the most abstract sense, but are put together out of individual components, some of which are linear. And here a critical distinction occurs: as noted previously, the relationship between contour drawing and representational or descriptive drawing is one that is extremely hard to break. Even though the basis of Mondrian's linear web exists in Picasso's scaffolding, Picasso's scaffolding remains tied, however tangentially at times, to form and to description of space. Mondrian's line has moved away just far enough from description of space to placement, a move Picasso quite consciously resisted, and in doing so has moved definitively away from any relationship to delineation. Mondrian's drawing *Sea and Starry Sky* is a transitional landmark both in his art and in the relationship of line to delineation. It mediates between Impressionism and abstraction, between observation and analysis, as it both records the sensations of flickering lights and moving patterns and reorganizes them conceptually without reference to specific objects.

In Italy the Futurists, Boccioni, Severini, Carrà, produced beautiful drawings as they adapted the Cubist canon to more conventional means. The rhythmic, sometimes violent distortion of form under the stress of centrifugal movement that characterizes Boccioni's striding figure, is an embodiment of the Futurists' attitude toward the tremendous energy of the forces shaping the modern world. The figure is wholly transformed by the force of energy. Like Léger, the Futurists are impressed by machines, but by their energy not their mechanistic form. Severini's drawing of a speeding train makes manifest, as successive multiplications of forms, a sequence of multiple views. Yet the Futurists remain tied to a romantic and Impressionist and Post-Impressionist conception of draftsmanship. Drawing in their work serves a completely traditional role as compositional study.

214

Jean Arp (1887–1966): ▷
Elementary Construction "according
to the Laws of Chance," 1916.
Collage. (405 × 325 mm.)
Kunstmuseum, Basel.

▽ El Lissitzky (1890–1941):
The Ball (Die Kugel), before 1924.
Collage and mixed media on
cardboard. (630 × 630 mm.)
Kunstarchiv, Pelikan-Aktiengesellschaft.

Umberto Boccioni (1882–1916):
Drawing after "The States of Mind:
Those Who Stay," 1912.
Pen and Indian ink. (325 × 425 mm.)
Judith Rothschild Collection.

Carlo Carrà (1881–1966):
The Red Horseman, 1913.
Pen and ink and watercolour. (260 × 362 mm.)
Dr Ricardo Jucker Collection, Milan.

△ Gino Severini (1883–1966):
The Train in the City, 1913.
Charcoal. (498 × 650 mm.)
The Metropolitan Museum of Art, New York.

Umberto Boccioni (1882–1916):
Muscular Dynamism, 1913.
Chalk and charcoal on paper. (863 × 590 mm.)
The Museum of Modern Art, New York.

From 1914 on, following from Theo van Doesburg's and Mondrian's conversion to Geometric Abstraction from symbolist and romantic styles, a strong school of non-objective art developed in the north. Kandinsky himself gradually converted to geometric non-objective art and he and Paul Klee following their brief earlier Expressionistic association actually became colleagues at the Bauhaus in 1920. At the same time non-objective art had become the style of the revolution in Russia. Non-objective painting seems basically a non-graphic style, yet I would like to propose that it has, particularly in Russia, at the root of its clean, geometric edge, the cutting of collage; and its absolute identification of basic form with color is also a collage convention.

Wassily Kandinsky became one of the first artists to practice total abstraction. His move to abstraction came about in relation to his spiritualist notions about the role of art. His idea was that art must go beyond the realm of the purely material and aspire to a spiritual state—it must release man from materialism so that he may seek his ultimate destiny in the spiritual. To him, music was the most spiritual of the arts, the least material and most abstract in that it was not tied to any physical object; "all the arts should aspire to the condition of music: as man had once aspired to the condition of the angels."[12]

Because Kandinsky regarded the material world as illusory and foreign to the spirit, he sought to detach the representation of an object from its material condition. His solution was to separate line from a specifically descriptive function to become the vehicle of search and of aspiration. Color only obliquely, and then only symbolically, referred to objects. It became, according to a theory in which color and sound are "synthetically" united in one sensation, symbolic of the spiritual, each color sounding a characteristic emotive note. Most importantly, line became the symbol of freedom; as color was released from material form, line also freed, released the "pure inner sound" of objects.

Kandinsky spoke and wrote constantly of inner necessity alone as determining the choice of objects and inner freedom as the only ethical criterion. Thus the new spiritual realm was to come from within and find expression in an "organically related" art. "A perfect drawing is one where nothing can be changed without destroying the essential inner life, quite irrespective of whether this drawing contradicts our conception of anatomy, botany, or other sciences. The question is not whether the coincidental outer form is violated but only if its quality depends on the artist's need of certain forms irrespective of reality's pattern."[13] The object was to become the embodiment of its spirit. In the same manner the canvas—or watercolor sheet—itself became the embodiment of a mental space and line a metaphor for the freedom of spirit from the body and its aspiration

Wassily Kandinsky (1866–1944):

Study for Composition VII, 1913.
Watercolour on grey paper. (249 × 352 mm.)
Städtische Galerie im Lenbachhaus, Munich.

◁ Improvisation, 1915.
Watercolour and brush wash. (375 × 480 mm.)
Mrs Bertram Smith Collection, New York.

toward salvation or "Resurrection." To Kandinsky this is a dynamic notion, not a symbolic one, and Kandinsky describes himself as carrying within his head fragmentary visions. The watercolors are these "fragmentary visions," studies for larger compositions. As he repeated his themes he simplified and abstracted, coming closer and closer to the inner feeling. Groups of abstracted motifs were combined for one composition. Kandinsky's sense of the independent functioning of line and color to express free-floating emotion and exaltation propelled him into formal abstraction. Franz Kupka tracing his own, though related route, may in fact have anticipated Kandinsky in the move into abstraction.

From 1909 to 1914 Kandinsky moved steadily from spontaneous abstraction from natural forms to portrayal of their inner character and into total abstraction in the 1920s with the development of a full-blown geometric style and a correspondingly totally generalized neutral space. Kandinsky's space can be described as the beginnings of "mental" space—it is a species of imaginary space that refers, without being specific, to what was once landscape, but has become too generalized to be characterized as landscape. It derives directly from the late landscapes of Cézanne, open and draftsmanly, with color reserved for volume and modulation, line for structure. In Kandinsky's space line becomes the direction of the inner forces moving toward man's ultimate destiny and spiritual reclamation. Graphological and emotionally expressive in his early work, Kandinsky's line gradually cools as the conceptual thrust—the rationalizing impulse—of the century asserts its influence on him. In its initial invention, however, it establishes the intimate graphological line as a major expressive vehicle capable of synthesizing a number of sensations including the auditory, tactile, and kinesthetic.

To the notion of the draftsman painter (inherent in the late work of Cézanne) Kandinsky contributed the idea of the vitalistic line. He spiritualizes the spontaneity and openness that were characterized in Cézanne as unfinished by establishing them as a function of a kind of ultimate "becoming" and an ongoing process of revelation. He contributed to all subsequent graphological styles this notion of the vitalistic line—line as abstract yet organic, a prime metaphor, paralleling the idea of the movement of line with the concept of growth toward the spiritual.

Paul Klee is a paradigm of the graphic artist; the essential qualities of his artistic intelligence are embedded in his drawing as a function of linear and formal inventions. His paintings are graphically conceived. Klee's intention was to present a new naturalism through an interchange.[14] The naturalism was to be the naturalism of the work itself – of natural phenomenon and pure idea, natural in that "art is a likeness of the creation."[15]

"Art does not render the visual, rather it makes visible. A tendency toward the abstract belongs to the essence of linear expression, hence graphic imagery by its very nature is apt to be both pattern-like and fantastic. It is also capable of great precision."[16]

Klee looked for the essential characteristic, the form-giving cause of objects. His tendency was to describe the cause as a "supra-mechanical force," organic but guided by a will to abstraction, a kind of cosmic hand pulling the strings and producing images like the puppet-monster in *Dance You Monster to My Soft Song*. Klee believed in abstraction as the key to the essence of form, but not in total abstraction. He insisted on the dual nature of line, autonomous and yet descriptive: "The elements must produce forms, but without the sacrifice of their own identities. They should preserve themselves."[17]

Paul Klee's art begins with the investigation of line. It leads his fantasy and his fantasy leads him constantly to new invention, new innovations. Line begins with a point, grows from a succession of such points; therefore it equals movement, movement equals growth, and growth and movement are characteristic of all living things. "The genesis, or process, of writing is a very good image of movement." The work of art, too, is experienced primarily as a process of formation, never as a product. (Line creates objects.) The eye following line in space, following the path marked out for it in the work, encounters "optical adventures" prepared for it by the artist, who takes advantage of the inherent kinetic power of the eye. The viewer is to create with the artist – to recreate his process.

Klee spoke of his art as "devotion to small things," of a microcosm that resonates within the macrocosm. His space is conceived of as somewhere just inside the front of the mind; intimately

Marc Chagall (1887):
Man Leaping over City, 1917.
Watercolour on paper. (380 × 390 mm.)
The Art Gallery of Ontario, Toronto.

Paul Klee (1879–1940):
Dance You Monster to my Soft Song!, 1922.
Watercolour and oil transfer drawing
on plaster-grounded gauze mounted on
gouache-painted paper. (449 × 327 mm.)
The Solomon R. Guggenheim Museum, New York.

221

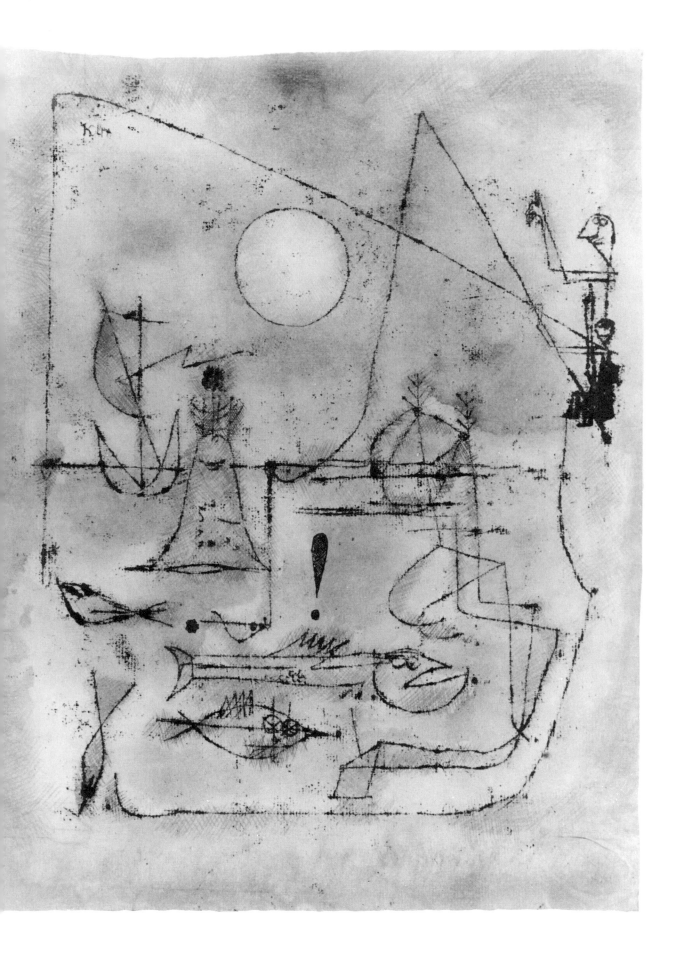

Paul Klee (1879–1940):
They are biting, 1920.
Watercolour on transfer
drawing. (310 × 235 mm.)
Tate Gallery, London.

focussed, yet capable of infinite imaginative expansion, it becomes wholly optical. The color wash that underlies Klee's drawing in the watercolors is conceived as a kind of luminous backscreen with the linear signs arranged in planes in the shallow space in front, or as mounting from top to bottom "pattern-like and fantastic" as though it were some sort of oriental screen; it is ultimately Cubist space. A horizon, when not explicit, is implied, "an imaginary safety belt that has to be believed in." Klee's fantasy, his sense of play, leads him to think "playfully" and organically in terms of techniques as well. Images and atmospheres grow from their materials. Technical innovation is never for the sake of cleverness, although skill is of immense importance to Klee. Although Klee compulsively categorized and classified, the actual interchange of techniques and mediums for drawing, watercolor, and painting is completely organic. *Dance You Monster to My Soft Song* is a technical mix of great complexity, sculptural and painterly, yet basically graphic in its use of drawing transferred by tracing from a preliminary drawing on one sheet through

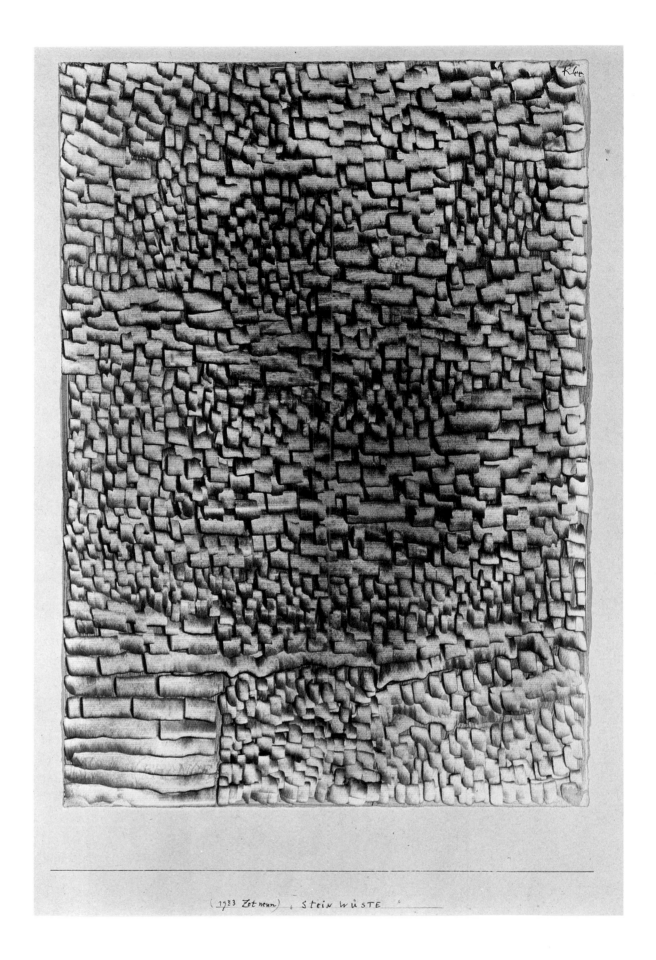

(1933 Zeichnung) STEiN WÜSTE

Paul Klee (1879–1940):
Wilderness of Stones
(Steinwüste), 1933.
Watercolour. (480 × 343 mm.)
Galerie Beyeler, Basel.

another prepared with an oil ground to leave a final image on the gauze. In *Steinwüste* the palette knife materializes the marks that are signs for stones. Here the image cannot have been preconceived but it cannot have been unpremeditated either. It grows from the material as the idea in the artist's mind is realized in the moment of its creation. Klee, although wholly sophisticated in the modern vocabulary, is essentially a solitary, an artist *sui generis*. Walter Benjamin noted this essential characteristic of Klee in writing about Kafka: "Kafka lives in a complementary world. (In this he is closely related to Klee whose work in painting is just as essentially solitary as Kafka's work is in literature.)"[18] This can be especially seen in Klee's very different approach to the drawing sheet: Klee's pasting of the drawing sheet onto the mount like a relief in effect separates it even more strongly from the world. The title, written carefully on the mount, is an integral part of the work, it both generates a parallel poetry and "brackets" the work, setting it further apart from the everyday. It is exactly this, especially as it is expressed

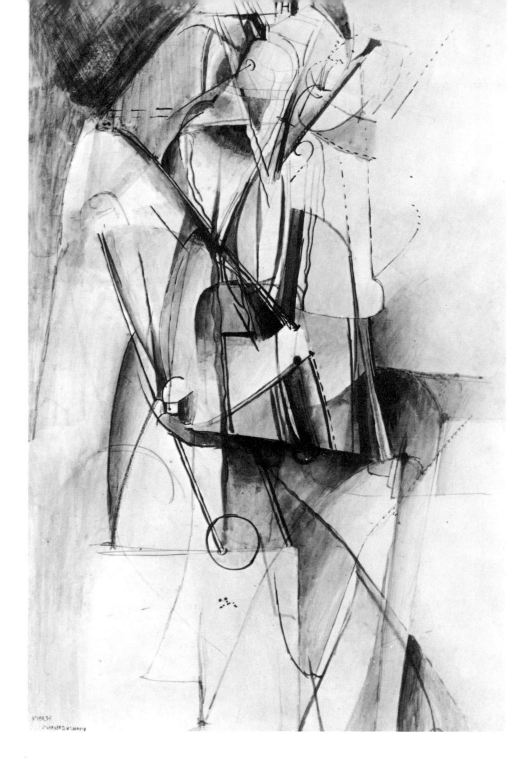

Marcel Duchamp (1887–1968):

Virgin (No. 1), July 1912.
Watercolour and pencil on paper. (336 × 252 mm.)
Philadelphia Museum of Art.

First research for ▷
"The Bride Stripped Bare by her
Bachelors, Even," July-August 1912.
Pencil and grey wash on
stout paper. (240 × 321 mm.)
Musée National d'Art Moderne,
Centre Pompidou, Paris.

in his interpretation of Cubist space, with the strong element of fantasy and semi-mechanical conception of form, perhaps somewhat Dada, that was admired by the Surrealist artists. Dada and Surrealism were principally ideological movements that dealt in philosophical, political, and poetic terms. For Dada and initially for Surrealism, the visual arts were considered subordinate. They had failed, through an excess of aestheticism and rationalism, to correspond to life. As early as 1912, Marcel Duchamp had announced that he wished to put painting "once again at the service of the mind." And in 1913, called the whole traditional art into question by selecting a bicycle wheel as a non-aesthetic work of art in an attempt to eradicate the distinctions between art and life. Duchamp whose early work forms a bridge between Cubism and Dada via Futurism affirmed the necessity of art, but came more and more to suspect that it was only possible outside of conventional art. He was convinced that art must derive from knowledge of the physical world; but that the individual work of art was to be a new reality in itself, not an imitation of reality; it was to be a *cervellite* (brain fact), not a "retinal" experience.

Duchamp began to look to visual structures outside of art, to non-aesthetic methods of rendering such as those of drafting and engineering diagrams, and to mechanisms and objects, until gradually he transcended art, actually renouncing painting as a profession. With his *Bicycle Wheel,* the transition from representation of objective reality to representation of objects to the object itself was completed. Art was transcended as handwork, it was conception in the form of selection or divination, not execution, which determined the work of art, putting art beyond aesthetic considerations, calling even the concept of originality into question, and initiating a crisis in modern art about objects and art versus art or non-art. Duchamp's rejection of "retinal" sensations as the basis for art and his projection of art into an intellectual "end game" became a basis later for conceptual art – an art projected on the basis of verbal diagrams, puns, philosophical speculations, time charts and systems.

If art was the indicator of the unknown for Duchamp, so too was science. The scientific principles of flux and disorder were later taken up by the Surrealists as confirmation of their own position; objective chance was the geometric locus of coincidences, the expression of hidden order. The use of simultaneity and Duchamp's obsession with actual movement is an expression of his belief in human experience as constantly subject to transmutation. In 1912, Duchamp, who was the first to apply these principles to art, had begun sketches for a work *(The Bride Stripped Bare By Her Bachelors, Even. The Large Glass)* based on a parallel metaphysical world proposed as a pseudoscientific system. These sketches, of which *La Mariée* is the first study for the work, expanded into the hundreds with notes and diagrams and photographs; they were later collected in "The Green Box." This was intended as a kind of Sears, Roebuck catalog or as Duchamp explained an "album to go with the 'Glass,' because as I see it, it must not be 'looked' at in the aesthetic sense of the word. One must consult the book and see the two together. The conjunction of the two things entirely removes the retinal aspect I don't like."[19]

In the course of the years, Duchamp's diagrams and drawings became the continuous record of an alternate life lived with an alter ego, Rose Sélavy. Duchamp continued to issue "bulletins" from his life, in the form of objects, books, collections of notes and diagrams, explorations into gambling, optics, chess and even an alternative language system with its own grammar. But more than a record, the ongoing speculation and recording on paper was the structuring of an interconnected life fabric, the first proposal for which is *La Mariée* and its manual *The Green Box*. In this Duchamp has in some way got "beyond" Leonardo. The artist's sketchbook as a record of random life notes has been systematized and put to use.

Actual construction of *The Bride Stripped Bare by Her Bachelors, Even (The Large Glass)* began in 1915 and was left definitively "incompleted" in 1923, leaving open the possibility of infinite metamorphoses. The *Large Glass* was made by collage technique using lead-foil, wire, and oil paint between two panes of glass.

In it Duchamp proposed that a two-dimensional representation is the projection (or shadow) of a three-dimensional object. Therefore, a three-dimensional form must be the perspective

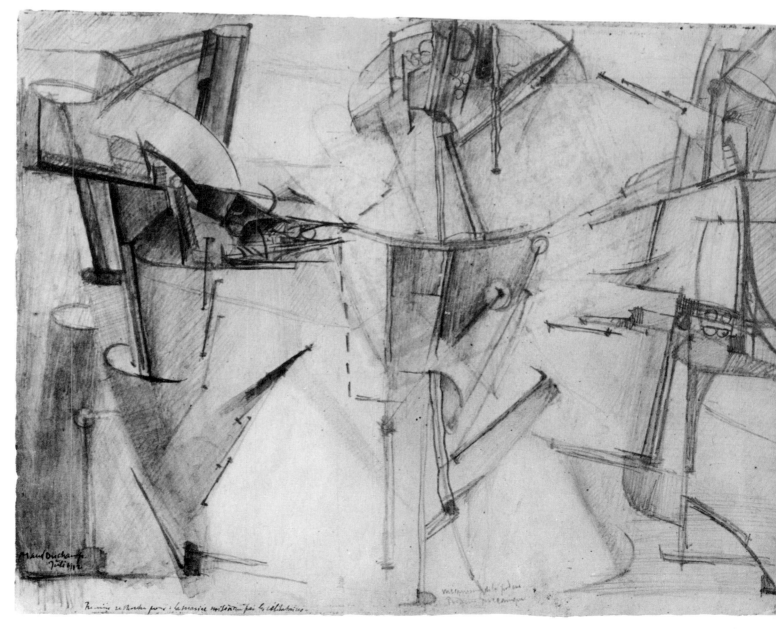

Max Ernst (1891–1976):

△ Bride of the Wind, c. 1925.
Pencil frottage on paper. (176 × 251 mm.)
Galerie Beyeler, Basel.

◁ The Swan is Very Peaceful, 1920.
Collage of photographs. (83 × 130 mm.)
Private Collection.

The Great Orthochromatic Wheel ▷
Which Makes Love to Measure, 1919.
Pencil and watercolour on printed
sheets. (355 × 225 mm.)
Louise Leiris Collection, Paris.

rendering of a fourth-dimensional form. By this logic, Duchamp proved the existence of a fourth dimension, unknowable except by revelation. This would seem to indicate that the fourth dimension is the ebb and flow of life itself, and the *Glass* a re-creation of the process of desire which is never fulfilled, an ironic metaphor for life. Here, Duchamp's pseudoscientific world and the real world interact and collage takes on the power of black magic ascribed to it by Max Ernst and Louis Aragon. Acting "beyond painting, he equalized the situation of art and life and ideally situated the spectator's role."

Two graphic techniques became the plastic foundations for Surrealist art, automatic drawing – or automatism – and the "collage aesthetic." The function of automatism was the suspension of the conscious mind to release the unconscious and to introduce chance and the "unreasonable order" of dreams to the making of art. Automatism grew from a Dada technique best exemplified by a series of automatic drawings from Jean (Hans) Arp's Dada period.

"Their starting point was the notion of vitality, the movement of the creative hand. There were no preconceived subjects, but as the patterns formed on the surface, they provoked poetic associations…, the artist preferring always the ambiguous form which suggested much but identified nothing." [20]

This description of the basic automatist plastic procedure holds true for Max Ernst and André Masson as well. Moreover, it serves to describe Arp's unique invention, biomorphism, the hybrid form abstracted from nature, which, as William S. Rubin has pointed out is the common plastic link in Surrealist iconography. The type of configuration this line produces is antithetical to relationships—nothing is subordinate to anything else; the entire image must be seen as a whole, all at once. It provided a means for the exploration of the unconscious and one of its antecedents is to be found in Expressionist drawing configuration, in the exaggeration of form to convey emotion. But it is Expression disciplined by Cubist structure and subordinated to a highly intellectualized process; a concomitant of this procedure, and another common denominator of Surrealist art, was the eradication of the traces of personality in the handling of paint.

For Max Ernst, drawing was an aid to enlarge "the active part of the mind's hallucinatory powers" to attend "simply as a spectator the birth of his own works." Ernst himself invented a number of graphic techniques to this end, one of the most important was frottage. "I am impressed by the obsession imposed upon my excited gaze by the wooden floor. I take from the boards a series of drawings. At random I drop pieces of paper on the floor and rub them with black lead. By examining closely the drawings thus obtained, I am surprised at the sudden intensification of my visionary capacities…" [21]

la grande roue orthochromatique qui fait l'amour sur mesure

The second basis for Surrealism, the "collage aesthetic," as practiced primarily by Ernst, has its origin ultimately in the technical innovation of Cubism. However, as the Surrealist poet Louis Aragon points out, collage as practiced by Ernst (and to a lesser extent by Arp) minimizes the pasting process.[22] What is essential to Aragon, and to Surrealism, is the quality of displacement which the juxtaposition of unrelated images in collage could magically conjure. In its negation of the real, this displacement was to produce a miraculous and liberating conciliation of the real and marvelous. Moreover, the marvelous was distinguished from the fantastic in that it could not be apprehended by reason. There, stated succinctly, is the basis for the idea of everyman as an artist and the artist as medium, which was inherent from the beginning in Dada's exemption of art from aesthetic concern. Aragon had Max Ernst specifically in mind, pointing out that the earlier Dada collage, the collage using photographs and illustrations, was still based on "amazement at the system"; that is to say, on glue techniques. Kurt Schwitters' collage belongs to this earlier type. Despite Schwitters' use of cast-off and random materials and his commitment to poetic content, his *Merz* collages remained structurally Cubist and based on the "system." Eventually, expanded into painting, the collage aesthetic became the basis on which the illusionist dream-space of Surrealism (as practiced first by Ernst and slightly later Salvador Dali) was explored. To Ernst, a master innovator in graphic techniques, the collage process was the "cultivation of the effects of a systematic displacement." The "pictorial inventor" of this collage style was the Italian Giorgio de Chirico, whose metaphysical drawings and paintings of 1911

◁ Giorgio de Chirico (1888–1978):
The Return of the Prodigal, 1917.
Pencil and gouache on paper. (288 × 203 mm.)
Private Collection.

Kurt Schwitters (1887–1948):
Radiating World, c. 1920.
Paper cut-out with oil. (952 × 680 mm.)
The Phillips Collection, Washington.

through 1917 form one of the bridges between the Cubist portrayal of objective though abstract reality and Surrealist-illusionist paintings based on purely interior models. De Chirico juxtaposed his images—usually objects from the studio, the classical past, and objects remembered from his childhood—according to wholly internalized priorities in an extraordinary dream-like landscape notable for its absolute stillness. His drawings are meticulous studies for these paintings. Of primary importance to the Surrealists was that de Chirico's exploration of exterior reality as the sign of interior reality pointed to a means within art for concrete realization of the unknown which Surrealism equated with the real. Space is typically developed on the basis of planar recession in which frequently illusionist deep space is juxtaposed to surface structure, creating a peculiar tension characteristic of much Surrealist art. Insisting on the objective reality of psychic experience, the Surrealists turned their vision wholly inward in order to imprint the interior vision on the exterior world. Energy was transferred from the creation of pictorial means to the creation of metaphoric images that functioned as icons. Thereby the identification of form and content that had been dominant in modern painting since the last third of the nineteenth century was temporarily broken. It is for this reason that Surrealist art may be considered, from a plastic point of view, despite its technical innovation, a conservative hiatus in modern art, although it is no small achievement to have opened up and explored the inner world of man, the unconscious, and to have invented an iconography and technique for doing so.

Joan Miró (1893):

The Family, 1924.
Black and red chalk on
sandpaper. (75 × 104 cm.)
The Museum of Modern Art, New York.

◁ Page from a sketchbook:
A Woman, 1940-1941.
Pencil. (155 × 208 mm.)
Joan Miró Foundation, Barcelona.

The Poetess, 31 December 1940. ▷
Gouache on paper. (380 × 457 mm.)
Collection of Mr and Mrs Ralph F. Colin,
New York.

In Joan Miró's work we see how the free elaboration of fantasy based on psychic automatism opens one form to another, opens from simple technical innovation into new formal means, moves line from drawing into painting as pure metaphor but also as the means for the free creation of metamorphic form to become the syntax of a painting style, whose structure is based on the collage aesthetic. Miró proposed several relationships between drawing and painting moving away from a purely traditional relationship in which preliminary drawings served as the means to study formal transpositions to a use of collage as a means for projecting form. At the same time he tended to use automatic drawing as a technique for more loosely conceived automatic paintings. Collage as a means to form created a more flatly patterned, screen-like

structure in which the carefully contoured forms are monumentally inscribed against an atmospheric imaginary landscape that becomes increasingly generalized and abstract, although it remains atmospheric. Miró's work oscillates between these two tendencies. *The Family* may be seen as an early example of Miró's mature style in which the two conceptions of form are proposed; the Cubist grid remains, as a device for placing the collage-like forms, united into a kind of frontal screen by the organically meandering lines extended from the bodily parts of the members of the family. The combination of linear and collagelike forms levitating between the geometric and organic, the real and the abstract, places Miró at a juncture of Cubist and Surrealist modes. The *Poetess* may be seen as a later, mature statement of this same spatial and

structural proposition, now wholly integrated and generalized in a union of formal and technical means. Miró is the consummate draftsman-painter, who works in terms of the absolute contrast of the painterly—proposed as space—and the linear which carries form. Both *The Family* and *Poetess* are based on this split conception; they are conceived spatially on the absolute frontality of the picture plane first propounded in the Cubist drawings and collages of 1912—on what I have called "collage space" but with the wholly imaginary space extending beyond this frontal screen that has come to be known as "inscape"—the space of Surrealism that exists only in the mind. It is this space and the extraordinary metamorphic linear invention which later influenced Arshile Gorky's work and became the basis for his extraordinary metamorphic drawing-paintings.

◁ Balthus (1912):
 "You needn't have touched me…"
 Illustration for *Wuthering Heights*
 by Emily Brontë, 1935.
 Pen and ink. (c. 255 × 240 mm.)
 Private Collection.

▽ Pablo Picasso (1881–1973):
 Nessus and Dejanira, 22 September 1920.
 Silver point. (222 × 270 mm.)
 The Art Institute of Chicago.

Henri Matisse (1869–1954):
Nude with Mirror, 1937.
Pen and ink on paper. (810 × 595 mm.)
Private Collection.

233

Salvador Dali (1904):
The Return of Ulysses, 1936.
Ink transfer (decalcomania),
pen and ink. (237 × 374 mm.)
Private Collection, New York.

The flight of European artists to America, in particular the Surrealists (and Mondrian) to New York during World War II, shifted the scene of avant-garde art innovations to the United States. In the United States three extraordinary draftsman-painters emerged—Arshile Gorky, Willem de Kooning and Jackson Pollock, their styles catalyzed by the arrival of the Europeans, and in particular by the notion of the source of art being in the subconscious and the use of Surrealist automatic drawing to bring forth these images and elaborate them. The technique of Surrealist automatic drawing became the basis on which Pollock incorporated drawing into painting, projected the drip technique, which once again changed not only the basis of illusionism but the very structure of art. Arshile Gorky is the transitional figure between European modernism and American modernism. His mature years coincide with the arrival of European artists fleeing World War II in Europe—with the transitional phase of American art as it worked its way through the influences of Cubism and Picasso and was liberated through the intervention of Surrealist influence, particularly free association and the conjuring of images from the subconscious and the elaboration of natural forms through automatic drawing. Gorky added to this amalgam of Cubist infrastructure and automatic drawing and biomorphic form the notion of expressive energy—a more active and expressionistic color drawing and the notion of "mental landscape" based on Kandinsky's model in his *Compositions*. *Summation* is not a study drawing; it may have begun as one but at some point its own elaboration must have clearly indicated its development beyond a preliminary stage. It is a drawing that comes as close in its conception and execution in the mode of color value drawing as drawing ever can to painting. Gorky's line is one of the most elegant in modern art; it comes from Ingres to become in Gorky's hand

André Masson (1896):
Blue Figure, 1925–1927.
Watercolour with ink drawing
collage. (610 × 482 mm.)
Mr and Mrs Edwin A. Bergman.

André Masson (1896):
Massacre, 1933.
Pen and Indian ink. (411 × 562 mm.)
Private Collection.

Arshile Gorky (1904–1948):
Summation, 1947.
Pencil, pastel and oil on buff paper
mounted on composition board. (202 × 258 cm.)
The Museum of Modern Art, New York.

voluptuous, caressing, "prolix" in its capacity to constantly metamorphose–give birth to new form. Gorky, however, does in fact work from study drawings. The major part of his drawings are studies, but unlike traditional study drawings, they go beyond the fragmentary or the preliminary–they push always toward self-sufficient expression. They represent variations on a theme, the painting being yet another variation realized in another medium. *Summation* is in fact the logical culmination of drawing conceived in this way. In the works of both Jackson Pollock and Willem de Kooning, the personal struggle, the biographic markings of the sketch appear as the generating source and subject of the work itself. Pollock wrote: "No sketches. Acceptance of what I do."[23] Both understood that drawing, freed from the limits of the preliminary, could generate independent works. Pollock is an artist obsessively involved with drawing. From 1948 to 1950, he subverts line, literally transforms it into an abstract, wholly non-descriptive tool for creating paintings of enormous linear variety. His densely poured skeins of paint create the first paintings that project an entirely coherent visual field, evenly accented, wholly optical, infinite, yet without allusion to pictorial or psychological space. Pollock's space is imaginary yet natural–the product of light (like Matisse's) creating a palpable sense of atmosphere; kept from illusionism by the material surface of the painting itself. The total involvement with line which subsumes image creates not only a new kind of pictorial structure but a new subject. The painting becomes a metaphor whose subject is the act of painting. In this act of painting everything is risked–traditional values, personal revelation–especially as the painting is "an image of the psyche" in which psyche and world are identified as fundamentally identical psychologically–and even the painting itself. The painting recapitulates in its process an ethical stance.

Jackson Pollock (1912–1956):
Echo, No. 25, 1951.
Enamel on unprimed canvas. (234 × 218 cm.)
The Museum of Modern Art, New York.

Then in late 1950, having used line for two years only for the creation of painting, Pollock seems
to have begun a serious investigation of the possibilities of drawing. He worked first in black-and-
white in poured ink in a small format on paper, then in colored inks on larger sheets, in series,
possibly as an alternative to series of drawings in poured enamel on canvas that wholly change
the terms by which drawing had previously been understood. In these black-and-white canvases,
particularly in *Echo,* which must be regarded as the masterwork of the series, Pollock blows the
scale of drawing right up to the monumental. Drawing in dripped black paint from one work
to the next on a continuous strip of white canvas, frame to frame, cinematographically, Pollock
created a series of drawings—a new kind of painting as drawing—breathtaking in their breadth
of scale and ambition. Indeed, *Echo* functions between drawing and painting just as it functions
optically between figuration and non-figuration.

But scale unrelated to size is an inherent quality of black-and-white drawing. The new spatial concept imposed by the black-and-white drawing is taken over in one heroic gesture from traditional drawing. In these works Pollock is re-examining and re-inventing the whole concept of how line works, of how form is described. Sometimes a line is positive, used for contour; sometimes the black is negative, surrounding the form; sometimes the two techniques are combined, creating, as Michael Fried has observed, a line "with no outside or inside" making the concept of contour one to be used with great care. The mark, the paint that thins and thickens, may simply be line, or, indeed, it may describe the contour, it may be positive or negative—form or shadow. Pollock is here, as in *Echo*, involved in a new kind of figure drawing, in which figuration is integrated optically into the all-over field through a subtle balance of descriptive and non-descriptive lines and linear elements. It is also totally integrated optically with its ground, through the sinking of the edges softly into the canvas (as they had into paper in his color stain drawings), so that line and ground are seen on the same plane and the flickering between positive and negative creates a wholly non-recessive space in which black-and-white elements are always on the same plane. This solution to the problem of figuration in all-over painting or invention may be compared with the Analytic Cubist's fracturing of the image. Although Pollock's solution for the total integration of structure and image is completely different in both means and visual effect from that of the Cubists, it is parallel in its ambitions to make the painting an autonomous construction, and as new and radical as was the Cubists' solution. Pollock's black-and-white canvases remain unique; a culminatory moment, an adumbration perhaps of the independence of drawing. They seem to have exhausted for Pollock himself all the possibilities of drawing at that moment.

Jackson Pollock (1912–1956):
Untitled, 1951.
Coloured inks on rice paper. (632 × 985 mm.)
Private Collection, New York.

Jackson Pollock, as Willem de Kooning later noted, "broke the ice," becoming the first American artist to break out of the straightjacket of provincialism—and on the most radical terms. De Kooning himself had remained closer to Gorky, to the tradition of Cubist structure and Surrealist form, incorporating to it a coloristic graphological tradition. De Kooning however sets new terms, tautening the space of the picture plane once again in an accommodation of a newly generalized, more abstract organic form. Like Gorky, de Kooning's first notion of drawing is from Ingres; he is basically a contour draftsman, but like Matisse, one who is essentially a colorist. To an extraordinary sense of color he brings an even more extraordinary sense of the tactile plasticity of paint. The marriage of these seemingly disparate approaches produces a new kind of drawing. For de Kooning, drawing functions in terms of "interchangeability." It is the means for the metamorphoses from naturalistic source to his characteristic vocabulary of abstract forms. By transposing the new abstract and disjunctive relationships he achieves a new spatial synthesis. But he retains always what he is pleased to call "likeness"—the memory of their source. As Tom Hess notes, "he will do drawings on transparent paper, scatter them one on top of the other, study the composite drawing that appears on top, make a drawing from this, reverse it, tear it in half, and put it on top of still another drawing." [24]

The *Collage* which we reproduce here is the prototype for a new kind of collage painting. Here de Kooning slices up drawings pinning them over each other to create a shift of planes—what he characterizes as a "jump"—a spatial displacement that is otherwise technically impossible; projected into painting in terms of contour drawing it creates the same displacement. De Kooning

Willem de Kooning (1904):

Two Women IV, 1952.
Pastel and charcoal on paper. (388 × 438 mm.)
Private Collection.

◁ Collage, 1950.
 Oil and enamel on cut papers,
 tacked with thumbtacks. (560 × 760 mm.)
 Private Collection, New York.

draws in and on his paintings, sometimes on paper right on top to test a form, sometimes using a "sliced" drawing as a template. Very frequently he draws directly in the paint with charcoal defining contour in a kind of all-over linear structuring and accenting of form—a kind of organic armature.

De Kooning working from a coloristic, painterly tradition, subverts painting to make drawings (it was not until the mid-sixties that de Kooning, for the first time since his early Ingres-like drawing of the forties, began to make small charcoal drawings, using the soft black line coloristically in the tradition of Matisse). In his series of women, paint and brush, charcoal and pastel, slicing and collage, are used for drawing of both large and small works. There is no distinction between the working method from large to small; all work is equally autographic and spontaneous in the immediacy of the marks—especially destructive of traditional ideas of finish. The sketch is elevated to a complete work. Even when a small work is a study for a larger one, the sketch is one action, one work, the painting another. Painting and drawing come together as a continuous process.

In terms of drawing a kind of climax had been reached: while the rapprochement between painting and drawing had been going on for some time, it was not until drawing had transformed itself through its autographic function and was actually absorbed into a new aesthetic of "incompleted painting" that drawing could finally cease to function as a step toward painting and become an independent action, that drawings could not only function as independent finished works, alternative modes of expression for artists whose primary work was in other mediums, but could function as a *third* major means of expression. The story of drawing from the mid-fifties onward is the story of a gradual disengagement of drawing as autography or graphological confession, a disengagement from painting and an emotive cooling of the basic mark, the line itself. There is a gradual move away from drawing as a "field" that wishes to include the world (like Rauschenberg's), from drawing that is painterly, coloristic and eclectically inclusive in its use of materials, toward more classical mediums and linear and tonal modes though used in new ways. Now the internal structure of the drawing as an object definitively

Robert Rauschenberg (1925):

Canto XXXIV, "Compound Fraud, Treacherous to Their Masters," from *34 Illustrations for Dante's Inferno*, 1959-1960. Gouache, watercolour, pencil and transfer (rubbing). (370 × 291 mm.) The Museum of Modern Art, New York.

Canto XXXI, "The Central Pit of Malebolge, ▷ The Giants," from *34 Illustrations for Dante's Inferno*, 1959-1960. Red and graphite pencils, gouache and transfer. (368 × 293 mm.) The Museum of Modern Art, New York.

changes to one that is non-hierarchical and contingent. Robert Rauschenberg wished to reclaim the real world and return it to the field of the work of art. To do so he proposed a new visual style informed by poetry, random musical composition, impelled by the static sounds of the environment, registering its disorganized sensations as a series of transferred impressions across the field of the picture. Through the mediation of drawing, he reorganizes the contingent and episodic into a cohesive work of art. His series of *Thirty-Four Drawings for Dante's Inferno* interprets the poet, passage by passage, with the images of the contemporary world. It is monumental in scope and cinematic in concept, in his frame by frame unfolding of Dante's narrative. Rauschenberg calls the Dante drawings "combine" drawings; they are in fact a species of illusionary collage in which Rauschenberg develops a technique for transferring to the drawing sheet already-appropriated images of the world from the popular press. For Rauschenberg, a picture is more like the real world when it is made out of the real world if only on the basis of a heroic fiction. The process of transfer drawing achieves representational images without the necessity of adhering to the convention of drawing as delineation projects "naturalistic" illusionism without warping the picture plane.

Jasper Johns, perhaps looking to older American traditions in painting and in particular to

American poetry, says: "I used things the mind already knows. That gave me room to work on other levels." Johns's image is a species of "ready-made"; the units which form it are ready-made. He begins with two givens: the first is the found image; the second is the highly charged brush stroke of Abstract Expressionism. Working with what is given, Johns initiates a rationalization of the process of making art. Beginning with the systematic exploitation of simple images, he reorganizes the structure of the work of art so that it is non-hierarchical, making his image identical in size and shape with the canvas itself, identifying object and surface as if both were one. The flag was the first image that Johns used, then the target; but the alphabet and numbers, because their serial order is naturally non-hierarchical, were most successful. Johns arranged his numbers and alphabet letters on a grid, repeating them serially across and up and down in logical order. At the same time he reorganized and reordered the "fast and loose" brush stroke of Abstract Expressionism. The process is most apparent in Johns's drawing which he seems to use almost analytically in relation to the process of painting. Johns's non-descriptive line, used for building tone, is confined to specific areas and composed of small repeated gestures. The line itself is always seen as line even as it merges with other lines to build tone, even when confined within the scheme defined by the motif.

Jasper Johns (1930):

Gray Alphabets, 1960.
Graphite and wash. (813 × 597 mm.)
Mrs Leo Castelli Collection, New York.

Diver, 1963.
Charcoal and pastel. (220 × 180 cm.)
Mr and Mrs Victor W. Ganz Collection, New York. ▷

Johns's ostensible subject is the object, but in fact it is just as much the line, the mark. Johns's line–the neutral scheme to which it adheres–signals rather than expresses openly; like Analytic Cubism it compacts, compresses; but now we are a few steps further in the process and henceforth this compact intensity will be a sign of all process drawing cut loose from delineation. It is here that Johns connects Cubist drawing and process, setting the stage for Sol LeWitt's later drawing proposals. Johns remarks: "Only a couple, three or four have been sketches or ideas when they were made into paintings and were done with that intention. Generally the drawings have been made just to make the drawing, and the simplest way for me to do it was to base it on a painting which existed, although they generally don't follow the painting closely."[25] Johns establishes a visual as well as a conceptual continuity across mediums and disciplines. By using the same image for two and three-dimensional work, by returning constantly to the same image and repeating the same work in several mediums and in two and three dimensions, and by making drawings after paintings of the same image, Johns is re-investigating the relationship among the three disciplines–painting, drawing, and sculpture. By his constant conceptual reshuffling, he is in one sense sorting out what is proper to each. In a sense Johns begins to make drawing as such available again as an independent discipline but now on new terms. The essential question is about the difference between tactile and visual sensations– the essential opposition that creates illusionism. The prime illusion is tactile, rendering three-dimensional objects on the two-dimensional plane so that they retain the appearance of three dimensions and assert themselves within the space as "so real that one could touch them." Touch substantiates. The idea of "substantiation" is among those things which can be observed as concerning Johns most vitally; drawing is the discipline most intimately concerned with touch.

Diver is one of a group of works connected with Hart Crane, the American poet who died by drowning. Its scale is literal, the handprints, the footprints and the sweep of the arms are literal direct imprints of the artist's hand and feet; the sweep of his arms is that of his actual body extension. Touch determines size, the size is the "field" of the artist's tactile sense. The movement from one hand position to the other records a passage in time and space as the

244

diver moves from rest position to the position poised ready to dive. *Diver* is a drawing in slow motion. The extent of the diver's reach determines the size of the drawing. The question here becomes not only one of the fact of the opacity or transparency of the picture plane, as the parts are seen as both on top and in back of the picture plane, but one of substantiation—one of identification of the whole artistic endeavor beyond that. The diver is "blind"—the water is dark—he can only see by touch; the artist can only make real what he can touch, know and make known by touch. The water is a shadowy region, now Johns's formerly precise strokes are random, suggestive, move restlessly. The ground—the sheet—becomes a kind of primordial matter, a metaphor for the formlessness that the artist brings to order. But the diver is always poised, the action is not consummated. There is an eternal interchange between the concrete and the suggested, the substantial and the insubstantial. The question is one of in what, where, how does the artist make visible the things he lives. The drawing embodies both question and answer.

Diver is perhaps the most ambitious single drawing in the last twenty years. Both senses of drawing are united here. In its questioning of the very grounds of art, *Diver* refers drawing to its conceptual essence, as it confronts the Aristotelian question of how artistic representation is possible at all. At the same time it is an ultimate graphological drawing, an ultimate statement about drawing and touch.

Jean Dubuffet (1901):
Le mechu, July 1953.
Oil on paper. (650 × 500 mm.)
Musée des Arts Décoratifs, Paris.

Robert Morris (1931):
Light-Codex-Artifacts 1 (Aquarius), 1974.
Vaseline and graphite on wall
(destroyed). (3.72 × 6.95 m.)
Photograph by courtesy of Leo Castelli
Gallery and Sonnabend Gallery, New York.

Cy Twombly (1928):
Untitled, 1971.
Chalk, oil and gouache
on cardboard. (690 × 870 mm.)
Musée d'Art et d'Histoire, Geneva.

With Johns, as with Rauschenberg, we can begin to trace a kind of history as a discipline projected by an increasing self-consciousness about style. The accumulation of available styles since the beginning of the century created a kind of "ready-made" heritage and resource but also created a crisis of a sort. On the one hand, serious drawing had been absorbed into painting; on the other, drawing had been consumed by the graphic arts, by advertising and the reproductive media, making it "unavailable" to the serious artist.

Rauschenberg and Johns, as well as Jean Dubuffet and Cy Twombly, had begun to make drawing available once more. Each artist of the new generation, the so-called Pop school, began to investigate and test his own approach in relation to previous styles and to previous notions and conventions of drawing by reappraising them at what may be described as an ironic distance, by isolating their specific conventions, conceptualizing them, and recreating them as stereotype paraphrase. This is especially true of Roy Lichtenstein whose references to tradition are at the core of his style. Drawing, and particularly the notion of drawing, is at the core of Lichtenstein's art. His painting is made by slide projection of small drawings onto the larger canvas. In many cases the drawings that are projected have themselves been studied in more informal sketches. They quote heavily from other mediums and other art. At first their quotation is from commercial art; as Lichtenstein notes, commercial art borrows "unwittingly" from high art whose basis is "in graphic techniques," so that he is involved in a third-hand recycle of style. Later he quoted directly from other twentieth century masters. Lichtenstein is involved in a kind of Platonism, "at a third remove from truth," with imitations of imitations.

Lichtenstein wishes "to reduce the visual world to unalterable universally valid form, thus renouncing the individuality and originality in which we are accustomed to find the principal criterion of artistic accomplishment." Accordingly, he imitates what is already an "imitation," hand-drawing the conventional marks of commercial reproduction processes, parodying the mechanical and the handmade at the same time and "reducing," as Duchamp had once exhorted himself to do; Lichtenstein's line is essentially a stereotype of the classical contour line. He copies by now classical twentieth-century drawings. like Carrà's Futurist *Horseman*, debunking the idea of drawing as personal handwriting and locating it as a function of idea. He is, in a sense, recapitulating Picasso's and Matisse's creation of twentieth-century art as a totally illusory construct, but in new terms, now so conventionalized as to be emblematic. Thus Pop art contributed to an ongoing cooling of the mark, a concentration on line as a

Roy Lichtenstein (1923):
Carlo Carrà "The Red Horseman" 1913, 1974.
Pencil and coloured crayons. (530 × 660 mm.)
Private Collection, New York.

stereotype, and to the idea of the "reproducibility" of gesture, as well as image, so that the idea of drawing as graphology, as a kind of personal handwriting, was a dead issue, as was spontaneity. And as a concomitant, the identification of drawing and painting–the incorporation of painting into drawing–was also a dead issue. A new idea of drawing was now to be proposed in terms of a crisis in art itself. For Frank Stella drawing itself was useless; it became a deductive function of the structure of painting and at that moment ended its relationship with painting and entered into a relationship with objects. Stella's paintings are deduced from Jasper Johns's identification of image and structure, the idea that the painting itself is an "object." This idea was inherent in Cubism but Stella made explicit that there was to be no question of illusionism nor mediation between the picture as illusion and the picture as symbol. Stella jettisoned the idea of balance and reciprocal relationship and deduced his "composition" from the shape of the canvas, making shaped canvases based on geometric figures that produced complex internal structures deepening their stretchers so that they became object-like, stressing surface and "wholeness." To a group of his contemporaries he projected the idea that a work of art could be either two-dimensional or three-dimensional; the issue became not making a work of art that was a painting or a sculpture but one that was two-dimensional or three-dimensional. Sol LeWitt begins with the formulation of a predetermined system–an idea of order, of structure–that precedes discipline or medium and applies to two and three-dimensional works in all mediums. Applied to drawing, LeWitt's idea radically changed attitudes toward that discipline, transforming its role as equal to that of painting and sculpture.

Sol LeWitt had started as a painter involved with ideas about ridding painting of illusionism, about the assertion of painting as an object and projected it into three dimensions. LeWitt took the principles of reduction and system still further, projecting a "minimal" art of three-dimensional construction, divorced from the traditional idea of relational sculpture. Among the conventions established for three-dimensional minimal art was that it was to be wholly legible all at once–literal and singular in form although its construction could be additive single forms or could be serially repeated and systematically varied but not "arranged" hierarchically. LeWitt began to make objects based on simple planar and linear components. By 1967 these objects were created as sequentially varied finite serial systems deployed in progression on the floor on a drawn grid. At the same time he began to draw instructions for his fabricators, using the simple conventions of hatching lines in four directions, to indicate surface planes and direction. Thus the projection of minimal art on a two-dimensional basis was established at the outset and led, by simple logical extension but only after an intervening idea, to an independent two-dimensional art. From minimal art, LeWitt concerned with something more fundamental than creating "irreducible objects" in 1967 moved into conceptual art, declaring that "idea or concept is the most important aspect of the work."[26] Under the aegis of conceptual art, LeWitt returned to fundamentals, and to LeWitt drawing was the fundamental discipline. Using the system he had developed for describing the planes of his objects, he began to make serial drawings on paper, using all of the four basic lines and systematically overlaying them; the drawing was finished when it had exhausted all the possible permutations. Color drawings were made on the same system using the three primary colors and black. The format of all of these drawings adhered to the basic square form of the plane, used additively, while the adherence to basic straight lines paralleled his use of simple linear members in open structures. These became the syntax for a newly systematic drawing projected on the basis of linguistic description. In October of 1968 LeWitt transferred these drawings to the wall, as the sculpture had been proposed on grids drawn on the floor. This made his drawings coextensive with the viewer's real space in an attempt to further cut down on illusionism and totally enfold the viewer in his subjective mental space.

Hanne Darboven (1941):　▷
Four Seasons (panel 4), 1973.
Pen and ink on paper. (179 × 150 cm.)
Dr Peter Ludwig Collection, Aachen.

Joseph Beuys (1921):
Untitled (Sun State), 1974.
Chalk on blackboard. (122 × 183 cm)
Ronald Feldman Fine Arts Gallery, New York.

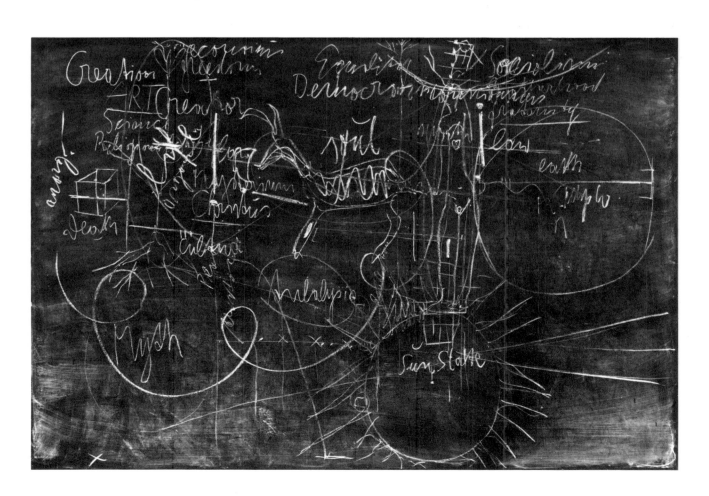

Walter de Maria (1935):
Half Mile Long Drawing: Two Parallel
Lines 12 Feet Apart, April 1968.
Chalk. (Width of each line 3 inches)
Mohave Desert, California.
Photograph by courtesy of
Heiner Friedrich Gallery, New York.

The instructions for the first wall drawing were very simple: "Lines in four directions (horizontal, vertical, diagonal left, and diagonal right) covering the entire surface of the wall. Note: The lines are drawn with hard graphite 8H or 9H as close together as possible (1/16″ apart, approximately) and are straight." Instructions were very quickly developed over the next few years for any number of variations. System, paradoxically, provided LeWitt with virtually unlimited flexibility and the alternatives immediately eliminated a number of problems. They eliminated subjective decisions since the individual system determines the structure of the work and the wall space available determines its area; when the designated wall is covered according to the directions of the system it is finished. Projecting the creation of the work of art by system—as the projection of pure idea—his idea—LeWitt made the decision that his personal touch was not necessary to assure the authenticity of the drawing. A LeWitt can be drawn more than once; the artist need not even be present. The system may be adapted to a variety of spaces; it is open-ended.

LeWitt asserts that process, in the sense in which Jackson Pollock's process, and therefore the artist's psyche, as subject is no longer meaningful. His work is not a cumulative record of its process. The work is the result of a series of logical prior choices systematically carried out. LeWitt's system is intimately tied to language as a regulating device. Just as in language content cannot be extracted from the web of structure in which it is embedded, so LeWitt's meaning has been embedded somewhere in the dialogue between the description that creates the work and its physical realization.

System, projected as language, establishes LeWitt's work as ritualistic—intended to ensure that the world works by following an arbitrary symbolic system with arbitrary rules. Instead of the creation of a subjective world in an imaginary space LeWitt has reached out and imposed his rules on the space of the world itself. His mental space is boundless, it is both within our mind's eye and at the limits of our touch. With the expansion of drawing into the landscape in the work of Walter de Maria—its imposition on the world once again—touch itself, limits, would seem suspended; mind and world are one.

LeWitt's transposition of his drawings from the restricted if traditional format of a sheet of paper to the architectural space of a wall with which it became absolutely identified was a radical move. It suggests transformation in the role, and the very nature, of the drawing medium, within both his own work and the history of the medium.

LeWitt's move was catalytic, as important for drawing as Pollock's use of the drip technique had been in the 1950s. Both opposed, through radical transformations in the way in which the thing is made, expectations of the way art ought to look—what it ought to be.

Sol LeWitt (1928):
All Possibilities of Two Lines Crossing
within modular squares of 36″ × 36″
using arcs from corners, straight lines,
not-straight lines, and broken lines, June 1972.
Pencil on white wall. (20 m. × 3.35 m.)
Dr and Mrs Bonomo Collection, Spoleto, Italy.

Notes to Chapter 6

1 Maurice Merleau-Ponty, "Cezanne's Doubt," trans. Sonia Brownell, *Art and Literature* (Lausanne), Spring 1965, p. 109.

2 Cézanne, quoted in the above, p. 111.

3 Parts of the discussion on collage are indebted to: Clement Greenberg. "The Pasted Paper Revolution," *Art News* (New York), October 1958, pp.46-49.
 and

4 Pierre Daix, *Le Cubisme de Picasso* (Neuchatel: Editions Ides et Calendes, 1979), Chapters 7 & 8, pp. 103-128.

5 Robert Rosenblum quoted in Daix, p. 128.

6 Meyer Schapiro, "Picasso's Woman with a Fan," reprinted in *Modern Art 19th and 20th Centuries* (New York: George Braziller: 1978), p. 117.

7 Henri Matisse, "Notes of a Painter on his Drawing," quoted in Jack Flam, *Matisse on Art* (London: Phaidon, 1973), p. 81.

8 *Ibid.*

9 Victor Carlsen, *Matisse as Draftsman* (Baltimore: The Baltimore Museum of Art, 1971), p. 156.

10 Henri Matisse quoted in Pierre Schneider, *Henri Matisse: Exposition Centenaire* (Paris: Grand Palais, April– Sept. 1970), p. 48.

11 Op. cit. Flam. "Interview with Verdet. 1952." p. 42.

12 Ross Neber, "Mentalism Versus Painting," *Artforum*, Feb. 1979, pp. 40-47.

13 Wassily Kandinsky, *On the Spiritual in Art,* Hilla Rebay (Ed.), New York, 1959, p. 161.

14 In the discussion of Paul Klee's work I am indebted to Sibyl Moholy-Nagy's introduction to Paul Klee, *Pedagogical Sketchbook* (New York: Frederick A. Praeger, 1953).

15 Paul Klee, "Opinions on Creation" reprinted in *Paul Klee* (New York: The Museum of Modern Art, 1941), pp. 10-13.

16 *Ibid.*

17 *Ibid.*

18 Walter Benjamin, "Some Reflections on Kafka," reprinted in *Illuminations,* ed. Hannah Arendt (New York: Schocken Books, 1978).

19 Marcel Duchamp in Pierre Cabanne, *Dialogues with Marcel Duchamp* (New York: Viking, 1971).

20 William S. Rubin, *Dada and Surrealist Art* (New York: Harry N. Abrams, Inc., 1970), p. 80.

21 Max Ernst, "An Informal Life of M. E. (as told by himself to a young friend)" in William S. Lieberman, ed., *Max Ernst* (New York: The Museum of Modern Art, 1961), p. 14.

22 Louis Aragon, "Challenge to Painting," 1930; quoted in Lucy Lippard, *Surrealists on Art* (Englewood Cliffs: New Jersey: Prentice-Hall, Inc., 1969), p. 39.

23 Handwritten note in the artist's files.

24 Thomas B. Hess, *Willem de Kooning* (New York: The Museum of Modern Art, 1968), p. 47.

25 Jasper Johns quoted in David Sylvester, *Jasper Johns Drawings* (Arts Council of Great Britain, 1974), p. 1.

26 Sol LeWitt, "Paragraphs on Conceptual Art," *Artforum* (New York, June 1967), pp. 79-80.

Bibliography

SOURCE WORKS ON THE ARTS AND THE TEACHING OF DRAWING

14th to 16th century

England

John SHUTE, *The First and Chief Groundes of Architecture*, 1563.

France

Jean BULLANT, *Règle générale d'Architecture de cinq manières de Colonnes* (1564), Rouen 1674. – Jean COUSIN, *Livre de perspective*, Paris 1560. – *Livre de pourtraiture, de maistre Jean Cousin*, Paris 1595. – Philibert DELORME, *Le premier tome de l'Architecture*, Paris 1568. – Jacques Androuet DU CERCEAU, *De Architectura*, Paris 1559. – *Leçons de Perspective positive*, Paris 1576. – Andreas VESALIUS, *Andrea Vesalii Bruxellensis, De humani corporis fabrica, Libri VII*, Basilia 1543. – VIATOR (Jean Pelerin LE VIATEUR), *De Artificiali Perspectiva*, Toul (Part. I) 1505, (Part. II) 1509.

Germany

Jost AMMAN. *Kunst- und Lehrbüchlein*, Frankfurt 1578. – Hans Sebald BEHAM, *Mass oder Proportion der Ros*, Nürnberg 1520. – Wendel DIETTERLIN, *Architectura: von Ausstheilung, Symmetria und Proportion der fünff Saeulen*, Nürnberg 1598. – Albrecht DÜRER, *Underweysung der Messung mit dem Zirckel und Richtscheyt in Linien, Ebnen und gantzen Corporen...*, Nürnberg 1525. – *Etliche Underricht zu Befestigung der Stett, Schloss und Flecken*, Nürnberg 1527. – *Hierinn sind begriffen vier Bücher von menschlicher Proportion...*, Nürnberg 1528. – (Albrecht DÜRER) *Alberto Durero pittore e geometra chiarissimo, Della simmetria dei corpi humani, Libri IV*, in Venetia 1591. – (Albrecht DÜRER) *Alberti Dureri, Institutionum geometricarum, Libri IV cum figuris*, Paris 1532. – Wenzel JAMNITZER, *Perspectiva Corporum Regularium*, Nürnberg 1568. – Heinrich LAUTENSACK, *Dess Circkels und Richtscheyts, auch der Perspectiva, und Proportion der Menschen und Rosse, kurtze, doch gründtliche Underweisung, dess rechten Gebrauchs...*, Frankfurt 1564. – Hans LENKER, *Perspectiva*, Nürnberg 1571. – Walter RIVIUS, *Unterrichtung zu rechtem Verstand der Lehr Vitruvii*, Nürnberg 1547. – Hieronymus RODLER, *Perspectiva*, Simmern 1511. – Walter RYFF, *... Das ist, des Menschen (oder Dein selbst) wahrhafftige Beschreibung oder Anatomi...*, Strassburg 1541. – Erhard SCHÖN, *Underweysung der Proportion und Stellung der Bossen*, Nürnberg 1534. – Lorenz STÖR, *Geometrica et Perspectiva*, Augsburg 1567.

Italy

Leon Battista ALBERTI, *De Re Aedificatoria*, Libri X (c. 1450-1472), Florentiae 1485. – *De Pictura*, Libri III (1435), Basilea 1540, Italian ed. *Della Pittura* (1436), Venezia 1447. – *Della Statua*, Venezia 1568. – Romano ALBERTI, *Trattato della mobilità della Pittura*, Roma 1585. – *Origine e progresso dell'Accademia del Disegno de' Pittori, Scultori ed Architetti in Roma*, Pavia 1604. – Giovan Battista ARMENINO, *De' veri precetti della pittura*, Libri III, Ravenna 1587. – Daniel BARBARO, *I dieci libri dell'Architettura tradotti e commentati da Monsignor Barbaro*, Venezia 1556. – *M. Vitruvii Pollionis De Architectura Libri Decem, cum commentariis Danielis Barbari*, Venezia 1567. – *La Pratica della Perspettiva*, in Venetia 1569. – Cosimo BARTOLI, *Del modo di misurare le distanze, le superfici, i corpi, le provincie, le prospettive...*, Venezia 1554. – Martino BASSI, *Dispareri in materia d'Architettura e Prospettiva*, Brescia 1572. – Giovan Bat-

tista BERTANO, *Gli oscuri e difficili passi dell'opera di Vitruvio*, Mantova 1588. – Michelangelo BIONDO, *Della nobilissima pittura*, Venezia 1549. – Baldassare CASTIGLIONE, *Il Cortegiano*, Venezia 1527. – Pietro CATTANEO, *I quattro primi Libri d'Architettura*, Venezia 1554. – Benvenuto CELLINI, *Due trattati, uno intorno alle otto principali arti dell'orificeria; l'altro in materia dell'arte della scultura...*, Firenze 1568. – Cennino CENNINI, *Libro dell'Arte* (c. 1390-1400), first ed. Roma 1821. – Cesare CESARINO, *Commento a Vitruvio*, Como 1521. – Gregorio COMANINI, *Il Ficino*, Mantova 1591. – Federico COMMANDINO, *Ptolomaci Planisphaerium Jordani Plan, F. Commandini in Pl. Commentarius...*, Venezia 1558. – Ignazio DANTI, *La Prospettiva di Euclide...*, Firenze 1573. – *Vita del Vignola, premessa a Vignola, due regole della prospettiva pratica*, Roma 1573. – Vincenzo DANTI, *Il primo libro del Trattato delle perfette Proporzioni di tutte le cose che imitare o ritrarre si possono con l'Arte del Disegno*, Firenze 1567. – Piero DELLA FRANCESCA, *Petrus Pictor Burgensis, De Prospectiva Pingendi*, (1482), first ed. Strasbourg 1899. – Ludovico DOLCE, *Catalogo della Pittura, intitolato l'Aretino*, Venezia 1557. – *Dialogo nel quale si ragiona della qualità, diversità e proprietà dei colori*, Venezia 1565. – Anton Francesco DONI, *Disegno partito in più ragionamenti*, Venezia 1549. – Pomponius GAURICUS, *De Sculptura*, Firenze 1504. – Giovanni Andrea GILIO, *Due dialoghi... degli errori de' pittori*, Camerino 1564. – Fra GIOCONDO, *M. Vitruvii De Architectura*, Venezia 1511. – Francesco di GIORGIO MARTINI, *Trattato d'architettura civile e militare* (after 1482), first ed. Torino 1841. – Francesco Maria GRAPALDI (GRAPALDUS), *De Partibus Aedium libri duo*, Parma 1494. – Francesco LANCILLOTTO, *Trattato di Pittura*, Roma 1509. – LEONARDO DA VINCI, *Trattato delle Pittura* (1490-1519), first ed. *Trattato della Pittura di Leonardo da Vinci, nuovamente dato in luce, con la vita dell'istesso autore, scritta da Rafael Du Fresne...*, Paris 1651. – Giovan Paolo LOMAZZO, *Trattato dell'Arte della Pittura, diviso in VII Libri, nei quali si contiene tutta la teoria e la pratica di essa Pittura*, Milano 1584. – *Idea del tempio della Pittura...*, Milano 1590. – (Fra) Luca PACIOLI, *Summa arithmeticae*, Venezia 1494. – *De V Corporibus regularibus*, Venezia 1507. – *De Divina Proportione*, Venezia 1509. – Andrea PALLADIO, *I quattro libri dell'Architettura*, in Venetia 1570. – Paolo PINO, *Dialogo di Pittura di Messer P.P. nuovamente dato in luce*, Venezia 1548. – Antonio POSSEVINO, *Tractatio de Poesi et Pictura ethnica, humana et fabulosa collecta cum vera, honesta et sacra*, Roma 1593. – Giovanni Antonio RUSCONI, *Dell'Architettura secondo i precetti del Vitruvio Libri X*, Venezia 1590. – Sebastiano SERLIO, *Regole generali di architettura sopra le cinque maniere de gli edifici, cioè toscano, dorico, ionico, corinthio e composito, con gli esempi dell'antichità, che per la maggior parte concordano con la dottrina di Vitruvio*, Libro IV, Venezia 1537. – *Il Primo libro d'architettura (Il secondo libro di perspettiva) di Sebastiano Serlio, ... Le premier livre d'architecture (Le second livre de perspective) de Sébastian Serlio, ... mis en langue françoyse par Jehan Martin, ...*, Paris 1545. – Lorenzo SIRIGATTI, *La Pratica di Prospettiva...*, in Venetia 1596. – Cristoforo SORTE, *Osservationi nella Pittura*, Venezia 1580. – V. THERIACA, *Discorso e ragionamento di ombre*, Roma 1551. – Benedetto VARCHI, *Due lezioni sopra la Pittura e Scultura*, Firenze 1549. – Giorgio VASARI. *Le Vite de' più eccellenti Architetti, Pittori e Scultori italiani da Cimabue insino a' tempi nostri: descritte in lingua toscana da Giorgio Vasari*, 3 parts in 2 vol., Firenze 1550. – *Le Vite de' più eccellenti Pittori, Scultori e Architettori, scritte e di nuovo ampliate da Giorgio Vasari co' ritratti loro e con l'aggiunta delle vite de' vivi e de' morti dell'anno 1550 insino al 1567*, 2 parts in 3 vol., Firenze 1568. – *Ragionamenti*, Firenze 1588. – Jacopo Barozzi DA VIGNOLA, *Regole delli cinque ordini di Architettura, in 32 tavole*, Venezia 1562. – VITRUVIUS, *Marcus Vitruvius Pollio. De Architectura*, first ed. by J. Sulpicius da Veroli and Pomponio Leto, 1486.

Low Countries

Joannes de VALVERDE, *Vivae imagines corporis humani*, Anversa 1579. – Jan Vredeman de VRIES, *Artis Perspectivae plurimum generum elegantissimae formulae...*, Anversa 1568. – *Perspective id est Celeberrima ars inspicientis aut transpicientis oculorum aciei...*, (part I). *Perspective, Pars altera, in qua praestantissima quaeque Artis praecepta*, (part II) Leyden, part I 1604, part II 1605.

Spain

Juan de ARFE Y VILLAFANE, *De varia commensuracion para la escultura y architectura*, Sevilla 1585.

17th and 18th centuries

England

William AGLIONBY, *Painting illustrated in three dialogues...*, London 1685. – Thomas BARDWELL, *The Practise of Painting and Perspective made easy*, London 1756. – James BARRY, *An enquiry into the real and imaginary obstructions to the acquisition of the arts in England*, London 1775. – R. BRADBERRY, *The Principles of Perspective*, London 1790. – J. BRISBANE, *The Anatomy of Painting*, London 1769. – Alexander BROWNE, *Ars pictoria*, London 1669. – Edmund BURKE, *Philosophical inquiry into the origin of our ideas of the sublime and beautiful*, London 1757. – John Lodge COWLEY, *The Theory of Perspective demonstrated in a method entirely new, ...*, 2 vol., London 1766. – Alexander COZENS, *A new method of assisting the invention in drawing original composition of landscape*, London 1785. – H. DITTON, *A Treatise of Perspective*, London 1712. – John ELSUM, *The Art of painting after the Italian manner: with practical observations on the principal colours and directions how to know a good picture*, London 1703. – J. FERGUSON, *The Art of Drawing Perspective made easy*, n.p. 1775. – D. FOURNIER, *A Treatise of the Theory and Practice of Perspective*. 1761. – Henry FUSELI (Johann Heinrich FÜSSLI), *Lectures on painting delivered at the Royal Academy*, 2 vol., London 1801-1820. – James GIBBS, *Rules for Drawing the Several Parts of Architecture...*, London 1732. – William GILPIN, *An essay upon prints containing remarks upon the principles of picturesque beauty*, London 1768. – *Three essays on picturesque beauty, on picturesque travel and on sketching of landscape*, London 1794. – William HALFPENNY, *Practical Architecture, or a sure guide to the true working according to the rules of that science...*, London 1724. – Joseph HIGHMORE, *The Practice of Perspective, on the principles of Dr. Brook Taylor...*, London 1763. – William HOGARTH, *Analysis of Beauty*, London 1753. – Joseph HOLDEN POTT, *An essay on landscape painting, with remarks, general and critical, on the different schools and masters, ancient and modern*, London 1782. – David HUME, *Of the standard of taste in four dissertations*, London 1757. – Inigo JONES, *The Designs of Inigo Jones consisting of plans and elevations for public and private buildings*, London 1727. – Joshua KIRBY, *The Perspective of architecture, in two parts, a work entirely new, deduced from the principles of Dr. Brook Taylor...*, 2 vol., London 1761. – Charles LA MOTTE, *Essay upon poetry and painting...*, London 1730. – Batty LANGLEY, *Practical geometry applied in the useful arts of building, surveying, gardening and mensuration*, London 1726. – Thomas MALTON, *A Compleat Treatise on Perspective in theory and practice*, London 1776. – B. MARTIN, *The Principles of Perspective explained*, London 1770. – Joseph MOXON, *Practical Perspective*, n.p. 1670. – Patrick MURDOCH, *Neutoni genesis curvarum per umbras, seu Perspectivae universalis elementa, exemplis coni sectionum et linearum tertii ordinis illustrata*, Londini 1746. – Edward NOBLE, *The Elements of linear perspective...*, London 1771. – Thomas PAGE, *The art of painting in its rudiment,*

progress and perfection, delivered exactly as it is put in practise, London 1720. – Richard PAYNE KNIGHT, Analitical enquiry into the principles of taste, London 1795. – Henry PEACHAM, The art of drawing with pen and limming in water colours, London 1606. – Uvedale PRICE, An essay on the picturesque as compared with the sublime and the beautiful, and on the use of studying pictures for the purpose of improving real landscape, London 1794. – A dialogue on the distinct characters of the picturesque and the beautiful, prefaced by an introductory essay on beauty, with remarks on the ideas of Sir Joshua Reynolds and Mr Burke upon that subject, Hereford 1801. – J. PRIESTLEY, A Familiar Introduction to the Theory and Practice of Perspective, London 1780. – Sir Joshua REYNOLDS, Discourses delivered at the Royal Academy, London 1769/1791. – Jonathan RICHARDSON, An essay of the theory of painting, London 1715. – The Connoisseur: an Essay on the whole Art of Criticism...., London 1719. – John RUSSELL, Elements of Painting with Crayons, London 1772. – William SALMON, Polygraphice, or the arts of drawings, engraving..., London 1672. – Palladio Londinensis, or the London art of building, London 1734. – William SANDERSON, Graphice. The use of the pen and pencil, or the most eccelent art of painting, London 1658. – Brook TAYLOR, Linear Perspective, London 1715. – Daniel WEBB, An inquiry into the beauties of painting and into the merits of the most celebrated painters, ancient and modern, London 1760. – W.F. WELLS, A Treatise on Anatomy and Proportions of the Human Figure, adapted to the arts of designing, painting and sculpture, London 1796.

France

Pierre ANGO, Pratique générale des fortifications, pour les tracer sur le papier et sur le terrain, sans avoir égard à aucune méthode particulière, Moulins 1679. – L'optique..., Paris 1682. – Jacques ALEAUME, Ja. Aleaumi Aurelii Confutatio problematis ab Henrico Monantholio..., Paris 1600. – Charles BATTEUX, Les Beaux Arts réduits à un même principe, Paris 1746. – François BLONDEL, Cours d'architecture enseigné dans l'Académie Royale d'Architecture, 2 vol., Paris 1675-1683. – Jacques-François BLONDEL, Cours d'architecture..., Paris 1771-1777. – Germain de BOFFRAND, Livre d'Architecture, Paris 1745. – Abraham BOSSE, La pratique du trait à preuves, de Monsieur Desargues lyonnais, pour la coupe des pierres in l'architecture..., Paris 1643. – Traicté des manières de graver en taille douce, Paris 1645. – Manière universelle de M. Desargues pour pratiquer la perspective par petit-pied, comme le géométral..., Paris 1648. – Sentiments sur la distinction des diverses manières de peinture, Paris 1649. – Moyen universel de pratiquer la perspective sur les tableaux ou surfaces irrégulières..., Paris 1653. – Représentation de diverses figures humaines, Paris 1656. – Traité des manières de dessiner les ordres de l'architecture antique en toutes leurs parties..., Paris 1664. – Traité des pratiques géométrales et perspectives enseignées dans l'Académie Royale de la peinture et sculpture, Paris 1665. – Le peintre converty aux précises et universelles règles de son art, Paris 1667. – Julius-Caesar BOULENGER, De Pictura, Plastica, Statuaria libri duo, Lyon 1627. – Jean Baptiste de BOYER, Marquis d'ARGENS, Examen critique des différentes Ecoles de Peinture, Paris 1768. – Louis BRETEZ, La Perspective practique de l'architecture..., Paris 1706. – Charles-Etienne BRISEUX, Architecture moderne ou l'art de bien bâtir ... tant pour les maisons des particuliers que pour les palais, Paris 1728. – Traité du Beau essentiel dans les Arts, Paris 1752. – M. BUCHOTTE, Les règles du dessein et du lavis, Paris 1721. – Salomon DE CAUS, La Perspective avec la raison des ombres et miroirs, Londres 1612. – Anne... Claude de CAYLUS, Nouveaux sujets de peinture et sculpture, Paris 1755. – Roland Freart de CHAMBRAY, Parallèle de l'Architecture antique et de la moderne, Paris 1650. – Idée de la perfection de la peinture..., Mans 1662. – Charles-Nicolas COCHIN, Voyage d'Italie, ou recueil de notes sur les ouvrages de Peinture et de Sculpture qu'on voit dans les principales villes d'Italie, 3 vol., Paris 1769. – Louis-Géraud de CORDEMOY, Nouveau traité de toute l'Architecture, Paris 1706. – Jean COURTONNE, Traité de la Perspective pratique, avec des remarques sur l'Architecture, ..., Paris 1725. – Charles-Antoine COYPEL, Discours prononcés dans les conferences de l'Académie Royale, Paris 1721. – Discours sur la peinture, Paris 1732. – Nic.-F. de CUREL, Essai sur la perspective linéaire et sur les ombres, Strasbourg 1766. – Michel-François DANDRE-BARDON, Traité de

Peinture, Paris 1772. – Augustin Charles D'AVILER (DAVILER), Cours d'Architecture, 2 vol., Paris 1691. – Girard DESARGUES, Exemple de l'une des manières universelles du S.G.D.L. (Girard Desargues, lyonnais) touchant la pratique de la Perspective..., Paris 1636. – Antoine DESGODETZ, Les édifices de Rome dessinés et mesurés exactement, Paris 1682. – Denis DIDEROT, Le Dessein, in: Encyclopédie ou Dictionnaire raisonné des Sciences, des Arts et des Métiers, Paris 1747-1766. – Essai sur la Peinture, Paris 1796. – Le Salon, Paris 1798. – Jean DUBREUIL, La Perspective practique, 3 vol., Paris 1642-1649. – Charles-Alphonse DU FRESNOY, De arte graphica, Paris 1667. – L'art de la Peinture (avec le dialogue sur les couleurs et les notes de Roger de Piles), Paris 1668. – DU PAIN DE MONTESSON, La Science des ombres par rapport au dessin. Avec le dessinateur au Cabinet et à l'Armée, Paris 1750. – B. DUPUY DU GREZ Traité sur la Peinture pour en apprendre la théorie et se perfectionner dans la Pratique, Toulouse 1699. – ESTEVE, Dialogues sur les Arts entre un artiste américain et un amateur français, Amsterdam 1756. – (Abbé) de FONTENAI, Dictionnaire des Artistes ou Notice historique et raisonnée des Architectes, Peintres, Graveurs, 2 vol., Paris 1776. – André FÉLIBIEN, Entretiens sur les Vies et les Ouvrages des plus excellents Peintres anciens et modernes, 5 vol., Paris 1666-1688. – Des Principes de l'Architecture, de la Sculpture et des autres Arts, qui en dépendent, avec un dictionnaire des termes propres à chacun de ces Arts, Paris 1676. – Conférences de l'Académie Royale pendant l'année 1667, Paris 1669. – Roland FREART, Parallèle de l'Architecture antique et de la moderne avec un recueil des dix principaux auteurs qui ont écrit des cinq ordres..., Paris 1650. – Idée de la perfection de la peinture, Paris 1662. – LE GUIDE des Jeunes Dessinateurs, Paris 1783. – Henricus HONDIUS, Instruction en la Science des Perspectives, Haag 1625. – Charles-Antoine JOMBERT, L'Architecture moderne, ou l'Art de bien bâtir pour toutes sortes de personnes..., 2 vol., Paris 1728. – Nouvelle Méthode pour apprendre à dessiner sans Maître, Paris 1740. – Méthode pour apprendre le dessein,... enrichie de 100 planches représentant différentes parties du Corps Humain d'après Raphaël et les autres grands Maîtres, plusieurs Figures Académiques dessinées d'après nature par M. Cochin, les proportions et les mesures des plus beaux Antiques qui se voient en Italie, et quelques études d'Animaux et de Paysage, Paris 1755. – Bibliothèque portative d'architecture élémentaire. à l'usage des artistes, divisée en 6 parties..., 2 vol., Paris 1764-1766. – Théorie de la figure humaine, considérée dans ses principes, soit en repos, soit en mouvement, ouvrage traduit du latin de Pierre Paul Rubens par C.-A. Jombert, Paris 1773. – L'œuvre de Sébastien Leclerc, 2 vol., Paris 1774. – De LA FONTAINE, Académie de la Peinture, nouvellement mise au jour pour instruire la jeunesse à bien peindre en huile et en miniature..., Paris 1679. – C.M. de LAGARDETTE, Règle des cinq ordres d'architecture de Vignole... Paris 1786. – Leçons élémentaires des ombres dans l'architecture, Paris 1797. – Nouvelles règles pour la pratique du dessin et du lavis..., Paris 1803. – Gerard de LAIRESSE, Het Groot Schilderboek, Amsterdam 1707. – Les Principes du Dessein, Amsterdam 1719. – Marc-Antoine LAUGIER, Essai sur l'Architecture, Paris 1753-1755. – Observations sur l'Architecture, La Haye-Paris 1765. – Manière de bien juger des ouvrages de Peinture, Paris 1771. – Johann Caspar LAVATER, Physiognomonische Fragmente zur Beförderung der Menschenkenntnisse und Menschenliebe..., Leipzig und Winterthur 1775-1778. – French edition: Essai sur la physiognomonie destiné à faire connoître l'homme et à le faire aimer..., 4 vol., La Haye 1781-1802. – Elements anatomiques d'Ostéologie et de Myologie à l'usage des Peintres et Sculpteurs, traduits de l'allemand par Gauthier de la Peyronie, ..., Paris 1797. – Charles LE BRUN, Méthode pour apprendre à dessiner les passions, ..., Paris 1667. – Conference de M. Le Brun sur l'expression générale et particulière, ..., Paris 1698. – Nicolas LECAMUS DE MÉZIÈRES, Le génie de l'Architecture ou l'analogie de cet art avec nos sensations, Paris 1780. – Sébastien LE CLERC, Pratique de la Géométrie, sur le papier et sur le terrain, Paris 1669. – Discours touchant le point de vue, Paris 1679. – Les Caractères des passions gravées sur les dessins de l'illustre Le Brun..., n.p. 1696. – Traité d'Architecture avec des remarques et des observations très utiles pour les jeunes gens qui veulent s'appliquer à ce bel art, Paris 1714. – Traité de géométrie théorique et pratique à l'usage des artistes..., Paris 1744. – Antoine LE PAUTRE, Les œuvres d'Architecture, Paris 1652. – Jean-Etienne LIOTARD, Traité des Principes et des

Règles de la Peinture, Genève 1781. – P.J. MARIETTE, Abecedario d'Orlandi ... Abecedario pittorico dall'Autore, nell'anno 1727, ristampato, corretto e accresciuto di molte professori e di altre notizie spettanti alla pittura, Manuscript 1727. – Description sommaire des dessins des grands maistres d'Italie, des Pays-Bas et de France, du cabinet de feu M. Crozat, avec des réflexions sur la manière de dessiner des principaux peintres, Paris 1741. – Eclaircissements sur quelques ouvrages de Pline concernant les arts qui dépendent du dessin, Manuscript 1745. – Samuel MAROLOIS, Perspective contenant la Théorie et Practicque, d'icelle, La Haye 1614-1615. – Opticae, sive perspectivae, partes quatuor, Amsterdam 1633. – La Perspective contenant tant la Théorie que la Pratique remise en volume plus commode que auparavant, Amsterdam 1638. – La Perspective contenant la Théorie, Practique, et Instruction fondamentale... par Jan Vredeman Frisoner, augmentée et corrigée en divers endroits par Samuel Marolois, Amsterdam 1651. – Estienne MIGNON, La Perspective spéculative et pratique où sont demontrez les fondemens de cet art, Paris 1643. – Pierre MONIER, Histoire des Arts qui ont rapport au dessin..., Paris 1698. – Charles MONNET, Etudes d'anatomie à l'usage des peintres, Paris n.d. – Jean-François NICERON, La Perspective curieuse..., Paris 1638. – ... Taumaturgus opticus..., Paris 1646. – R.M. PARISET, Nouveau livre des principes de dessein recüeilli des Etudes des meilleurs Maitres tant anciens que modernes, Paris n.d. – Pierre PATTE, Discours sur l'Architecture, Paris 1754. – Mémoires sur ... l'Architecture, Paris 1769. – Essai sur l'Architecture théâtrale, Paris 1782. – Charles PERRAULT, Parallèles des anciens et des modernes en ce qui regarde les Arts et les Sciences, Amsterdam 1693. – Claude PERRAULT, Ordonnances de cinq espèces de colonnes selon la méthode des Anciens, Paris 1676. – Edmond-Alexandre PETITOT, Raisonnement sur la perspective, pour en faciliter l'usage aux Artistes. Ragionamento sopra la prospettiva per agevolarne l'uso ai professori, Parme 1758. – Roger de PILES, Eléments de peinture pratique..., Paris 1684. – L'Idée du peintre parfait, préface à l'Abrégé de la vie des peintres..., Paris 1699. – Dialogue du Coloris, Paris 1699. – Cours de Peinture par principes, Paris 1708. – De SAINT-MORIEN, La Perspective Aérienne, soumise à des principes puisés dans la Nature; ou Nouveau Traité de Clair-Obscur et de Chromatique, à l'usage des artistes, avec figures, Paris 1788. – TANUDE, Traité d'Anatomie, d'Ostéologie et de Miologie nécessaire au Dessin, Paris n.d. (late 18th century). – Henri TESTELIN, Sentiments des plus habiles peintres sur la pratique de la peinture et sculpture mis en table de précepts, Paris 1680 and 1696. – François TORTEBAT, Abrégé d'anatomie accomodé aux Arts de Peinture et Sculpture. Ouvrage très utile et très nécessaire à tous ceux qui font profesion du dessein..., Paris 1760. – TRAITÉ abrégé du dessein et de la peinture en mignature, Genève 1750. – TRAITÉ de la Peinture en Mignature pour apprendre aisément à peindre sans Maître, La Haye 1708. – J.L. VAULEZARD, Perspective cylindrique et cônique..., ou traicté des apparences veuës par le moyen des miroirs cylindriques ou côniques..., Paris 1630. – Claude-Henri DE WATELET, L'Art de peindre, Poème avec des Réflexions sur les différentes parties de la Peinture, Paris 1760. – Essai sur les Jardins, Paris 1772. – Dictionnaire des Arts de Peinture, Sculpture et Gravure, 5 vol., Paris 1792.

Germany

Johann Dominicus FIORILLO, Geschichte der zeichnenden Künste von ihrer Wiederauflebung bis auf die neuesten Zeiten, von J.D. Fiorillo..., 5 vol., Göttingen 1798-1808. – Geschichte der zeichnenden Künste: Geschichte der Malerei..., Göttingen 1798. – Geschichte der zeichnenden Künste in Deutschland und den vereinigten Niederlanden, von J.D. Fiorillo..., 4 vol., Hannover 1815-1820. – Johann Rudolf FÜSSLI, Künstler-Lexicon allgemeines, Zürich 1763. – Salomon GESSNER, Brief über die Landschaftsmahlerey an Herrn Füesslin, Zürich 1787. – George Christoph GÜNTHER, Praktische Anweisung zur Pastellmalerei, Nürnberg 1792. – Christian Ludwig von HAGEDORN, Betrachtungen über die Mahlerey, 2 vol., Leipzig 1762. – Johann Daniel HERTZ, Natura artis studio feliciter repraesentata... oder gründliche und vollkommene Anweisung zum Zeichnen und kunstmässige völlige Ausarbeitung menschlicher Statur..., Augsburg 1723. – P. Athanasius KIRCHER, Athanasii Kircheri..., Ars magna lucis et umbrae..., Libri X, Roma 1646. – Anton Raphael MENGS, Gedanken über die Schönheit und den Geschmak in der Malerey...,

Zürich 1774. – *Hinterlassene Werke*, 3 vol., Halle 1786. – Friedrich Christoph MÜLLER, *Gebrauch der Transparente zum zeichnen nach der Natur: nebst einer Anleitung zum portraitieren*, Frankfurt und Leipzig 1776. – Peter MUELLER, *De pictura sive praecognita pictura, de excellentia artis pictoriae, de privilegiis iam picturae quam pictorum, de abusu picturae et poena pictorum*, Jena 1692. – Johann Daniel PREISSLER, *Die durch Theorie erfundene Practic, oder gründlich-verfasste Reguln deren man sich als einer Anleitung zu berühmter Künstlere Zeichen-Wercken bestens bedienen kan*, 3 vol., Nürnberg 1728-1731. – Joseph Friedrich von RACKNITZ, *Darstellung und Geschichte des Geschmacks der vorzüglichsten Völker, in Beziehung auf die neuere Auszierung der Zimmer und auf die Baukunst*, Leipzig 1736. – *Briefe über die Kunst an eine Freundinn*, Dresden 1792. – Friedrich Eberhard RAMBACH, *Einige Gedanken über den Werth und Nutzen der Alterthumskunde für die bildenden Künstler...*, Berlin 1794. – Friedrich Wilhelm Basil von RAMDOHR, *Charis, oder über das Schöne und die Schönheit in den nachbildenden Künsten*, 2 vol., Leipzig 1793. – Christian Rudolph REINHOLD, *Die Zeichen- und Mahlerschule*, Münster und Osnabrück 1786. – Joachim von SANDRART, *Teutsche Academie der edlen Bau-Bild- und Mahlerey-Künste...*, 2 vol., Nürnberg 1675-1679. – Joannes SCHEFFER, *Graphice, id est de arte pingendi liber singularis*, Nürnberg 1669. – Johann Georg SULZER, *Allgemeine Theorie der schönen Künste...*, 2 vol., Leipzig-Berlin 1771-1774. – Georg Heinrich WERNER, *Nützlich Anweisung zu der Zeichenkunst deren Blumen, oder wie ein jeder auf eine sehr leichte Art nach geometrischen und perspektivischen Grundsätzen im Nachzeichnen derer Blumen verfahren soll*, Erfurt 1765. – *Werners Anweisung, alle Arten von Prospekten nach den Regeln der Kunst und Perspektiv von selbst zeichnen zu lernen, nebst einer Anleitung zum Plafond- und Freskomalen für Zeichner, Maler, Bildhauer, und alle Arten von Künstler...*, Erfurt 1781. – Johann Joachim WINCKELMANN, *Gedanken über die Nachahmung der griechischen Werke in der Mahlerey und Bildhauerkunst*, Dresden 1755. – *Abhandlung von der Fähigkeit der Empfindung des Schönen in der Kunst...*, Dresden 1763. – *... Geschichte der Kunst des Alterthums*, 2 vol., Dresden 1764. – *Versuch einer Allegorie besonders für die Kunst*, Dresden 1766.

Italy

Pietro ACCOLTI, *Lo Inganno degli Occhi, Prospettiva pratica... Trattato in acconcio della Pittura*, Firenze 1625. – Francesco ALGAROTTI, *Saggio sopra l'Architettura*, Pisa 1753. – *Saggio sopra la Pittura*, Bologna 1762. – *Saggi sopra l'Accademia di Francia..., in Roma*, Livorno 1763. – Filippo BALDINUCCI, *Notizie de' Professori del Disegno da Cimabue in qua*, 21 vol., Firenze 1681-1728. – *Vocabolario toscano delle Arti del Disegno*, Firenze 1681. – *Lettera al Marchese Capponi, nella quale risponde ad alcuni quesiti in materia di Pittura*, Firenze 1687. – *La Veglia o Dialogo di sincero veri, in cui si disputano e sciolgono varie difficultà pittoriche*, Firenze 1690. – *Lettera ... intorno al modo di dar Proporzione alle Figure in Pittura e Scultura...*, Livorno 1802. – Pietro Antonio BARCA, *Avvertimenti e regole circa l'architettura civile, scultura, pittura...*, Milano 1620. – Laurenzo BELLINI, *Exercitatio Anatomica de Structura e Usu rerum...*, Amstelodami 1665. – Giovan Pietro BELLORI, *Le Vite de' Pittori, scultori ed architetti moderni...*, Roma 1672. – Saverio BETTINELLI (Diodoro DELFICO), *Lettere XX di una Dama ad una sua Amica sulle belle arti*, Venezia 1793. – Fra D. Francesco BISAGNO, *Trattato della Pittura fondato nell'autorità di molti eccelenti in questa professione, fatto a comune beneficio de' virtuosi*, Venezia 1642. – Federico BORROMEO, *De Pictura sacra*, Libri duo, Milano 1634. – Francesco BORROMINI, *Opus Architectonicum...*, Roma 1735. – Giovanni Gaetano BOTTARI, *Dialoghi sopra le tre arti del Disegno*, Lucca 1754. – Giovanni BRANCA, *Manuale d'Architettura cioè breve e risoluta pratica in sei Libri*, Ascoli 1629. – Fabricio CAPRINI MOTTA, *Trattato sopra la struttura de' Teatri e Scene che a' nostri giorni si costumano*, Guastalla 1676. – Gaspare COLOMBINA, *Discorso distinto in IV capitoli, nel I de' quali si discorre del Disegno e modi di esecitarsi in esso, nei II della Pittura...*, Padova 1623. – A. COMOLLI, *Bibliografia storico-critica dell'architettura*, Roma 1791. – Bernardino CONTINO, *La Prospettiva pratica...*, Venezia 1684. – Giovan Francesco COSTA, *Elementi di Prospettiva per uso degli Architetti e Pittori*, Venezia 1747. – Odoardo FIALETTI, *Il vero modo et ordine per* disegnar tutte le parti e membra del corpo humano, diviso in piu pezzi, in Venetia 1608. – Antonio FRANCHI, *La Teorica della Pittura, ovvero Trattato delle materie più necessarie per apprendere con fondamento quell'Arte...*, Lucca 1739. – Giacomo FRANCO, *Della Nobiltà del disegno, diviso in due libri...*, in Venetia 1611. – Teofilo GALLACINI, *Trattato sopra gli errori degli Architetti*, Venezia 1767. – Ferdinando GALLI-BIBIENA, *L'Architettura civile preparata sulla geometria e ridotta alle Prospettive, considerazioni pratiche*, Parma 1711. – *Direzioni a' Giovani Studenti nel Disegno dell'Architettura Civile, nell'Accademia Clementia dell'Instituto delle Scienze...*, Venezia 1725. – Giuseppe GALLI DA BIBIENA, *Architetture e prospettive...*, Augustae 1740. – B. GENCA, *Anatomia per uso e intelligenza del Disegno*, n.p. 1691. – C. GIGLI, *La Pittura trionfante scritta in IV Capitoli*, Venezia 1615. – Francesco LANA, *Podromo: overo Saggio di Alcune Inventioni, Nuovo Premesso dell'Arte Maestra*, Brescia 1670. – Luigi LANZI, *Storia Pittorica dell'Italia...*, Bassano 1789. – Carlo Cesare MALVASIA, *Felsina Pittrice. Vite de' Pittori Bolognesi*, Bologna 1678. – Girolamo MASI, *Teoria e pratica di Architettura civile...*, Roma 1788. – Francesco MILIZIA, *Dell'Arte di vedere nelle belle Arti del Disegno secondo i principi di Sultzer di Mengs*, Venezia 1781. – *Dizionario delle belle Arti del Disegno*, Bassano 1787. – Giovanni Battista MONTANO, *Libro d'Architettura*, Roma 1608. – Guidobaldo DEL MONTE, *Perspectivae libri sex*, Pesaro 1600. – G. MORO, *Anatomia ridotta all'uso de' Pittori e Scultori*, n.p. 1679. – Ludovico Antonio MURATORI, *Riflessioni sopra il buon gusto*, Colonia 1721. – Carlo Cesare OSIO, *Architettura Civile*, Milano 1641. – Giandomenico OTTONELLI, S.J. Pietro da CORTONA, *Trattato della Pittura e Scultura, uso ed abuso loro, composto da un Theologo e da un Pittore, per offrirlo ai Sigg. Accademici del Disegno di Firenze*, Firenze 1652. – Giovan Battista PAGGI, *Definizione e divisione della Pittura*, Genova 1607. – Jacopo PALMA, *Regole per imparare a Disegnare i Corpi Humani*, Venezia n.d. (1636). – Lione PASCOLI, *Vite de' Pittori, Scultori ed Architetti Moderni*, 2 vol., Roma 1730-1736. – Giovanni Battista PASSERI, *Vite de' Pittori, Scultori ed Architetti...*, Roma 1772. – Andrea POZZO (PUTEUS), *Perspectiva Pictorum et Architectorum*, Roma 1693-1702. – Carlo RIDOLFI, *Le Meraviglie dell'Arte*, 2 vol., Venezia 1648. – Salvator ROSA, *Satire*, Amsterdam n.d. (c. 1664). – Vincenzo SCAMOZZI, *Dell'Idea dell'Architettura universale*, Venezia 1615. – Francesco SCANNELLI, *Microcosmo della Pittura*, Cesena 1657. – L. SCARAMUCCIA, *Le Finezze de' pennelli italiani*, Pavia 1674. – Giovanni Antonio SELVA, *Catalogo dei quadri, dei disegni e dei libri che trattano dell'arte del disegno della Galleria del fu Sig. Conte Algarotti in Venezia*, Venezia n.d. (1776). – Pietro TESTA, *Trattato di Pittura* (manuscript). – Giuglio TROILI (PARADOSSO), *Paradossi per praticare la prospettiva senza saperla...*, Bologna 1672. – Guido UBALDO, *Perspectivae Libri sex*, Pesaro 1600. – G. VIOLA ZANINI, *Dell'Architettura, Libri due*, Padova 1629. – E. ZANNOTTI, *Trattato teorico-pratico di Prospettiva*, Bologna 1766. – Gianpietro ZANOTTI, *Storia dell'Accademia Clementina di Bologna*, Bologna 1739. – *Avvertimenti per l'incamminamento di un giovane alla pittura*, Bologna 1756. – Federico ZUCCARO, *L'Idea de' Scultori, Pittori e Architetti divisa in due Libri*, Torino 1607.

Low Countries

Franciscus AGUILONIUS, *Opticorum Libri VI*, Anversae 1630. – Godefroy BIDLOO, *Godefridi Bidloo Anatomia humani corporis, centum et quinque tabulis per... G. de Lairesse ad vivum delineatis...*, Amsterdam 1685. – Petrus CAMPER, *Verhandeling over het Natuurlijk verschil der Wezenstrekken in Menschen van onderscheiden Landaart en Ouderdom... over het schoon in Antyke beelden en Gesneeden steenen...; eene nieuwe Monnier om hoofden... te tekenen...*, Utrecht 1731. – Wilhelm GOEREE, *Inleyding tot de Praktyk der Algemeene Schilderkonst*, Middelburgh 1670. – *Natuurlyk en Schilderkonstig Antwerp der Menschkunde...*, Amsterdam 1683. – G. Jacob S'GRAVESANDE, *Verhandeling over perspectief*, Den Haag 1711. – Gerard HOET, *Ontslote deure der tekenkunst...*, Leeuwarden 1713. – Samuel van HOOGSTRATEN, *Inleyding tot de hooge schoole der schilderkonst, anders de zichtbaere verdeelt, in negen leerwinkels, van besteedt doort eene der zanggodinnen...*, Middelburgh 1641. – Franciscus JUNIUS (du JON), *De schilder-konst der ouden begrepen in drie boecken*, Middelburg 1641. – *De pictura veterum...*, Amsterdam 1637. – Karel VAN MANDER, *Het Leven der Moderne oft dees-tijtsche doorluchtinge* *Italiensche Schilders...*, Alkmaar 1603. – *Het Schilder-boeck, waer in voor eerst de leerlustighe jueght den «Grondt der edel vry schilderconst» in verscheyden deelen wort voorghedraghen...*, Haerlem 1604. – Chrispijn VAN DE PASSE, *Van't light der Teken-en Schilderkonst..., De la lumière de la peinture et de la desseing...*, Amsterdam 1643. – Jacob DE WIT, *Teekenboek der Proportien van't Menschelyke Lighaam*, Amsterdam 1747.

Spain

Vicente CARDUCHO, *Dialogos de la pintura*, Madrid 1633. – Jose Garcia HIDALGO, *Principios para estudiar el arte de la pintura*, 1691. – Felippe NUNEZ, *Arte poetica e da pintura, e symetria, con principios da perspectiva*, Lisboa 1615. – *Arte de pintura*, Lisboa 1767. – Francisco PACHECO, *Arte de la pintura, su antiguedad y grandezas...*, Sevilla 1649.

19th century

England

R. L. BEAN, *Anatomy for the use of Artists*, London 1841. – Charles BELL, *Essays on the Anatomy of Expression in Painting*, London 1806. – R. BROWN, *Principles of Practical Perspective*, London 1815. – E. EDWARDS, *A Practical Treatise of Perspective*, London 1803. – T. H. FIELDING, *Synopsis of Practical Perspective lineal and aerial*, London 1829. – John FLAXMAN, *Anatomical Studies of the Bones and Muscles for the use of Artists*, London 1833. – E. GARBETT, *Rudimentary treatise on the principles of design in architecture*, London 1850. – J. GARRY, *Introduction to Perspective*, London 1820. – *Treatise on Perspective*, London 1826. – George HAMILTON, *The Elements of Drawing*, London 1827. – J.D. HARDING, *The Principles and Practice of Art*, London 1845. – D.R. HAY, *The Natural Principles of Beauty, as developed in the Human Figure*, London 1852. – C. HAYTER, *An Introduction to Perspective*, London 1813. – R. KNOX, *A Manual of Artistic Anatomy*, London 1852. – J. MARSHALL, *Anatomy for Artists*, London 1878. – *A Rule of Proportion for the Human Figure*, London 1879. – Mary Ph. MERRIFIELD, *Original Treatises... on the Arts of Painting*, 2 vol., London 1849. – W.Y. OTTLEY, *The Italian School of Design being a series of facsimilis of original drawings by the most eminent painters*, London 1823. – G. SIMPSON, *The Anatomy of the Bones and Muscles as applicable to the Fine Arts*, London 1825. – J. TINNEY, *A Compendious Treatise of Anatomy adapted to the Arts of Designing*, London 1827. – H. WARREN, *Artistic Anatomy of the Human Figure*, London 1852. – Nathaniel WHITTOCK, *The Art of Drawing and Colouring from Nature, Flowers, Fruit and Shells*, London 1829. – J. WOOD, *Elements of Perspective*, London 1799.

France

J. ADHÉMAR, *Traité de perspective à l'usage des artistes*, Paris 1836. – *Traité des ombres*, Paris 1840. – Gérard AUDRAN, *Les Proportions du Corps humain, mesurées sur les plus belles Figures de l'Antiquité*, Paris 1801. – (Ch. BARGUE et J.L. GÉRÔME), *Des modèles de Dessin*, Paris 1868. – Charles BAUDELAIRE, *L'Art romantique, Curiosités esthétiques, Variétés critiques*, Paris 1859. – Charles BLANC, *Grammaire des arts du dessin. Architecture, sculpture, peinture, jardins, gravure... eau-forte... camaïeu... lithographie...*, Paris 1867. – Etienne BONNAND, *Le Dessin*, Privas 1896. – François Joseph BOSIO, *Traité élémentaire des Règles du Dessin*, Paris 1801. – C. BOUTEREAU, *Nouveau manuel complet du dessinateur ou traité théorique et pratique de l'art du dessin*, Paris 1847. – F. BRACQUEMOND, *Du dessin et de la couleur*, Paris 1865. – A. CASSAGNE, *Traité pratique de Perspective*, Paris 1866. – *Guide de l'alphabet du dessin ou L'art d'apprendre et d'enseigner les principes rationnels du dessin d'après nature*, Paris 1880. – *Le dessin enseigné par les Maîtres*, Paris 1890. – Jules Antoine CASTAGNARY, *Salons 1857-1870*, Paris 1892. – Marie Elisabeth CAVÉ, *Le Dessin sans maître, méthode pour apprendre à dessiner de mémoire...*, Paris 1850. – *L'Aquarelle sans maître, méthode pour apprendre l'harmonie des couleurs*, Paris 1851. – A. CHARLES, *Traité de perspective linéaire comprenant les ombres et les réflexions...*, Paris n.d. – E.L.G. CHARVET, *De l'étude de la composition dans l'enseignement des arts du dessin*, Paris 1882. – M. CHAUSSIER, *Recueil anatomique à l'usage des Jeunes Gens qui se destinent à l'étude de la chirurgie, de la médecine, de la peinture et de*

la sculpture, Paris 1820. – A. CHEVILLARD, *Leçons nouvelles de perspective*, Paris 1868. – Michel Eugène CHEVREUL, *Loi du contraste simultané des couleurs*, Paris 1838. – Charles CHOQUET, *Traité de perspective linéaire à l'usage des artistes*, Paris 1823. – Chr. CLOPET, *Leçons élémentaires de perspective linéaire*, Paris 1884. – *Géométrie descriptive. Etude du Point et de la Droite*, Paris 1884. – *Etude des Applications perspectives*, Paris 1885. – Victor COUSIN, *Du vrai, du beau et du bien*, Paris 1858. – Edouard CUYER, *Eléments d'Anatomie des Formes*, Paris 1888. – *Le Dessin et la Peinture*, Paris 1893. – Eugène DELACROIX, *De l'enseignement du dessin par Eugène Delacroix*, in: *Revue des Deux Mondes*, Paris 1850. – *Journal, précédé d'une étude par P. Flat, Notes et éclaircissement par P. Flat et R. Piot*, Paris 1893-1895. – Louis DELAISTRE, *Cours méthodique du dessin et de la peinture*, 3 vol., Paris 1842. – J.B. DELESTRE, *De la Physiognomonie*, Paris 1866. – J. DUMESNIL, *Histoire des plus célèbres amateurs français et de leurs relations avec les artistes*, Paris 1858. – Marcel DURRIEU, *Cours pratique de dessin d'après les objets usuels*, Paris n.d. (1891). – Michel-François DUTENS, *Principes abrégés de Peinture*, Tours 1803. – Amaury DUVAL, *Monuments des arts du dessin chez les peuples tant anciens que modernes, recueillis par le Baron Vivant Denon ... pour servir à l'histoire des arts*, 4 vol., Paris 1839. – Mathias DUVAL, *Anatomie artistique, cours professé à l'Ecole des Beaux-Arts* (manuscript, 1884). – *Précis d'Anatomie à l'usage des artistes*, Paris 1891. – Mathias DUVAL et Albert BICAL, *L'Anatomie des Maîtres*, Paris 1890. – Mathias DUVAL et Edouard CUYER, *Histoire de l'Anatomie plastique. Les Maîtres, les Livres et les Ecorchés*, Paris n.d. (1898). – Pierre ESCUYER, *Traité élémentaire de perspective à l'usage des Peintres, Graveurs, Sculpteurs et Amateurs des Beaux-Arts*, Genève 1824. – Antoine ETEX, *Cours élémentaires de dessin par Antoine Etex, statuaire, architecte et peintre*, Paris 1859. – J. FAU, *Anatomie des Formes du Corps Humain, à l'usage des peintres et des sculpteurs*, Paris 1865. – G. FRAIPONT, *L'art de prendre un croquis et de l'utiliser*, ..., Paris n.d. (1892). – *Le dessin à la plume*, Paris n.d. (1895). – *Le Crayon et ses fantaisies, sanguine, crayon noir, crayon blanc, etc.*, Paris n.d. (1896). – *L'art d'utiliser ses Connaissances en Dessin*, Paris n.d. – José FRAPPA, *Les expressions de la physionomie humaine*, Paris n.d. – Théophile GAUTIER, *Les Beaux-Arts en Europe*, Paris 1855. – *L'Art moderne*, Paris 1856. – Frédéric GILLET, *Enseignement collectif du dessin par démonstrations orales et graphiques*, Paris 1869. – Edmond et Jules de GONCOURT, *Etudes d'Art*, Paris 1893. – F. A. A. GOUPIL, *Traité d'aquarelle et de lavis en six leçons, avec planche ornementale pour servir à l'intelligence de la théorie universelle des mélanges et des contrastes de la couleur*, ..., Paris 1858. – *Le Pastel, simplifié et perfectionné*, ..., Paris 1858. – *Géométrie populaire artistique et dessin linéaire familier, ... suivi du dessin d'après nature, sans maître; système d'Abraham Bosse et de Cavé, perfectionné par Goupil*..., Paris 1859. – *La Perspective expérimentale, ou l'Orthographe des formes à l'usage des amateurs et des artistes peintres, sculpteurs et architectes*, ..., Paris 1860. – *L'Aquarelle et le Lavis appliqués à l'étude de la figure en général, du portrait d'après nature, du paysage, de la marine, des animaux et des fleurs*, ..., Paris 1861. – *Le dessin mis à la portée de toutes les intelligences, orné de 44 sujets d'étude graduée*, Paris 1862. – *L'art de dessiner, mis à la portée de tous*..., Paris 1363. – *Traité du dessin au trait en général et de l'ornement, contenant les principes les plus faciles à l'usage des industries artistiques et des écoles professionnelles*..., Paris 1869. – *Traité méthodique et général du dessin, du coloris, de l'aquarelle et du lavis appliqués à l'étude de la figure*, ..., Paris 1876. – *Traité de paysage mis à la portée de tous*, Paris n.d. (1882). – *Le dessin expliqué à tous, appliqué à l'intelligence de la Nature et à l'étude des Arts qui, toutes deux, révèlent à l'homme la connaissance du Beau!*, Paris n.d. – Henri GUERLIN, *L'art enseigné par les Maîtres: le Dessin*, Paris n.d. – Eugène GUILLAUME, *Essais sur la théorie du dessin et de quelques parties des arts*..., Paris 1896. – François GUIZOT, *Etudes sur les Beaux-Arts, Salon de 1801*, Paris 1852. – Henry HAVARD, *Lettre sur l'enseignement des Beaux-Arts*, Paris 1879. – L.F. von HELMUTZ, E. W. BRÜCKE, *Principes scientifiques des Beaux-Arts*, Paris 1878. – Pierre François JACOBS, *Etudes Anatomiques de l'homme dessinées à Rome*..., Bruxelles 1861. – Théodore JOUFFROI, *Cours d'Esthétique* (1822), Paris 1843. – J.-B.-O. LAVIT, *Traité de perspective*..., 2 vol., Paris an XII (1804). – Claude-Nicolas LEDOUX, *L'Architecture considérée sous le rapport de l'Art, des Mœurs et de la Législation*, Paris 1804. – Louis-Nicolas LESPINASSE, *Traité de perspective linéaire*..., Paris an IX (1801). – J.-B. LÉVEILLÉ, *Méthode nouvelle d'anatomie artistique*..., Paris 1863. – Gaspard MONGE, *Géométrie descriptive*, Paris 1800. – Paillot de MONTABERT, *Traité complet de la Peinture*, Paris 1829. – Jean-Baptiste OUDRY, *Discours sur la pratique de la peinture et ses procédés principaux: ébaucher peindre à fond et retoucher*, dans: *Le Cabinet de l'Amateur* 1861-1862. – J.-L.-G.-B. PALAISEAU, *Traité de perspective à l'usage des peintres, architectes et graveurs et généralement de tous ceux qui s'occupent du dessin*, Paris 1818. – Pierre-Joseph PROUDHON, *Du Principe de l'art et de sa destination sociale*, Paris 1865. – Antoine-Chrysostome de QUATREMÈRE DE QUINCY, *Considérations sur les Arts du Dessin en France*, Paris 1791. – *Essai sur la nature, le but et les moyens de l'imitation dans les beaux-arts*, Paris 1823. – *Essai sur l'idéal*, Paris 1837. – *Discorso storico di architettura*, Mantova 1842. – Etienne REY, *Méthode analytique, mnémonique et synthétique pour l'enseignement du dessin*, Paris 1834. – Paul RICHER, *Anatomie artistique. Description des formes extérieures du corps humain au repos et dans les principaux mouvements*, Paris 1890. – Karl ROBERT, *Le Fusain sans maître*, Paris 1874. – *Précis d'aquarelle*, Paris 1894. – Charles ROCHET, *Traité d'anatomie, d'anthropologie et d'ethnographie appliqué aux Beaux-Arts*, Paris 1886. – Amaranthe ROUILLET, *Nouveau manuel pour apprendre sans maître, par un procédé infaillible les proportions de la tête, de l'académie et les principes généraux en tous genres de la perspective*..., Paris 1857.

– Guillet de SAINT-GEORGES, *Mémoires inédits sur la vie et les ouvrages des membres de l'Académie Royale de peinture et de sculpture*, 2 vol., Paris 1854. – Rodolphe TOEPFFER, *Essai de Physiognomonie*, Genève 1845. – Jean-Pierre THENOT, *Essai de perspective pratique pour ... dessiner d'après nature*..., Paris 1826. – *Cours complet de dessin linéaire et perspectif, démontrant les variations de l'apparence de formes des corps ainsi que leurs ombres et reflets, etc.*..., Paris 1836. – *Principes de perspective pratique mis à la portée de tout le monde*..., Paris 1837. – *Morphographie, ou l'Art de représenter fidèlement toutes les formes et apparences des corps solides par le dessin linéaire et perspectif, traité élémentaire*..., Paris 1838. – *Les règles du lavis et de la peinture à l'aquarelle appliquées au paysage*..., Paris 1840. – *La Miniature mise à la portée de toutes les intelligences*..., Paris 1856. – *Le Pastel appris sans maître, orné du tableau contenant les six couleurs six fois graduées*..., Paris 1856. – Pierre-Henri DE VALENCIENNES, *Eléments de Perspective pratique à l'usage des artistes, suivis de réflexions et conseils à un élève sur la peinture et particulièrement sur le genre du paysage*, Paris 1799-1800. – L.L. VALLÉE, *Traité de la science du dessin contenant la théorie générale des ombres, la perspective, etc... pour faire suite à la géométrie descriptive du même*, 2 vol., Paris 1821. – Edmond VALTON, *Le dessin. Théorique et Pratique*, Paris n.d. – Eugène VIOLLET LE DUC, *Dictionnaire raisonné de l'architecture française du XI*[e] *au XVI*[e] *siècle*, ..., 10 vol., Paris 1868. – *Ce que réclame au XIX*[e] *siècle l'enseignement de l'architecture*, ..., Paris 1869. – *Enseignement du dessin dans les établissements scolaires de Paris*, Paris 1875. – *Conférence de M. Viollet-Leduc sur l'enseignement des arts du dessin (au Palais de l'Industrie, le 19 octobre 1876)*, Paris n.d. (1876). – *Histoire d'un dessinateur. Comment on apprend à dessiner*, Paris n.d. (1879). – *Comment on devient un dessinateur*, Paris n.d. (1885). – Louis VITET, *L'Académie Royale de Peinture et de Sculpture*, Paris 1861.

Germany

C. BRÜNNER, *Anatomie für Künstler, Zeichen- und Turnlehrer*, Kassel 1897. – Konrad FIEDLER, *Schriften über Kunst*, Leipzig 1896. – Hans FREYBERGER, *Perspektive nebst einem Anhang über Schattenkonstruktion und Parallelperspektive*, Leipzig 1899. – G. HAUCK, *Die malerische Perspektive, ihre Praxis, Begründung und ästhetische Wirkung*, Berlin 1882. – Adolf HILDEBRANDT, *Das Problem der Form in der bildenden Kunst*, 1893. – Guido SCHREIBER, *Malerische Perspektive*, Karlsruhe 1854. – *Lehrbuch der Perspektive*, Leipzig n.d. – Gottfried SEMPER, *Der Stil in den technischen und tektonischen Künsten*, München 1878-1879.

Italy

Fr. ALBERI, *Discorso sul disegno*, Padova 1810. – Giovanni Battista ARMENINO, *De Veri Precetti della Pittura*, Pisa 1823. – Leopoldo CICOGNARA, *Del Bello*, n.p. 1808. – P. SELVATICO, *Storia estetico-critica delle Arti del Disegno*, Venezia 1856.

GENERAL WORKS

J. ADHÉMAR, *Le Dessin Français du XVI^e siècle*, Lausanne 1954. – *Les Portraits dessinés du XVI^e siècle au Cabinet des Estampes*, Paris 1973. – G. ADRIANI, *J. Beuys*, Cologne 1973. – S. ALEXANDRIAN, *L'Univers de Gustave Moreau*, Collection "Les Carnets de dessins" Paris 1975. – W. AMES, *Drawings of the Masters. Italian Drawings from the 15th to the 18th Century*, London 1963. – A. ANANOFF, *L'œuvre dessiné de Jean-Honoré Fragonard*, 4 vol., Paris 1961-70. – *L'œuvre dessiné de François Boucher, catalogue raisonné*, 2 vol., Paris 1966. – P. d'ANCONA, *Tiepolo a Milano, gli affreschi di Palazzo Clerici*, Milan n. d. – W. ANDERSEN, *Cezanne's Portrait Drawings*, Cambridge (Mass.) 1970. – K. ANDREWS, *National Gallery of Scotland, Catalogue of Italian Drawings*, 2 vol., Cambridge 1968. – *ANTHOLOGIE du dessin français au XX^e siècle*, Geneva 1951. – F. ANZELEWSKY, *Albrecht Dürer: Verzeichnis sämtlicher Zeichnungen, Staatliche Museen Preussischer Kulturbesitz*, Berlin 1972. – G. APOLLINAIRE / L. ARAGON / H. ARP,... *La tour Eiffel de Robert Delaunay, Apollinaire, Aragon, Arp... Poèmes inédits*, Paris 1974. – U. APOLLONIO, *Futurismo*, Milan 1970. – L. ARAGON, *L'exemple de Courbet*, Paris 1952. – M. ARCHER, *British Drawings in the Indian Office Library*, 2 vol., London 1969. – H. ARP / A. BRETON / P. MONDRIAN, *Art of this Century. Objects, drawings, photographs, paintings, sculptures, collages 1910 to 1942*, New York 1942 (new ed. 1968). – R. ASSUNTO, *Trattatistica*, in Enciclopedia universale dell'arte vol XIV Florence 1966. – R. BACOU, *Dessins florentins du Trecento et du Quattrocento*, Paris 1952. – *Odilon Redon*, Geneva 1956. – *Ils existent. Le saviez-vous? Nous vous avons déjà fait découvrir les tableaux de ce Musée méconnu. Voici quelques pièces de son admirable Cabinet des Dessins*, in L'Œil No. 28 1957. – *Il settecento francese*, Collection "I Disegni dei Maestri", Milan 1970. – *Piranèse: gravures et dessins*, Paris 1974. – *Millet: dessins*, Fribourg 1975. – R. BACOU / A. CALVET, *Dessins du Louvre, Ecoles Allemande, Flamande et Hollandaise*, Paris 1968. – R. BACOU / F. VIATTE, *Dessins du Louvre, Ecole Italienne*, Paris 1968. – C. O. BAER, *Landscape Drawings*, New York 1969. – P. BAROCCHI, *Michelangelo e la sua scuola. I disegni di Casa Buonarroti e degli Uffizi*, Florence 1962. – *Vasari Pittore*, Florence 1964. – Eugène BATTISTI, *La Proporzione*, in Enciclopedia universale dell'arte vol XI Florence 1963. – F. BAUMGART, *Grünewald. Tutti i disegni*, Florence 1974. – J. BEAN, *Les dessins italiens de la collection Bonnat*, Paris 1960. – *100 European Drawings in the Metropolitan Museum of Art*, New York 1964. – J. BEAN / F. STAMPFLE, *Drawings from New York Collections*, vol. 1: *The Italian Renaissance (exhibited at the Metropolitan Museum of Art, 1965/66)* New York 1965. Vol 2: *The Seventeenth Century in Italy (exhibited at the Pierpont Morgan Library 1967)* New York 1967. Vol. 3: *The Eighteenth Century in Italy (exhibited at the Metropolitan Museum of Art 1971)* New York 1971. – M. BEAN, *La Collection des dessins d'Hubert Robert au Musée de Valence*, Lyon 1968. – H. U. BECK, *Jan van Goyen, 1596-1656, vol. 1: Katalog der Handzeichnungen*, Amsterdam 1972. – *Jan van Goyen, 1596-1656, vol. 2: Katalog der Gemälde*, Amsterdam 1973. – H. L. BECKER, *Die Handzeichnungen Albrecht Altdorfers*, Munich 1938. – J. BÉGUIN, *Dictionnaire technique et critique du dessin*, Brussels/ Paris 1978. – S. BÉGUIN, *L'Ecole de Fontainebleau*, Paris 1960. – *Le XVI^e siècle européen, Peintures et Dessins dans les Collections publiques Françaises*, Paris 1965/66. – *Il cinquecento francese*, Collection "I Disegni dei Maestri", Milan 1970. – *Le XVI^e siècle français*, Pully 1976. – S. BÉGUIN / R. MARINI, *Tout l'œuvre peint de Veronese*, Paris 1970. – L. BEHLING, *Die Handzeichnungen des Mathis Gothart Nithart genannt Grünewald*, Weimar 1955. C. F. BELL, *Drawings by Old Masters in the Library of Christ Church Oxford*, Oxford 1941. – P. BELLINI, *Catalogo completo dell'opera grafico di U. Boccioni*, Milan 1972. – *Catalogo completo dell'opera grafica di P. Gauguin*, Milan 1972. – O. BENESCH, *Die Zeichnungen der Niederländischen Schulen des XV und XVI Jahrhunderts, beschreibender Katalog der Handzeichnungen in der graphischen Sammlung Albertina*, Vienna 1928. – *Venetian Drawings of the Eighteenth Century in America*, New York 1947. – *A Catalogue of Rembrandt's Selected Drawings*, London 1947. – *The Drawings of Rembrandt*, 6 vol., London 1954-57. – *Rembrandt as a Draughtsman*, London 1960. – *Meisterzeichnungen der Albertina. Europäische Schulen von der Gotik bis zum Klassizismus*, unter Mitarbeit von E. Benesch, Salzburg

1964. – *Collected Writings* (ed. by Eva Benesch), Vol. 1: *Rembrandt*, New York 1970. Vol. 2: *Netherlandish and Dutch art of the 17th century, Italian art, French art*, New York 1971. Vol. 3: *German and Austrian art of the 15th and 16th centuries*, New York 1972. Vol. 4: *German and Austrian Baroque art. Art of the 19th and 20th centuries*, London 1973. – *The Drawings of Rembrandt*, enlarged and ed. by Eva Benesch, 6 vol., London 1973. – E. BERCKENHAGEN, *Die Französischen Zeichnungen der Kunstbibliothek Berlin*, Berlin 1970. – B. BERENSON, *The Drawings of the Florentine Painters*, 3 vol., London 1903, augmented ed. Chicago 1938. – *Disegni di maestri fiorentini del rinascimento*, Florence 1954. – *Disegni di pittori fiorentini*, 3 vol., Milan 1961. K. BERGER, *Géricault; Drawings and Watercolors*, New York 1946. – *O. Redon, Fantasy and Color*, New York 1965. – F. BERGOT, *Musée de Rennes, Dessins de la Collection Robien*, Rennes 1973. – W. BERNT, *Die Niederländischen Zeichner des 17. Jahrhunderts*, 2 vol., Munich 1957-58. – L. BERTI, *Michelangelo. I disegni*, Novara 1965. – *L'Opera completa del Pontormo*, Milan 1973. – A. BERTINI, *Botticelli*, Collection "I grandi maestri del disegno" Milan 1953. – *I disegni italiani della Biblioteca Reale di Torino*, Rome 1958. – A. BETTAGNO, *Disegni di una collezione veneziana del Settecento*, Venice 1966. – J. BEUYS, *Zeichnungen, 1947-1959, Gespräch zwischen J. B. und Hagen Lieberknecht geschrieben von J.B.*, Cologne 1972. – P. BJURSTRÖM, *German Drawings, Nationalmuseum*, Stockholm 1972. – *French Drawings. Sixteenth and Seventeenth Centuries, Nationalmuseum*, Stockholm 1976. P. BJURSTRÖM / B. DAHLBÄCK, *Témoignages sur l'éphémère, (Décors et costumes disparaissent souvent sans laisser de traces...)* in L'Œil No. 24 1956. – V. BLAKE, *The Art and Craft of Drawing...*, Oxford 1927. – A. BLONDEL / Y. PLANTIN, *Pionniers du XX^e siècle, l'Expressionnisme naturaliste de Guimard au Castel Beranger*, in L'Œil No. 194 1971. – A. BLUM / Ph. LAUER, *La miniature française aux XV^e et XVI^e siècles*, Paris/Brussels 1930. – A. BLUNT, *Artistic Theory in Italy, 1450-1600*, Oxford 1940. – *The French Drawings... at Windsor Castle*, London 1945. – *Art and Architecture in France, 1500-1700*, London 1953. – *The Drawings of G. B. Castiglione and Stefano della Bella... at Windsor Castle*, London 1954. – *Rinascimento*, in Enciclopedia universale dell'arte vol. XI Florence 1963. – *Nicolas Poussin*, 2 vol., London/New York 1967. – A. BLUNT / E. CROFT MURRAY, *Venetian Drawings of the XVII and XVIII Centuries... at Windsor Castle*, London 1957. – E. BOCK / J. ROSENBERG, *Die Zeichnungen niederländischer Meister im Kupferstichkabinett zu Berlin*, 2 vol., Berlin 1930. – H. BODMER, *Leonardo, des Meisters Gemälde und Zeichnungen*, Stuttgart/Berlin 1931. – P.H. BOERLIN / T. FALK / R. W. GASSEN / D. KOEPPLIN, *Hans Baldung Grien im Kunstmuseum Basel*, Basel 1978. – J. BOLTEN, *Dutch Drawings from the Collection of Dr. C. Hofstede de Groot*, Utrecht 1967. – H. BONNIER, *L'Univers de Rembrandt*, Collection "Les Carnets de dessins" Paris 1969. – K. G. BOON, *Netherlandish Drawings of the Fifteenth and Sixteenth Centuries, catalogue of the Dutch and Flemish Drawings in the Rijksmuseum, Amsterdam*, 2 vol., The Hague 1978. – F. BORSI, *Bruxelles 1900*, Brussels 1974. – F. BOUCHER / Ph. JACOTTET, *Le dessin français au XVIII^e siècle*, Lausanne 1952. – H. BOUCHOT, *Les Portraits aux crayons des XVI^e et XVII^e siècles conservés à la Bibliothèque Nationale*, Paris 1884. – *Catalogue de dessins relatifs à l'Histoire du Théâtre conservés au Département des Estampes de la Bibliothèque Nationale*, Paris 1896. – J. BOUCHOT-SAUPIQUE, *Catalogue des pastels du Musée du Louvre*, Paris 1930. – *Quatorze dessins de Greuze au Louvre*, Paris 1939. – H. BOUTERON / J. TREMBLOT, *Catalogue général des Manuscrits des Bibliothèques publiques de France. Paris, Bibliothèque de l'Institut, Ancien et Nouveau Fonds*, Paris 198. – Th. BOWIE, *The Sketchbook of Villard de Honnecourt*, Bloomington 1959. – A. BRAHAM / P. SMITH, *François Mansart, Studies in Architecture*, 2 vol., London 1973. – H. BRAUER / R. WITTKOWER, *Die Zeichnungen des Gianlorenzo Bernini*, 2 vol., Berlin 1931. – A. BREJON, *L'Univers de Poussin*, Collection "Les Carnets de dessins" Paris 1977. – A. E. BRINCKMANN, *Michelangelo Zeichnungen*, Munich 1925. – C. M. BRIQUET, *Recherches sur les Premiers Papiers en Occident et en Orient du X^e au XIV^e siècle*, Paris 1886. – *Les Filigranes. Dictionnaire historique des marques du papier*, Geneva 1907. – Ch. BROWN, *Bruegel: paintings, drawings and prints*, London 1975. – C. BRUNI, *Catalogo generale di G. de Chirico.* 6 vol., Milan 1971. – M. BUCCI / L. BERTOLINI, *Camposanto monumentale di Pisa: affreschi e sinopie*, Pisa 1960. – J. BUDDE,

Beschreibender Katalog der Handzeichnungen in der Staatlichen Kunstakademie Düsseldorf, Düsseldorf 1930. – L. BURCHARD / R. A. D'HULST, *Rubens Drawings*, 2 vol., Brussels 1963. – M. BUTLIN, *Turner Watercolours*, London 1962. – J. BYAM SHAW, *The Drawings of Francesco Guardi*, London 1951. – *The Drawings of Domenico Tiepolo*, London 1962. – *Drawings by Old Masters at Christ Church*, 2 vol., Oxford 1972-73. – M. CALVESI, *Il Futurismo*, Milan 1961. – U. Boccioni, incisioni e disegni, Florence 1973. – *Le Futurisme*, Paris 1976. – L. CARLUCCIO, *194 disegni di Giorgio De Chirico*, Turin 1969. – R. CARRIERI, *Il Disegno Italiano Contemporaneo*, Milan 1945. – D.N. CARVALHO, *Forty Centuries of Ink*, New York 1904. – J. CASSOU, *On the Demarche of the Creative Thought*, in Gazette des Beaux-Arts 1948. – *Henri Matisse, Carnet de dessins*, 2 vol., Paris 1955. – *Kandinsky Interférences, aquarelles et gouaches*, Paris 1960. – J. CASSOU / D. FEDIT, *Kupka*, Paris 1964. – *Catalogue of the Drawings Collection of the Royal Institute of British Architects*, 11 vol., London 1968. – J. CATHELIN, *Arp*, Paris 1959. – A. CERONI, *A. Modigliani, dessins et sculptures*, Milan 1965. – A. M. CETTO, *Aquarelles d'A. Dürer*, Basel 1954. – A. CHAPPUIS, *The Drawings of Paul Cézanne, a catalogue raisonné*, 2 vol., Greenwich (Conn.) 1973. – A. CHASTEL, *Carta tinta*, in L'Œil No. 12 1955. – *Art et Humanisme à Florence au temps de Laurent le Magnifique*, Paris 1959. – *Les arts de l'Italie*, 2 vol., Paris 1963. – *Léonard de Vinci: La Peinture. Textes traduits, réunis et annotés par A. C. avec la collaboration de R. Klein*, Paris 1964. – *Le grand atelier d'Italie 1460-1500*, Paris 1965. – *Le seizième siècle européen. Peintures et dessins dans les collections publiques françaises*, Paris 1966. – *La crise de la Renaissance, 1520-1600*, Geneva 1968. – *Le mythe de la Renaissance, 1420-1520*, Geneva 1969. – *Hommage à Dürer: Strasbourg et Nuremberg dans la première moitié du XVI^e siècle. Actes du Colloque de Strasbourg, novembre 1971*, Strasbourg 1972. – A. CHASTEL, R. KLEIN, *L'Europe de la Renaissance, l'âge de l'Humanisme*, Paris 1963. – Ph. de CHENNEVIÈRES, *Les Dessins du Louvre, vol. 1: Ecoles Flamande, Hollandaise et Allemande; vol. 2: Ecole Italienne; vol. 3: 1 et 2 Ecole Française*, Paris n.d. (1882). – Ph. de CHENNEVIÈRES / A. de MONTAIGLON, *Abecedario de Mariette et autres notes inédites de cet amateur sur les arts et les artistes*, 6 vol., Archives de l'Art Français 1851- 60. – P. CHEVALLIER / D. RABREAU, *Le Panthéon*, Paris 1977. – M. CHIARINI, *Vedute romane. Disegni dal XVI al XVIII secolo*, Rome 1971. – *I disegni italiani di paesaggio dal 1600 al 1750*, Collection "Il disegno italiano" Venice 1972. – W. A. CHURCHILL, *Watermarks in paper*, Amsterdam 1935 (new ed.: Amsterdam 1965). – J. CLAPARÈDE, *Montpellier, Musée Fabre. Dessins de la Collection Alfred Bruyas et autres dessins des 19^e et 20^e siècles*, Paris 1962. – R. H. CLAPPERTON, *Paper. An historical account of its making by hand from the earliest times down to the present day*, Oxford 1934. – K. CLARK, *Catalogue of the Drawings of Leonardo da Vinci... at Windsor Castle*, 2 vol., Cambridge 1935. – *Rembrandt and the Italian Renaissance*, London 1966. – *The Drawings of Leonardo da Vinci... at Windsor Castle*, 2nd ed., 3 vol., London 1968. – *An Introduction to Rembrandt*, London 1978. – L. CLÉMENT DE RIS, *Les Amateurs d'autrefois*, Paris 1877. – R. COGNIAT, *Dessins et aquarelles du 20^e siècle*, Paris 1966. – A. COMINI, *Gustav Klimt*, New York/London 1975. – W. G. CONSTABLE, *Canaletto, Giovanni Antonio Canal 1697-1768*, 2 vol., Oxford 1962. – D. COOPER, *Fernand Léger et le nouvel espace*, Geneva 1949. – *Pastels d'Edgar Degas*, Basel 1952. – *Dessins et aquarelles de Van Gogh*, Basel 1955. – F. Léger, dessins de guerre 1915-1916, Paris 1956. – A. CORBEAU, *Léonard de Vinci, Manuscrit C et D de l'Institut de France*, 2 vol., Grenoble 1964. – *Léonard de Vinci, Manuscrit A de l'Institut de France*, 3 vol., Grenoble 1972. – J. CORDEY, *Les dessins français des XVI^e et XVII^e siècles au British Museum*, in Bulletin de la Société de l'Histoire de l'Art Français 1932. – D. CORDIER, *Les Dessins de Jean Dubuffet*, Paris 1960. – H. O. DORFIATO, *Piranesi Compositions*, London 1951. – R. CORK, *Vorticism and Abstract Art in the first machine age*, 2 vol., London 1976. – *CORPUS graphicum bergomense: disegni inediti di collezioni bergamasche*, Bergamo 1969. – *CORRESPONDANCE des Directeurs de l'Académie de France à Rome avec les Surintendants des Bâtiments, publiée d'après les manuscrits des Archives Nationales*, 17 vol., Paris 1887-1912. – R. de COTTE, *Inventaire des Desseins et autres papiers renfermés dans ses porte-feuilles de Monsieur de Cotte, Bibliothèque Nationale (manuscrit)* Paris. – S. COTTÉ, *L'Univers de Claude Lorrain*, Collection "Les Carnets de dessins" Paris 1970. – *L'Univers de Rubens*,

Collection "Les Carnets de dessins" Paris 1973. – Cl. COULIN, Dessins d'architectes. Choix de dessins et d'acquis du IX^e au XX^e siècle, Paris 1962. – J. COX-REARICK, The Drawings of Pontormo, Cambridge (Mass.) 1964. – J.P. CRESPELLE, Toulouse Lautrec, Feuilles d'études, Paris 1962. – E. CROFT-MURRAY / P. HULTON, British Museum. Drawings by British Artists, XVI and XVII centuries, London 1960. – E. DACIER / Ch. MARTINE, 52 dessins d'Antoine Watteau, Paris 1930. – E. DACIER / P. RATOUIS DE LIMAY, Pastels français des XVII^e et XVIII^e siècles, Paris/Brussels 1927. – G. DALLI REGOLI, Lorenzo di Credi, Pisa 1966. – J.E. DARMON, Dictionnaire des peintres miniaturistes sur vélin, parchemin, ivoire et écaille, Paris n.d. – F. DAULTE, L'aquarelle française au XX^e siècle, Fribourg 1968. – B. DEGENHART, Studien über Lorenzo di Credi. Credis Porträtdarstellung, in Pantheon vol. VIII 1931. – Antonio Pisanello, Vienna 1941. – Europäische Handzeichnungen aus fünf Jahrhunderten, Zürich 1943. – Italienische Zeichnungen des frühen 15. Jahrhunderts, Basel 1949. – B. DEGENHART / A. SCHMITT, Disegni del Pisanello e di Maestri del suo tempo, Venice 1966. – Corpus der Italienischen Zeichnungen 1300-1450, 4 vol., Berlin 1968. – M. DELACRE, Les dessins de Michel-Ange, Brussels 1938. – M. DELACRE / P. LAVALLÉE, Dessins de Maîtres anciens réunis par M.C. et P.L., Paris 1927. – A. DE LEIRIS, The Drawings of Edouard Manet, Berkeley/Los Angeles 1969. – A.J.J. DELEN, Cabinet des estampes de la ville d'Anvers. Catalogue des dessins anciens, Ecoles flamande et hollandaise, 2 vol., Brussels 1938. – J.P.F. DELEUZE, Histoire et description du Museum royal d'histoire naturelle…, Paris 1823. – L. DELISLE, Le Cabinet des manuscrits de la Bibliothèque Nationale, Paris 1868-81. – G. DELOGU, Disegni veneziani del settecento, Milan/Zürich 1947. – Tintoretto, Collection "I grandi maestri del disegno", Milan 1953. – L. DEMONTS, Musée du Louvre: Les dessins de Léonard de Vinci, Paris n.d. – Musée du Louvre: Les dessins de Michel-Ange, Paris n.d. – Musée du Louvre: Les dessins de Claude Gellée dit le Lorrain, Paris n.d. – Catalogue des dessins de Claude Lorrain au Musée du Louvre, Paris 1923. – Musée du Louvre: inventaire général des dessins des Ecoles du Nord, Ecoles Allemande et Suisse, 2 vol., Paris 1937-38. – P. DESCARGUES, Fernand Léger, Paris 1955. – P. DESCARGUES / F. PONGE, Picasso, Paris 1974. – P. DESCARGUES / A. MALRAUX / F. PONGE, G. Braque, Paris 1971. – A. DIETERICH, Goya: dessins, Paris 1975. – L. DIMIER, Histoire de la peinture de portrait en France au XVI^e siècle, Paris 1924. – Histoire de la Peinture Française du retour de Vouet à la mort de Le Brun 1627-1690, 2 vol., Paris 1926. – Dessins français du XVI^e, Paris 1937. – B. DÜRRIES, Deutsche Zeichnungen des 18. Jahrhunderts, Hannover 1942. – M. G. DORTU, Toulouse Lautrec et son œuvre, catalogue raisonné, 6 vol., New York 1971. – A. DREXLER, The Architecture of the Ecole des Beaux-Arts, New York 1977. – Z. DROBNA, Gothic Drawing, Prague 1956. – J. DUPIN, Joan Miró, Leben und Werk, Cologne 1961; – Joan Miró, Life and Work, New York 1962. – L. DUSSLER, Italienische Meisterzeichnungen, Munich 1948. – Die Zeichnungen des Michelangelo, kritischer Katalog, Berlin 1959. – C. EISLER, Drawings of the Masters: Flemish and Dutch Drawings, New York 1963. – Dessins de Maîtres du XVI^e au XX^e siècle, Lausanne/Paris 1975. – L. EITNER, Géricault. An album of drawings in the Art Institute of Chicago, Chicago 1960. – A. EMILIANI, Bronzino, Milan 1960. – R. ESCHOLIER, Delacroix, peintre, graveur, écrivain, 3 vol., Paris 1926-29. – M. and M. FAGIOLI DELL'ARCO, Bernini, una introduzione al gran teatro del barocco, Rome 1967. – C. FAIRFAX MURRAY, Drawings by Old Masters, Collection of J. Pierpont Morgan, 4 vol., London 1905-12. – Two Lombard Sketchbooks in the Collection of C.F.M., London 1911 – R. FALB, Il tacuino senese di Giuliano da San Gallo, 49 Facsimili di disegni d'Architettura, Scultura ed Arte applicata, Sienna 1889. – D. FEDIT, Paris, Musée National d'Art Moderne: l'œuvre de Kupka, Paris 1966. – F. FELS, Claude Monet, 30 reproductions de peintures et dessins, Paris 1925. – J. FENYÖ, Disegni veneti del Museo di Budapest, Venice 1965. – North Italian Drawings from the Collections of the Budapest Museum of Fine Arts, Budapest 1965. – P.N. FERRI, Catalogo riassuntivo della raccolta di disegni antichi e moderni, posseduti dalla R. Galleria degli Uffizi di Firenze, Rome 1890. – M. FEUILLET, Les dessins e H. Fragonard et de H. Robert des Bibliothèques et Musée de Besançon, Paris 1926. – A.J. FINBERG, Complete Inventory of the Drawings of the Turner Bequest, 2 vol., London 1909. – Turner's Sketches and Drawings, London 1910. – O. FISCHER, Geschichte der deutschen Zeichnung

und Graphik, Munich 1951. – J. FLEMING, Robert Adam and his Circle in Edinburgh and Rome, London 1962. – H. FOCILLON, Benvenuto Cellini, Paris n.d. – Giovanni Battista Piranesi: essai de catalogue raisonné de son œuvre, Paris 1918. – Giovanni Battista Piranesi 1720-1778, Bologna 1967. – A. FONTAINE, Les Collections de l'Académie Royale, Paris 1910. – A. FORLANI, I disegni italiani del Cinquecento, Collection "Il disegno italiano" Venice 1962. – A. FORLANI TEMPESTI, Raffaello. I disegni, Novara 1968. – Capolavori del Rinascimento, il primo cinquecento toscano, Collection "I Disegni dei Maestri" Milan 1970. – A. FORLANI TEMPESTI / A.M. PETRIOLI-TOFANI, I grandi disegni italiani degli Uffizi di Firenze, Milan n.d. – F. FOSCA, Liotard, Paris 1928. – Peintre turc, in L'Œil No. 16 1956. – M. FOSSI TODOROW, I disegni del Pisanello e della sua cerchia, Florence 1966. – L'Italia delle origine a Pisanello, Collection "I Disegni dei Maestri" Milan 1970. – B. FOUCART, Trois siècles de dessins français, in L'Œil No. 279 1978. – L.H. FOWLER / E. BAER, The Fowler Architectural Collection of the Johns Hopkins University, Baltimore 1961. – H.M. FOX, André Le Nôtre, Garden Architect to the King, London 1962. – S.J. FREEDBERG, Andrea del Sarto, Cambridge (Mass.) 1963. – G. FREEDLY, Theatrical Designs, New York 1940. – K. FREY, Die Handzeichnungen Michelangiolos Buonarroti, Berlin 1909-11. – new ed. Berlin 1964. – M.J. FRIEDLÄNDER, Albrecht Altdorfer. Ausgewählte Handzeichnungen.., Berlin n.d. – Die Grünewald Zeichnungen der Sammlung Savigny, Berlin 1926. – Jan Gossart, Berlin 1930. – M.J. FRIEDLÄNDER / E. BOCK, Handzeichnungen deutscher Meister des 15. und 16. Jahrhunderts, Berlin n.d. – Staatliche Museen zu Berlin: Die Zeichnungen alter Meister im Kupferstichkabinett, hrsg. von M.J.F. Die deutschen Meister, beschreibendes Verzeichnis bearbeitet von E.B., Berlin 1921. – W. FRIEDLÄNDER, Nicolas Poussin. Die Entwicklung seiner Kunst, Munich 1914. – W. FRIEDLÄNDER / A. BLUNT, The Drawings of Nicolas Poussin, 5 vol., London 1939-74. – B.H. FRIEDMAN, J. Pollock, energy made visible, New York 1972. – L. FRÖHLICH-BUM, Parmigianino und der Manierismus, Vienna 1921. – C.L. FROMMEL, Baldassare Peruzzi als Maler und Zeichner, Vienna 1967-68. – R.E. FRY, On a Fourteenth Century Sketchbook, in Burlington Magazine 1906. – S. FUMET, Georges Braque, Paris 1966. – H. von GABELENTZ, Fra Bartolomeo und die florentiner Renaissance, Leipzig 1922. – J. GALLEGO, L'Univers de Goya, Collection "Les Carnets de dessins" Paris 1977. – E. de GANAY, André Le Nostre, 1613-1700, Paris 1962. – P. GANZ, Handzeichnungen schweizerischer Meister des XV.-XVII. Jahrhunderts, 12 fasc., Basel 1904-08. – Handzeichnungen von Hans Holbein dem Jüngeren, Berlin 1903. – Die Handzeichnungen Holbein d.J., kritischer Katalog, Basel 1911-37. – Les dessins de Hans Holbein le jeune catalogue raisonné et 8 vol. de planches, Geneva 1939. – Die Zeichnungen Hans Heinrich Füsslis, Berne 1947. – P. GASSIER, Les dessins de Goya. Les Albums, Fribourg 1973. – P. GASSIER/J. WILSON, Vie et œuvre de Francisco Goya. L'œuvre complet illustré: peintures, dessins, gravures, Fribourg 1970. – W. GAUNT, L'Univers de Turner, Collection "Les Carnets de dessins" Paris 1974. – C. GEELHAAR, P. Klee, Leben und Werk, Cologne 1974. – S. GEIST, Brancusi, the sculpture and drawings, New York 1975. – W. GEORGE, H. Matisse. Dessins, Paris 1925. – L'Univers de Rouault, Collection "Les Carnets de dessins" Paris 1971 – J.A. GERE, Taddeo Zuccaro: his development studied in his drawings, London 1969. – Il manierismo a Roma, Collection "I Disegni dei Maestri" Milan 1970. – C.G. GERLI, Disegni di Leonardo da Vinci, Trento 1974. – H. GERSON, Philips de Koninck, Berlin 1936. – T. GERSZI, Capolavori del rinascimento tedesco, Collection "I Disegni dei Maestri" Milan 1970. – Netherlandish Drawings in the Budapest Museum, 2 vol., Amsterdam/New York 1971. – F. GIBBONS, Catalogue of Italian Drawings in the Art Museum, Princeton University, 2 vol., Princeton 1977. – C. GIEDION-WELKER, Paul Klee, London 1952. – Kandinsky, Zürich 1972. – M. GIEURE, Braque dessins, Paris 1955. – C. GILBERT, Savoldo's drawings put to use; a study in Renaissance workshop practice, in Gazette des Beaux-Arts 1953. – D. GIOSEFFI, Prospettiva, in Enciclopedia universale dell'arte vol. XI Florence 1963. – R. GIRARDET, Louis XIV. La manière de montrer les jardins de Versailles, Paris 1951. – T.L. GIRSHAUSEN, Die Handzeichnungen Lucas Cranach d.A., Diss. Frankfurt 1936. – J. GLAESEMER, Paul Klee, Handzeichnungen, vol. 1: Kindheit bis 1920, Berne 1975. – Paul Klee, die farbigen Werke im Kunstmuseum Bern, Berne 1976. – A. GLEIZES, Du Cubisme et des

moyens de le comprendre, Paris 1920. – La peinture et ses lois. Ce qui devait sortir du Cubisme, in La Vie des lettres et des arts 1924. – Vers une conscience plastique, Paris 1932. – Puissance du Cubisme, Chambéry 1969. – G. GLÜCK / F.M. HABERDITZL, Die Handzeichnungen von Peter Paul Rubens, Berlin 1928. – J. GOLDING, Cubism. A history and an analysis, 1907-1914, London 1959. – Le Cubisme, Paris 1962. – Marcel Duchamp: The Bride stripped bare by her bachelors, Even, London 1973. – Fernand Léger: The Mechanic, Ottawa 1976. – L. GOLDSCHEIDER, Michelangelo Drawings, London 1951. – R. GOLDWATER, Primitivism in Modern Art, New York 1967. – R. GOLDWATER/M. TREVES, Artists on Art, from the XIV to the XX century, New York 1945: new ed. 1972. – V. GOLOUBEW, Les Dessins de Jacopo Bellini au Louvre et au British Museum, 2 vol., Brussels 1912. – J. GOMEZ SUCRE, Spanish Drawings, New York 1949. – E. de GONCOURT, Catalogue raisonné de l'œuvre peint, dessiné et gravé de P.P. Prud'hon, Paris 1876. – J.A. GORRIS / G. MARLIER, Le journal du voyage d'Albrecht Dürer dans les anciens Pays Bas 1520-1521, accompagné du Livre d'esquisses à la pointe d'argent et illustré par la peinture et dessins exécutés pendant le voyage, traduit et commenté par J.A.G. et G.M., Brussels 1970. – E. GRADMANN, Dessins de maîtres espagnols, Basel n.d. – Spanische Meisterzeichnungen, Frankfurt 1939. – Bildhauer-Zeichnungen, Basel 1943. – S. GRANDINI, Jean Arp: pensieri, poesie, disegni, collages, Lugano 1976. – G. de GRASSI, Tacuino di disegni, Codice della Biblioteca civica di Bergamo. Prima edizione integrale in fac-simile, Bergamo 1961. – L. GRASSI, Disegni del Bernini, Bergamo 1944. – Storia del disegno, Rome 1947. – Il disegno italiano dal trecento al seicento, Rome 1956. – I disegni italiani del trecento e quattrocento, Collection "Il disegno italiano" Venice n.d. (1961). – Il Libro dei disegni di Jacopo Palma il Giovane all'Accademia di San Luca, Rome 1968. – G. GRIGSON, English Drawings from S. Cooper to Gwen Paul, London 1955. – W. GROHMANN, Paul Klee, Handzeichnungen 1921-1930, Berlin 1934. – The Drawings of Paul Klee, New York 1944. – Paul Klee, London/New York/Paris/Stuttgart 1954. – Kandinsky, sa vie, son œuvre, Paris 1958. – Paul Klee, Handzeichnungen, Cologne 1959. – Paul Klee, sa vie, son œuvre, son enseignement, Paris 1969. – Vicomte de GROUCHY, Everhard Jabach, collectionneur parisien, 1695, Paris 1894. – J. GUIBERT, Les Dessins du Cabinet Peiresc au Cabinet des Estampes, Paris 1910. – J. GUIFFREY, Musée du Louvre, P.P. Prud'hon. Peintures, Pastels, Dessins, Paris 1924. – J. GUIFFREY / P. MARCEL, Inventaire général des dessins du Musée du Louvre et du Musée de Versailles, Ecole Française, 11 vol., Paris 1907-38. – D.F. von HADELN, Zeichnungen des Jacopo Tintoretto, Berlin 1922. – Zeichnungen des Tizian, Berlin 1924. – Venezianische Zeichnungen des Quattrocento, Berlin 1925. – Venezianische Zeichnungen der Hochrenaissance, Berlin 1925. – Venezianische Zeichnungen der Spätrenaissance, Berlin 1926. – Handzeichnungen von G.B. Tiepolo, Florence 1927. – The Drawings of G.B. Tiepolo, 2 vol., Paris 1928. – Die Zeichnungen von Antonio Canal, genannt Canaletto, Vienna 1930. – W. HAFTMANN, Marc Chagall, gouaches, dessins, aquarelles, Paris 1975. – Marc Chagall, Paris 1975. – O. HAHN, Masson, Paris 1965. – Warhol, Paris 1972. – H. HAHNLOSER, Villard de Honnecourt, Kritische Gesamtausgabe des Bauhüttenbuches, Vienna 1935. – P. HALM / B. DEGENHART / W. WEGNER, Hundert Meisterzeichnungen aus der Staatlichen graphischen Sammlung, Munich 1958. – A.D.F. HAMLIN, A History of Ornament, 2 vol., New York 1973. – K. HAMMER, Jacob Ignaz Hittorff, Ein Pariser Baumeister 1792-1867, Stuttgart 1968. – A. d'HARNONCOURT / K. McSHINE, Marcel Duchamp, New York 1973. – J.C. HARRIS, Edouard Manet, Graphic Works. A definitive catalogue raisonné, New York 1970. – F. HARTT, Giulio Romano, 2 vol., New Haven 1958. – The Drawings of Michelangelo, London 1971. – M. HARVEY, Notes on the wall of Sol LeWitt, Notes sur les dessins muraux de Sol LeWitt, Geneva 1977. – P. HATTIS, Four Centuries of French Drawings in the Fine Arts Museum of San Francisco, San Francisco 1977. – C. de HAUKE, Seurat et son œuvre, Paris 1961. – R. HAUSSMANN, Am Anfang war Dada, Giessen/Steinbach 1972. – L. HAUTECŒUR, Le Louvre de Louis XIV et les Tuileries, Brussels 1927. – Histoire du Louvre, Paris 1928. – Histoire de l'Architecture classique en France, Paris vol. I-II 1948, vol. III-VII 1957, new ed. vol. I-IV 1967. – E. HAVERKAMP-BEGEMANN / S.D. LAWDER / C.W. TALBOT, Drawings from the Clark Art Institute. A catalogue raisonné of the Robert Sterling Clark Collection of European and American Drawings, sixteenth

through nineteenth centuries..., 2 vol., New Haven 1964. – J. HAYES, The Drawings of Thomas Gainsborough, 2 vol., London/New Haven 1971. – Gainsborough Paintings and Drawings, London 1975. – E. HEAWOOD, Watermarks, mainly of the 17th and 18th centuries, Hilversum 1950. – M. HEFFELS, Kataloge des germanischen Nationalmuseums Nürnberg: Die deutschen Handzeichnungen. Vol. 4: Die Handzeichnungen des 18. Jahrhunderts, Nuremberg 1969. – V. HEFTING, L'Univers de Jongkind, Collection "Les Carnets de dessins" Paris 1976. – D. HEIKAMP, La manufacture de tapisserie des Medicis, in L'Œil No. 164-165 1968. – J. S. HELD, Rubens: Selected Drawings, 2 vol., London/New York 1959. – K. HENDERSON, Pastels, London/New York 1952. – M. D. HENKEL, Le dessin hollandais, des origines au XVIIIe siècle, Paris 1931. – R. L. HERBERT, Essay on Drawing, Yale University, New Haven 1960. – Seurat's Drawings, New York 1962. – L. HERMANN, Turner: paintings, watercolours, prints and drawings, London 1975. – K. HERRMANN-FIORE, Dürers Landschaftsaquarelle, Berne 1972. – T. B. HESS, W. de Kooning, New York 1969. – W. de Kooning Drawings, Greenwich 1972. – G. F. HILL, Dessins de Pisanello, Paris/Brussels 1929. – A. M. HIND, Catalogue of Drawings by Dutch and Flemish Artists, preserved in the Department of Prints and Drawings in the British Museum, 4 vol., London 1923-31. – British Museum, Catalogue of the Drawings of Claude Lorrain, London 1926. – M. HIRST, Perino del Vaga and his circle, in The Burlington Magazine, August 1966. – R. HOBBS, O. Redon, Boston 1977. – H. R. HOETINK, Tekeningen van Rembrandt en zijn school. Catalogus van de verzameling in het Museum Boymans-van Beuningen, Rotterdam 1969. – L'Univers de Dürer, Collection "Les Carnets de dessins" Paris 1971. – C. HOFSTEDE DE GROOT, Original Drawings by Rembrandt, 4 vol., The Hague 1903-11. – R. HOHL, Claude Lorrain und die barocke Landschaftszeichnung. Das Landschaftslavis als prägnante Gestalt der Barockkunst. Die Entwicklung in Rom, von Adam Elsheimer bis Claude Lorrain, Basel 1972. – M. HOOG, Paris, Musée National d'Art Moderne: Robert et Sonia Delaunay, Paris 1967. – L'Univers de Cézanne, Collection "Les Carnets de dessins" Paris 1971. – P. HUARD, Léonard, dessins anatomiques, Paris 1961. – P. HUARD / M. D. GREMEK, Léonard de Vinci. Dessins scientifiques et techniques, Paris 1962. – C. HÜLSEN / A. MICHAELIS, Codex Escurialensis: ein Skizzenbuch aus der Werkstatt D. Ghirlandaios, 2 vol., Soest 1975. – E. HÜTTINGER, Zeichnungen von G. de Chirico, Zürich 1970. – W. HUGELSHOFER, Schweizer Handzeichnungen des 15. und 16. Jahrhunderts, Freiburg im Breisgau 1928. – Schweizer Zeichnungen von Niklaus Manuel bis A. Giacometti, Berne 1969. – P. HUISMAN, L'aquarelle française au XVIIIe siècle, Fribourg 1968. – R. A. d'HULST, De Tekeningen van Jacob Jordaens, Brussels 1956. Jordaens Drawings, 4 vol., Brussels 1974. – D. HUNTER, Papermaking through Eighteen Centuries, New York 1930. – Papermaking: the History and Technique of an Ancient Craft, New York 1943. – H. HUTTER, Die Handzeichnung, Entwicklung, Technik, Eigenart, Vienna 1966. – Le dessin, ses techniques, son évolution (French translation by Maurice Muller-Strauss) Vienna 1966. – Lucas Cranach der Ältere in der Akademie der bildenden Künste Wien, Vienna 1972. – R. HUYGHE, L'Univers de Watteau, Collection "Les Carnets de dessins" Paris 1968. – R. HUYGHE / P. H. JACCOTTET, Le dessin français au XIXe siècle, Lausanne 1948. – N. IVANOFF, Il seicento, scuole veneta, lombarda, ligure, napoletana, Collection "Il disegno italiano" Venice 1963. – H. L. C. JAFFÉ, Mondrian und der Stijl, Cologne 1967. – Pablo Picasso, New York/London 1964. – Piet Mondrian, New York 1970. – M. JAFFÉ, The Literature of Art, Rubens as a Draughtsman, in The Burlington Magazine No. 748 1965. – Rubens as a Collector of Drawings, part three, in Master Drawings vol. IV No. 2 1966. – A. JAMMES, Louis XIV, sa Bibliothèque et le Cabinet du Roi, in The Library 1965. – P. JAMOT / J. DUPONT, Les plus beaux dessins français du Musée du Louvre (1350-1900), Brussels 1936-37. – U. JENNI, Das Skizzenbuch der internationalen Gotik in den Uffizien: der Übergang vom Musterbuch zum Skizzenbuch, Vienna 1976. – I. JIANON, Brancusi, Paris 1963. – J. Arp, Paris 1973. – A. JOHN, Drawings, London 1941. – U. E. JOHNSON, Contemporary 1900-1940, Collection "I Maestri del Disegno" Milan 1965. – Contemporanei 1940-65, Milan 1967. – C. JOHNSTON, Il seicento e il settecento a Bologna, Collection "I Disegni dei Maestri" Milan 1970. – A. JOUBIN, E. Delacroix, Voyage au Maroc, 1832, lettres, aquarelles et dessins, publiés avec une introduction et des notes d'A.J., Paris 1930. – Journal de Eugène Delacroix, 3 vol., Paris 1932. – Correspon-

dance générale de Eugène Delacroix, 5 vol., Paris 1936-38. – A. JOUBIN / J. L. VAUDOYER, Journal de Eugène Delacroix, introduction et notes par A.J., avant-propos de J.L.V., 3 vol., Paris 1960. – H. JOUIN, Charles Le Brun et les arts sous Louis XIV, Paris 1889. – M. JOYANT, Henri de Toulouse Lautrec, 1864-1901; vol. 1: peintures, vol. 2: dessins, estampes et affiches, Paris 1926-27. – R. JUDSON, The Drawings of Jacob de Gheyn II, New York 1973. – D. H. KAHNWEILER, Picasso, dessins 1903-1907, Paris 1954. – W. KANDINSKY, Interférences, Aquarelles et dessins, Paris 1960. – Ecrits complets, 2 vol., Paris 1970-75. – E. KAUFMANN, Three Revolutionary Architects: Boullée, Ledoux, Lequeu, Philadelphia 1960. – G. KESNEROVA / P. SPIELMANN, Les dessins français de Prague. XIXe XXe siècles, Paris 1969. – M. KITSON, Claude Lorrain: Liber Veritatis, London 1978. – Paul KLEE, Tagebücher 1898-1918, Cologne 1957. – Gedichte, mit Zeichnungen, Hrsg. von F. Klee, Zürich 1960. – Paul Klee par lui-même et par son fils Félix Klee. La vie et l'œuvre du peintre d'après les documents tirés de ses notes et de sa correspondance inédite, trad. et adaptation de M. Besset, Paris 1963. – Ecrits sur l'art, Paris 1973. – La pensée créatrice, textes recueillis et annotés par J. Spiller, Paris 1973. – Schiften, Rezensionen und Aufsätze, Hrsg. von Chr. Geelhaar, Cologne 1976. – Histoire naturelle infinie, textes recueillis et annotés par J. Spiller, Paris 1977. – F. KNAPP, Andrea del Sarto und die Zeichnungen des Cinquecento, Halle 1905. – K. A. KNAPPE, Dürer. Das graphische Werk, Vienna 1964. – G. KNOX, Catalogue of the Tiepolo Drawings in the Victoria and Albert Museum, London 1960. – C. KOCH, Die Zeichnungen Hans Baldung Griens, Berlin 1941. – W. KOSCHATZKY / K. OBERHUBER / E. KNAB, I grandi disegni italiani dell'Albertina di Vienna, Milan 1971. – M. KOZLOFF, Jasper Johns, New York 1972. – J. KRUSE, Die Zeichnungen Rembrandts und seiner Schule im Nationalmuseum zu Stockholm, 2 vol., The Hague 1920. – O. KURZ, Giorgio Vasari's Libro de' Disegni, in Old Master Drawings December 1937. – Il Libro de' Disegni di Giorgio Vasari, in Studi Vasariani Florence 1950. – Bolognese Drawings of the XVII and XVIII centuries... at Windsor Castle, London 1955. – J. KUZNETSOV, Capolavori fiamminghi e olandesi, Collection "I Disegni dei maestri" Milan 1970. – A. de LABARRE, Les Manuscrits à peinture de la Cité de Dieu de Saint Augustin, 2 vol., Paris 1909. – E. J. LABARDE, Dictionary and Encyclopedia of Paper and Paper Making, Amsterdam 1952. – H. P. LANDOLT, Das Skizzenbuch Hans Holbeins des Aelteren im Kupferstichkabinett Basel, 2 vol., Olten/Switzerland 1960. – 100 dessins de Maîtres des XVe siècle et XVIe siècle, tirés du Cabinet des Estampes de Bâle, Basel 1972. – K. LANGE / F. L. FUHSE, Dürers schriftlicher Nachlass, Halle 1893. – J. LANTHEMANN, Modigliani 1884-1920, catalogue raisonné, Paris 1970. – G. LAPOUGE, L'Univers de Michel-Ange, Collection "Les Carnets de dessins" Paris 1973. – J. LASSAIGNE, Toulouse-Lautrec, Collection "Les Grands Maîtres de la Peinture", Paris 1946. – Dessins de Severini, Paris 1947. – Marc Chagall – Dessins inédits, Geneva 1968. – J. B. A. LASSUS / A. DARCEL, Album de Villard de Honnecourt, manuscrit publié et annoté par J.B.A. L., ouvrage mis à jour par A. D., Paris 1968. – H. LAPAUZE, Les portraits dessinés de J. A. D. Ingres, Paris 1903. – Ingres, sa vie, son œuvre, Paris 1911. – Histoire de l'Académie de France à Rome, Paris 1924. – A. P. LAURIE, Pigments and Mediums of the Old Masters, New York 1914. – J. LAUTS, Carpaccio Paintings and Drawings, London 1962. – P. LAVALLÉE, Dessin français du XVIIIe siècle à la Bibliothèque de l'Ecole des Beaux-Arts, Paris 1928. – Le Dessin français du XIIIe au XVIe siècle, Paris 1930. – Musée du Louvre, Collection de reproductions de dessins: vol. 3: H. Fragonard, Paris 1938; vol. 4: E. Delacroix, Paris 1938; vol. 5: A. Watteau, Paris 1939; vol. 1: Musée de Rennes, Paris 1939; vol. 13: Fr. Boucher, Paris 1942. – Les techniques du dessin, leur évolution dans les différentes écoles d'Europe, Paris 1943. – Le dessin français, Paris 1948. – M. LEIRIS, A. Masson, Massacres et autres dessins, Paris 1971. – M. LEIRIS / G. LIMBOUR, A. Masson aux Univers, Geneva 1947. – P. A. LEMOISNE, Degas et son œuvre, 4 vol., Paris 1946. – R. LEPELTIER, Restauration des dessins et estampes, Fribourg 1977. – H. LEPORINI, Die Stilentwicklung der Handzeichnung XIV.-XVIII. Jahrhundert, Vienna 1925. – Die Künstlerzeichnung. Ein Handbuch für Liebhaber und Sammler, Berlin 1928. – U. LEROQUAIS, Les Livres d'heures manuscrits de la Bibliothèque Nationale, 3 vol., Paris 1927. – J.J. LEVEQUE, L'Univers de Millet, Collection "Les Carnets de dessins" Paris 1975. – Sol LEWITT, in "Studio International" London 1969. – Arcs and Lines, Lau-

sanne 1974. – Lines and Colors, n.p. 1975. – J. LEYMARIE, Les Crayons français du XVIe, Paris 1947. – Les dessins de Degas, Paris 1948. – Manet, Paris 1952. – Pastels, dessins et aquarelles de Renoir, Paris 1953. – Paul Gauguin, aquarelles, pastels et dessins en couleurs, Basel 1960. – Braque, New York 1961. – Monet, 2 vol., Paris 1964. – Corot, New York 1966; new enlarged ed. New York/London 1979. – Picasso Drawings, New York 1967. – Who Was Van Gogh?, New York 1968; new ed., Van Gogh, New York/London 1977. – Impressionist Drawings from Manet to Renoir, New York 1969. – Picasso, The Artist of the Century, New York/London 1972, new updated ed. 1976. – Balthus, New York/London 1978. – J. LEYMARIE / F. CACHIN NORA, Klee au Musée d'Art Moderne, Paris 1972. – J. LEYMARIE / J. CASSOU, Fernand Léger, Dessins et Gouaches, Paris 1972. – W. S. LIEBERMAN, Matisse. 50 years of his graphic art, New York/London 1957. – A Treasury of Modern Drawing: the Joan and Lester Avnet Collection in the Museum of Modern Art, New York 1978. – G. LIMBOUR, Masson: Dessins, Paris 1951. – J. G. LINKS, Townscape Painting and Drawing, London 1972. – F. LIPPMANN, Zeichnungen von Albrecht Dürer in Nachbildungen, 7 vol., Berlin 1883-1929. – E. G. LOEBER, Supplement to Labarre's Dictionary and Encyclopedia of Paper and Paper Making, Amsterdam 1967. – C. LORRAIN, Claude Lorrain. Arkadische Welt: Meisterwerke der Landschaftsmalerei aus dem Liber Veritatis des Claude Lorrain, 1600-1682, Wuppertal-Barmen 1971. – F. LUGT, Les marques de collections de dessins et d'estampes, Amsterdam 1921, supplement The Hague 1956. – Les dessins des écoles du Nord de la collection Dutuit, Paris 1927. – Musée du Louvre. Inventaire général des dessins des écoles du Nord, école hollandaise, 2 vol. Paris 1929-31. – Beiträge zu dem Katalog der niederländischen Handzeichnungen in Berlin, Berlin 1931. – Musée du Louvre. Inventaire général des dessins des écoles du Nord, Rembrandt, Paris 1933. – Musée du Louvre. Inventaire général des dessins des écoles du Nord, école flamande, 2 vol., Paris 1949. – Ecole nationale supérieure des Beaux-Arts, Paris. Inventaire général des dessins des écoles du Nord, école hollandaise, Paris 1950. – Musée du Louvre. Inventaire général des dessins des écoles du Nord. Maîtres des Anciens Pays Bas nés avant 1550, Paris 1968. – E. McCURDY, The Notebooks of Leonardo da Vinci, 2 vol., London 1938. – D. MAHON, I Disegni del Guercino nella collezione Mahon, Bologna 1967. – M. MAHONEY, The Drawings of Salvator Rosa, 2 vol., London/New York 1977. – K. E. MAISON, Honoré Daumier. Catalogue raisonné des paintings, watercolours and drawings, 2 vol., London 1968. – K. S. MALEVITCH, Essays on Art, 1915-1933, 2 vol., Copenhagen 1968. – De Cézanne au suprématisme: tous les traités parus de 1915-1922, Lausanne 1974. – Ecrits, Paris 1975. – M. MALINGUE, Matisse. Dessins, Paris 1949. – H. MALO, Chantilly, Musée Condé, Cent deux dessins de Nicolas Poussin, Paris 1933. – N. S. MANGIN, Catalogue de l'œuvre de Braque, Paris 1959. – G. MARCHINI, Su i disegni d'architettura del Vasari. Il Vasari storiografo e artista, in Atti del congresso internazionale nel IV centenario della morte (1974) Florence 1976. – G. MARCHIORI. Matisse, Paris 1967. – K. MARKS, From the Sketchbooks of the Great Artists, New York 1972. – K. MARTIN, Edouard Manet, Aquarelles et Pastels, Basel 1958. – Skizzenbuch des Hans Baldung Grien, 2 vol., Basel 1959. – J. MATHEY, Graphisme de Manet, 2 vol., Paris 1961-63. – P. L. MATHIEU, Gustave Moreau, sa vie, son œuvre, catalogue raisonné de l'œuvre achevé, Fribourg 1976. – H. MATISSE, Ecrits et propos sur l'art. Textes, notes établis par D. Fourcade, Paris 1972. – A. L. MAYER, Die Skizzenbücher Francisco Goyas, Berlin n.d. – Handzeichnungen spanischer Meister, 150 Skizzen und Entwürfe vom 16.-19. Jahrhundert, Leipzig 1915. – A.H. MAYOR, Giovanni Battista Piranesi, New York 1952. – P. MAZARS, L'Univers de Fragonard, Collection "Les Carnets de dessins" Paris 1972. – J. MEDER, Handzeichnungen aus der Albertina und anderen Sammlungen, 12 vol., Vienna 1893-1908. – Das Büchlein vom Silberstift, Vienna 1909. – Die Handzeichnung, Vienna 1919/1923. – Handzeichnungen französischer Meister in der Albertina, Vienna 1922. – The Mastery of Drawing, translated and revised by Winslow Ames, 2 vol., New York 1978. – P. MELLEN, Jean Clouet, catalogue raisonné des dessins, Paris 1971. – A. MERTON, Die Buchmalerei in St. Gallen, vom 9.-11. Jahrhundert, Leipzig 1923. – C. METTRA, L'Univers de Van Gogh, Collection "Les Carnets de dessins" Paris 1972. – U. MIDDELDORF, Raphael's Drawings, New York 1945. – H. MIELKE / M. WINNER, Die Zeichnungen alter Meister im Berliner Kupferstich-

kabinett: *Peter Paul Rubens, kritischer Katalog der Zeichnungen*, Berlin 1977. – Joan MIRO. *Carnets catalans, dessins et textes inédits présentés par Gaëtan Picon*, Geneva 1976; *Catalan Notebooks: unpublished drawings and writings*, New York/London 1977. – C. MONBEIGGOGUEL, *Il manierismo fiorentino*, Collection "I Disegni dei Maestri" Milan 1970. – *Inventaire des dessins italiens du Musée du Louvre. Vasari et son temps*, Paris 1972. – A. MONGAN, *One Hundred Master Drawings*, Cambridge (Mass.) 1949. – A. MONGAN / P.J. SACHS, *Drawings in the Fogg Museum of Art*, 2 vol., Cambridge (Mass.) 1940. – G. MONNIER, *Dessin*, in Encyclopedia universalis 1969. – *Degas, dessins* in La Revue du Louvre et des Musées de France No. 6 1969. – *Pastels du XVIIᵉ et XVIIIᵉ siècle du Musée du Louvre*. Tome 18 de l'Inventaire des collections publiques françaises 1972. – *Dessins inédits pour la colonnade du Louvre* in Monuments historiques No. 3/4 1972. – *Pastels et miniatures du XVIIIᵉ siècle* in La Revue du Louvre et des Musées de France No. 6 1973. – *La genèse d'une œuvre de Degas: Sémiramis construisant une ville*, in La Revue du Louvre et des Musées de France No. 5/6 1978. – E. MOREAU-NÉLATON, *Chantilly, Les crayons français du XVIᵉ siècle*, Paris 1910. – *Les Clouet et leurs Emules*, Paris 1924. – J. MORENO VILLA, *Dibujos del Instituto de Gijón*, Madrid 1926. – I. MOSKOWITZ, *Great Drawings of all times*, series edited by I.M., New York 1962. – R.J. MOULIN, *H. Matisse. Dessins*, Paris 1968. – E. MULLINS, *The Art of G. Braque*, New York 1963. – L. MUNZ, *Bruegel, the Drawings, complete edition*, London 1961. – M. MURARO, *Disegni veneti della collezione Janos Scholz*, Venice 1957. – H. NAEF, *Avec Ingres à Rome*, in L'Œil No. 41 1958. – *Rome vue par Ingres*, Lausanne 1960. – *Ingres, Rom*, Zürich 1962. – *Die Bildniszeichnungen von J.A.D. Ingres*, Berne 1977. – L. NORMAN / A. MOGELON / B. THOMPSON, *Pastel, charcoal and chalk drawing: history, classical and contemporary techniques*, London 1973. – F. NOVOTNY / J. DOBAI, *Gustave Klimt*, Salzburg 1967. – K. OBERHUBER, *Observations on Perino del Vaga as a draughtsman*, in Master Drawings IV 1966. – *Raphaels Zeichnungen*, Berlin 1972. – *Disegni di Tiziano e della sua cerchia, con l'assistenza di Hilliard Goldfarb*, Venice 1976. – K. OETTINGER / K.A. KNAPPE, *Hans Baldung Grien und Albrecht Dürer in Nürnberg*, Nuremberg 1963. – F. O'HARA, *J. Pollock*, New York 1959. – L.S. OLSCHKI, *I disegni della R. Galleria degli Uffizi in Firenze*, 10 vol., Florence 1912-21. – H. OLSEN, *Federico Barocci*, Copenhagen 1962. – G. PACCHIONI. *C. Carrà*, Milan 1959. – R. PALLUCCHINI, *I designi del Guardi al Museo Correr di Venezia*, Venice 1943. – *Piazzetta*, Milan 1956. – *Giovanni Bellini*, Milan 1959. – E. PANOFSKY, *Albrecht Dürers Kunsttheorie vornehmlich in ihrem Verhältnis zur Kunsttheorie der Italiener*, Berlin 1915. – *Handzeichnungen des Michelangelo*, Leipzig 1922. – *The Codex Huygens and L. da Vinci's art theory*, London 1940. – *Albrecht Dürer*, 2 vol., Princeton 1948. – *The Life and Art of A. Dürer*, Princeton 1955. – *The History of the Theory of Human Proportions as a Reflection of the History of Styles* and *The First Page of Giorgio Vasari's "Libro"* in *Meaning in the Visual Arts*, New York 1955. – *Architecture gothique et pensée scolastique*, Paris 1967. – *La perspective comme forme symbolique*, Paris 1975. – E. PANSU, *Ingres dessins*, Paris 1977. – K.T. PARKER, *Drawings of the Early German Schools*, London 1926. – *The Drawings of Antoine Watteau in the British Museum*, in Old Master Drawings 1930. – *The Drawings of Antoine Watteau*, London 1931. – *Catalogue of the Collection of Drawings in the Ashmolean Museum*, 2 vol., Oxford 1938-56. – *The Drawings of Hans Holbein... at Windsor Castle*, London 1945. – *Holbein, Selected Drawings from Windsor Castle*, London 1954. – K.T. PARKER / J. MATHEY, *Antoine Watteau. Catalogue complet de son œuvre dessiné*, 2 vol., Paris 1957. – G. PASSAVANT, *Verrocchio. Skulpturen, Gemälde und Zeichnungen*, Düsseldorf 1959. – J. PECIRKA, *Degas dessins*, Paris 1963. – C. PEDRETTI / J. ROBERTS, *Drawings by L. da Vinci at Windsor Castle, newly revealed by ultra-violet light*, in The Burlington Magazine 1977. – H.J. PENDERLEITH, *The Conservation of Prints, Drawings and Manuscripts*, Oxford 1937. – S.M. PERCIVAL, *Les portraits au crayon en France au XVIᵉ siècle*, in Gazette des Beaux-Arts II 1962. – A.E. PÉREZ SÁNCHEZ, *Catálogo de los Dibujos de la Real Academia de San Fernando*, Madrid 1967. – *Gli spagnoli dal El Greco a Goya*, Collection "I Disegni dei Maestri" Milan 1970. – J.M. PÉROUSE DE MONTCLOS, *Boullée, Essai sur l'art*, Paris 1968. – *Etienne-Louis Boullée 1728-1799*, Paris 1969. – M. PETZET, *Soufflots Ste Geneviève und der französische Kirchenbau des 18. Jahrhunderts*, Berlin 1961.

– N. PEVSNER, *Academies of Art, Past and Present*, Cambridge 1940. – A. PFANNSTIEL, *Dessins de Modigliani*, Lausanne 1958. – F. di PIETRO, *Disegni sconosciuti e disegni finora non identificati di Federico Barocci negli Uffizi*, Florence 1913. – T. PIGNATTI, *Il Quaderno dei disegni del Canaletto alle Gallerie di Venezia*, Milan 1958. – *Carpaccio*, Geneva 1958. – *I disegni veneziani del settecento*, Collection "Il disegno italiano" Venice 1966. – *Disegni dei Guardi*, Florence 1967. – *La scuola veneta*, Collection "I Disegni dei Maestri" Milan 1970. – *Tiepolo, disegni*, Florence 1974. – *I grandi disegni italiani nelle collezioni di Oxford*, Milan 1976. – *I grandi disegni italiani nelle collezioni di Venezia*, Milan 1977. – A. PISANELLO, *Les Dessins de Pisanello et son Ecole, conservés au Musée du Louvre*, 4 vol., Paris 1911-20. – G. PIVA, *La tecnica della pittura ad olio e del disegno artistico. Con note sulla tecnica di alcuni grandi pittori del passato...*, Milan 1970. – F. PONGE, *Braque – Dessins*, Paris 1950. – J. POPE-HENNESSY, *The Complete Work of Paolo Uccello*, London 1950. – A.E. POPHAM, *The Drawings of Parmigianino*, London n.d. – *Catalogue of Drawings by Dutch and Flemish Artists... in the British Museum; Dutch and Flemish drawings of the XV and XVI centuries*, London 1932. – *A Handbook to the Drawings and Watercolours in the Department of Prints and Drawings, British Museum*, London 1939. – *The Drawings of Leonardo da Vinci*, London 1946. – *Correggio's Drawings*, London/New York 1957. – *Italian Drawings in the Department of Prints and Drawings in the British Museum. Artists working in Parma in the sixteenth century*, London 1967. – *Catalogue of the Drawings of Parmigianino*, 3 vol., London/New Haven 1971 – A.E. POPHAM / K.M. FENWICK, *European Drawings in the Collection of the National Gallery of Canada*, Ottawa 1965. – A.E. POPHAM / P. POUNCEY, *Italian Drawings in... the British Museum: The fourteenth and fifteenth centuries*, 2 vol., London 1950. – A.E. POPHAM / J. WILDE, *The Italian Drawings of the XV and XVI Centuries... at Windsor Castle*, London 1949. – A.E. POPP, *Leonardo da Vinci, Zeichnungen*, Munich 1927. – *Andrea Verrocchio*, in Old Master Drawings 1927. – R. PORTALIS, *Les dessinateurs d'illustrations au XVIIIᵉ siècle*, 2 vol., Paris 1877. – P. POUNCEY / J.A. GERE, *Italian Drawings in the Department of Prints and Drawings in the British Museum. Raphael and his circle*, 2 vol., London 1962. – U. PROCACCI, *Sinopie e affreschi*, Florence 1961. – H. PRUDENT, *Les dessins d'architecture au Musée du Louvre, Ecole française*, Paris n.d. (c. 1880). – *Les dessins d'architecture au Musée du Louvre, Ecole italienne*, Paris n.d. (c. 1880). – P. QUARRE, *Dessins français du XVIIᵉ et XVIIIᵉ*, des Collections du Musée de Dijon, Dijon 1960. – L. RAGGHIANTI-COLLOBI, *Disegni della Fondazione Horne*, Florence 1963. – *Il Libro de' Disegni del Vasari*, 2 vol., Florence 1974. – *Filippo Brunelleschi – un uomo un universo*, Florence 1977. – L. RAGGHIANTI / G. DALLI REGOLI, *Firenze 1470-1480. Disegni dal modello*, Pisa 1975. – G. RAIMONDI, *Disegni di Carrà*, Milan 1942. – P. RATOUIS DE LIMAY, *Le Pastel en France au XVIIIᵉ siècle*, Paris 1946. – H. READ, *The Art of J. Arp*, New York 1968. – J.C. REARICK, *The Drawings of Pontormo*, 2 vol., Cambridge 1964. – L. REAU, *Dessins de Boucher*, Paris 1928. – T. REFF, *The Notebooks of E. Degas: a catalogue of the thirty-eight notebooks in the Bibliothèque Nationale and other collections*, 2 vol., Oxford 1976. – P. RENOIR / S. PIRRA, *125 dessins inédits de P.A. Renoir*, Turin 1971. – L. RETI, *The Unknown Leonardo*, Maidenhead 1974. – J.F. REVEL, *Précurseurs ou utopistes?* in L'Œil No. 87 1962. – *L'invention de la caricature*, in L'Œil No. 109 1964. – *Viollet-le-Duc, précurseur de l'architecture moderne*, in L'Œil No. 110 1964. – G. REYNOLDS, *John Constable's Sketchbooks of 1813-1814*, 3 vol., London 1973. – E.K.J. REZNICEK, *Die Zeichnungen von Hendrick Goltzius*, 2 vol., Utrecht 1961. – C. RICCI, *Jacopo Bellini e i suoi Libri di Disegni*, 2 vol., Florence 1909. – S. de RICCI, *Le dessin français*, Paris n.d. – J.P. RICHTER, *The Literary Works of Leonardo da Vinci, compiled and edited from the original manuscripts by J.P.R.*, 2 vol., Oxford 1977. – A. ROBAUT, *L'œuvre de Corot. Catalogue raisonné et illustré*, 5 vol., Paris 1905. – A. ROBAUT / E. CHESNAU, *L'œuvre complète de Eugène Delacroix, peintures, dessins, gravures, lithographies, (catalogue de A.R., commentaires de E.C.)*, Paris 1885 – M. ROETHLISBERGER, *Notes on the Drawing Books by Jacopo Bellini*, in The Burlington Magazine 1956. – *Un libro inedito del rinascimento lombardo con disegni architettonici*, Rome 1957. – *Claude Lorrain, l'Album Wildenstein*, Paris 1962. – *Bartholomé Breenbergh*, in L'Œil No. 138 1966. – *Claude Lorrain, the drawings*, 2 vol., Berkeley 1968. – *Bartholomäus Breenbergh*

Handzeichnungen, Berlin 1969. – *The Claude Lorrain Album in the Norton Simon Inc. Museum of Art*, Los Angeles 1971. – *L'Opera completa di Claude Lorrain*, Milan 1975. – C. ROGER-MARX, *Eugène Boudin*, Paris 1927. – *Rembrandt*, Paris 1960. – *Trois siècles de sanguine*, in Jardin des Arts 1964. – *Les dessins à la plume*, in Jardin des Arts 1965. – *L'Univers de Delacroix*, Collection "Les Carnets de dessins" Paris 1970. – *L'Univers de Daumier*, Collection "Les Carnets de dessins" Paris 1972. – R. ROLI, *I Disegni italiani del seicento*, Treviso 1969. – B. ROSE, *J. Pollock: works on paper*, Greenwich 1972. – H. ROSENAU, *Boullée and Visionary Architecture*, London 1976. – H. ROSENBERG, *Arshile Gorky, the man, the time, the idea*, New York 1963. – *De Kooning*, New York 1974. – J. ROSENBERG, *Great Draughtsmen from Pisanello to Picasso*, Cambridge (Mass.) 1959. – *Die Zeichnungen Lucas Cranachs d.Ä.*, Berlin 1960. – P. ROSENBERG, *Il seicento francese*, Collection "I Disegni dei Maestri" Milan 1970. – P. ROSSI, *I disegni di Jacopo Tintoretto*, Florence 1975. – G. ROUCHES, *Musée du Louvre: dessins publiés sous la direction de G. Rouchès par Bouchot-Saupique, J. Alazara, E. Dacier, P. Lavallée, G. Rouchès, M. Sérullaz, J. Wilhelm*, 15 fasc., Paris 1938-42. – *Musée du Louvre. Nicolas Poussin, quatorze dessins*, Paris 1938. – *Musée du Louvre. Fra Bartolomeo, quatorze dessins*, Paris 1942. – W. RUBIN, *Picasso in the collection of the Museum of Modern Art*, New York 1972. – U. RUGGERI, *Disegni lombardi secenteschi dell'Accademia Carrara di Bergamo*, Bergamo 1972. – E. RUHMER, *Grünewald Zeichnungen*, Cologne 1970. – F. RUSSOLI, *Modigliani – Drawings and Sketches*, New York 1969. – *Il novecento*, Collection "I Disegni dei Maestri" Milan 1970. – P. SADDY, *Henri Labrouste architecte*, Paris 1977. – L. SAINT-MICHEL, *L'Univers de Corot*, Collection "Les Carnets de dessins" Paris 1974. – L. SALERNO, *Salvator Rosa*, Milan 1963. – *Proporzione*, in Enciclopedia universale dell'arte vol XI Florence 1963. – *Trattatistica*, in Enciclopedia universale dell'arte vol XIV Florence 1966. – R. SALVINI, *Tutta la pittura del Botticelli*, 2 vol., Milan 1958. – *Albrecht Dürer: disegni*, Florence 1973. – F.J. SANCHEZ CANTON, *Los Caprichos de Goya y sus dibujos preparatorios*, Barcelona 1949. – *Dibujos españoles*, 5 vol., Madrid 1930; *Spanish Drawings*, London 1964. – *Dibujos de Goya*, Madrid 1954. – *Catalogo del Museo del Prado*, Madrid 1963. – M. SANKES, *Dessins du 15ᵉ siècle: groupe Van der Weyden, essai de catalogue des originaux du maître, des copies et des dessins anonymes, inspirés de son style*, Brussels 1969. – A. SCHARF, *Filippino Lippi*, Vienna 1935. – R.W. SCHELLER, *A Survey of Medieval Model Books*, Haarlem 1963. – G. SCHIFF, *Zeichnungen von J.H. Füssli 1741-1825*, Zürich 1959. – E. SCHILLING, *Altdeutsche Meisterzeichnungen*, Frankfurt 1934. – *Zeichnungen der Künstlerfamilie Holbein*, Basel 1954. – *Städelsches Kunstinstitut Frankfurt am Main: Katalog der deutschen Zeichnungen, Alte Meister*, 3 vol., Munich 1973. – E. SCHILLING / A. BLUNT, *The German Drawings... at Windsor Castle*, London 1970. – A. SCHMARSOW, *Federico Barocci's Zeichnungen, eine kritische Studie*, 4 vol., Leipzig 1909-13. – A.A. SCHMID, *Die Gemälde und Zeichnungen von Matthias Grünewald*, Strasbourg 1907-11. G. SCHMIDT, *Aquarelles de Paul Cézanne*, Basel; in English, Basel 1952. – D.D. SCHNEIDER, *Works and Doctrines of J.I. Hittorff 1792-1867*, 2 vol., New York 1977. – C.O. SCHNIEDWIND, *A Sketchbook by Toulouse Lautrec owned by the Art Institute of Chicago*, 2 vol., New York 1952. – A. SCHOELLER/ J. DIETERLE, *1ᵉʳ supplément à "L'Œuvre de Corot" par A. Robaut*, Paris 1948. – *2ᵉ supplément à "L'Œuvre de Corot" par A. Robaut*, Paris 1956. – J. SCHOLZ, *Italian Drawings in the Art Museum of Princeton University*, in Burlington Magazine vol. 109 1967. – *Italian Master Drawings 1350-1800 from the Janos Scholz Collection*, New York 1976. – J. SCHOLZ / A. HYATT-MAYOR, *Baroque and Romantic Stage Design*, New York 1950. – J.S.M. SCHÖNBRUNNER / J. MEDER, *Handzeichnungen alter Meister aus der Albertina und anderen Sammlungen*, 12 vol., Vienna 1896-1908. – R. SCHOOLMAN / C. SLATKIN, *Six Centuries of French Master Drawings in America*, New York 1950. – K.H. SCHREYL, *Joseph Maria Olbrich; Die Zeichnungen in der Kunstbibliothek Berlin*, Berlin 1972. – S. SCHULZ, *Villard de Honnecourt et son "carnet"*, in L'Œil No. 123 1965. – H. SCHURITZ, *Die Perspektive in der Kunst Dürers*, Frankfurt 1919. – A. SCHWARZ, *The Complete Works of Marcel Duchamp*, London 1969. – U. SCOTI-BERTINELLI, *Giorgio Vasari scrittore*, Pisa 1905. – J. SCOTT, *Piranesi*, London 1975. – R.R.M. SEE, *Pastels anglais, 1750-1830*, Paris 1911. – W. von SEIDLITZ, *Leonardo da Vinci, der Wendepunkt der Renaissance*, 2 vol.,

Berlin 1909. – W.C. SEITZ, *Arshile Gorky, Paintings, Drawings, Studies*, New York 1962. – G. SELIGMAN, *The Drawings of Georges Seurat*, New York 1947. – J. SELZ, *Dessins et aquarelles du XIXe siècle*, Naefels 1976. – M. SÉRULLAZ, *Musée du Louvre: Camille Corot, quatorze dessins*, Paris 1939. – *Musée du Louvre: Les dessins de Delacroix, dessins, aquarelles et lavis*, Paris n.d. (1952). – *Les plus beaux dessins français du XIXe siècle*, Paris 1963. – *Mémorial de l'exposition Eugène Delacroix organisée au Musée du Louvre à l'occasion du centenaire de la mort de l'artiste*, Paris 1963. – *Dessins français de Prud'hon à Daumier*, Fribourg 1966. – M. and A. SÉRULLAZ, *L'ottocento francese*, Collection "I Disegni dei Maestri" Milan 1970. – M. SÉRULLAZ/ L. DUCLAUX / G. MONNIER, *Dessins du Louvre, Ecole française*, Paris 1968. – J. SHEARMAN, *The Drawings of Nicolas Poussin. Catalogue raisonné*, London 1963. – *Andrea del Sarto*, 2 vol., Oxford 1965. – G. SHERINGHAM, *Drawings in pen and pencil from Dürer's day to ours*, in The Studio 1922. – C. SIBERTIN-BLANC, *Remarques sur les dessins de Sébastien Leclerc exposés à Metz en 1937*, in Bulletin de la Société de l'Histoire de l'Art Français 1938. – E. SINDONA, *Pisanello*, Milan 1961. – O. SIRÉN, *Florentiner Trecentozeichnungen*, in Jahrbuch der Preussischen Kunstsammlungen 1906. – R. SISTU, *Dessins par G. De Chirico*, Rome 1964. – S. SLIVE, *Drawings of Rembrandt, with a Selection of Drawings by his Pupils and Followers*, 2 vol., New York 1965. – F. SMEJKAL, *Le dessin surréaliste*, Paris 1974. – C.H. SMYTH, *Bronzino as Draughtsman*, New York 1971. – J.T. SOBY, *Paintings, Drawings, Prints: Salvador Dali*, New York 1941. – *Modigliani*, New York 1954. – G. De Chirico, New York 1955. – *Arp*, New York 1958. – *Joan Miró*, New York 1959. – W. SPIES, *Max Ernst, Frottages*, Paris 1968. – *Max Ernst, Œuvre-Katalog*, 3 vol., Cologne 1975. – F.C. SPRINGELL, *Connoisseur and Diplomat, the Earl of Arundel's Embassy to Germany in 1636…*, London 1963. – F. STAMPFLE/ J. BEAN, *Drawings from New York Collections II. The Seventeenth Century in Italy*, Greenwich 1967. – *Metropolitan Museum of Art and The Pierpont Morgan Library, New York: Drawings from New York Collections III. The Eighteenth Century in Italy*, New York 1971. – V.V. STECH, *Rembrandt. Dessins et gravures*, Paris 1964. – L. STEINBERG, *Jasper Johns*, New York 1963. – D. STILLMAN, *The Decorative Work of Robert Adam*, London 1966. – A. STIX/ L. FRÖHLICH-BUM, *Die Zeichnungen der Venezianischen Schule*, Vienna 1926. – *Die Zeichnungen der Toskanischen, Umbrischen und Römischen Schulen in der Graphischen Sammlung Albertina*, Vienna 1932. – A. STIX / A. SPITZMÜLLER, *Beschreibender Katalog der Handzeichnungen in der Staatlichen Graphischen Sammlung Albertina*, Vienna 1941. – R.F. STOLL, *Drawings by Francisco Goya*, New York 1954. – W.L. STRAUSS, *Albrecht Dürer, the Human Figure: the Complete Dresden Sketchbook*, New York 1972. – *The Complete Drawings of Albrecht Dürer*, 6 vol., New York 1974. – A. STROBL, *G. Klimt: Zeichnungen und Gemälde*, Salzburg 1972. – D. SUTTON, *Thomas Howard, Earl of Arundel and Surrey, as a Collector of Drawings*, in The Burlington Magazine 1947. – *French Drawings of the Eighteenth century*, London 1949. – J.J. SWEENEY, *Paul Klee: Paintings, Watercolours 1913 to 1939*, New York 1941. – *Marc Chagall*, New York 1946. – *Joan Miró*, Barcelona 1970. – B. TAYLOR, *Watercolour painting in Britain: vol. 1: 18th century, vol. 2: Romantic period, vol. 3: Victorian period*, London 1966-68. – J.C. TAYLOR, *Futurism*, New York 1961. – D. TERNOIS, *Inventaire général des dessins des Musées de Province, vol. 3: Les dessins d'Ingres au Musée de Montauban. Les Portraits*, Paris 1959. – *Jacques Callot: catalogue complet de son œuvre dessiné*, Paris 1962. – A.

TERRASSE, *L'Univers de Théodore Rousseau*, Collection "Les Carnets de dessins" Paris 1976. – *L'Univers de Seurat*, Collection "Les Carnets de dessins" Paris 1976. – B. TEYSSÈDRE, *Roger de Piles et les débats sur le coloris au siècle de Louis XIV*, Paris 1957. – C. THIEM, *Neu entdeckte Zeichnungen Vasaris und Naldinis für die Sala Grande des Palazzo Vecchio in Florenz*, in Zeitschrift für Kunstgeschichte 1968. – *Florentiner Zeichner des Frühbarock*, Munich 1977. – J. THIIS, *Leonardo da Vinci; The Florentine Years of Leonardo and Verrocchio*, London n.d. (1913). – H. THOMAS, *The Drawings of Giovanni Battista Piranesi*, New York 1954. – J. THUILLIER, *Les tableaux et les dessins d'Everard Jabach*, in L'Œil september 1961. – *Doctrines et querelles artistiques en France au XVIIe: quelques textes oubliés ou inédits*, in Archives de l'Art Français No. XXIII 1968. – *Les débuts de l'histoire de l'art en France et Vasari*, in Atti del Congresso internazionale nel IV Centenario della morte Florence 1974. – H. TIETZE, *Albrecht Altdorfer*, Leipzig 1923. – *Venetian Drawings*, New York 1944, 2nd ed. 1970. – *European Master Drawings in the United States*, New York 1947, 2nd ed. 1973. – *Tintoretto, the Paintings and Drawings*, London 1948. – *Titian Paintings and Drawings*, London 1950. – H. TIETZE / O. BENESCH, *Beschreibender Katalog der Handzeichnungen in der Graphischen Sammlung Albertina, IV-V. Die Zeichnungen der deutschen Schulen bis zum Beginn des Klassizismus*, Vienna 1933. – H. TIETZE / E. TIETZE-CONRAT, *Kritisches Verzeichnis der Werke Albrecht Dürers, vol. 1: Der junge Dürer, Verzeichnis der Werke bis zur venezianischen Reise im Jahre 1505*, Augsburg 1928. – *The Drawings of the Venetian Painters in the 15th and 16th Centuries*, New York 1944. – W. TIMM, *Meisterzeichnungen aus sechs Jahrhunderten*, Berlin 1960. – C. de TOLNAY, *Die Zeichnungen Pieter Bruegels*, Munich 1925. – *History and Technique of Old Master Drawings*, New York 1943. – *Michelangelo, vol. 1: The Youth of Michelangelo, vol. 2: The Sistine Ceiling, vol. 3: The Medici Chapel, vol. 4: The Tomb of Julius II, vol. 5: The Final Period*, Princeton 1943-60. – C. de TOLNAY / P. BAROCCHI, *Disegni di Michelangelo*, Milan 1964. – E. TRIER, *Zeichner des XX. Jahrhunderts*, Berlin 1956. – W. UBERWASSER, *Hans Holbein Zeichnungen*, Basel 1947. W. UHDE, *Vincent van Gogh*, Vienna 1936. – L. VACHTOVA, *Fr. Kupka*, London 1968. – L. VAGNETTI, *Disegno e architettura*, Genoa 1958. – *Il linguaggio grafico dell'architetto*, Genoa 1965. – J. VALLERY-RADOT, *Le dessin français au XVIIe siècle*, Lausanne 1953. – J.G. VAN GELDER, *Dutch Drawings and Prints*, New York 1959. – L. VAN PUYVELDE, *The Flemish Drawings at Windsor Castle*, London 1942. – I.Q. VAN REGTEREN ALTENA, *The Drawings of Jacob de Gheyn II, an introduction to study of his drawings*, Amsterdam 1936. – *Holländische Meisterzeichnungen des 17. Jahrhunderts*, Basel 1948. – A. VAN SCHENDEL, *Le dessin en Lombardie jusqu'à la fin du XVe siècle*, Brussels 1938. – G. VASARI, *Le Vite de più eccellenti pittori, scultori ed architettori scritte da… con nuove annotazioni e commenti di G. Milanesi*, 9 vol., Florence 1906. – L. VAYER, *Meisterzeichnungen aus der Sammlung des Museums der Bildenden Künste in Budapest, 14.-18. Jahrhundert*, Berlin/Budapest 1956. – *Chefs-d'œuvre du dessin de la Collection des Beaux-Arts de Budapest, XIVe-XVIIIe siècle*, Budapest 1957. – C.M. de VECCHI DI VAL CISMON / L. ROVERE / V. VIALE / A.E. BRINCKMANN, *Filippo Juvarra*, Milan 1937. – M. VELASCO, *Catálogo de la Sala de Dibujos de la Real Academia de San Fernando*, Madrid 1941. – A. VENTURI, *G. Vasari, Gentile da Fabriano e il Pisanello*, Florence 1896. – *Storia dell'arte italiana*, 11 vol., Milan 1901-39. – *Choix de cinquante dessins de Raffaello*, Paris 1927. – *Pisanello*, Rome 1939. –

L. VENTURI, *Cézanne, son art, son œuvre*, Paris 1936. – *Cézanne*, New York/London 1978. – J. VETH / S. MÜLLER, *Albrecht Dürers niederländische Reise*, 2 vol., Berlin 1918. – G. VIGNI, *Disegni di Tiepolo*, Padua 1942. – E. VIOLLET-LE-DUC, *Voyage aux Pyrénées, 1833: lettres à son père et journal de route, dessins, lavis et aquarelles de l'auteur*, Lourdes 1972. – R. VISCHER, *Luca Signorelli und die italienische Renaissance*, Leipzig 1879. – W. VITZTHUM, *Juvarra et l'Architecture théâtrale*, in L'Œil No. 115-116 1964. – *Cento disegni napoletani*, Florence 1967. – *Le dessin français des Offices*, in L'Œil No. 168-169 1969. – *Il barocco a Napoli e nell'Italia meridionale*, Collection "I Disegni dei Maestri" Milan 1970. – H. VOSS, *Über einige Gemälde und Zeichnungen aus dem Kreise Michelangelos*, in Jahrbuch der Königlich-Preussischen Kunstsammlung 1913. – *Zeichnungen der italienischen Spätrenaissance*, Munich 1928. – D. WALDMAN, *Roy Lichtenstein*, New York 1969. – I. WARE, *Designs of I. Jones and others*, Farnborough 1971. – R. WARNER, *Dutch and Flemish Flowers and Fruit Painters of the XVIIth and XVIIIth centuries*, Amsterdam 1975. – W. WEGNER, *Die niederländischen Handzeichnungen des 15.-18. Jahrhunderts*, 2 vol., Berlin 1973. – K. WEITZMANN, *Illustration in Roll and Codex, a study of the origin and method of text illustration*, Princeton 1970. – A. WERNER, *Degas Pastels*, London 1969. – C. WHITE, *Dürer, the Artist and his Drawings*, London 1971. – E. WICKHOFF, *Die italienischen Handzeichnungen der Albertina*, Vienna 1892. – J.F. WIJSENBEEK, *Piet Mondrian*, New York 1968. – J. WILDE, *Italian Drawings in the British Museum, Michelangelo and his studio*, London 1953. – J. WILHELM, *François Le Moyne. Quatorze dessins du Musée du Louvre*, Paris 1942. – G. WILKINSON, *Turner's Early Sketchbooks*, London 1972. – *The Sketches of Turner R.A. 1802-20*, London 1974. – A. WILTON, *Turner in der Schweiz, Turner en Suisse*, Dubendorf 1976. – *British Watercolours 1750 to 1850*, London 1977. – F. WINKLER, *Mittel-niederrheinische und westfälische Handzeichnungen des 15. und 16. Jahrhunderts*, Freiburg im Breisgau 1932. – *Die Zeichnungen Albrecht Dürers*, 4 vol., Berlin 1936-39. – M. WINNER, *Federskizzen von Benvenuto Cellini*, in Zeitschrift für Kunstgeschichte 1968. – F. WINZINGER, *Deutsche Meisterzeichnungen der Gotik*, Munich 1949. – *Albrecht Altdorfer Zeichnungen*, Munich 1952. – *Die Zeichnungen Martin Schongauers*, Berlin 1962. – *Albrecht Altdorfer, Graphik, Holzschnitte, Kupferstiche, Radierungen (cat. raisonné)*, Munich 1963. – R. WITTKOWER, *Architectural Principles in the Age of Humanism*, London 1952. – *The Drawings of the Carracci… at Windsor Castle*, London 1952. – *Art and Architecture in Italy 1600 to 1750*, London 1958. – K. WOERMANN, *Handzeichnungen alter Meister im Königlichen Kupferstichkabinett in Dresden*, Munich 1896. – J. WOODWORD, *Tudor and Stuart Drawings*, London 1951. – F. WORMALD, *English Drawings of the tenth and eleventh centuries*, London n.d. – L.H. WÜTHRICH, *Burgen und Wehrbauten in Landschaftszeichnungen des 17.-19. Jahrhunderts*, Berne 1967. – R.P. WUNDER, *Extravagant Drawings of the Eighteenth Century, from the Collection of The Cooper Union Museum*, New York 1962. – A. WYATT, *Le "Libro dei Disegni" du Vasari*, in Gazette des Beaux-Arts, 1859. – G. ZAMPA, *L'Opera completa di Dürer*, Collection "Classici dell'Arte" Milan 1968. – C. ZERVOS, *Pablo Picasso, œuvres de 1895 à 1967*, 25 vol., Paris 1932-72. – W. ZIEGLER, *Die manuellen graphischen Techniken*, Halle 1912. – F. ZINK, *Kataloge des Germanischen Nationalmuseums Nürnberg. Die deutschen Handzeichnungen, vol. 1: Die Handzeichnungen bis zur Mitte des 16. Jahrhunderts*, Nuremberg 1968.

EXHIBITION CATALOGUES

Amsterdam
Rembrandt 1669-1969, Rijksmuseum 1969. – *Franse Tekenkunst, van de 18de eeuw vit Nederlandse Verzamelingen* (J.W. Niemeijer), Rijksmuseum 1974.

Ann Arbor:
Architectural and Ornament Drawings of the 16th to the early 19th Centuries, The Collection of the University of Michigan, Museum of Art 1965.

Arles:
Picasso, Dessins, Gouaches, Aquarelles 1898-1957, Musée Réattu 1957.

Augsburg:
Hans Holbein der Ältere und die Kunst der Spätgotik, Rathaus 1965.

Baden-Baden:
Präraffaeliten, Staatliche Kunsthalle 1973-74.

Baltimore:
Matisse as a draughtsman, Museum of Art 1971. (San Francisco, California Palace of the Legion of Honor; Chicago, Art Institute).

Basel:
Paul Gauguin, zum 100. Geburtsjahr (G. Schmidt), Kunstmuseum 1950. – *Die Malerfamilie Holbein in Basel*, Kunstmuseum 1960. – *Anfänge der Graphik, Holzschnitte, Kupferstiche, Zeichnungen des 15. Jahrhunderts*, Kupferstichkabinett der Öffentlichen Kunstsammlung 1970. – *Paul Klee: Gemälde, Aquarelle, Zeichnungen, Druckgraphik*, Kunstmuseum 1976. – *Zeichnen-Bezeichnen*, Kunstmuseum 1976. – *Paul Cézanne, 150 Zeichnungen im Kunstmuseum Basel...*, Kunstmuseum 1978.

Berlin:
Römische Barockzeichnungen aus dem Berliner Kupferstichkabinett (P. Dreyer), Staatliche Museen Preussischer Kulturbesitz 1969. – *Pieter Bruegel d. Ä. als Zeichner*, Kupferstichkabinett, Staatliche Museen 1975.

Berne:
Henri Matisse 1950-54; Les grandes gouaches découpées, Kunsthalle 1959. – *Paul Klee: das graphische und plastische Werk* (M. Franciscano, Chr. Geelhaar, J. Glaesemer...), Kunstmuseum 1975. – *Paul Klee: L'œuvre des dernières années 1937-1940* (J. Glaesemer, M. Baumgartner, M.L. Schaller), Kunstmuseum 1979.

Bloomington:
The Academic Tradition (S. Whitfield), Indiana University Art Museum 1968.

Bologna:
I Carracci, disegni (D. Mahon), Palazzo dell'Archiginnasio 1956. – *Il Guercino, disegni* (D. Mahon), Pinacoteca Nazionale 1968. – *Niccolò dell'Abbate*, Palazzo dell'Archiginnasio 1969.

Brussels:
Dessins français du Musée du Louvre, Bibliothèque Royale Albert Ier 1936-37. – *Esquisses de Rubens*, Musées Royaux des Beaux-Arts de Belgique 1937. – *Dessins hollandais de Jérôme Bosch à Rembrandt*, Bibliothèque Royale Albert Ier 1937-38. – *Dessins hollandais du siècle d'or, choix de dessins provenant de Collections publiques et particulières néerlandaises*, Bibliothèque Royale Albert Ier 1961. – *Le Siècle de Bruegel, la peinture en Belgique au XVIe siècle*, Musées Royaux des Beaux-Arts de Belgique 1963. – *Dürer et son temps, chefs-d'œuvre du dessin allemand de la Collection du Kupferstichkabinett Berlin, XVe et XVIe siècle*, Musées Royaux des Beaux-Arts de Belgique 1964. – *Le siècle de Rubens*, Musées Royaux des Beaux-Arts de Belgique 1965. – *Cent dessins de maîtres anciens du Cabinet des Estampes de Dresde*, Bibliothèque Royale Albert Ier 1967. – *Dessins de paysagistes hollandais du XVIIe siècle* (C. van Hasselt), Bibliothèque Royale Albert Ier 1968. (Rotterdam, Museum Boymans-van Beuningen; Paris, Institut Néerlandais; Berne, Kunstmuseum 1969). – *Turner watercolours lent by the British Museum*, Musée d'Art Moderne 1970. – *Bruxelles 1900, Capitale de l'art nouveau* (R.L. Delevoy, G. Wieser, M. Culot), Ecole Nationale Sup. d'Architecture et des Arts Visuels 1971. – *Van Rembrandt tot Van Gogh. Tekeningen van hollandse meesters uit de verzamelingen van de Koninklijke Musea voor Schone Kunsten van België*, Musées Royaux des Beaux-Arts de Belgique 1971. – *Dessins flamands et hollandais au 17e siècle*, Bibliothèque Royale Albert Ier 1972-73. – *Vélins du Museum*, Bibliothèque Royale Albert Ier 1974. – *Albert Dürer aux Pays-Bas, son voyage (1520-1521), son influence*, Musées Royaux des Beaux-Arts de Belgique 1977.

Cambridge (GB):
17th Century Flemish Drawings and Oilsketches (C. van Hasselt), Fitzwilliam Museum 1958.

Cambridge (USA):
Memorial Exhibition, Works of Art from the Collection of Paul J. Sachs (1878-1965), Fogg Art Museum, Harvard University 1965-67. (New York, Museum of Modern Art). – *Ingres: Centennial Exhibition 1867-1967* (A. Mongan, H. Naef), Fogg Art Museum, Harvard University 1967. – *Tiepolo: A Bicentenary Exhibition 1770-1970* (G. Knox, A. Mongan), Fogg Art Museum, Harvard University 1970.

Chicago:
Gauguin, Paintings, Drawings, Prints, Sculpture, Art Institute of Chicago 1959. – *Picasso in Chicago*. *Paintings, Drawings and Prints from Chicago Collections*, Art Institute 1968. – *Rembrandt after three hundred years*, Art Institute 1969.

Cleveland:
The Graphic Art of Federico Barocci (E.P. Pillsbury, L.S. Richards), Museum of Art and Yale University Art Gallery 1978.

Cologne:
Rodolphe Bresdin (H.A. Peters), Wallraf-Richartz-Museum 1972. (Frankfurt, Städelsches Kunstinstitut 1972-73).

Darmstadt:
Gustav Klimt, drei Internationale der Zeichnung (O. Breicha, R. Leopold), Kunsthalle 1970.

Detroit:
Romantic Art in Britain, Paintings and Drawings 1760-1860, The Detroit Institute of Arts 1968. (Philadelphia Museum of Art).

Essen:
Gustav Klimt, Zeichnungen aus Albertina- und Privatbesitz, Museum Folkwang 1976.

Florence:
Disegni d'arte decorativa (L. Marcucci), Gabinetto disegni e stampe degli Uffizi 1951. – *Disegni manoscritti e documenti*, Gabinetto disegni e stampe degli Uffizi 1952. – *Disegni veneziani del sei e settecento* (M. Muraro), Gabinetto disegni e stampe degli Uffizi 1953. – *Disegni dei primi manieristi italiani*, Gabinetto disegni e stampe degli Uffizi 1954. – *Disegni di Filippino Lippi e Piero di Cosimo* (M. Fossi), Gabinetto disegni e stampe degli Uffizi 1955. – *Disegni di Jacopo Tintoretto e della sua scuola* (A. Forlani), Gabinetto disegni e stampe degli Uffizi 1956. – *Affreschi staccati* (U. Baldini, L. Berti), Galleria degli Uffizi 1958. – *Disegni italiani di cinque secoli*, Gabinetto disegni e stampe degli Uffizi 1961. – *Disegni di Michelangelo* (P. Barocchi), Gabinetto disegni e stampe degli Uffizi 1962. – *Disegni del Vasari e della sua cerchia* (P. Barocchi), Gabinetto disegni e stampe degli Uffizi 1964. – *Disegni fiamminghi e olandesi* (E.K.J. Reznicek), Gabinetto disegni e stampe degli Uffizi 1964. – *Disegni dei fondatori dell'Accademia delle Arti del Disegno* (P. Barocchi, A. Bianchini, A. Forlani, M. Fossi), Gabinetto disegni e stampe degli Uffizi 1965. – *Designi di Perino del Vaga e la sua cerchia*, Gabinetto disegni e stampe degli Uffizi 1966. – *Disegni degli Zuccari (Taddeo e Federico Zuccari e Raffaellino da Reggio)* (J.A. Gere), Gabinetto disegni e stampe degli Uffizi 1966. – *Disegni italiani della Collezione Santarelli* (A. Forlani Tempesti, M. Fossi Todorow, G. Gaeta, A.M. Petrioli), Gabinetto disegni e stampe degli Uffizi 1967. – *Disegni di Bernardo Buontalenti* (I.M. Botto), Gabinetto disegni e stampe degli Uffizi 1968. – *Disegni francesi da Callot a Ingres* (P. Rosenberg), Gabinetto disegni e stampe degli Uffizi 1968. – *Feste e apparati medicei da Cosimo I a Cosimo II* (disegni e incisioni) (A.M. Petrioli Tofani, G. Gaeta), Gabinetto disegni e stampe degli Uffizi 1969. – *Disegni di Alessandro Allori* (S. Lecchini Giovannoni), Gabinetto disegni e stampe degli Uffizi 1970. – *Omaggio a Dürer* (stampe e disegni) (A.M. Petrioli Tofani), Gabinetto disegni e stampe degli Uffizi 1971. – *Disegni italiani di paesaggio del seicento e del settecento* (M. Chiarini), Gabinetto disegni e stampe degli Uffizi 1973. – *Disegni di Federico Barocci* (G. Bertelà), Gabinetto disegni e stampe degli Uffizi 1975. – *Tiziano e il disegno veneziano del suo tempo* (W.R. Rearick), Gabinetto disegni e stampe degli Uffizi 1976. – *Disegni antichi degli Uffizi. I tempi del Ghiberti* (F. Bellini), Gabinetto disegni e stampe degli Uffizi 1978.

Geneva:
Dessins flamands et hollandais du XVIe au XVIIIe siècle. Collections des Musées Royaux des Beaux-Arts de Belgique, Musée d'Art et d'Histoire, Cabinet des Estampes 1969-70. – *Dessins anciens d'Architecture et de Décoration* (A. de Herdt), Musée d'Art et d'Histoire 1979.

Genoa:
Opere grafiche di Umberto Boccioni (G. Bruno), Palazzo dell'Accademia 1968.

Ghent:
Roelant Savery, Museum voor Schone Kunsten 1954.

Hamburg:
Spanische Zeichnungen von El Greco bis Goya, Kunsthalle 1966. – *Piranesi*, Kunsthalle 1970.

Helsinki:
P.P. Rubens, Esquisses-Dessins-Gravures, Athenaeum, 1952-53.

Houston:
Builders and Humanists, University of St. Thomas 1966. – *Visionary Architects, Boullée, Ledoux, Lequeu*, University of St. Thomas 1967-68. (New York, Metropolitan Museum of Art; Chicago, Art Institute). – *Art Nouveau, Belgium, France* (Y. Bunhammer), Institute for the Arts, Rice University 1976.

Ingelheim am Rhein:
Honoré Daumier, Peintures, Dessins, Lithographies, Sculptures, Villa Schneider 1971.

Karlsruhe:
Hans Baldung Grien, Staatliche Kunsthalle 1959. – *200 französische Meisterzeichnungen 1530 bis 1830*, Staatliche Kunsthalle 1972-73. (Berlin; Bremen).

Kassel:
Turner und die Dichtkunst: Aquarelle, Graphik, Staatliche Kunstsammlung 1976.

Krefeld:
J. Beuys, Zeichnungen 1946-1971, Museum Haus Lange 1974.

Lille:
Dessins italiens du Musée de Lille, Musée des Beaux-Arts 1967-68. (Amsterdam; Brussels).

London:
Turner Collection (D.S. McColl), National Gallery 1920. – *Italian Drawings*, Royal Academy, Burlington House 1930. – *Leonardo da Vinci, quincentenary exhibition*, Royal Academy, Burlington House 1952. – *Drawings by Old Masters*, Royal Academy, Burlington House 1953. – *Tiepolo Drawings*, Victoria and Albert Museum 1961-62. – *Old Master Drawings from National Gallery of Scotland*, Colnaghi Gallery 1966. – *France in the eighteenth century*, Royal Academy, Burlington House 1968. – *The Art of Claude Lorrain*, Hayward Gallery 1969. – *Leonardo da Vinci*, The Queen's Gallery, Buckingham Palace 1969-70. – *The Art of Drawing, 1100 BC – AD 1900*, British Museum 1972. – *English Drawings and Watercolours*, Colnaghi Gallery 1972. – *Dessins flamands du dix-septième siècle, Collection Frits Lugt, Institut Néerlandais Paris* (C. van Hasselt), Victoria and Albert Museum 1972. (Paris, Institut Néerlandais; Berne, Kunstmuseum; Brussels, Bibliothèque Royale Albert Ier). – *An American Museum of Decorative Art and Design, Designs from the Cooper-Hewitt Collection*, Victoria and Albert Museum 1973. – *Old Master Drawings from Chatsworth* (J. Byam Shaw, T.S. Wragg), Victoria and Albert Museum 1973. – *Salvator Rosa*, Hayward Gallery 1973. – *Turner 1775-1851*, Tate Gallery 1974-75. – *Drawings by Michelangelo*, British Museum 1975. – *Leonardo da Vinci, Anatomical Drawings from the Royal Collection*, Royal Academy, Burlington House 1977. – *Rubens, Drawings and Sketches* (J. Rowlands), British Museum 1977.

Los Angeles:
The Cubist Epoch, County Museum of Art 1970-71. (New York, Metropolitan Museum of Art). – *The Claude Lorrain Album in the Norton Simon Inc. Museum of Art* (M. Roethlisberger), Norton Simon Inc. Museum of Art 1971. – *Géricault*, County Museum of Art 1971-72. (Detroit Institute of Arts; Philadelphia Museum).

Lucerne:
Zeichnungen italienischer Meister, aus den Sammlungen Schloss Fachsenfeld, Stiftung Ratjen Vaduz, Staatsgalerie Stuttgart, Staatliche Graphische Sammlung München, Kunstmuseum 1979.

Manchester:
Dutch and Flemish Landscape Drawings, Whitworth Art Gallery 1976.

Milan:
L'opera grafica di Carrà (G. Ballo), Accademia di Brera 1967.

Montreal:
Dessins italiens aux Etats-Unis et au Canada (W. Vitzthum), Musée des Beaux-Arts 1970.

Munich:
Rembrandt-Zeichnungen, Staatliche Graphische Sammlung 1957. – *Paul Gauguin* (K. von Etzdorf), Haus der Kunst 1960. – *Italienische Zeichnungen der Frührenaissance*, Staatliche Graphische Samm-

lung 1966. – *Italienische Zeichnungen 15.-18. Jahrhundert*, Staatliche Graphische Sammlung 1967. – *Europäische Meisterwerke aus Schweizer Sammlungen*, Staatliche Graphische Sammlung 1969. – *Das Aquarell 1400-1950*, Haus der Kunst 1972-73.

New York:
Modern Drawings (M. Wheeler), Museum of Modern Art 1947. – *Drawings by Giovanni Battista Piranesi*, Pierpont Morgan Library 1949. – *The first quarter century of the Pierpont Morgan Library*, Pierpont Morgan Library 1949. – *Landscape Drawings. Bruegel to Cézanne*, Pierpont Morgan Library 1953. – *Drawings and Oilsketches by P.P. Rubens from American Collections* (A. Mongan, F. Stampfle), Pierpont Morgan Library 1956. (Cambridge, Fogg Art Museum). – *Rembrandt Drawings from American Collections* (F. Stampfle, E. Haverkamp Begemann), Pierpont Morgan Library 1960. (Cambridge, Fogg Art Museum). – *The Graphic Work of Umberto Boccioni* (J. C. Taylor), Museum of Modern Art 1961. – *Odilon Redon, Gustave Moreau, Rodolphe Bresdin*, Museum of Modern Art 1961-62. (Chicago, Art Institute). – *Drawings from New York Collections I. The Italian Renaissance* (J. Bean, F. Stampfle), Metropolitan Museum of Art 1965-66. – *Drawings from New York Collections II. The Seventeenth Century in Italy* (J. Bean, F. Stampfle), Metropolitan Museum of Art 1967. – *Willem De Kooning* (T.B. Hess), Museum of Modern Art 1968. – *Drawings from Stockholm, a loan exhibition from the National Museum* (P. Bjurström), Pierpont Morgan Library 1969. (Boston, Museum of Fine Arts; Chicago, Art Institute). – *Drawings from New York Collections III. The 18th Century in Italy* (J. Bean, F. Stampfle), Metropolitan Museum of Art 1971. – *Giovanni Battista Piranesi, Drawings and Etchings at Columbia University*, Columbia University 1972. – *Major Acquisitions of the Pierpont Morgan Library 1924-1974: Drawings* (F. Stampfle), Pierpont Morgan Library 1974. – *Architectural and Ornament Drawings* (M.L. Myers), Metropolitan Museum of Art 1975. – *Drawings from the Collection of Mr and Mrs Eugene V. Thaw* (F. Stampfle, C.D. Denison, E.V. Thaw), Pierpont Morgan Library 1975-76. (Cleveland, Museum of Art; Chicago, Art Institute). – *Drawing Now: 1955-1975* (B. Rose), Museum of Modern Art 1976 (Albertina, Vienna; Kunsthaus, Zürich). – *European Drawings from the Fitzwilliam* (M. Jaffé, D. Robinson, M. Cormack), Pierpont Morgan Library 1976-77. (Baltimore Museum of Art; Minneapolis Institute of Art; Philadelphia Museum of Art…). – *Cézanne, the late work* (T. Reff, L. Gowing…), Museum of Modern Art 1977. – *Rembrandt and his Contemporaries. Dutch Drawings of the 17th Century* (C. van Hasselt), Pierpont Morgan Library 1977-78. (Paris, Institut Néerlandais). – *XV-XVI Century Northern Drawings from the Robert Lehman Collection* (G. Szabo), Metropolitan Museum of Art 1978. – *French and Italian Neoclassical Drawings and Prints from the Cooper-Hewitt Museum*, The Smithsonian Institution 1978. – *17th Century Italian Drawings in the Metropolitan Museum of Art* (J. Bean), Metropolitan Museum of Art 1979.

Nuremberg:
Albrecht Dürer 1471-1971, Germanisches National Museum 1971.

Ottawa:
European Drawings, National Gallery of Canada 1965. – *Jacob Jordaens* (A.M. Jaffé), National Gallery of Canada 1968. – *European Drawings from Canadian Collections 1500-1900*, National Gallery of Canada 1976.

Otterlo:
Function of Drawings, Rijksmuseum Kröller-Müller 1975.

Paris:
L'Art des Jardins de France, du XVIe siècle à la fin du XVIIIe siècle, Musée des Arts Décoratifs 1913. – *Le Siècle de Louis XIV*, Bibliothèque Nationale 1927. – *Exposition de dessins italiens*, Orangerie 1931. – *Pisanello, Médailles, Dessins, Peintures*, Bibliothèque Nationale 1932. – *Estampes de Rembrandt et d'Albert Dürer*, Petit Palais 1933. – *Hubert Robert 1733-1808*, Orangerie 1933. – *Art italien des XVe et XVIe siècles*, Ecole des Beaux-Arts 1935. – *Jacques Callot et les graveurs lorrains du XVIIe siècle. Guide et catalogue de l'exposition du IIIe centenaire de la mort de Callot*, Bibliothèque Nationale 1935. (Nancy, Musée Lorrain). – *L'Aquarelle de 1400 à 1900*, Orangerie 1936. – *Les plus beaux manuscrits français du VIIIe au XVIe siècle*, Bibliothèque Nationale 1937. – *Rembrandt. Dessins et Eaux-Fortes*, Orangerie 1937. – *Le dessin français de Fouquet à Cézanne*, Orangerie 1950. – *Le paysage hollandais au XVIIe siècle*, Orangerie 1950. – *Dessins florentins du Trecento et du Quattrocento*, Louvre, Cabinet des Dessins 1952. –

Hommage à Léonard de Vinci, exposition en l'honneur du cinquième centenaire de sa naissance, Louvre 1952. – *Musée Boymans de Rotterdam, Dessins du XVe au XIXe siècle*, Bibliothèque Nationale 1952. – *Philippe de Champaigne* (B. Dorival), Orangerie 1952. – *Henri Labrouste*, Bibliothèque Nationale 1953. – *Chefs-d'œuvre de la Collection Edmond de Rothschild au Musée du Louvre, Dessins et Gravures*, Orangerie 1954. – *Le Dessin, de Toulouse-Lautrec aux Cubistes* (B. Dorival), Musée National d'Art Moderne 1954. – *Dessins de Maîtres florentins et siennois de la première moitié du XVIe siècle* (J. Bouchot-Saupique), Louvre, Cabinet des Dessins 1955. – *Dessins de jeunesse de Delacroix*, Louvre, Cabinet des Dessins 1955. – *De David à Toulouse-Lautrec, chefs-d'œuvre des collections américaines*, Orangerie 1955. – *Les manuscrits à peintures en France du XIIIe au XVIe siècle*, Bibliothèque Nationale 1955. – *Odilon Redon*, Orangerie 1956-57. – *La collection Lehman*, Orangerie 1957. – *Enluminures et dessins français du XIIIe au XVIe siècle*, Louvre, Cabinet des Dessins 1957. – *De Clouet à Matisse, Dessins français des Collections américaines* (A. Houghton, S.J. Bouchot), Orangerie 1958-59. (Rotterdam, Museum Boymans; New York, Metropolitan Museum of Art). – *Dessins florentins de la collection Filippo Baldinucci* (R. Bacou), Louvre, Cabinet des Dessins 1958. – *Le XVIIe siècle français* (M. Laclotte), Petit Palais 1958. – *Dessins de Jean-François Millet* (R. Bacou), Louvre, Cabinet des Dessins 1960. – *Dessins français du XVIIe siècle. Artistes français contemporains de Poussin* (J. Bouchot-Saupique), Louvre, Cabinet des Dessins 1960. – *Les Dessins italiens de la collection Bonnat* (J. Bean), Louvre 1960. – *Dessins romains du XVIIe siècle. Artistes italiens contemporains de Poussin*, Louvre, Cabinet des Dessins 1960. – *Nicolas Poussin*, Louvre 1960. – *Le siècle de Louis XIV*, Musée des Arts décoratifs 1960. – *L'Art français au XVIIe siècle*, Ecole des Beaux-Arts 1961. – *Jean Arp*, Musée National d'Art Moderne 1962. – *Dessins des Carrache* (R. Bacou), Louvre, Cabinet des Dessins 1962. – *Dessins de Corot*, Louvre, Cabinet des Dessins 1962. – *Première exposition des plus beaux dessins du Louvre et de quelques pièces célèbres des collections de Paris*, Louvre 1962. – *Delacroix, dessins* (R. Bacou), Louvre, Cabinet des Dessins 1963. – *Dessins de l'Ecole de Parme*, Louvre, Cabinet des Dessins 1964. – *Le dessin français dans les collections hollandaises*, Institut Néerlandais 1964. (Amsterdam, Rijksmuseum). – *Centenaire de Toulouse-Lautrec*, Petit Palais 1964. – *Le Nôtre et l'art des jardins*, Bibliothèque Nationale 1964-65. – *L'Art français au XVIIIe siècle*, Ecole des Beaux-Arts 1965. – *Eugène Boudin, aquarelles et dessins*, Louvre, Cabinet des Dessins 1965. – *Giorgio Vasari, dessinateur et collectionneur* (C. Monbeig-Goguel), Louvre, Cabinet des Dessins 1965. – *Viollet-Le-Duc*, Hôtel de Sully 1965. – *Le XVIe siècle européen. Dessins du Louvre* (G. Monnier), Louvre, Cabinet des Dessins 1965-66. – *Le XVIe siècle européen. Peintures et dessins dans les collections publiques françaises*, Petit Palais 1965-66. – *Vincent van Gogh, dessinateur*, Institut Néerlandais 1966. – *Hommage à Picasso*, Grand Palais 1966-67. – *Le Cabinet d'un Grand Amateur P. J. Mariette 1694-1774, Dessins du XVe siècle au XVIIIe siècle* (R. Bacou, M. Sérullaz, F. Viatte, F. Lugt), Louvre 1967. – *Dessins français du XVIIIe siècle, Amis et contemporains de P.J. Mariette* (L. Duclaux), Louvre, Cabinet des Dessins 1967. – *Ingres*, Petit Palais 1967-68. – *Théodore Rousseau*, Louvre 1967-68. – *Maîtres du Blanc et Noir au XIXe siècle de Prud'hon à Redon* (R. Bacou), Louvre, Cabinet des Dessins 1968. – *Degas, œuvres du Musée du Louvre, Peintures, Pastels, Dessins, Sculptures*, Orangerie 1969. – *Dessins de Taddeo et Federico Zuccaro* (J. A. Gere), Louvre, Cabinet des Dessins 1969. – *Hubert Robert, Les Sanguines du Musée de Valence*, Musée Jacquemart-André 1969. – *Paysagistes hollandais du XVIIe siècle*, Institut Néerlandais 1969. – *Hommage à Marc Chagall* (J. Leymarie), Grand Palais 1969-70. – *Paul Klee*, Musée National d'Art Moderne 1969-70. – *De François 1er à Henri IV. Les Clouets à la Cour des Rois de France* (J. Adhémar), Bibliothèque Nationale 1970. – *Dessins du Nationalmuseum de Stockholm*, Louvre, Cabinet des Dessins 1970. – *Henri Matisse, Exposition du Centenaire* (P. Schneider), Grand Palais 1970. – *Rembrandt et son temps, Dessins des collections publiques et privées conservées en France*, Louvre 1970. – *Le Siècle de Rembrandt*, Petit Palais 1970-71. – *Boucher, gravures et dessins*, Louvre, Cabinet des Dessins 1971. – *Dessins du Musée de Darmstadt*, Louvre, Cabinet des Dessins 1971. – *A. Dürer*, Bibliothèque Nationale 1971. – *Mansart*, Hôtel Sully 1971. – *Cent dessins du Musée Kröller-Müller* (R.W. D. Oxenaar), Institut Néerlandais 1971-72. – *Dessins d'Architecture du XVe au XIXe siècle dans les col-

lections du Musée du Louvre* (G. Monnier), Louvre, Cabinet des Dessins 1972. – *Dessins de la collection du Marquis de Robien conservés au Musée de Rennes*, Louvre, Cabinet des Dessins 1972. – *Le Livre*, Bibliothèque Nationale 1972. – *Pastels au XVIIe et au XVIIIe siècle* (G. Monnier), Louvre, Cabinet des Dessins 1972. – *Vincent van Gogh*, Orangerie 1972. – *Dessins flamands et hollandais du XVIIe siècle, provenant des Musées soviétiques*, Institut Néerlandais 1973. – *G. Braque, l'espace et son parcours* (J. Leymarie), Orangerie 1973-74. – *Dessins français du Metropolitan Museum de New York. De David à Picasso*, Louvre, Cabinet des Dessins 1973-74. – *Acquisitions récentes de toutes époques de la Fondation Custodia (Coll. Frits Lugt)*, Institut Néerlandais 1974. – *Cartons d'artistes du XVe au XIXe siècle*, Louvre, Cabinet des Dessins 1974. – *Dessins du Musée Atger, Montpellier*, Louvre, Cabinet des Dessins 1974. – *Gustave Moreau, catalogue des Peintures, Dessins, Cartons, Aquarelles*, Musée Gustave Moreau 1974. – *Dessins du Musée National d'Art Moderne, 1890-1945* (P. Georgel, M.J. Stern, M. Tabart), Musée National d'Art Moderne 1974-75. – *Le Néoclassicisme français. Dessins des Musées de province*, Grand Palais 1974-75. – *Dessins italiens de l'Albertina de Vienne*, Louvre, Cabinet des Dessins 1975. – *Dessins italiens de la Renaissance*, Louvre, Cabinet des Dessins 1975. – *Hommage à Corot, Peintures et dessins des collections françaises*, Orangerie 1975. – *H. Matisse, dessins et sculpture* (D. Bozo, D. Fourcade), Musée National d'Art Moderne 1975. – *Michel-Ange au Louvre, les dessins* (R. Bacou, F. Viatte), Louvre, Cabinet des Dessins 1975. – *Palladio et les Palladiens français*, Hôtel de Sully 1975. – *Voyageurs au XVIe siècle*, Louvre, Cabinet des Dessins 1975. – *Jean François Millet* (R. L. Herbert, R. Bacou, M. Laclotte), Grand Palais 1975-76. – *Dessins du Musée des Beaux-Arts de Dijon*, Louvre, Cabinet des Dessins 1976. – *Dessins français de l'Art Institute de Chicago, de Watteau à Picasso* (H. Joachim, G. Monnier), Louvre, Cabinet des Dessins 1976-77. – *Puvis de Chavannes*, Grand Palais 1976-77. – *Le corps et son image, anatomies, académies*, Louvre, Cabinet des Dessins 1977. – *De Burne-Jones à Bonnard, dessins provenant du Musée National d'Art Moderne* (J. Lafargue), Louvre, Cabinet des Dessins 1977. – *Grands et petits maîtres des Flandres et de Hollande, dessins de 1525 à 1700 du Cabinet d'un amateur d'Amsterdam*, Institut Néerlandais 1977. – *Collections de Louis XIV, dessins, albums, manuscrits* (R. Bacou et al.), Orangerie 1977-78. – *Gustave Courbet*, Grand Palais 1977-78. – *Cézanne, les dernières années (1895-1906)*, Grand Palais 1978. – *Jasper Johns*, Musée National d'Art Moderne, Centre Pompidou 1978. – *Nouvelles attributions* (R. Bacou), Louvre, Cabinet des Dessins 1978. – *Rubens, ses maîtres, ses élèves, dessins du Musée du Louvre*, Louvre, Cabinet des Dessins 1978. – *Claude Lorrain, dessins du British Museum*, Louvre, Cabinet des Dessins 1978-79. – *Le paysage en Italie au XVIIe siècle, dessins du Musée du Louvre* (R. Bacou), Louvre, Cabinet des Dessins 1978-79. – *Dessins français du XIXe siècle du Musée Bonnat à Bayonne*, Louvre 1979. – *Hector Horeau*, Musée des Arts Décoratifs 1979. – *Charles de Wailly, peintre architecte dans l'Europe des lumières* (M. Moser, D. Rabreau), Caisse nationale des Monuments Historiques et des Sites 1979. – *Le siècle de Rubens et de Rembrandt, dessins flamands et hollandais du XVIIe siècle de la Pierpont Morgan Library de New York* (F. Stampfle), Institut Néerlandais, Paris 1979-80. (Antwerp, London, New York).

Philadelphia:
H. Matisse, retrospective exhibition of paintings, drawings and sculpture, Philadelphia Museum of Art 1948. – *Masterpieces of Drawing*, Philadelphia Museum of Art 1950-51. – *Giovanni Benedetto Castiglione* (A. Blunt, W. Percy), Philadelphia Museum of Art 1971.

Phoenix (Arizona):
Forty-two British Watercolours from the Victoria and Albert Museum (J. Murdoch), Phoenix Art Museum 1977. (Salt Lake City, Utah Museum of Fine Arts; …).

Rome:
Disegni fiorentini del Museo del Louvre dalla Collezione di Filippo Baldinucci (R. Bacou, J. Bean), Gabinetto Nazionale delle Stampe 1959. – *Il Disegno francese da Fouquet a Toulouse-Lautrec*, Palazzo Venezia 1959. – *Il ritratto francese da Clouet a Degas*, Palazzo Venezia 1962. – *Il Paesaggio nel disegno del cinquecento europeo* (R. Bacou, F. Viatte, G. della Piane Perugini), Villa Medici 1972-73. – *Piranèse et les Français 1740-1790*, Villa Medici 1976. (Dijon, Palais des Etats de Bourgogne; Paris, Hôtel Sully).

Rotterdam:
Rembrandt. Tentoonstelling ter herdenkig van de Geboorte van Rembrandt, Museum Boymans-van Beuningen 1956. (Amsterdam, Rijksmuseum; Stockholm, Nationalmuseum; Vienna, Albertina). – *Hendrick Goltzius als Tekenaar,* Museum Boymans-van Beuningen 1958. (Haarlem, Teylers Museum). – *Jean Gossaert dit Mabuse* (H. Pauwels, H.R. Hoetink, S. Herzog), Museum Boymans-van Beuningen 1965. (Bruges, Musée communal Groeninge). – *Le Cabinet d'un Amateur, dessins flamands et hollandais des XVI^e et XVII^e siècles d'une collection privée d'Amsterdam,* Museum Boymans-van Beuningen 1976-77. (Paris; Brussels).

Rouen:
Nicolas Poussin et son temps, Musée des Beaux-Arts 1961. – *Choix de dessins anciens* (P. Rosenberg, A. Schnapper), Bibliothèque Municipale 1970. – *L'écorché,* Musée des Beaux-Arts 1977.

Schaffhausen:
Die Zeichnungen des 16. und 17. Jahrhunderts (F. Thöne), Museum zu Allerheiligen.

Stockholm:
Italienska Handtechningar fran 1400- och 1500 talen (O. Sirén), Nationalmuseum 1917. – *The two churches of the Hôtel des Invalides, a history of their design* (P. Reuterswärd), Nationalmuseum 1965. – *Les dessins italiens de la Reine Christine de Suède* (J.Q. van Regteren Altena), Nationalmuseum 1966.

Toronto:
Master Drawings from a Private New York Collection, Art Gallery of Ontario 1971. – *French Master Drawings of the 17th and 18th centuries in North American Collections* (P. Rosenberg), Art Gallery of Ontario 1972-73. (Ottawa, National Gallery of Canada; San Francisco, California Palace of the Legion of Honor; New York, The New York Cultural Center).

Tours:
Dessins et manuscrits de Léonard de Vinci: Ambrosiana, Galeries d'Italie, Musées de France, Musée des Beaux-Arts 1956.

Trieste:
Pitture, disegni e stampe del 700 dalle Collezioni dei Civici Musei di Storia ed Arte, Museo Sartorio 1972.

Turin:
Robert e Sonja Delaunay (G. Wellen). Galleria Civica d'Arte Moderna 1960.

Venice:
Cento antichi disegni veneziani (G. Fiocco), Fondazione Cini 1955. – *Disegni veneti di Oxford* (K.T. Parker), Fondazione Cini 1958. – *Disegni veneti in Polonia* (M. Mrazinska), Fondazione Cini 1958. – *I disegni del Codice Bonola del Museum di Varsavia* (M. Mrazinska), Fondazione Cini 1959. – *Disegni veneti dell'Albertina di Vienna* (O. Benesch, K. Oberhuber), Fondazione Cini 1961. – *Canaletto e Guardi* (K.T. Parker, J. Byam Shaw), Fondazione Cini 1962. – *Disegni veneti del Settecento della Fondazione Giorgio Cini e delle collezioni venete* (A. Bettagno), Fondazione Cini 1963. – *Disegni veneti del Museo di Leningrado* (L. Salmina), Fondazione Cini 1964. – *Disegni veneti del Settecento nel Museo Correr di Venezia* (T. Pignatti), Fondazione Cini 1964. – *Disegni veneti del Museo di Budapest* (I. Fenyö), Fondazione Cini 1965. – *Disegni del Pisanello e di maestri del suo tempo.* (B. Degenhart, A. Schmitt), Fondazione Cini 1966. – *Dal Ricci al Tiepolo, I pittori di figura del Settecento a Venezia* (P. Zampetti), Palazzo Ducale 1969. – *Disegni teatrali di Inigo Jones* (R. Strong, G. Folena), Fondazione Cini 1969. – *Disegni teatrali dei Bibiena* (M.T. Muraro, E. Povoledo, G. Folena), Fondazione Cini 1970. – *Disegni veronesi del Cinquecento* (T. Mullaly), Fondazione Cini 1971. – *Venetian Drawings of the 18th Century* (A. Bettagno, G. Palewski), Fondazione Cini 1971. – *Disegni veneti del Museo di Stoccolma* (P. Bjurström). Fondazione Cini 1974. – *Disegni di Tiziano e della sua cerchia* (K. Oberhuber), Fondazione Cini 1976. – *Italienische Miniaturen der Renaissance* (P. and I. Toesca), Fondazione Cini 1977. – *Disegni di Giambattista Piranesi* (A. Bettagno), Fondazione Cini 1978.

Versailles:
Charles Le Brun, peintre et dessinateur (J. Thuillier, J. Montagu), Château de Versailles 1963.

Vienna:
Gustav Klimt, Zeichnungen, Albertina 1963 – *Parmigianino und sein Kreis* (K. Oberhuber), Albertina 1963. – *Claude Lorrain und die Meister der römischen Landschaft im XVII. Jahrhundert* (E. Knab), Albertina 1964-65. – *Meisterzeichnungen aus dem Museum der Schönen Künste in Budapest* Albertina 1967. – *Jacques Callot und sein Kreis* (E. Knab), Albertina 1968-69. – *Europäische Meisterzeichnungen aus dem Zeitalter Albrecht Dürers* (E. Knab, N. Keil, F. Koreny), Albertina 1971. – *Von Ingres bis Cézanne,* Albertina 1976-77. – *Zeichnung heute, Drawings now: eine Ausstellung des Museums of Modern Art New York,* Albertina 1976-77. (Zürich, Kunsthaus).

Washington:
Dutch Drawings. Masterpieces of Five Centuries (J.Q. van Regteren Altena), National Gallery of Art 1958-59. (New York, Pierpont Morgan Library; Chicago, Art Institute). – *Old Master Drawings from Chatsworth,* National Gallery of Art 1963-63. (New York, Pierpont Morgan Library; Boston, Museum of Fine Arts; ...). – *Italian Architectural Drawings, lent by the Royal Institute of British Architects,* National Gallery of Art 1966. – *Festival Designs by Inigo Jones,* National Gallery of Art 1967-68. (Houston; Los Angeles; Detroit; Ottawa; ...). – *François Boucher in North American Collections, 100 Drawings* (R. Shoolman Slatkin), National Gallery of Art 1973-74. (Chicago, Art Institute). – *Jacques Callot, prints and related drawings* (H.D. Russell), National Gallery of Art 1975. – *Leonardo da Vinci, anatomical drawings from the Queen's collection at Windsor Castle,* National Museum of History and Technology 1976. (Los Angeles County Museum of Art). – *Master Drawings from the Collection of the National Gallery of Art and promised gifts* (A. Robinson), National Gallery of Art 1978. – *Hubert Robert, Drawings and Watercolors,* National Gallery of Art 1978. – *Drawings by Fragonard in North American Collections,* National Gallery of Art 1978-79. (New York, Frick Collection).

Williamstown (Mass.):
Dutch and Flemish Masters, Sterling and Francine Clark Art Institute 1960.

Winterthur:
Théodore Géricault, Kunstmuseum 1953. – *Von Toepffer bis Hodler, Die Schweizer Zeichnung im 19. Jahrhundert* (R. Hohl), Kunstmuseum 1968. (Chur, Kunsthaus; Luzern, Kunstmuseum; Basel, Kunstmuseum; ...).

Worcester (Mass.):
The Virtuoso Craftsman: Northern European Design in the Sixteenth Century, Worcester Art Museum 1969.

Zürich:
Handzeichnungen alter Meister aus Schweizer Privatbesitz, Kunsthaus 1967. – *G.B. Piranesi,* Graphische Sammlung, Eidg. Technische Hochschule 1976. – *Turner und die Schweiz,* Kunsthaus 1976. – *Jean-Etienne Liotard* (F. Baumann, R. Storrer), Kunsthaus 1978.

List of Illustrations

Dimensions are given in millimetres (mm.) or, for larger works, in centimetres (cm.) or metres (m.). Height precedes width.

Index of Names and Places

278

PUBLISHED SEPTEMBER 1979.

FILMSET BY TYPELEC, GENEVA.
COLOUR PLATES BY LITH-ART, BERNE.
PRINTED BY ROTO-SADAG, GENEVA.
BINDING BY ROGER VEIHL, GENEVA.

PRINTED IN SWITZERLAND

2202 042

ly